FASHION, HISTORY, MUSEUMS

FASHION, HISTORY, MUSEUMS

Inventing the Display of Dress

JULIA PETROV

BLOOMSBURY VISUAL ARTS
LONDON · NEW YORK · OXFORD · NEW DELHI · SYDNEY

BLOOMSBURY VISUAL ARTS
Bloomsbury Publishing Plc
50 Bedford Square, London, WC1B 3DP, UK
1385 Broadway, New York, NY 10018, USA
29 Earlsfort Terrace, Dublin 2, Ireland

BLOOMSBURY, BLOOMSBURY VISUAL ARTS and the Diana logo
are trademarks of Bloomsbury Publishing Plc

First published in Great Britain 2019
This paperback edition published 2021

Cover design by Adriana Brioso
Cover image: Dresses during the Dior exhibition, July 3, 2017 in Paris,
France. (© ALAIN JOCARD/AFP/Getty Images)

A catalogue record for this book is available from the British Library.

A catalog record for this book is available from the Library of Congress.

ISBN:	HB:	978-1-350-04899-7
	PB:	978-1-350-22966-2
	ePDF:	978-1-350-04900-0
	eBook:	978-1-350-04901-7

Typeset by Integra Software Services Pvt. Ltd.
Printed and bound in Great Britain

To find out more about our authors and books visit www.bloomsbury.com and
sign up for our newsletters.

CONTENTS

LIST OF ILLUSTRATIONS

Figures

Tables

LIST OF PLATES

ACKNOWLEDGMENTS

This book is based on PhD research conducted at the University of Leicester, which was financially supported by a doctoral fellowship from the Social Sciences and Humanities Research Council (SSHRC) of Canada. I am particularly grateful to my PhD supervisors, Dr. Sandra Dudley and Dr. Sheila Watson, and my thesis examiners, Professor Simon Knell and Professor Christopher Breward, for their guidance.

The cost of licensing images to use as illustrations was generously subvented with a publication grant from the Pasold Research Fund.

Excerpts from Chapter 1 first appeared in Petrov, J. (2012), "Cross-Purposes: Museum Display and Material Culture," *CrossCurrents*, 62 (2) (June 2012): 219–23, and Petrov, J. (2014), "'Relics of Former Splendor': Inventing the Costume Exhibition, 1833–1835," *Fashion, Style & Popular Culture*, 2 (1) (October 2014): 11–28. Excerpts from Chapters 2 and 4 first appeared in Petrov, J. (2014), "Gender Considerations in Fashion History Exhibitions," in M. Riegels Melchior and B. Svensson (eds) *Fashion and Museums: Theory and Practice*, 77–90, London: Bloomsbury.

My writing and research was materially improved with the advice and help of Vlada Blinova, Dr. Maude Bass-Krueger, Colleen Hill, Dr. Kate Hill, Dr. Anne-Sofie Hjemdahl, Dr. Marie Riegels Melchior, Gail Niinimaa, Professor Lou Taylor, Dr. Gudrun Drofn Whitehead.

I am grateful for the assistance given to me by individuals at the institutions studied as part of this research, particularly Deirdre Lawrence, Angie Park, Monica Park (Brooklyn Museum); Rosemary Harden, Vivien Hynes, Elaine Uttley (Fashion Museum, Bath); Anne-Frédérique Beaulieu, François Cartier, Cynthia Cooper, Nora Hague, Geneviève Lafrance (McCord Museum); Harold Koda, James Moske, Shannon Bell Price, Sarah Scaturro (Metropolitan Museum of Art); Anu Liivandi, Dr. Alexandra Palmer, Nicola Woods (Royal Ontario Museum); Beatrice Behlen, Richard Dabb (Museum of London); Jack Glover Gunn, Alexia Kirk, Christopher Marsden, Victoria West (Victoria and Albert Museum).

At Bloomsbury, I would like to thank Hannah Crump, who encouraged me as I moved the manuscript to the proposal stage, and Frances Arnold, who took it

on. Thanks also to Pari Thomson and her successor Yvonne Thouroude, whose careful attention to administrative matters made the process go smoothly. The comments of the anonymous reviewers helped me to refine my ideas and structure.

None of this would have been possible without the ongoing patience of my friends and family, who provided technical, financial, and emotional support over the last decade.

INTRODUCTION: FASHION AS MUSEUM OBJECT

It has become easy to become complacent about fashion exhibitions in museums. Their sheer number and extravagant scale have drowned out the skeptics who once questioned the place of fashion in the museum. Yearly, and even monthly, news media outlets report lists of the must-see fashion exhibitions worldwide, anticipating the avid interest of their readership. Richly illustrated reviews of the major retrospectives in global centers appear in academic journals and the mainstream media alike; catalogs are sold like coffee-table books. With their associated celebrity spectacle, their designer glamour, and their mystique of intimate history, it is tempting to take contemporary fashion exhibitions at face value.

However, the display of historical fashion is not uninformed or insignificant. It does not merely reflect the technical possibilities, museal conventions, and aesthetic preferences of any given period; neither is it only a chance product of the combination of the resources of the museum and the embodiment of the subjective personal visions of the curatorial and design teams responsible for the exhibit. Far from being passively formed, it is a result of an active series of choices that have at their core particular assumptions about the role of historical dress in culture, then and now; moreover, this has wide-reaching consequences and significance. It is not only the experience and opinion of museum visitors that are affected but the practice of other museums changes in a cycle of emulation and visual echo; fashion history and theory as they written are also dependent on what the authors have seen. When Elizabeth Wilson, a pioneer of contemporary fashion theory, wrote about museum displays of dress being eerie, uncanny, and dead, she was referring to her experiences at the Victoria and Albert Museum's (V&A) Costume Court (2010: 2); the contention colors her book *Adorned in Dreams*, first published in 1985, and many works on the topic published since. With its evidently fundamental influence on academic literature,

therefore, documenting the actual practices, aims, and outcomes of fashion curation and, more specifically, of historical fashion curation is important. The research presented in this book is an overview of the possibilities for exhibitions of historical fashion as they have been realized over the last century across national boundaries; furthermore, it highlights the multiple ways in which the representations of fashion within the museum have also engaged with wider discourses within popular culture and academic writing on fashion's role in society and culture more generally.

This book defines and describes the varied representations of historical fashion within museum exhibitions in Britain and North America by critically analyzing trends in museum fashion exhibition practice over the past century. The comparative narrative traces the origins of these in the eighteenth and nineteenth centuries and follows their manifestations in permanent and temporary museum gallery displays from 1912 up to the present day. Building on existing studies of museums and fashion, and drawing on archival material not in the public domain, this book takes the long view to synthesize trends into a broader analysis. In so doing, it contributes to a growing body of academic writing on the history of museums and on fashion curation and provides a historical framework for exhibitions of historical fashion to both disciplines. The presence of fashion in the museum has a surprisingly long history which challenges contemporary assumptions about past practice.

Museum collections of fashion, as well as exhibitions with a fashion theme or major component, are seen to be on the rise worldwide (Clark, de la Haye, and Horsley 2014: 170). Each generation of academics, journalists, and curators celebrates a "new" peak of fashion visibility. It is true that at one time, fashion was a newcomer to museums; yet this entry into the hallowed halls of heritage came earlier than is commonly realized. As a result, it was integrated into traditions of curation and historical discourse long before the 1980s. The year 2011 marked the 100th anniversary of the first instance of a major public museum in the English-speaking world putting on a display of historical fashion. One hundred years later, fashion exhibitions began to break museum visitor attendance records—not just for that category of display but for any kind of exhibition. Fashion first gained independent recognition of its status as a museum-worthy object in England and America just before the First World War (Petrov 2008), and the greatest growth of fashion history collections in museums across Britain and North America occurred between the 1930s and 1960s (Taylor 2004). Along the way, fashion's inherent conventions have come up against better-established museum conventions of display and discussion.

Indeed, rather than a linear evolution of fashion curation from amateur to spectacular, this book argues that contemporary fashion exhibitions, while benefiting from more spectacular design and technological interventions, are not innovative but instead use the same core display and narrative strategies, which

have been commonly reproduced across most museum exhibitions of historical fashion since at least the early twentieth century. Due to these differences in degree, the discussion in the book is divided into thematic chapters that compare and contrast exhibitions from different museums and decades to illuminate the various ways in which historical garments have been displayed in museums and the different discourses that curators and exhibition makers have relied upon when building their textual and visual narratives.

Terminology

Although museums have defined the objects of apparel they collect variously as dress, clothing, costume, fashion, or simply textiles, for the purposes of this book, the term "fashion" best describes the garments made within the fashion system of goods exchange and in accordance with its aesthetic and value systems. To avoid excessive repetition, other synonyms will be used throughout. In addition, discussion will be largely limited to historical fashion exhibitions. Because "contemporary" is relative to the age of the subject under discussion, "historical" is here taken to mean not the work of designers living or working at the time under discussion nor garments in active circulation in the wardrobes of consumers of fashion in the period being considered. However, for clarity and context, some examples are provided throughout of exhibitions that did include material by practicing designers.

I have specifically chosen to focus on exhibitions of fashion in museums that also collect it as a category of artifact. Displays of historical dress have also been featured in commercial spaces, art galleries, and historical houses; these have interesting morphologies and present questions of their own. Yet this book is concerned primarily with an investigation of how fashion has been integrated into the intellectual and physical architecture of the museum institution. In this way, this book is related to the project set out by John Potvin, defining the "spaces which influence the display and representation of fashion" (2009: 6). In essence, by applying a visual culture methodology to the museum display, I am investigating the ways that "visibility and visuality conspicuously give fashion meaningful shape, volume, and form" (Potvin 2009: 7) in the exhibition space.

The exhibition itself, in all its varying forms, is a type of utterance: it takes a position and makes a statement about the artifacts within. While that formulation generally presupposes notions of authorship and authority, as well as varying levels of audience understanding, I maintain that there is a dynamic between these two and do not posit the exhibition as a straightforward and undemocratic dictum set by curators to passive recipients (Carpentier 2011). Rather, I view the exhibition as an articulation of a more nebulous set of social constructs that results in a shared iconography. The exhibition, while both a product of curatorial

authorship and a potential site for independent or collaborative meaning-making, is here examined for its content, which I assume to be recognized to some extent by both participants in the museum's discourse.

Case studies and comparisons

This book empirically traces museum fashion exhibition practice over the twentieth and early twenty-first centuries, teasing out the correspondences between the varied modes of visual display, didactic textual content, and implicit objectives of past exhibitions. The evidence for these is drawn from exhibitions presented by six institutions chosen for their global importance in the field of fashion history collecting and their representativeness of a type of disciplinary museum. Archival material forms the backbone of the primary source material, illustrating practice in depth at these six institutions.

In Britain, I focus on the V&A, a national museum of decorative art and home of (chronologically) the second major public collection of costume in the country (after the Museum of London) but currently the most important museum collecting and exhibiting fashion in Britain. I also examine the history of the Fashion Museum in Bath (known as the Costume Museum prior to 2007), founded by Doris Langley Moore, as one among several museums devoted solely to fashion and based around the founding collection of a single individual. Both of these institutions originated various modes of dress display, which were influential on fashion curatorial practice worldwide. The United States is represented by the history of the Brooklyn Museum's fashion collection, as it was displayed in a municipal museum of art, design, and social history before the bulk of it was transferred to the Metropolitan Museum of Art (also referred to as the Met) in Manhattan. Likewise, I have looked at the practice of fashion curation at the Met before and after its incorporation of the previously independent Museum of Costume Art, which is now known as the Costume Institute. The ties between these two institutions, as well as their similarities and differences to British museum practice, made them appropriate case study choices. The Canadian examples are the Royal Ontario Museum (ROM), a major provincial museum with a long history, and the McCord Museum, a municipal social history museum in Montreal; both collections reflect the economic status of the cities where they are housed; they are also the largest public collections of costume in Canada. Culturally situated between America and Britain, Canadian museums formed an important part of the comparative analytical strategy for this research. Furthermore, they demonstrate the influence of both British and American approaches to displaying fashion in the museum in sites outside the acknowledged global centers of practice.

Archival material was supplemented by media reports, academic reviews, as well as secondary theoretical literature on these and other institutions (including some of the most visible and influential French, Belgian, German, and Dutch museums currently collecting and exhibiting historical fashion to demonstrate the diverse range of global practice). For practical reasons, it was not possible to examine practice in other English-speaking countries, such as Australia and New Zealand, in detail; however, published reviews of the history of fashion exhibitions there show that the display of historical dress began significantly later than elsewhere in the English-speaking world and followed international conventions (Douglas 2010; Labrum 2014).

Each institution has held many exhibitions, and so, rather than being an exhaustive survey, the analysis discusses those exhibitions that could be fruitfully compared with others due to their similarity in scope and content, focusing on similar time periods or aesthetic themes. While the selection of case studies cannot claim to be comprehensive, it is far from arbitrary. The book examines some of the most visible and influential museums in the English-speaking world, currently collecting and exhibiting historical fashion. The analysis is representative of museum practice at large, as it demonstrates a shared preoccupation with displaying particular themes in fashion history frequently shared by other museums that feature in examples throughout this book. Doubtless, a broader study or one focused on non-English-speaking countries would uncover even more examples and perhaps reveal further location-specific discourses to which fashion was affiliated when displayed.

Methodological approach

I am a practicing curator and dress historian, with training in art history, material culture, and museology. From my professional and academic perspectives, I naturally observe the mechanics of displays, as well as the meanings that emerge from the combination of text, object, and viewing environment that makes up an exhibition. Because of my experience as a curator and exhibition coordinator, I understand that creating a display is a complex process and therefore understanding exhibitions that are no longer viewable required my historical research skills, in order to piece together the remaining fragments of evidence for disappeared displays. This book is therefore written from my position as an informed historian: a commentary on the efforts of my fellow practitioners but not as a how-to guide or reflection on best practice.

Archival material, such as installation photographs and object lists, was combined in analysis with published accounts of exhibitions (exhibition reviews and catalogs, for example) in order to reconstruct the physical arrangement and the intended as well as implied discursive messages of past displays. The

possibility for the phenomenological analysis of visitor experience and meaning-making in a gallery disappears along with the dismantled display; the analysis is therefore limited to the methodology allowed by the surviving sources: texts and images. The constructed nature of the exhibitionary assemblage was made evident repeatedly during the research process. Files for past exhibitions sometimes contained only unlabelled installation photographs, making it difficult or impossible to determine the theme of the exhibition without reference to a corresponding text that would eliminate the need for such speculation. It became clear that examining exhibitions using only visual methodology would not reveal sufficient information, and all the elements—text, images, object—would need to be considered together. A focus on the syntax of an exhibition reveals the grammar by which it constructs meaning.

The analysis of historical exhibitions presents certain methodological challenges. There are many theoretical perspectives from which writers have analyzed contemporary exhibitions, and these do provide broad categories of museum functions to look for in historical material: the sociopolitical role of the museum, its educational and communicative roles, as well as the sensory, material, and aesthetic experiences of its visitors are all vital areas for research and evaluation. Yet all these analyses depend on the reactions of present audiences willing to share their experience with researchers. Doing a history of past exhibition displays from this perspective is difficult as it is impossible to observe or interview visitors to gauge the success or failure of the museum's modes of communication—their intellectual and sensory experiences are no longer available for direct analysis.

Moreover, even if it were possible to capture these past experiences, the methodology of analyzing museum exhibitions is overwhelmingly biased toward one type of experience: the visual. While commercial fashion environments are possessed of materiality and facilitate particular sensory responses, exhibition environments are highly, even predominantly, visual (Bennett 1998). Fashion within the museum environment in particular takes on a heightened visuality at the expense of hapticity (Petrov 2011), due to the norms and rules surrounding the need for the preservation of objects, the physical arrangement of objects in the space, and the physical and visual relation of visitors to the objects on display. Although the particular items on display mostly still exist within the museum collection, and even the mannequins or other display supports might survive in storerooms, they are removed from their display-specific configuration and therefore lack that particular materiality. A historian has limited access to the curatorial aims of the individuals who put the displays together and even less insight into the opinions of those who saw the finished gallery displays. Indeed, museum exhibitions, although experienced as material assemblages, in history become visual or textual objects, and as a result, exhibitions are primarily analyzed by museologists as visual media (Hooper-Greenhill 2000; Bal

2003). While the sensory aspects of exhibitions are only an emerging agenda for museological research, it is nevertheless important to note the possible limits the predominantly visual and textual standard approaches may place on interpreting accurately what was undoubtedly a richer (though lost) visitor experience.

The dominant exhibitionary form is the spectacular. Despite potentially being made up of various elements (objects, text, graphics, light, sound, live interpretation, and interactive technologies), exhibitions "communicate through the senses," the primary sense being visual, by a process that is both cognitive and cultural. This process "encompasses the way people think about what they see and the meanings they attach to it" (Kaplan 2002: 37). Early museological writings even conflated curatorial practice with visual psychology, defining a "trained museologist" as "an educationalist familiar with the problems of visual perception" (Whittlin 1949: 194). The visual sense, then, was not one that relied on pure physical perception but on a disciplined cognition and interpretation of that vision. Not only does the exhibition flatten the material into the visual with three-dimensional objects behind glass or other barriers, but it also substitutes the tactile for the verbal, where suggestions of materiality are described in didactic labels. The exhibition is an act of representation, which acts on a symbolic level.

Riello suggests that "dress history today is able to communicate with the public at large not so much through publications, but through visual presentations, in the first place those of galleries and exhibitions and in the second place through virtual exhibition spaces on the web" (2011: 4). For him, the dress historian is a museum curator, and dress history is a primarily visual discipline. I agree with Riello and have chosen to use primarily a visual studies approach to the classification of costume curatorship in this book. A visual studies methodology reveals how the design elements within museum artifacts (fashionable dress, in this instance)—color, line, form, shape, space, texture, and value—are organized or composed according to design principles and compositional themes—balance, contrast, emphasis, movement, pattern, rhythm, unity/variety—to structure an exhibition and convey the intent of the curator. The particular compositional devices, it is argued, are drawn from existing discourses within which fashion circulates, and visual references to these through the design and organization of exhibitions help to express the intellectual principles upon which the exhibition is founded. Thus, it is not merely the curatorial didactic texts that make an exhibition but also the visual devices that organize artifacts into a coherent whole. This kind of historical research into the reasons (cultural and individual) behind exhibition design choices highlights the way in which the display environment is informed by visual assumptions and conventions.

In addition, museum display is not unmediated. Indeed, the immersive interpretive environment of a museum exhibition is reliant on its component parts to build narrative and atmosphere (Forrest 2013). A traditional[1] exhibition requires

the *presence* of objects, and their *presentation* in a spatial arrangement wherein the objects become a *representation* of a conceptual subject (Dubé 1995: 4, emphasis added). In a UNESCO journal special issue on museum exhibitions, Raymond Montpetit (1995) points out that while the logic of early collections was evident only to their creators and their colleagues, modern museums now tend to follow a script, which makes the invisible logic of the subject matter coherent through a textual and spatial narrative of introduction, exposition, and conclusion. As Stephanie Moser has pointed out, exhibition interiors are critical to display analysis. Even display furniture, such as

> cabinets, shelves, plinths, pedestals, and stanchions can situate objects and cultures within a particular intellectual framework. For instance, historic wooden cabinets can define objects as curiosities. Ultramodern designer cases in steel and glass, in contrast, can impart objects with an identity as commodities, encouraging us to see them like consumer products in a shop window. (2010: 25–26)

The exhibitionary assemblage can be analyzed as a whole and as a sum of its parts—artifacts, labels, furniture, color, lighting, marketing material, scholarly catalogs, and wider cultural discourse such as exhibition reviews. Thus, this book undertakes a rhetorical discourse analysis of visual and textual exhibition text, comparing specific examples to one another and to wider cultural trends.

This book analyzes the exhibition as a product, not as a process, and then categorizes the variations of that product. This reflects the fact that the behind-the-scenes compromises made by curatorial, conservation, and design teams are not generally seen by museum visitors and are rarely documented in surviving archival material. Existing examinations of fashion exhibitions have tended to focus on the curator, and only a few sources have acknowledged the tension between curatorial aims and accomplished results. Flavia Loscialpo (2016) admits that there is always a balance between the curator-led authorship and the processual, dialogic nature of the exhibition as experienced by visitors. Eleanor Wood (2016) uses the example of the Gallery of English Costume in Manchester to demonstrate how curatorial goals may be shaped, modified, and sometimes stymied by institutional limitations such as display infrastructure, funding, administrative attitudes, and curatorial legacies. While curators are generally responsible for determining the theme of a show, much of the research, and the selection of objects, they are not always responsible for its design, layout, or even text copy. For example, at the ROM, many layout decisions were determined by the architectural firm that built and outfitted the galleries. For each exhibition, alongside the curator—who selects pieces, writes the text, and finds graphics—there are 3D designers who plan layouts, 2D designers who produce graphics and labels, an interpretive planner who edits

for accessibility, technicians and preparators who are responsible for platforms, mounts, and supports, conservators who ensure pieces are exhibitable, a head of programming who acts as project manager, and an individual responsible for French translation in this bilingual museum. The roles of fashion curators vary by size and administrative complexity of an institution, too—a large museum will have a team of conservators, designers, educators, marketers, and technicians, whose input may override curatorial intentions. This is just one reason to not assign credit for the final look of a show to its curator or privilege their perspective. Therefore, this book does not intend to position the collector, curator, or designer as the sole author of an exhibition; in practice, exhibitions are composed of a series of decisions made by many actors (not all simultaneously), but it is only the result, visible through its traces in the archival record, that is under consideration here.

Categorizing curation

The multiplicity of viewpoints on the relevance of fashion to culture demonstrates the many potential representations of it in a museum setting. Fashion falls between disciplinary boundaries: sometimes classed as a decorative art, occasionally slotted into social history, or displayed as an anomaly in and of itself, it does not, therefore, draw on any single set of display norms conventional to its subject class. As this book will show, the affiliation of fashion with any given discipline has had important repercussions not only for its potential intellectual content but also for the visual communication of that content. The very act of harnessing fashion to any disciplinary discourse has implications for what it is made to say and, equally, the visual and narrative means by which it is made to say it. In the strongest exhibitions, scenography and the physical mechanics of display will combine with curatorial narrative to deliver a message; sometimes, however, the narrative is superimposed onto a standard set of exhibitionary forms, which are drawn from separate fashionable discourses. Parallel critical approaches are therefore necessary, and throughout this book, I draw upon museological theory on exhibition display and history; historiography; body theory; semiology; fashion studies; materiality and phenomenology; and visual representation. Synthesizing these approaches achieves a hermeneutical analysis of the museum interpretation of historical fashion.

It became clear at an early stage of the research that the development of historical fashion exhibitions did not follow a neat evolutionary trajectory that showed the development of one form into another. Rather, it was evident that multiple display strategies coexisted simultaneously, sometimes within a single exhibition, and that though preferences for these waxed and waned, their use was not always in keeping with the dictums of exhibition theoreticians. Therefore,

the issue of why any given display mode was used became important, and for this reason, the discussion in the book is divided into thematic chapters that compare and contrast exhibitions from different museums and decades. Exhibitionary forms are not natural or self-evident, and that their diversity reflects an equal diversity of curatorial goals. The analysis in this book focuses on how the mechanics of display (mannequins, props, labels, and settings) influences the informational and narrative content of exhibitions by re-presenting historical fashion. These ephemeral traces of assemblages, which are no longer intact, are compared to critical and theoretical literature to provide a new evaluation of the relationship of display to wider cultural narratives.

The material suggests that the discourses of historical fashion exhibitions have been heavily influenced by the anxieties and values placed upon fashion more generally. The discipline of fashion curation is deeply rooted in and dependent upon much earlier display practices in museums, galleries, and shops. Moreover, historical fashion, as it has been displayed in the case study institutions, also reflects the function of the museum institution itself, especially its visual marking of time and social contexts.

Overview

While I have avoided writing a simplistic time line or biography of fashion history exhibitions, the book nevertheless begins with an overview of the precedents for the twentieth-century entry of fashion into museum exhibitions. It is evident from the earliest material on the subject that a continuity exists in the discourses around exhibitions of historical fashion: for example, the 1833 exhibition of Cromwellian relics on waxwork mannequins, the 1847 satirical suggestion of a museum of fashion trends, and the 1869 editorial advocating for a costume reference collection for artists are all direct antecedents of contemporary display culture. Therefore, the history of fashion exhibitions presented here is organized into typologies based on display characteristics and thematic premise, making the connections between museum fashion and other contexts for fashion clear.

The thematic chapters that follow compare and contrast exhibitions across case study and other institutions over the last century. The chapters are divided into themes—commerce, social science, art, theater, living contexts, and history— that can be considered as prisms through which one can view the development and deployment of museum conventions utilized within exhibitions of fashion history. These themes have arisen directly out of the archival material studied. The interplay between personal and world-historical narratives in exhibitions, the celebration of consumerism and corporate brand identity, and claims to aesthetic universality and quality continued to surface across historical fashion exhibitions in all the institutions studied. The simultaneous materiality and ephemerality of

historical dress are also shown to demonstrate the paradox of historical fashion in the museum: the near-impossibility of satisfactorily conveying the embodied experience of fashion in its routine manifestation. In each exhibition studied, display techniques were used to highlight some particular feature of the objects on display, usually connecting them to a larger narrative. This "selective valuing of one feature over another" (Knell 2012: 323) demonstrates the contingent nature of the museum exhibition. In each chapter, the broad theme acts as an overarching concept for the related means by which historical fashion has been contextualized in exhibitions through visual symbolism and metaphor. Evidence of the connections between the different contexts for fashion (in shopping, art, theater, and even the personal wardrobe) is presented as being key to the understanding of fashion in the museum. Even within each broad context, fashion may be framed in a variety of ways, and so this book offers a wide range of possibilities, rather than focusing too closely on a limited few.

The conclusion returns to a more chronological approach and reviews the changes in the field, which have occurred after roughly 100 years of development. While there are certainly more fashion exhibitions worldwide than ever before, can they be said to be innovative? Has the scholarly discourse around fashion exhibitions caught up with the reality?

After all, fashion historians have only recently begun to acknowledge and examine the history of fashion in museums. Daniel Roche's seminal book *The Culture of Clothing*, first published in French in 1989, begins with the following sentence: "[W]hilst the last decades of the twentieth century have seen the appearance of museums of fashion, a phenomenon by definition short-lived, historians have yet to think how to write about something other than these sumptuous and insubstantial phantoms" (1994: 3). Yet this sentence contains a mistake: in fact, museums of fashion appeared earlier in the twentieth century. Furthermore, while fashion theory, in large part, thanks to scholars like Roche, has certainly moved forward in its methodology, and with evidence drawn from various sources and methodologies from many disciplines, nuanced and definitive narratives have emerged, dress historians have thus far made few inroads into examining the "insubstantial phantom" that is the museum exhibition of historical fashion. This book, then, provides a history of fashion in the museum through the methods of its display.

1
FOUNDATION GARMENTS: PRECEDENTS FOR FASHION HISTORY EXHIBITIONS IN MUSEUMS

The public is fascinated with fashion and eager for content from authoritative sources such as museums. This has led to a surge in media around the subject. We may think that documentaries showing behind the scenes of dress displays like *The First Monday in May* (2012) are new, and yet that is not entirely true. Pathé newsreels featured the costume collections of New York museums as early as 1934 ("Caught by the Camera No. 14") and later filmed historian and curator James Laver at the V&A ("Pathé Pictorial" 1952) and collector Doris Langley Moore's private museum in Kent in the 1950s ("Ancient Models" 1955); the acquisition of socialite Heather Firbank's wardrobe by the V&A was celebrated with a Board of Trade short film called *Sixty Years of Fashion,* which featured models wearing gowns from the museum's and Doris Langley Moore's collections in the galleries in 1960; New York television station WNDT devoted a half-hour of evening television in 1963 to visiting the MFA Boston exhibition *She Walks in Splendor* ("Television" 1963: 52); Diana Vreeland's legendary exhibition *The Eighteenth Century Woman* was the subject of a 1982 documentary narrated by the top model (and granddaughter of designer Elsa Schiaparelli) Marisa Berenson. These rare glimpses show the development of fashion exhibitions over the twentieth century. However, the roots of these displays go back much further.

This chapter explores the sociocultural circumstances surrounding the exhibiting of fashion in museums in Britain and North America. While the first permanent display of historical fashion in an English-language museum opened in 1911, historical dress had been displayed in various ways and venues since the late eighteenth century. From wax museums such as Salmon's and Tussauds to effigies in royal robes in palaces across Europe, dress reform campaigns

(including the International Health Exhibition in 1884), and commercial exhibitions (notably, the Palais du Costume at the Paris Exposition Universelle of 1900), a brief overview of the venues and display techniques of these early exhibits reveals the foundations of many conventions used today, such as chronological display, realistic mannequins, authentic props and settings, and corporate sponsorship. The final section reviews the early discussions about principles and considerations for staging fashion exhibitions in museums and signposts perspectives that will be discussed further in this book.

Prehistory of fashion exhibitions

The earliest documented mention of a fashion museum comes from the eighteenth-century journal *The Spectator*. The 1712 article that first suggested such a notion was written by Sir Richard Steele as an indictment of male and female folly in following fashion. The author proposed "to have a Repository built for Fashions, as there are Chambers for Medals and other Rarities," with the façade of the building in the shape of a Sphinx and its architectural details imitating lace, fringe, ribbon, and other modish accessories, with a suitable poetic motto in Latin over the door (219–220). The space inside would consist of two galleries (for men and women), with shelves of false books: actually boxes containing dolls[1] dressed in historical fashions. Contemporary designs would also be documented in a like manner, and the author humorously suggests that an old dandy, bankrupted by his interest in fashion, might be appointed Keeper. The author of this parody furthermore insists that the museum will succeed because of the education in appropriate dressing that the visitor will receive; the prestige that will be afforded to England over France (the capital of fashion); the documentary evidence it would afford of the persistently extravagant nature of fashion (shaming young and old alike); and that it would free up historians for more noble pursuits:

> Whereas several great Scholars, who might have been otherwise useful to the World, have spent their time in studying to describe the Dresses of the Ancients from dark Hints, which they are fain to interpret and support with much Learning, it will from henceforth happen, that they shall be freed from the Trouble, and the World from useless Volumes. (Steele 1712: 220)

The piece is satirical, but simultaneously visionary, not least because museums devoted to any aspect of everyday life had not yet actually been founded. Its comic effect comes from the risibility of such a notion for an early eighteenth-century audience. Yet it also communicates the main objections to a fashion museum, ones that would continue to be raised for nearly two hundred years

until the first fashion exhibition was staged in an English-speaking museum; fashion had long been associated with meaningless frippery, and for this reason, even serious calls for its close study (Planché 1834) and collection and display ("Notes and Incidents" 1869), which came in the nineteenth century, were largely ignored until some decades later. The very notion of a fashion museum would continue to inspire only humor and contempt until the late nineteenth century.

In her book *Establishing Dress History* (2004), Lou Taylor has outlined the fitful and often fraught development of collections of textiles and clothing in museums in Britain, France, Eastern Europe, and the United States. Her well-researched narrative need not be repeated at length here, but of her conclusions, it should be highlighted that unlike other aspects of the fine and applied arts, fashionable costume was not widely seen as a natural museum object, at least in eighteenth- and nineteenth-century Britain. In addition, even at the early stage of its musealization, varied disciplinary approaches by collectors and curators ensured that the display of antique fashion, infrequent and uncommon as it was, was often as an accessory to narratives about materials, techniques, or political events and not exhibited on its own merits as it is today (Taylor 1998: 340).

A confluence of factors from outside the museum world finally served to enable the exhibition of historical costume as an artifact of social history and art in museums in the early twentieth century. As I have demonstrated elsewhere (Petrov 2008), the Museum of London's display of costume at Kensington Palace in 1911 was the first such permanent display in the UK; however, a reviewer at the time seemed unmoved by the aesthetics of the exhibition (Figure 1.1), writing,

> In the methods of exhibition employed for the main collection there is nothing startlingly novel. Several Tudor worsted caps, rescued from the London Ditch, and forming part of Mr. Seymour Lucas's large collection, are effectively displayed on roughly carved wooden heads, with the hair represented in the style of the period. The costumes generally are mounted on manikins without hands or feet, but provided with appropriate wigs which, to judge from their freshness, are of modern date. (Bather 1912: 295)

Despite the relative novelty of the presence of fashionable dress within a history museum, the critic failed to see any novelty in the method of its display. This suggests that historical fashion had been publicly exhibited prior to 1911, as expectations of display conventions had already been preformed.

The very earliest displays of dress were commemorative and royal in nature. For example, the fourteenth-century military accoutrements of Edward the Black Prince, hung above his tomb in Canterbury, included his tunic (this was recently exhibited in *Opus Anglicanum*, V&A, 2016–2017). Similarly, armories often included items of ceremonial clothing, and the Livrustkammaren in Stockholm in particular had a tradition of preserving the bloodied clothing of

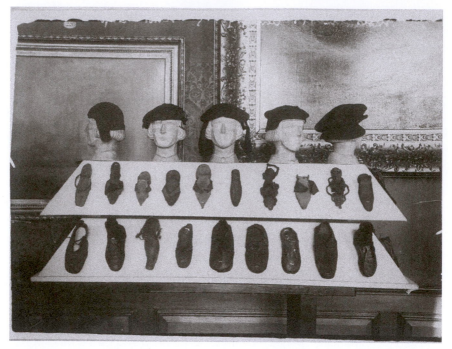

Figure 1.1 Unknown photographer, press image, *c*. 1912: "Costumes Added to the London Museum, Kensington Palace. Tudor caps (in top row) and shoes of the 15th century (two bottom rows)," London Museum Photo Albums, Museum of London archives. © Museum of London.

royals wounded in military glory since the seventeenth century (Gronhammar and Nestor 2011: 12). Royal clothing was also displayed on effigies, such as those at Westminster Abbey (first described as a public attraction in 1754; see Timbs 1855). These, in turn, inspired the waxworks of the eighteenth century such as Tussauds, established in 1802 in London. Tussauds in particular was famous for purchasing the authentic clothing of the individuals it memorialized (Sandberg 2003).

The first example of an exhibition of civilian dress, however, occurred in the early 1830s. As I have described elsewhere (Petrov 2014a), the heirs of an eccentric recluse named Mrs Luson, descended through marriage from Oliver Cromwell himself, arranged for her collection of the clothes worn by Cromwell's family to be displayed on realistic wax mannequins in London's Regent Street in 1833 and again on the Strand in 1834 and 1835. The costumes were accompanied by accessories as well as relevant biographical details culled from journals in the family's possession. Critics of the time were gratified by the authenticity of the presentation and the educational opportunity to study historically significant objects.

While it does not feature a museum exhibition in the contemporary sense of the term, the episode described above does illustrate the necessary prerequisites for the public exhibition of historical fashion. A growing interest in the minutiae of national history, combined with a desire for authenticity in visual detail, allied to the traditional taste for relics of great men was, throughout the nineteenth century, given ever-greater circulation within an expanding number of institutions for public entertainment, recreation, and education. The growth of these institutions also permitted the display of the authentic (or authentic-looking) objects (Sandberg 2003), as opposed to generalized simulacra reproduced in books of engravings or in paintings. (Even so, fashion objects were, and frequently still are, used as illustrations of an implicit time line or as proof of the veracity of visual representations, not the other way around; see Mackrell 1997.) In addition, as collectible objects moved from being rare and exotic unique treasures to being parts of series in categories of broadly similar mass-produced objects, the quantity of these created the possibility of more and more such institutions—a symbiotic system.

A sympathetic public for a museum of fashion, however, took a long time to develop. In 1864, mirroring the much-earlier disdain of Sir Richard Steele, the *Birmingham Daily Post* sneered at the citizens of Dresden, who "having nothing better to do just now, are devoting their attention to the all-important question of clothes" by erecting "a kind of national gallery of the artistic in clothes, to be called 'The Museum of Fashion'" ("News of the Day" 1864: 1). History does not record whether this project ever came together, although it is possible that the "Costume Chamber" of the Historical Museum portion of the Museum Johannaeum contained the fruits of those efforts by 1870 (Baedeker 1870: 368). Elsewhere on the Continent, the Practical Art Exhibition held at the Palais de l'Industrie in Paris featured eleven galleries devoted to "a grand exhibition of the garments of the past, the Retrospective Museum of Costume" (Hooper 1874: 624). This was a temporary display (in 1896, a permanent museum of dress for Paris—the *Salon National de la Mode*—was mooted, though it was not until much later[2] that this was to happen; "Museum of Dress" 1896), which included paintings showing fashions over the ages, lay figures dressed speculatively in costumes of periods before any artifacts survived, as well as dresses from the seventeenth and eighteenth centuries in glass cases. Because it was held in Paris, the capital of fashion, such an endeavor was not seen as strange by contemporary commentators.

Back in Britain, the International Health Exhibition, held in London in 1884, also featured displays of historical dress, but these were costumes made up by the firm Auguste and Co. from the designs of organizer Lewis Wingfield and were meant to set off the designs of "rational" dress proposed for contemporary women. The costumes were presented on wax figures manufactured by John Edwards of Waterloo Road—"which if not so finished in their modelling as some

of the portrait figures which keep up the fame of Madame Tussauds collection, are still sufficiently lifelike for the purpose" ("Health Exhibition" 1884: 3)— representing wealthy and peasant classes for each period from 1066 to 1820 (Wingfield 1884: vi–vii), with sixty mannequins in total.

Ten years later again, an exhibition similar to the 1874 Paris venture was held in New York's Madison Square Garden for the benefit of charity. The International Costume Exhibition featured modern and historical fashion, and the latter was displayed on lay figures (mannequins) on a stage. The dress on display seems to have been a mixture of costumes as well as historical artifacts, representing men's and women's wear from the thirteenth century to the end of the eighteenth century; a newspaper description listed a "Costume of the Time of Henry VIII" and followed it with "Genuine Spanish costume of the time of 1560" ("Exhibition of Costumes" 1895: 8), which aptly illustrates the slippage of terminology that makes research in the field difficult. The early nineteenth century was represented by a display of objects associated with the Napoleonic period; the description of the "multitude of pictures, costumes, and hangings pertaining to the time of the First Empire" ("Exhibition of Costumes" 1895: 8) is ambiguous and does not clearly identify whether these were genuine historical artifacts or representations.

The rising public interest in the material history of dress did eventually have an effect on museums: for example, the Met began actively collecting historical fashion by the beginning of the twentieth century and listed two purchases of fashion (a French waistcoat, 07.70, and a cotton embroidered Regency dress, 07.146.5) for the first time in 1907 (Metropolitan Museum of Art 1907a: 74, b: 146). In 1908, it received a gift of a

> blue silk brocade dress, Italian; two embroidered silk coats, one embroidered velvet coat, pair of embroidered knee breeches, pair of Louis XV leather slippers, one Empire dress of embroidered mull, one linen waistcoat, three silk waistcoats, two collars of embroidered mull, and one bone [sic] waist of satin brocade with sleeves, French. (Metropolitan Museum of Art 1908: 104–105)

from painter William J. Baer and in 1910, it acquired a major collection of costumes of late eighteenth- and early nineteenth-century garments among the contents of the houses belonging to the Ludlow family from descendant Maria James. Although the Baer gift and the Ludlow dresses were put on limited display in the recent accessions gallery, this did not herald a sea change in attitudes. Indeed, *Vogue* magazine crowed that "America has narrowly escaped an invasion by ghosts," when reporting on the fact that the painter Talbot Hughes's collection was to stay in England at the V&A and not, as had been originally intended, America ("Other Times, Other Costumes" 1914: 37). Although the V&A and the Museum of London established their displays in the prewar period, there would not be a fashion-specific exhibition at the Met until 1929, when a loan collection

of eighteenth-century French costume and textiles from Mrs Philip Lehman was exhibited (Morris 1929: 78–79). While models wearing the museum's gowns appeared on photographic postcards showing the American period rooms in 1924 (Figure 1.2), the museum's own collection was only physically displayed in 1932 (*Costumes 1750–1850*), twenty-five years after it seems to have first established and thirty-seven years after historical fashion had been displayed to

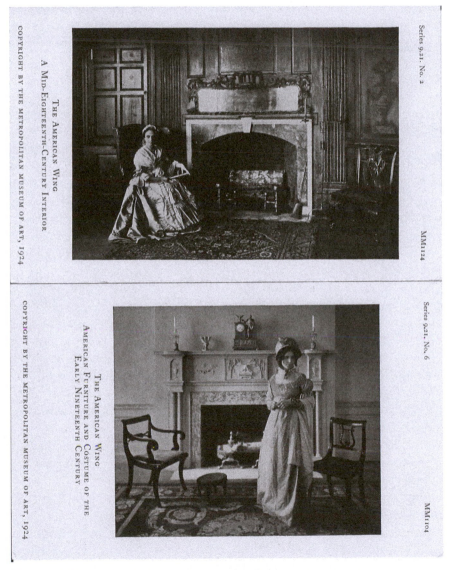

Figure 1.2 Two postcards from the Metropolitan Museum of Art, American Wing series, 1924. Models are wearing dresses from the Ludlow gift (11.60.232a,b and 11.60.230). Author's collection.

public acclaim in Madison Square Garden. While this may seem like the fulfillment of the facetious prophecy made by the *Spectator* over 200 years earlier, it must be noted that a gallery of fashion within a museum is not the same thing as a fashion museum; that was not to happen in the United States until the Museum of Costume Art was founded in 1937 in New York and in Britain with the 1947 establishment of the Gallery of English Costume at Platt Hall in Manchester (as a subsidiary of the Manchester Art Gallery), which was followed by the founding of Doris Langley Moore's independent Museum of Costume in Kent in 1955[3] (for short histories of the musealization of fashion, see Fukai 2010 and Steele 2012).

Fashion in museums

Table 1.1 summarizes the integration of fashion into the collections and displays of the major museums, which serve as primary case studies for this book. What is immediately evident is that fashion was included before the Second World War but that staffing, financial support, and gallery space began to dramatically expand in the second half of the twentieth century. English collectors and museums led the field, followed closely by American institutions. Probably due to lower populations, a more conservative society, and the lack of a significant local fashion industry, Canada was relatively late to have dedicated fashion spaces in its museums.

Elsewhere in the English-speaking world, Australia, which though treated to news of English fashion exhibitions since 1835 ("Court Costume" 1835: 4), was chided by private collectors[4] for not keeping up with England in terms of promoting its own history through dress (Kusko 1969: 22). Few museums had their own collections: Tasmania's Queen Victoria Museum borrowed pieces from private collectors to populate their display of 1850–1880 costume in 1945 ("Costume Display" 1945: 4). As Healy (2018) has noted, the Australian experience of historical fashion was moulded largely by traveling exhibitions from the V&A and the Met. Now, however, the National Gallery of Victoria is home to an extensive collection of fashionable dress worn by Australians and hosts major in-house exhibitions on the topic.

In New Zealand, although museums had collections of historic fashionable clothing, they did not have the space to display it. The director of the Old Colonists Museum in Auckland, upon receiving the donation of an 1887 wedding dress, apparently the first example of clothing in the collection, lamented in 1939 that New Zealand museums were not on par with international museum practice: "I have long felt that our collection is incomplete without some examples of the clothes that were worn in colonial days. Historical museums all over the world make a feature of costume, and the displays in such institutions as the London Museum are exceedingly interesting." In an interesting echo of another early London museum's display, he also suggested that "there is a fairly large

Table 1.1 *Fashion in the case study institutions*

Museum	Collection type	Date established	Department name	First appearance of fashion in galleries	Significant events
Victoria and Albert Museum (London)	Arts and manufactures; decorative arts and design	1852	From 2001: furniture, textiles, and fashion From 1978: textiles and dress; previously, only textiles	1913	1913: Harrods gift of historic fashion collection prompts specialized costume gallery, called the Costume Court 1971: Cecil Beaton exhibition dramatically widens the scope of collection to include contemporary dress 2012: Fashion Gallery (40) to reopen following renovation
Metropolitan Museum of Art (New York)	Fine and decorative arts	1870	Pre-1946: decorative arts; thereafter, Costume Institute	1929	1907: first purchase of fashionable dress 1929: loan exhibition of eighteenth-century fashion 1932: first exhibition of museum's own fashion collection 1946: incorporates Costume Institute (previously Museum of Costume Art) 2009: acquisition of Brooklyn Museum costume collection
Brooklyn Museum (New York)	Fine and decorative arts	1897	Before 2009: costumes and textiles	1925	1925: major architectural expansion made room for costume galleries 2009: costume collection transferred to Metropolitan Museum of Art
Royal Ontario Museum (Toronto)	World culture and natural history	1912	Textiles and costumes	1933	1939: textiles department established, galleries include a costume gallery 1989: New Costume and Textile Gallery 1996: dedicated "fashion costume" curator added to the staff 2008: opening of Patricia Harris Gallery of Textiles and Costume in new wing
McCord Museum (Montreal)	Canadian social history	1921	Costume and textiles	1957	1971: permanent costume gallery opens1972: begins to collaborate with Montreal Fashion Group to collect examples of contemporary Canadian design 2018: incorporates the collection of the Montreal Fashion Museum
Fashion Museum (Bath)	Contemporary and historical fashion	1963	n/a	1963	1963: Doris Langley Moore gifts her personal collection (previously displayed partially in various locations including Eridge Castle in Kent and the Brighton Royal Pavilion from 1955) to the city of Bath; originally opens as Museum of Costume. 2007: Name changed to Fashion Museum

space on the ground floor of the library, underneath the stairway, where it would be possible to place a large glass case, artificially lighted, for the display of costumes upon stands," if enough artifacts were to be assembled and the city council persuaded to pay for the case ("Early Costumes" 1939: 10); before the receipt of the Talbot Hughes's collection from Harrods in 1913, there may have only been one case devoted to dress in the V&A: a newspaper description stated that "the smaller articles of costume ... are grouped in a large case at the foot of the Art Library staircase" ("The Victoria and Albert Museum" 1904: 5). As Labrum (2014) has shown, until quite recently, New Zealand museums typically integrated what few pieces they had into historical dioramas or cases of mixed materials from various periods. Curators were limited by their institutional focus on social history, as well as by limitations on display space, although they were aware of trends internationally, even consulting their English counterparts and taking on loan artifacts and travelling exhibitions. (Labrum 2009, 2014)

During the period under consideration here, institutions were constantly being compared to one another. The peripatetic collection of Doris Langley Moore (which eventually settled in Bath) was particularly singled out as an example of good practice: "Not even Paris has such a museum," crowed *The Picture Post* in 1951 as the founder planned its displays (Beckett 1951: 19). Artist and critic Quentin Bell was left unimpressed by the rearrangement of the V&A Costume Court in 1958; the imperial splendor of the architecture of the great octagonal space did the costumes no favors:

> Whether the "Costume Court," Room 40 at the Victoria and Albert Museum, was originally built to house costume I do not know; but it would be hard to find a gallery at once so large and so unsuitable for this purpose. The monstrous dome and the titanic arches fill the hall with an oppressive emptiness beneath which a generous sample of the museums' very fine collection of women's clothes seems dwarfed, isolated, and insignificant. (Bell 1958: 586)

The accompanying photograph showed headless mannequins in rococo gowns, stiffly posed under a harsh white light against pale walls with only a single tapestry relieving the clinical starkness. In Bell's opinion, this style of display was ill-suited for an exhibition on social history or even art: "[T]o my mind, the Langley Moore collection, lately at Eridge Castle and soon I believe to find a new home in Brighton, remains the model of how this sort of thing should be done" (Bell 1958: 386). The V&A Costume Court, after later redisplay, became a model of good practice itself, its approach contrasted with the Met as an example of leading approaches to inspire practice in places like Canada's ROM (Livingstone 1989: C1; Palmer 2008a: 40). Likewise, in North America, there were acknowledged authorities on costume exhibitions, who were consulted when necessary: Polaire Weissman, one of the founders of what became the Costume Institute at the Met,

helped to install the 1945 inaugural exhibition of the Elizabeth Day McCormick collection at the Museum of Fine Arts (MFA) in Boston, for example (Freece 2011: 118). The MFA borrowed more than expertise for its costume displays: at one time, they loaned mannequins from the Los Angeles County Museum of Art for use in exhibition (see Chapter 5).

Once within museum galleries, fashion was represented in very particular ways during this early period. Luca Marchetti (2016: 207) states that early fashion exhibitions adopted one of two modes of conceptual organization: one stream focusing on its commercial usefulness, the other describing its decorative aesthetics. These were certainly some of the traditional curatorial conceptualizations of fashion once it entered the museum, but there were also others before immersive theatricality became the norm. In her overview of fashion studies, Naomi Tarrant wrote that depending on their collections, museums might choose displays that highlight stylistic changes in silhouette over time, clothing based on regional traditions and preferences, clothes as worn within social settings, or the works of key individuals in fashion (1999: 19–20).

The visual classification of fashion as a reflection of sociocultural development was only one part of a greater drive toward the classification of global knowledge (Maroevic 1998); the so-called "scientific approach" to its study (Cunnington 1947) was an aspect of its methodology. The concurrent expansion of the secular political state and its growing tolerance for religious diversity from the Early Modern period through the nineteenth century meant that relics, traditionally an aspect of religious worship, diminished in spiritual significance and grew in historical significance, testifying to the creation of a new faith based on a mythology of social progress and enacted through cultural nostalgia (Sandberg 2003). Such progressivist thinking meant that the passage of time now had a material expression (see Chapter 7) and that the growth in intellect and achievement was understood as being mirrored physically by the objects of industrial production—to document and demonstrate this, museums had been built. The growing emphasis on rationality and practicality did not defuse the power of the personal; throughout the evolution of the move to considering relics as historical evidence of the lives of ancestors, their remarkable trans-temporal qualities remained appreciable: "[T]o touch something that has been in bodily contact with one of our heroes can be a moving experience and an intimate and tangible link with the past" (Ribeiro 1995: 5). Costume in particular, due to its being a trace of a body, was particularly effective at enabling viewers to perform mental chrono-spatial displacements, psychologically participating in times and mores past (see Chapter 7): "By its means the member of the general public can see a little farther into the past than before" ("History in Clothes" 1962: 9). This has been most overtly expressed in waxwork exhibitions, from the royal effigies in Westminster Abbey to the historical heroes and antiheroes of Madame

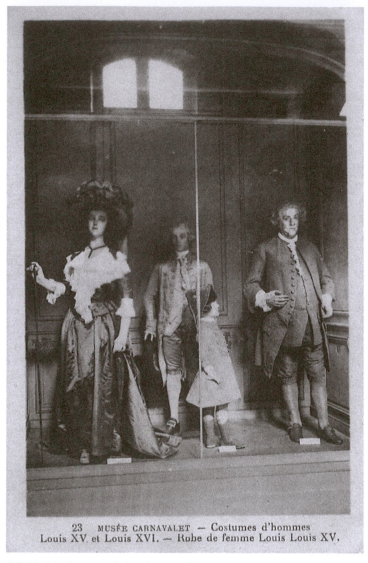

23 MUSÉE CARNAVALET — Costumes d'hommes
Louis XV. et Louis XVI. — Robe de femme Louis Louis XV.

Figure 1.3 Undated postcard showing wax figures wearing costumes from the collection of the Society for Historical Costume in the Musée Carnavalet. Author's collection.

Tussauds—in both cases, the wax "body" was a lifelike and accurate support for the clothing actually worn by the personages represented (for a detailed description, see Timbs 1855: 753–754). When museums used wax mannequins to display dress, as did the Paris Museum of Costume (now the City of Paris Fashion Museum, Figure 1.3) in one of its early incarnations, the effect was intended to bring to life well-known historical figures:

Wax models full of dignity appear almost lifelike, arranged in the ancient costumes so admirably preserved. The manner of dressing the hair, the expressions on the faces, the perfection of each detail, all help to reproduce with startling effect famous and ancient personages. (Depreaux 1920: 63)

Walking past vitrines such as these, it would not have been difficult to imagine, as the author of the above review did, that one was communing with the great and the good of French history.

Although it was not until the middle of the twentieth century that curators were able to describe the reliquary function of the fashion gallery in technical literature, authors such as Mark Sandberg (2003) have made the compelling case that this was its effect for museum visitors in earlier periods as well. The following quote by Zillah Halls is a particularly well-articulated version of this perspective:

If costume is collected with a definite policy in view, it can tell us more than any other type of museum collection about how people looked and felt and lived at any particular time. A garment can be regarded as the remaining outer shell of a living person and will reflect that person's taste, position, way of life, or even a transient mood of gaiety or grief, more faithfully and more directly than other arts, which took longer to produce so that spontaneity was lost, and which, being also more expensive, are characteristic only of a wealthy minority. The trouble and difficulty involved in preparing an informative and attractive display is invariably well worthwhile, and will probably do more to popularize the museum with the public than any other facet of the work of a curator of a general local museum. (Halls 1968: 303)

The personal characteristics of former wearers, in addition, were recognizable through visitors' own personal experience with clothing, and, due to the constant circulation of images of historical fashion in theater, painting, cinema, and fancy dress (not to mention family collections of more recent vintage), museum publics had a longer memory for fashion than might be expected. Certainly, this explained fashion's power and appeal in the museum. Yet, Karyn Jean Harris was able to write:

After all, costumes like other specimens of museum quality are a part of our culture and heritage, and most people have an inner desire to learn more about their ancestry as well as to relive some of their own personal memories. (1977: 1)

It remained unclear precisely how the authentic dress object in a museum could add to the knowledge base established by dress as depicted in other media.

Justifying fashion in the museum

Thus, despite the entry of fashion, which had previously circulated in the outer orbit of the museum, into its exhibition halls, questions about the wider purpose of this class of object remained unanswered: Was fashion able to act as an accurate record of history, to encourage personal reflection, or to inspire similar craftsmanship? Furthermore, should it do any or all of these things, and how might that be coaxed from its material?

It took a long time to begin to answer these questions because of lingering prejudices. A major one was the association of the technical skills involved in the curation and conservation of clothing with what Taylor calls (and Palmer echoes) "feminine domestic[5] occupations" and "a sort of on-going child-care akin to changing diapers" (Taylor 1998: 348; Palmer 2008a: 47–48, 54) underrated by society at the best of times. It is unfair, however, to refer to the prejudice against fashion museology as being solely based in misogyny; the charges Taylor quotes as being levelled at costume history for "aspiring no higher than antiquarian status" (Taylor 1998: 349) reveal that connoisseurship, as practiced by generations of gentleman dilettantes, was no more welcome in academia than Taylor's eponymous "laundry": woman's work.

No matter one's position on the feminist spectrum, however, it is unarguable that fashion curation has been treated less like a profession and more like a set of informal skills to be learned through practice.[6] The sharing of skills and knowledge has been piecemeal and hardly subject to any overarching methodology. Just one example may serve to illustrate the typical case: ROM's (then a division of the University of Toronto) textiles curator Katherine B. "Betty" Brett devised the exhibition *Modesty to Mod* in 1967 while on unpaid leave (the museum was facing ruinous budget struggles). To research the design and layout, she toured other leading institutions:

> Following the announcement of the award of a Centennial Grant in October, Mrs. Brett went to England for two weeks to spend one week at the Gallery of English Costume in Manchester which houses the Cunnington collection of English Costume, the most important of its kind in England and the one most closely related to our own collection. Displays of costumes in the Victoria and Albert Museum and the Assembly Rooms in Bath (the Boris [*sic*] Langley Moore Collection) were studied with a fresh eye and particularly for hints on how not to display costume! (Swann 1968: 271)

In the end, the design was one of Brett's own invention, with contributions from the museum's designer Harley Parker (a former student of Josef Albers and associate of Marshall McLuhan), assistant curator Paula Zoubek (a textile artist), and Dorothy and Harold Burnham (retired previous department curators).

Specialist literature about fashion exhibitions, when there was any, was unsatisfactory for anyone seeking a discussion of the discursive meanings of displayed dress. The advice literature tends to be about technical cost-cutting measures and basic conservation (*cf.*: Buck 1958; Giffen 1970; Briggs 1972; Ginsburg 1973; Keck 1974; Harris 1977; Summerfield 1980; Tarrant 1983; *Mannequins* 1988; Palmer 1988; Robinson and Pardoe 2000; Brunn and White 2002; Flecker 2007; Bathke et al. 2016) with anecdotal reports about particular exhibition enterprises (Brooks and Eastop 2016). In fairness, most of these manuals were not aimed at specialist fashion history curators; rather, they were aimed at generalist curators dealing with a lack of resources. Sarah Levitt's anecdotal but entertaining essay in the 1987–1988 Social History Curators' Group journal is an example of the limited literature available to curators: Levitt set out to answer the question "why are so many costume displays so awful?" (1988: 6) and through explaining the varied existing approaches, the technical and cost limitations of good practice, a lack of professional training, pervasive misogyny, and an overall lack of aesthetic taste concluded that for most museums with costume collections, good displays with adequate interpretation are an impossibility.

Museum-specific periodicals were no more helpful: *Museums Journal* (founded in 1901) first included technical discussion in 1932 (Stevens 1932: 226–227), with more theory in 1935 (Thomas 1935: 1–19), whereas the Association of American Museums' periodicals (launched in 1924) did not include specialist articles about dress exhibitions before 1977 (Young Frye 1977: 37–42). Both journals took nearly thirty-five years of publication to first include fashion curation in their advice literature, despite the fact that fashion exhibitions were regularly featured in calendar listings and collections of historical costume were consistently acknowledged as being popular (e.g., Pick 1938). Only in 1998 did the UK Museums and Galleries Commission release a comprehensive guide to caring for costume and textile collections, which included conservation-related considerations related to display but no hints on the intellectual or aesthetic considerations in mounting exhibitions.

It seems that museum staff who intended to put on exhibitions about dress would refer to precedents they saw in person and also by reading reviews or accounts of fashion exhibitions elsewhere. Large museums are more likely to share details of their work in published form, and this was certainly the case in the early years of fashion museology, just as it is today. For example, the American Home Economics Association highlighted the Met's 1932 account of mounting its first large-scale fashion history display (Breck 1932) in their journal:

How the Metropolitan Museum of New York City arranged on short order for its recent exhibit of costumes of the late eighteenth and early nineteenth century is amusingly described in the Museum's *Bulletin* for May. The account

reveals the difficulties of adapting mannequins prepared for other uses, and may be suggestive in connection with less elaborate exhibits. (American Home Economics Association 1932: 651)

As many home economists who specialized in dress and textiles worked in museum contexts (including in clothing and textile collections in post-secondary institutions) and may have been contemplating the problems of exhibiting costume, such suggestions would have been welcome to readers of the journal.

This reliance on inspiration from travel and individual ingenuity continued for decades. With the advent of specialist programs, such as the London College of Fashion's "Fashion Curation" program, an increase in subject specialist networks, such as the Dress and Textile Specialists (DATS) group, with their conferences and training events, academic publications, and growing public interest in the discipline—as evidenced by magazines profiling the work done by curators such as Kimberly Chrisman-Campbell (2017)—this may slowly be changing.

Sarah Levitt defined good costume interpretation as

creating a thought provoking display, with a clearly expressed story line capable of raising fresh and stimulating ideas in the mind of the beholder. The museum worker is likely to be conscious of this type of interpretation, but other kinds go on whether we are aware of them or not. Some costume curators do not realize that they "interpret" every time they fill a case, and many more do not stand back at the end of the process, work out the messages they have conveyed, and consider whether they wanted to convey them in the first place. (Levitt 1988: 6)

Unfortunately, despite her awareness that these were important issues in fashion curation, Levitt's article was a criticism of the shortfalls of existing practice, especially in small museums. Until very recently, there has been comparatively little academic interest in examining the theory and practice of curating fashion exhibitions, despite the fact that these are acknowledged by all the major authors on the study of dress history (Arnold 1973; Taylor 2002, 2004; Breward 2003a; Cumming 2004) to be an important source of information about historical costume for the public.

This oversight may have been due to the quotidian nature of dress itself. In 1992, the V&A's fashion curators described their own obsolescence:

The fact that everyone wears clothes ensures the universal appeal of the subject. Visitors are at ease with the exhibits, quickly relating them to their own bodies and they are uninhibited about expressing opinions about clothes of the past as well as recent times. This instant familiarity generates curiosity and often precludes the need for a specialist interpreter. (Mendes, Hart, and de la Haye 1992: 1)

However, if this is indeed so, what can a museum bring to such a one-sided conversation? In what ways have museums shaped the representation of fashion history for their audiences? The following chapters will attempt to answer these questions by demonstrating how fashion's fraught history in the museum has contributed to its fragmented and often confused presentation in exhibitionary contexts, leading to competing approaches that continue to the present day. This book posits the stylistic differences between exhibitions as sets of competing tropes within a larger discourse of fashion across contexts and media. Fashion, as a flexible signifier, is multivalent; so too are exhibitions about it.

2

WINDOW SHOPPING: COMMERCIAL INSPIRATION FOR FASHION IN THE MUSEUM

In his work on the "exhibitionary complex," Tony Bennett (1996) showed how nineteenth-century museums and galleries were intimately connected in their design and conception to the expanding commercial architecture of the same period. The technical possibilities and visual experiences of industrial exhibitions and shopping arcades found analogous applications in museum spaces. As Mackie noted, "Both the retail shop and the public repository are designed for the display of information that is predominantly visual: looking is a means for possession as well as knowledge" (1996: 325). This blurring of commercial and intellectual cultures within the museum continues to create unease and controversy, particularly in the case of fashion exhibitions (Anaya 2013; Gamerman 2014).

This chapter investigates how the introduction of fashion—an increasingly important economic and social product in the industrial period—into museums created new connections and tensions between these two worlds. It was because of its position between the disciplines of economy and history that historical fashion entered and was interpreted in museums. Museum objects are often said to have "historical value," connoting their perceived importance in documenting or calling to mind some external event popularly held to be of cultural importance. Historical fashion in museums has worked with and against more worldly notions of value with contradictory outcomes. In this chapter, case study material will inform a review of the early connections between museums and commercial contexts for fashion, the key ontological differences between fashion in commercial and museal spheres (in particular, its move from the "now" to the "then"), the partnerships and echoes between museums and the fashion industry, and the promotion of fashion consumerism in museum exhibitions,

either through valorizing the wardrobes of fashion mavens, highlighting designers and brands, or by imitating fashion consumption environments in exhibit design.

Commerce and culture in the 1840s–1850s

Bennett (1995, 1996) has convincingly demonstrated that museums, galleries, and other public collections arose at the same time as what McKendrick, Brewer, and Plumb (1982) and McCracken (1988) have called the "consumer revolution," which predated and indeed may have caused the Industrial Revolution. Consequently, they utilized a similar visual vocabulary; however, it must be noted that, at least initially, the objects on display at museums and at shopping centers were different: the British Museum, for example, was largely a museum of ancient archaeological artifacts and not of the material culture of the everyday. However, by the middle of the nineteenth century, contemporary periodical sources bear out a slippage of terminology and approach between the two. For example, in Albert Smith's 1842 *Punch* series on "The Physiology of the London Idler," the Pantheon Bazaar was described as combining "the attractions of the Zoological Gardens and National Gallery, together with a condensed essence of all the most entertaining shop-windows," and in particular, "the al fresco and gratuitous exhibition of wax-work at the door of the tailor's opposite" was highlighted as an attraction of note (1842: n.p.). The following year, *Punch* ran a series of articles on "The Gratuitous Exhibitions of London," which was a thematic compendium of amusing metropolitan sights for the *flâneur*-about-town. The term "exhibition" was used loosely: the suggestions included some public displays, but the majority was comprised of entertaining street scenes. Shopping arcades were thought to be particularly filled with opportunities for diversion, and at least one installment was devoted solely to one of these: the Lowther Arcade. Here, the writing style approached that of the growing genre of travel guidebooks (Murray's *Handbooks for Travellers*, first published in 1836, for example) and the metaphor of the wax museum was obvious:

> The stranger will not fail to be struck by the representation of two headless gentlemen in a hunting-coat and dressing-gown at an adjacent tailor's. They are placed behind a brass barrier, and have something very awful in their appearance. The legend attached to them is unknown; but they possibly represent the guillotined victims of some revolution—probably the same in which fell the decapitated ladies at the staymaker's in Berners'-street, whose heads are supposed to have migrated to the hair-dresser's in the covered passage of Burlington, which is somewhat similar in its features to that of Lowther—*arcades ambo*. ("Gratuitous Exhibitions" 1843: 235)

Even at this early date, the author and the reader clearly shared in a mutual literacy of the waxwork exhibition: the deployment of a physical barrier to produce an effect of awe, the macabre combination of prosthetic bodies with the apparent relics of those they represent, and the expectation that the viewer responds to the sight by recalling a historical event and emotionally responding to it (see also Sandberg 2003). Here, and in the previous quotation, clothing displayed for commercial purposes was marked out as a key item of interest. The conventions of display[1] from the commercial sphere were, even at this early stage, connected to those within museums and "heritage" attractions; a continuity of visual strategies common to both spheres is evident across the primary source material.

It was not only male urban wanderers who were seen as natural audiences for fashion exhibitions. In 1847, *Punch* suggested that the British Museum might be of more interest to women[2] if it included fashion within its remit:

> Fashion and dress always present points of interest to the sex we are desirous of enticing within the walls of the British Museum; and we propose, therefore, to invest the great national depository with attractions for the female visitor, by commencing a collection of the newest patterns in caps, shawls, bonnets, *visites*, and other articles of attire, which come home to us all—in bandboxes, with tolerably long bills tacked on to them. ("Hints to the British Museum": 59)

Although the British Museum's commissioners did not act on *Punch*'s suggestion of institutionalizing fashion in its galleries,[3] Victorian Londoners, male and female, could nevertheless continue to enjoy the spectacle in commercial venues. Their informal skills of observation and maneuvring in public spaces would have been equally valuable in a gallery of costume.

The museal mind-set was applied to fashion in other contexts. As an 1874 report from Paris mused, "What are the long lines of the boulevard windows and those of the Rue de la Paix but an exhibition of clothes? From hat to shoe, from innermost flannel to outermost velvet, every style and article of human costume is exhibited" (Hooper 1874: 624). Indeed, the materiality of the museum was not limited to the interiors of public collections, as women's fashionable magazines used the word "museum" to mean a collection or compendium even in a literary sense (e.g., *The Lady's Monthly Museum; Or, Polite Repository of Amusement and Instruction*, an English monthly women's magazine published between 1798 and 1832, or the *Ladies' Cabinet of Fashion, Music and Romance* published between 1832 and 1870, its title a clear derivation of the notion of a cabinet of curiosities). It could, as contemporary journalism demonstrates, also be found along the high street (Figure 2.1):

In the magnificent linen drapery establishments of Oxford and Regent Streets, the vast shop-fronts, museums of fashion in plate-glass cases, offer a series of animated *tableaux* of *poses plastiques* in the shape of young ladies in morning costume, and young gentlemen in whiskers and white neckcloths, faultlessly complete as to costume, with the exception that they are yet in their shirt sleeves, who are accomplishing the difficult and mysterious feat known as "dressing" the shop window. By their nimble and practised hands the rich piled velvet mantles are displayed, the *moire* and *glacé* silks arranged in artful folds, the laces and gauzes, the innumerable whim-whams and fribble-frabble of fashion, elaborately shown, and to their best advantage. (Sala 1859: 77)

According to this extract from journalist George Sala, then, a museum of fashion was not necessarily associated with the irrelevant past. The active construction and consumption of acceptable aesthetics were documented in window displays and could equally be documented in a museum. Furthermore, this extract demonstrates the currency of museum display conventions outside the heritage context in the commercial world.

However, displaying dress in a museum is a fundamentally different prospect than staging it to appeal to a buyer in a store. This is not just down to the

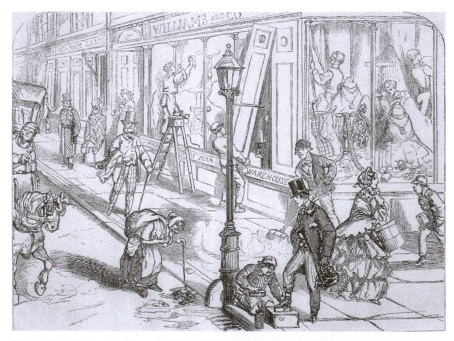

Figure 2.1 William McConnell, "Eight O'Clock A.M.: Opening Shop," from page 87 of *Twice Round the Clock; or, The Hours of the Day and Night in London* (Sala 1859).

conservational considerations necessary but also has to do with the way in which the museum context fundamentally changes the nature of fashion once it enters its collections and exhibit spaces. An ontological discussion is necessary at this juncture to explain the distinction between fashionable clothing and fashion as museum artifact; this is a crucial difference that enables the museum to stand apart from the store while evoking that environment through display and didactic text.

Fashion and time: Museums and narratives

The key element of the definition of fashion is not essentially material—that is, the term does not refer to particular objects of clothing, textiles, or accessories. Neither is it simply aesthetic; instead, its peculiarity lies in the changeable nature of that aesthetic. It is the periodicity and ephemerality of fashion that distinguishes that term from its erstwhile synonyms. As a commodity shaped by producers' and consumers' changing tastes, fashion is doomed to pass from the now into the then and lose its economic value while gaining its very self-definition. If fashion had a scientific formula, it would be change over time, and it is this chronological aspect that makes it such an appropriate museum object.

As Peter Corrigan points out, fashion is subject to multiple divisions of time simultaneously—hours, days, weeks, seasons, years, decades, reigns, and centuries (Corrigan 2008: 71)—but fashion is always doomed to die by virtue of its planned obsolescence. In earlier centuries, this was seen as its moral failing (cf.: Johnson, Torntore, and Eicher 2003b; Ribeiro 2003; Purdy 2004); unable to retain useful features to adapt to changing circumstances, it shed its decorative skins entirely and was constantly being reinvented, making it unreliable and untrustworthy in the eyes of social commentators. More recently, however, it has been seen as emblematic of postmodern society at large, and both Caroline Evans's volume *Fashion at the Edge: Spectacle, Modernity, and Deathliness* (2003) and Judith Clark's *Malign Muses/Spectres* (2004–2005) project celebrated the cannibalistic reincarnations of fashion as being illustrative of the logical conclusion of pervasive mercantile capitalism in all aspects of contemporary life.

It has become the museum's role to preserve these "fossils of the mode" ("High Fashion" 1946: 499). These objects, rescued from their certain deaths as commodities, are placed into a narrative within a museum, which produces new, authorized historical meanings for them as embodied memories (Silverstone 1994: 162–163). Therefore, fashion in the museum is an inherently historical object, even when it is displayed as technology, design, or art. Even items of

clothing exhibited as examples of contemporary design, however, are historicized by the very act of taking them out of a system of commodity exchange, where their economic value is in their being "of the now" (seasonal, for example), into a symbolic system where they merely *represent* the now in a museal intellectual context, which seeks to relate the present to the past in a unified worldview. This is not because museums are only of or about the past but because they layer a temporal significance onto objects; the clothing object is represented by the museum as being historical insofar as it is documentary. This distancing (see Chapter 7) historicizes the contemporary; to use Peter McNeil's terms, it is a curatorial intervention that makes "use of the past to help make the present 'strange'" (2009: 164). Even a couture gown from the present season, if it is displayed in a museum, undergoes what Appadurai calls a commodity pathway diversion (1986), as it is not for sale but iconic of the narrative the museum wishes to tell. The item of clothing becomes a fashion moment and its staging recreates "a fashion moment" (Colburn 2018: 49). Thus, material in exhibitions that contain work by designers still in active practice may still be characterized as "historical fashion."

Fashion's musealization follows naturally—it is designed to fade away and therefore inspires anxious nostalgia, which is combated through the museum process. As Alexandra Palmer, curator of the ROM in Canada, writes, even the physical decay of artifacts is denied, at least in public representations (Palmer 2008a: 58–59). Indeed, the 1833 exhibition of clothing belonging to the Cromwell family, alluded to in Chapter 1, was lauded at the time for being in such an excellent state of preservation that "the silk and ornaments possess all the splendour and brilliancy of yesterday's manufacture" ("Female Costume" 1833: 3). In 1958, reviewing the redisplay of the V&A's Costume Court, a journalist wondered, "it is astonishing how fresh many of these 200-year-old gowns still look, and, among minor things, there is one little apron, embroidered with a design of simplified horns of plenty [possibly T.210–1929], which looks as if it had been made yesterday" (Museums Correspondent 1958: 10). For these commentators, it seemed impossible to believe that something so long out of fashion could seem so fresh and desirable.

The earliest museum collections of historical dress rarely included any fashions that might have been worn within living memory: Plate 57 *of Old English Costumes* (1913), which cataloged the collection of painter Talbot Hughes as donated by Harrods to the V&A, showed the latest gown in the collection and gave its date as 1868–1878, a fashion over thirty-five years out of date by that point. Iconic of past difference, this made the contrasting present stand out in relief. Fashion photographers have been aware of the effects of such juxtapositions for a long time. An Easter fashion feature included with the Sunday newspaper supplement *Family Weekly* on March 20, 1955, had models in new fashions posing in front of the new Costume Institute display *The Fine Art of Costume* (1954–1955),

the spring styles echoing the Regency and Edwardian ensembles in their high necklines, rounded bosoms, full skirts, and long torsos. Yet no matter how the models echoed the poses of the mannequins behind them, the older styles were still inevitably of the "bygone times" of "yesteryear" (Rice 1955: 43). The past, by its strangeness, evoked the present even more strongly—a canonical past and a progressive future being part of the teleological narrative of Western progress.

If fashion is of the present, what happens to it when it enters a museum, which is about the past? It gains a different temporality and a new significance from that museally contextualized temporality. Fashion, as such, cannot exist in the museum—in order to be fashion again, it needs to be seen from the present, not within the past. In commodity fashion discourse, "the dress you wore only a few years ago is only an old dress, and sometimes just a comical old dress at that" (Betty (Katharine) Brett 1957, quoted in Palmer 2008a: 57) but in the museum, it becomes a costume—a synecdoche (Bal 1996: 148) made to be representative of a time and place.

Fashion in the museum becomes an object of cultural critique and is transformed into something it was not, originally—its economic value as a commodity on the open market is stripped away, and its power for self-expression is absorbed back onto hegemonic narratives consistent with the museum's social position. Furthermore, it has been suggested that the introduction of fashion-themed exhibitions into the museum display calendar serves to "promote the museum as trendy and up-to-date" (Haller Baggesen 2014: 17; see also Riegels Melchior 2011). Some museums, such as MoMu in Antwerp, actively align themselves with the commerce of fashion in order that their exhibitions more accurately reflect the industry's realities:

> MoMu wanted to be very close to the fashion system, to be open to it, to look to the future and to help shape it. Indeed, its closeness to the fashion system was reflected by the initial choice of: staging only temporary exhibitions every six months following the fashion industry's calendar; buying contemporary garments during the fashion week; and customizing the museum's guards in accordance to the exhibitions. (Pecorari 2012a: 119)

This is a challenging direction, as it requires balancing corporate branding agendas with the museum's need for intellectual freedom; however, when successful, exhibitions have the potential of demystifying the creative process.

The Guggenheim's decision to stage a retrospective of Giorgio Armani's designs in 2000 was criticized less as an example of profane fashion entering the sacred space of the art museum—Christopher Breward commented at the time that "exhibitions like those of Saint Laurent and Armani, with their assaults on the hallowed spaces of art that have themselves long since realised the economic benefits of coming on like exclusive boutiques, remind us that culture

and commerce are more closely related than some critics would like" (2003b: B18)—and more for the weakness of the design and academic insight that plagued it, seemingly in favor of product marketing; this was despite the fact that Harold Koda was one of the two curators of the exhibition and immediately thereafter was hired as curator-in-charge of the Costume Institute at the Met, where his tenure was largely filled with successes. To cite Breward again, "the overriding impression was of a glossy but ephemeral department-store window" (2003b: B18), and the show has become notorious as an example of collusion with a consumer brand that was, as critic Blake Gopnik put it, "more sales pitch than curating" (2000: R7). Yet, if the question of whether fashion can be given the same critical attention as art is set aside, the fact remains that fashion brings the art gallery space closer to that of a store, and the gallery increases the value of the fashion displayed within. As John Potvin insightfully wrote in reference to the Armani exhibition, "the fashion show on the one hand and the museum on the other [are] parallel spaces in which the act of seeing and being seen, the desire for and pleasure of, fold into each other" (2012: 60). It is probably no coincidence that nostalgic trends in fashion appeared alongside the founding of museums, which allowed people to adopt a new way of engaging with the past and looking back on it as a distance irrevocably separated from them.

This widespread acceptance of the distancing of historical thought is perhaps why Diana Vreeland's exhibitions at the Met (Plate 1) were so shocking to museum colleagues internationally (Menkes 1983: 8) and to commentators such as Deborah Silverman (1986). Vreeland curated her shows according to her expertise as editor of *Vogue*, mixing styles and periods, appealing to the fashion market, and often promulgating myths rather than histories (Clark 2011: 233). As Valerie Steele notes, fueling her desire to be entertaining rather than educational, Vreeland had an "intuitive awareness that the clothing of the past was never 'costume', but rather was the 'fashion' of its day" (Steele 2008: 11). Her notorious 1981 exhibition *The Eighteenth Century Woman* was exquisitely styled; mannequins were abstracted, painted in metallic tones, posed and accessorized theatrically. The exhibition did not please costume scholars, who found the mannequins with Lurex-covered faces and use of modern accessories "disturbing": a reviewer wrote, "not only does this trivialize the clothes to give a *Vogue*'s eye view of fashion, but it serves to distract the mind from the high quality of the textiles, many of which gain their effect from subtlety" (Ribeiro 1983: 156). Interviewed in connection to the exhibition opening, Vreeland justified her design decisions by exclaiming, "Some museums want old clothes to look old; I think they should look starched, fresh and delicious" (Menkes 1981: 9). This attitude was substantially different than the previously accepted methods of displaying eighteenth-century attire at the Costume Institute, appealing more to fashion industry aesthetics than to museum conventions (for detailed discussion, see Martin and Koda 1993). Vreeland's application of contemporary taste to

previously distant history broke all the rules of modernism, wherein the decorative and the temporal were associated with mass culture, while high culture preferred the timeless (Purdy 2004: 9–10).

What is interesting, however, is that as fashion is such a familiar presence in people's lives from their wardrobes and their shopping experiences, its intimate connotations continue to leak into even the most cerebral representations of costume in museums (Petrov 2011). Fashion historians de la Haye and Wilson gave an excellent example of this in their book *Defining Dress*:

> Clothes, all in all, are enormously meaningful and are deeply entwined with our lives. In 1993 the Biba exhibition (shown in Newcastle-upon-Tyne and Leicester, but not in London) recreated the ambience of the Biba shops in Kensington in the 1960s and early 1970s. It drew large crowds. A visitors' book solicited comments and the response was insightful—long entries amounting in some cases to autobiographical extracts as writers recorded in detail where, when and why they wore their first Biba garment and what it had meant to them—showing a whole generation of women whose identities had been formed by a culture in which the dresses of a particular designer had played a crucial role in establishing the ambience of the times. These women, now in their forties and fifties, were to be seen at the exhibition reminiscing with friends and reliving their youth. (de la Haye and Wilson 1999: 6)

When people engage with dress in museums by remembering their personal histories, they are engaging with it as fashion, not as costume. There is a clear reciprocity between consuming fashion in commercial contexts and consuming historical fashion in museums.

Historical fashion, contemporary cultural capital

Museum fashion could also be reintegrated into the fashion industry. Many world capitals advocated for a fashion museum in order to stimulate the local clothing industry: just as Richard Steele saw his 1712 fashion museum playing an important part in reducing French influence in the luxury goods market (Mackie 1996), the rift between Germany and France in the First World War enabled the Berlin Fashion Museum Society to arrange an exhibition of historical clothing to inspire and educate producers and consumers of fashion (von Boehm 1917). The pieces shown in this 1917–1918 exhibition were later collected by the Museum for German History (Deutsches Historisches Museum) (Rasche 1995). This was no futile aim: there are many examples of this museum-fueled nostalgia

being used for economically productive ends. For example, in 1974, a collection of gowns inspired by nineteenth-century examples on display at the Costume Institute was retailed through Bonwit Teller. The designer, Eleanor Brenner, was inspired by the exhibits to evoke in her modernized reproductions what she saw as the more authentic, romantic, and simple lifestyle of the original wearers of these clothes (Christy 1974: 11).

The stereotyping effect of industrialization on the world of material goods meant that museums were increasingly filled with artifacts infused with nostalgia— objects crafted in the past, collected because of a perceived supremacy of skill over that available to the contemporary craftsman. Decorative arts museums and collections in particular, such as the V&A, were dedicated to the gospel of "honest labour," produced by hand by craftsmen before the advent of the aesthetically and morally dishonest machine age (see Eastlake 1868; Morris 1882a, b). In 1913, the department store Harrods donated the historical dress collection of genre painter Talbot Hughes to the museum (Petrov 2008), with the hope that "the collection would stimulate the imagination of the present and the future, and would help in the scheme of colour and design, which was so necessary to the dressmaker" ("Old English Dress" 1913: n.p.).

In fact, the costume collection continued to be seen as "a sort of rather unholy by-product of the textile industry" (Gibbs-Smith 1976: 123) for many years thereafter, although recently, the administration has become much more appreciative of the benefits of such collaborations. As part of a 2000–2001 exhibition, *Curvaceous*, the museum asked Central Saint Martins students to reinterpret historical undergarments for contemporary fashion. Zac Posen's dress, made in response to the challenge, of strips of leather held together with hooks and eyes is itself now in the museum collection (T.213–2004). Even more recently, in 2015, the museum's archives were mined for patterns to be used in a capsule collection for the high street clothing chain Oasis, fulfilling the founding intentions.

Similar motivations were behind the incorporation of the private Museum of Costume Art, founded in 1937 by Irene Lewisohn, into the Met in New York. Although then Met president William Church Osborn privately confessed that he was horrified to think "that we will be in the button business" (1944), the 1945 notice on the front page of the American Museums Association newsletter was very clear on the subject of connections with the fashion industry:

The Museum of Costume Art has been made a branch of the Metropolitan Museum of Art under the name Costume Institute of the Metropolitan Museum of Art. [...] Announcement of this was made by William Church Osborn, president of the Metropolitan Museum, at a December 12 meeting of leaders of the fashion industry. [...] Exhibitions of the new Costume Institute are arranged especially for fabric and clothing designers. The current

showing, *Hats and Headdresses*, includes more than a hundred American and European models. ("Costume Institute Becomes" 1945: 1)

Thus, despite the name of the institution suggesting an aesthetic focus, the museum was really geared toward economic productivity. The term "art" might here be more fruitfully interpreted as something approaching Platonic or Aristotelian productive mimesis, the practical application of creativity and skill. This was hardly surprising in the context, as one of the founders of the Museum of Costume Art was Morris D. C. Crawford, the research editor for the fashion industry publication *Women's Wear Daily*, and the advisor to the Board of Directors in charge of fund-raising was Dorothy Shaver, president of the high-end department store Lord & Taylor (Weissman 1977: n.p.). As early as 1928, the founders of the Museum-cum-Institute had partnered with industry to organize an exhibition at the Stern Brothers department store in Manhattan to raise support for a permanent home for the collection ("Costume Show" 1928: 35). By 1958, a brochure text emphasized over and over again its primary audiences:

> The reason for the Costume Institute [...] to stimulate the creativity of the American fashion industry [...] Located in New York City, focal point of costume design and study in America, the Costume Institute sits at the very heart of those great industries to which its services are vitally essential. It benefits all who work in the various fields of costume—fashion theatre, editorial, promotion, manufacture, merchandising, research. [...] Adjoining the Study Storage is a series of designer's rooms where professionals may work in privacy. Here is where ideas are born. [...] In this creative atmosphere, designers translate the past into tomorrow's fashions. [...] Leading internationally-known designers use the Costume Institute regularly as a stimulus to new fashion inspiration. (*Costume Institute* 1958: n.p.)

An interview with Executive Director Polaire Weissman in 1961 highlighted the Institute's importance in offering "a blend of stimulation and information to students, fashion designers, people who promote and sell clothes and those who suddenly need to know some facts about their history" (Bender 1961: 42). Ten years later, a special issue of the Met's *Bulletin* dedicated to the Costume Institute featured interviews with designers who shared how they used the collection to inspire and inform their work (Moore 1971). An example of this symbiotic relationship comes from 1954, when the young American designer James Galanos received the American Fashion Critics "Winnie" award at the Met; he was pictured in *LIFE* magazine in one of the Costume Institute galleries, surrounded by models wearing his dresses, their full skirts and long trains echoing those on the mannequins wearing gowns from the nineteenth century ("Collection of Kudos": 147) (Figure 2.2). Even today, the galleries provide valuable

Figure 2.2 Modern and museum fashion at the Met. Original caption: "These comparisons between the ultrasmart evening gowns of today and those worn by the well dressed lady of fashion a century or more ago were made in the fashion wing of the Metropolitan Museum of Art, where the Costume Institute's collection of gowns, depicting the evolution of fashions for several hundreds of years, is on display. The 1954 fashions were designed by James Galanos of California, winner of the 12th annual Coty American Fashion critics Award. In the photo at left the Galanos creation (left) is a gold and black metallic evening gown built over a pellon and black silk taffeta. Compare it with the ball gown of cloth of silver vertically striped with blue silk and gold tinsel, brocaded in polychrome and trimmed with silver lace, beside it, which dates from the 18th century, Louis XV period. French, of course." Bettmann/Getty Images.

inspiration. In the 2017 documentary *House of Z*, designer Zac Posen (who interned at the Costume Institute when a high school student) discusses how he visited the *Charles James: Beyond Fashion* exhibition, and he is shown studying construction details of the garments prepared for display in the conservation studio (Plate 2); these are later translated into an elaborate evening gown (itself inspired by the architecture of the Guggenheim Museum's skylight) in his fall 2015 American comeback runway show.[4]

Similarly close relationships between costume collections and the fashion industry are widespread throughout the United States.[5] In 1941, the Brooklyn Museum's Industrial Division arranged a display of hats from the museum's collection: "The main purpose of the exhibition was to bring to the attention of millinery designers the great wealth of source material in the world-wide range of the Museum's millinery collections." These were accompanied by contemporary creations forecasting future trends by renowned milliner Sally Victor: "They were based on the museum's collections, and showed the inspiration which a creative designer may draw from the Museum's material in the production of modern millinery which is neither a replica nor a mere adaptation of an older form" ("Museum as Fashion Centre" 1941: 109).[6] Such collaborative relationships were promoted in a speech by the New York textile industrialist Raymond Brush to the annual meeting of the American Associations of Museums in 1948 (Brush 1948: 7–8), and similar sentiments led to the establishment of so-called "fashion groups" of various cities—nonprofit professional organizations that promote their industry—which actively participate in the foundation, administration, and fund-raising for museums such as the Los Angeles County Museum of Art, where designer members contributed examples of their own work as the basis for contemporary collections ("Fashion An Art in Museums" 1949: 248)[7] as well as funding a new costume gallery ("Los Angeles Museum" 1953: 2), and the Philadelphia Museum of Art, where the collection displays (see Plate 7) were financed by the local branch: "The Philadelphia Museum of Art has received $15,000 for the installation of a second gallery in its Fashion Wing. [...] an enterprise of the Fashion Group of Philadelphia" ("Philadelphia Museum" 1950: 3). This ambitious expansion was intentionally modeled after the New York example, as the announcement of its inaugural display stated:

> Thus, the Philadelphia Museum will now take its place alongside the Metropolitan Museum with its Institute of Costume Art, alongside the Brooklyn Museum, and others which have strong collections, as a center of research and inspiration for all concerned with the making and merchandising of products of fashion. (Kimball 1947: 3)

Canada has its own branches of the fashion group, and the ROM's collection was also dependent on their efforts at mid-century: "The Fashion Group of Toronto,

an organization of women working with fashions, 'spots' really fine dresses of new styles and asks the owner to give it to the museums when she no longer wants it" (Usher 1958: 25). It must be noted, however, that even with the help of industry partners, contemporary styles could still be outmoded by the time they reached the museum, as the then curator Betty (Katherine) Brett noted: "We try to get a 'name' garment typical of the era, though we may have to wait 10 years before it is discarded" (Usher 1958: 25).

Although the time of the founding of the Costume Institute was closely linked to government efforts to boost industry production in the Depression and wartime period (Weissman 1977: n.p.), as a separately funded entity within the Metropolitan, the Costume Institute continues to maintain close relationships with the American fashion and textile industries, which still bring important mutual benefits in publicity and financial support. From the very beginning, industry availed itself of the resources of the museum, as a financial statement for the Museum of Costume Art from 1941 stated: "Firms and stores on Fifth Avenue, as well as the Manufacturers of the Seventh Avenue District are constantly coming in to use the source material in the museum, both in study storage and in the library" ("Brief Statement" 1941: 3). The ROM's Collection enjoyed similar popularity: "Designers come from as far as New York to study our collection" (Usher 1958: 25). Equally, such close relationships between museums and the industry are still maintained by these and other museums:[8] the V&A's "Fashion in Motion" events promote British high fashion, and the Bath Fashion Museum comes the closest to fulfilling *Punch's* suggestion by collecting and exhibiting contemporary designs in its "Dress of the Year" series, established by Doris Langley Moore herself in 1963 (Byrde 1984: 150). Under this scheme, contemporary fashion is documented and simultaneously layered with historical significance.

Fashion museum collections, in addition to inspiring and promoting commercial fashion, can provide a valuable aura of history to stores and design brands. Increasingly, the attractive nostalgia and the perceived authenticity that a (sometimes fictional) date of establishment can lend to a brand are recognized for their economic power (De Ruyck, Van den Bergh and Van Kemseke 2009). Indeed, savvy marketing on the part of both stores and museums has led to fruitful collaborations in the past. The Harrods gift of antique dresses was first displayed in the company's own flagship Kensington store during the 1913 Christmas shopping season alongside modern outfits (Mendes 1983: 78) and generated publicity for the store and the V&A through sales of commemorative illustrated books (*Old English Costumes* 1913). In 1945, long before the McCord Museum costume collection had premises of its own or indeed was even recognized as an entity within the museum, a Montreal department store, Henry Morgan and Company, displayed pieces of historical fashion on loan from the museum to commemorate its centennial ("Century of Style" 1945: 5). This exhibition no doubt portrayed the store as having native Montreal pedigree, but it may also have been the first time

that Montrealers became aware of the McCord Museum's fashion treasures, as it was not until 1957 that the Costume and Textiles collection was formally founded. Similarly, New Zealand department stores were displaying costumes before museums. A concerned Auckland citizen wrote to the local newspaper decrying the lack of investment in irreplaceable material culture by public officials:

> In view of the interest shown in the display by a Queen Street firm of the clothing worn during the last 75 years I think that it would be very wise if the city, either through the old Colonists' or the war memorial museum, acquired a complete set of the clothing as worn by New Zealanders—men and women, adult and child, during the last 100 years. The museum has a fine display of what the Maori wore 100 years ago and the average person could better describe the Maori costume than what the ordinary *pakeha*[9] wore in 1840. As time marches on it will be increasingly difficult to see authentic costumes. (Bustle 1941: 4)

Apart from the casual racism evident in the author's view of white settlers (but not Maori) as being New Zealanders, the letter demonstrates the public interest but lack of resources for viewing dress history in that country. It also underscores how vital commercial enterprise was for promoting fashion's place in museums across the English-speaking world.

Deborah Silverman (1986) has written a detailed history of the collaborations between the Bloomingdale's department store and the Costume Institute in New York under the leadership of Diana Vreeland in the 1970s and 1980s. However, even earlier than this, department stores and fashion boutiques were closely involved with the work of the Costume Institute. The fund-raising "Fashion Ball," often referred to as "the party of the year," an annual event since 1946, is one opportunity for the fashion industry to support the museum financially. In 1960, for example, the department store Saks Fifth Avenue heavily sponsored the Ball ("Party of the Year" 1960) (see Figure 6.5). In 1963, the "Art in Fashion" publicity campaign featured jewelery, fashion, art, and furniture from the museum's collection in the store windows of luxury shops along fifty blocks of Fifth Avenue leading up to the museum: Tiffany, Bergdorf Goodman, Van Cleef and Arpels, Henry Bendel, Bonwit Teller, Helena Rubinstein, Revlon, Best and Company, De Pinna, Cartier, Saks Fifth Avenue, Lord and Taylor, and B. Altman all featured museum artifacts interspersed with their own products to "salute" the museum and its upcoming benefit gala ("Fifth Avenue" 1963). More recently, the "party of the year" has become a fashion event in its own right; in an even more interesting twist, iconic Gala looks have been musealized; for example, the gown worn by Annette de la Renta to the 2012 Costume Institute Gala was featured in a 2017–2018 exhibition devoted to the work of her husband at the Museum of Fine Arts, Houston (co-curated by *Vogue* editor André Leon Talley).

Selling style

The pervasive influence of commercial fashion within the museum is perhaps unsurprising given its history. This chapter has already traced the confused visual landscape of museums and department stores in the nineteenth century and the presence of museum objects in department store displays in the twentieth century. It has also been noted that some of the visual conventions of displaying historical fashion were imported into the museum through the influence of individuals affiliated with both the museum world and the world of the fashion industry. This stands to reason, however, as the genre of the fashion exhibition did not spring fully formed *ex nihilo*, and its early years were filled with some debate among practitioners as to how best to develop it.

Indeed, one of the earliest discussions of this problem featured in a 1936 issue of *Museums Journal*. The example of the Hereford Museum's efforts to mount a display of historical dress is illustrative of the challenges faced and solutions found by early costume curators:

> Stands were necessary to display the costumes, and here a great problem presented itself. Naturally the dresses would look better on figures or stands than on hangers, but modern stands were useless for the majority, owing to the vagaries of ideas of beauty, in addition to the increase in size of the average woman during the past one hundred and fifty years. Repeated requests for gifts brought forth some sixty stands of this century but of old-fashioned shape, from local drapers, and surgical operations were performed upon these as soon as they arrived. The sizes of waists and busts were reduced by many inches. [...] Men have not varied in size so much, and stands were borrowed from the local tailor which exactly fitted uniforms from the early nineteenth century. (Morgan 1936: 170)

The practice, as archival research has shown, was not unusual, but this source is particularly revealing as to the motivations behind the choice of display technique. Indeed, the V&A availed itself of fifty commercial expandable wire mannequins bought at a discount from Harrods after the store's own exhibition of the same costumes had ended (Gaze 1913). Likewise, Doris Langley Moore used shop mannequins when planning her museum displays: "Forced to use our ingenuity, we mounted heads and arms on old dressmakers' dummies [...] we also adapted and even reshaped commercial dummies which had grown out of date, and were given to us, very helpfully, by several firms" (Langley Moore 1961: 280). Some of these figures are still used for display by the museum today, and particularly the Edwardian wax mannequins[10] (Figure 2.3) are rare survivals, artifacts in their own right. Langley Moore was reluctant to convey the air of the store fully, however: "Their heads were a troublesome problem since we had to

Figure 2.3 Edwardian wax mannequin models, an eighteenth-century outfit at the Museum of Costume, Bath, *c.* 1980. Courtesy Gail Niinimaa.

exclude anything recognizable as a shop-window model [...] repainted and re-wigged, some were by no means unpresentable" (Langley Moore 1961: 280). Her squeamishness was not shared by other curators, and many museums still use commercial mannequins for their displays,[11] some appropriating their retail "aura" to great effect.

For example, in 1975, the Brooklyn Museum commissioned Rootstein mannequins of the type used in major department stores, famed for being modeled after celebrities, for their *Of Men Only* exhibition (Figure 2.4). The exhibition book was in the style of a mail-order catalog,[12] a form of shopping the curator Elizabeth Ann Coleman assumed the audience to be familiar with: "Practically everyone recognizes a mail order catalogue and receives them [...]

Figure 2.4 Brooklyn Museum Archives. Records of the Department of Photography. *Of Men Only*. (September 18, 1975–January 18, 1976). Installation view. Courtesy Brooklyn Museum.

the mode of presentation is designed to stimulate the reader's interest in the subject matter whether that interest is based upon fashion history, nostalgia, curiosity or retail clothing economics" (1975: 2). Indeed, some of the mannequins used in the display were actually recognizable from the high street: a 1973 book about window display featured photographs of one of the mannequins used in the exhibition (initially modeled after British actor Jeremy Brett: "Men in Vogue," 1971: 9) in the windows of New York department store Bonwit Teller. Of that establishment, Joel wrote, "The men's store of Bonwit Teller, New York, continues to use natural-looking male mannequins as the prototype of the well-dressed, pace-setting sophisticate they identify as their customer" (Joel 1973: 121), and perhaps this is also why the same commercial mannequin model was used as a representation of modern[13] man at the Fashion Museum in Bath in the same decade (Figure 2.5). Rootstein continue to supply mannequins and display figures to the Fashion Museum, the V&A, and the Costume Institute for their historical fashion exhibitions, though these are not always used in the same explicitly referential manner as in *Of Men Only*.

Figure 2.5 Undated postcard of 1975 bridal costumes in the collection of the Museum of Costume, Bath. Suit is worn by the Jeremy Brett Rootstein mannequin. Author's collection.

The exhibition aroused a great deal of interest in the fashion industry. The exhibition's curator and designer were interviewed for *Visual Merchandising* magazine. The article not only contains much useful information about the technical aspects of staging *Of Men Only* but also refers to the commercial inspiration used for its design. Daniel Weidmann, the chief designer, stated,

> These exhibit techniques are adaptive to store windows, as well. As a matter of fact, many of my ideas come from those I have seen utilized in the windows when I stroll downtown. The only difference between my display and that of a

store is that I can't drill a hole in a shoe to put a pole through for a mannequin stand. Nor can I nail things or put pins into them to much extent because I'm dealing with museum pieces. ("Of But Not For Men Only" 1975: 37)

There was a further connection to the high street in that the department store Barneys sponsored newspaper ads and radio publicity for the exhibition ("Marketing Observer" 1975).

Twenty years later, the Costume Institute redisplayed its galleries with 120 new mannequins, which also evoked the commercial fashion world. Developed in collaboration with the manufacturers Ralph Pucci and Goldsmiths, the face of fashion history across the centuries was the supermodel Christy Turlington. The exhibition stylist felt that her face represented a timeless femininity (Topalian 1992: 18A), yet it was also obviously of its time, as Turlington then dominated the pages of high-end fashion magazines. It was appropriate, then, that the opening installation featuring mannequins with her body, painted gray, was called *Fashion and History: A Dialogue*. These mannequins modeled after her are still in production and are used in fashion exhibitions around the world.[14]

References to the retail environment in the design of fashion exhibitions have been a recurring trope used for nostalgic or aspirational reasons in a range of displays. The Smithsonian's Hall of American Costume featured a vignette of a "Dressmaker's Salon of the 1800s," designed to call to mind an earlier era of fashion fabrication. Likewise, among the early vignettes featured at the Museum of Costume (Fashion Museum) in Bath was one titled "The Draper's Shop," set in the 1860s, and another titled "A Shawl Shop 1870–80" (*Museum of Costume* 1971; Byrde 1980) (Figure 2.6): "the first of the Victorian scenes represents a busy afternoon at a smart draper's and haberdasher's, when shops, however fully stocked, were still relatively small and intimate and not nearly so departmental as now" (Langley Moore 1969: 21). Yet other displays used the shop metaphor as a symbol of modernity: the 1971 V&A *Fashion: An Anthology* exhibition was designed by Michael Haynes, a visual merchandiser for the fashion industry, and although guest curator Cecil Beaton himself was anxious that "the exhibition should not look like shop windows, and the construction of the display area has made that effect difficult to avoid" (Glynn 1971: 14), the exhibition press release "promised that, with Haynes's involvement, the show would have 'all the originality and liveliness of the best shop windows in London'" (de la Haye 2006: 138). Indeed, the Christian Dior section (the exhibition was divided chronologically as well as by designer or stylistic movement) was specifically styled to look like the brand's boutique[15] (Figure 2.7); the corbelled arch that acted as a niche referenced the exterior architecture of the Place Vendôme in Paris, home of many of the great couture salons. In addition, the section used fittings from the London salon of the couturier, and the evening dress laid out on

Figure 2.6 "The Shawl Shop," historic display at Museum of Costume, Bath. Courtesy Fashion Museum, Bath and North East Somerset Council, UK/Bridgeman Images.

a chair echoes the contemporary practice of couturiers to display their clothes in this way (Clark, de la Haye, and Horsley 2014: 106). The Biba section of the English contemporary part of the exhibition was styled to resemble the Biba boutique and advertising campaigns, while props identical to those used in the store were donated by the designer, Barbara Hulanicki (Clark, de la Haye, and Horsley 2014: 117).[16] The exhibition therefore knowingly echoed the shopping environments in which audiences would have been accustomed to seeing the clothes on display.

Figure 2.7 View of the Dior boutique display from the V&A exhibition, *Fashion: An Anthology by Cecil Beaton*, October 1971–January 1972. © Victoria and Albert Museum, London.

Many exhibitions of haute couture contain aspirational branding. The Costume Institute frequently collaborates with fashion houses to obtain funding and object loans: the 1996 Christian Dior retrospective exhibition was sponsored by Christian Dior,[17] and the 2005 Chanel show was made possible by Chanel. The logos of both brands appeared prominently in the entry signage for both exhibitions. Equally, the *griffe*, or signature, of Chanel was used for the title signage. This mark of the maker served as a reminder of the production aspects of couture, something highlighted in the Costume Institute's 1995 exhibition *Haute Couture* through the use of dressmaking

dummies (recognizable by their wheeled claw feet, stump necks, and articulated arms) in sections that dealt with the materials and making of high fashion.[18] In the 2007 V&A exhibition *The Golden Age of Couture,* tailoring details were showcased in a runway installation, referencing the spectacle of high fashion. Similarly, in 2016, the redesigned *Fashion and Style* gallery at the National Museum of Scotland placed dressed mannequins on an illuminated catwalk-style plinth, which cuts diagonally across the long courtyard gallery space. The most obvious evocation of a fashion show catwalk was used in the eponymous show at the Rijksmuseum in 2016, where mannequins moved slowly along a motorized runway (Figure 2.8).

The intervisuality of high fashion was well illustrated by the Met's *The Model as Muse: Embodying Fashion* (2009) exhibition, which featured mannequin vignettes recreating iconic fashion photographs over fifty years, 1947–1997. The public could therefore encounter three-dimensional versions of images featured in the fashion periodicals of that period—images that, even when featured in editorial layouts by famous photographers such as Richard Avedon and Cecil Beaton, served to promote the work of the designers whose dresses were on display. Curiously, the exhibition creative consultant John Myhre did not choose to feature the mannequins created to resemble such famous supermodels, not

Figure 2.8 Installation view of motorized runway, *Catwalk*, Rijksmuseum, Amsterdam, February 20–May 22, 2016. Photograph by Franklin Heijnen, April 2, 2016.

even any of the 120 Ralph Pucci Christy Turlingtons previously commissioned by the Costume Institute in 1992, even though there would have been precedents: Cecil Beaton, in collaboration with exhibition designer Michael Haynes, had himself used the Rootstein Twiggy figure to display a gown worn by the legendary supermodel in his *Fashion: An Anthology* show (Clark, de la Haye, and Horsley 2014: 119). Given curator Harold Koda's statement that "there are certain women in certain periods with whom you identify with the fashion of the time. What we are saying is that she becomes the embodiment of fashion" (quoted in Cosgrave 2009), it seems a curious omission not to musealize the surrogate bodies of those who defined a period in fashion history. Yet, as a model is intentionally a cipher—an icon of a lifestyle, meant to be complementary to and not distracting from the clothes she wears—the decision to evoke the experience of turning the pages of a fashion magazine is also understandable.

Amy de la Haye (2006) has begun to explore the relationship between the museum and the high-fashion magazine in her work, and its implications are intriguing. Not unlike the Museum of Modern Art's postwar exhibitions of good design (Staniszewski 1998), where consumers were encouraged under the aegis of "style," fashion exhibitions feed directly back into the fashion cycle by being featured in the same media outlets and inspiring the same set of creatives[19] and manufacturers as they promote. Indeed, *Vogue*, the Costume Institute, and American designers form a powerful trifecta of tastemakers for the American fashion industry. American *Vogue*'s influential editor Anna Wintour is also the chair of the fund-raising Gala, the "Party of the Year," whose celebrity attendees are featured in the pages of the magazine itself. In gratitude for her patronage, the museum renamed the wing housing the Costume Institute the Anna Wintour Costume Center in 2014. The collaboration has even spawned a publication (sponsored by the New York department store, Saks Fifth Avenue), documenting the exhibitions, parties, and *Vogue* editorial page spreads that mutually referenced each other from 2001 to 2014 (Bowles 2014). Yet this collaboration goes back even further: as early as 1943, the Museum of Costume Art, as it was then called, lent iconic period hats and outfits for a feature on *Vogue's* fiftieth anniversary. The models wearing the artifacts personified both the magazine and its readers across time; the magazine and the museum merged to become one ("Fifty Years of *Vogue*" 1943: 33–36, 109). This cross-promotion shared a visual language. Most recently, a fictional Met Gala (complete with plausible exhibit on the fashion of European royalty) was even filmed in the museum, and featured exclusive designs by Dolce and Gabbana, Valentino, Zac Posen, and others, as a crucial part of the plot of the 2018 feminist heist movie, *Ocean's 8*. For plausibility, the collaboration of the Met, Anna Wintour, designers, and celebrities were all necessary (Lee 2018: web) for the audience to recognize the impact and influence of the Gala and *Vogue* on fashion consumption.

The clotheshorse consumer

The practice of highlighting women of style is familiar from the publishing industry: from the photographs of fashionable society women in Emily Burbank's 1917 book *Woman as Decoration*, to the spreads of glossy fashion and lifestyle magazines, to "street style" photo-documentation by the late Bill Cunningham of *The New York Times* and Scott Schuman's popular "Sartorialist" blog. Museums have fulfilled their need to collect important clothing with documented provenance by collecting the wardrobes of some of the fashionable women of history. Just recently, exhibitions on the topic have included *Nan Kempner: American Chic* (Costume Institute 2006–2007); *High Style: Betsy Bloomingdale and the Haute Couture* (FIDM Museum 2009); *Daphne Guinness* (Museum at FIT 2011); *Isabella Blow: Fashion Galore!* (Somerset House, London, 2013–2014); *Jacqueline de Ribes: The Art of Style* (Costume Institute 2015–2016). The Palais Galliera, Musée de la Mode de la Ville de Paris, displayed the wardrobe of the fashionable aristocrat and muse Comtesse de Greffuhle in 2015–2016, which was redisplayed at the Museum at FIT later in 2016, and prior to that had featured the collection of the Parisian *vendeuse* of couture Alice Alleaume in *Roman d'une garde-robe: Le Chic d'une Parisienne de la Belle Epoque aux Années 30*, staged at the Musée Carnavalet in 2013–2014.

While there is a precedent as early as 1928, with the Brooklyn Museum's exhibition of the Worth-designed couture wardrobe of Mrs W. A. Perry ("Museum Exhibits Solve Fashion Enigmas" 1928: 10), the meteoric rise of this genre is probably traceable back to the 1970s. Cecil Beaton's 1971 *Fashion: An Anthology* exhibition featured clothes that he had collected from the wardrobes of women whose style he esteemed. In his exhibition proposal, he wrote, "I would hope to flatter the donors by only asking for specific garments that I had seen and admired; and would be very selective in anything that was merely 'offered'" (quoted in de la Haye 2006: 130).[20]

A similarly socialite wardrobe-based exhibition was held in 1999 at the Fashion Museum in Bath. *Women of Style* featured six women otherwise unconnected apart from their personal style: Mary Curzon, Mary Endicott, Helen Gardner, Martita Hunt, Dame Margot Fonteyn (see Figure 6.14), and Molly Tondalman. Label copy focused on the women's emotional connection to their clothing and their shopping habits: "It is obvious that Mary loved fashion when you see how many pairs of shoes she owned [...] Mary frequently bought the same style of shoe in several different colours" (Harden 1999: 4). Both exhibitions included portraits and images of the women featured, though only the Bath exhibition made any attempt to model the mannequins after them; it seems the women themselves were on display, contrary to the statements of curatorial intention to display personal style.

As I have noted elsewhere (Petrov 2014b), there is an undercurrent of sexism present in such presentations. To describe only certain women as "women of style" suggests that the majority of women have none; likewise, the exclusion of typical clothing from gallery spaces instills a class consciousness in viewers, who are led to believe that only the social elite have consumption habits worth aspiring to (a message reinforced in the fashion media). Cheryl Buckley and Hazel Clark's recent chapter (2016) on museum collections of fashion in London and New York, for example, contrasted institutional collecting policies and critiqued their lack of engagement with contemporary quotidian clothing, defining representation not as display methods but rather as quantitative presence or absence. This kind of social disciplining has occurred over hundreds of years, as nobles on parade or royal effigies in their splendid regalia[21] created a symbolic equivalence between dress and status. Apart from the magnificence on display in armories, waxwork exhibitions such as Madame Tussauds also reinforced the class hierarchy with displays of real royal regalia on look-alike wax bodies.[22] Real female consumers, on the other hand, have been moralistically maligned for centuries for their "excessive" desire for fashion, decried as gluttonous, vain, and unthinking. In recent years, the moral shortcomings of the habit for fast fashion have been explained as environmentally unsound and insensitive to capitalist exploitation. However, as Phoebe Maltz Bovy (2017) has described, the alternative—the high-end capsule wardrobe, which requires both financial and aesthetic asceticism—is merely a different kind of excessive consumption and one that is encouraged almost exclusively for female, not male, consumers. Conveniently, the women whose wardrobes are museum-worthy evade both environmental and capitalist critique: instead of going to a landfill, their discarded clothes are preserved in nonprofit institutions for the benefit of the less privileged public. And yet, even a review of the earliest American display of historical dress noted that fashion is truly populist. Describing the Smithsonian's First Ladies exhibit (Figure 2.9), *Vogue* opined,

> The United States National Museum at Washington has some very stupid collections which remain unvisited year after year, except possibly, in rare instances, when a professorial person enters in search of more professorial knowledge. It now has something of real interest to offer, something which will appeal to the heart and pride of every woman—the original costumes worn by the mistresses of the White house from the time of the first presidential administration to the present, as well as many other historic dresses; and, in many instances, though hanging in side cases, they throw even more light on the history of dress than the gowns worn by the First Ladies of the Land, which, draped on ivory colored plaster manikins, occupy the central position. ("Gowns That Have Cut" 1916: 59)

Figure 2.9 Postcard, *c*. 1965, showing the White House Blue Room furnished vignette of the First Ladies Hall, Museum of History and Technology, Smithsonian Institution. Author's collection.

This early journalist recognized that these elite women, though interesting for their association with political history, were not the best representatives of the story of fashion.

Even in exhibitions where specific women were not recognizable, they were portrayed through their appetites: sexual and sartorial. The Costume Institute's exhibitions *The Eighteenth-Century Woman* (1981; see above) and *Dangerous Liaisons* (2004) paired social history with a heavy emphasis on consumerism. The curatorial message for both exhibitions was that by surrounding themselves with particular kinds of material culture, the eighteenth-century elite fashioned themselves and molded their social interactions accordingly (Bernier 1981; Koda and Bolton 2006). The lively manner in which the latter exhibition, in particular, was staged served to enable audiences to empathize with the desires and diversions of the people who inhabited such lavish clothing and surroundings and may have tapped into a cultural stereotype of Rococo hedonism. Indeed, the newspaper description of the 1963–1964 exhibition *Period Rooms Re-Occupied in Style* focused solely on the consumer culture of the time (Figure 2.10):

> The street is the museum corridor with the wonderfully preserved 18-century [*sic*] storefront from Paris, behind which passerby may see the remarkable early porcelains of Sèvres. Two mannequins have been added to the scene,

window shoppers of the time of Louis XVI. The fashionable shopping attire that Paris provided one of the shoppers was an open robe worn over a matching petticoat in striped silk with coppery orange iridescence. ("Museum's Rooms" 1963: 171)

The porcelain was to later provide the exact shade of pink for the walls of Vreeland's 1981 show (Menkes 1981: 9). By walking through the interiors of the period rooms, or past animated vignettes, viewers also became part of the value hierarchy on display.

Figure 2.10 Postcard, *c.* 1965, showing installation view of *Period Rooms Re-Occupied in Style*, with a female and child mannequin by an eighteenth-century shop front. Author's collection.

Exit through the gift shop

For their Yohji Yamamoto exhibition, *Dream Shop*, MoMu transformed the galleries into a version of a boutique, complete with fitting rooms; according to Romano (2011), this enabled the museum to be truer to the designer's vision of fashion being for living, moving consumers. While most museums are unwilling to breach conservational protocol to this degree in their galleries, a similar effect can be achieved through complementary marketing in the ubiquitous exhibition gift shop; for example, the 2017 Costume Institute exhibition, *Rei Kawakubo/ Comme des Garcons: Art of the In-Between,* was accompanied by Comme des Garcons bags and T-shirts designed exclusively for the Met, allowing visitors whose sartorial appetites had been whetted to try out these fashions for themselves. Thus, further commercial context for fashion exhibitions must be noted, and this is the practice of monetizing the fashion exhibition through making pieces available in the gift shop at the end of enfilade of glamorous galleries. While visitors do not attend fashion exhibitions to shop the pieces on display, the designers represented in these exhibitions can attract new customers through raising brand awareness and, sometimes, direct income through sales of stock in the gift shop: for example, the Museum of Fine Arts, Houston, Oscar de la Renta exhibition (2017–2018) was accompanied by a boutique stocked by the company. As John Potvin notes, "Fashion has transformed museums and art galleries with myriad block busters featuring past and living designers, and these hallowed institutions have adopted the cornerstone of fashionable goods marketing by creating desire and stimulating and fulfilling need" (2009: 4–5).

The interiors of some galleries may even be indistinguishable from the gift shop: the curatorial team developing the fashion and textile gallery for the Bowes Museum in the UK noted that fashionable stores in London emulated museum display techniques by spotlighting merchandise in glass cases; they then referenced those retail settings in their gallery design (Gresswell, Hashagen, and Wood 2016: 147). *The House of Viktor and Rolf*, a retrospective of the Dutch design duo, was a serious academic endeavor—curated by the Barbican Art Gallery's senior curator, with a catalog cowritten by noted fashion historian and cultural theorist Caroline Evans. The exhibition, which included an enormous dollhouse filled with miniature versions of the pieces on display, was designed by Siebe Tettero, who was responsible for the interiors of the Viktor and Rolf boutiques in Dubai, Milan, and Moscow. Even more confusingly, the shop had the designer's pieces for sale. Likewise exhibition maker Judith Clark has staged historical fashion within the Bal Harbour Shops, a luxury mall in Miami, as a way of inquiring whether there was a fundamental difference between what is on sale and what is on display. While the museum is not a shop window for any given designer, clothing purchased in a retail setting may enter the museum,

and through the process of deaccessioning, the museum object may reenter the marketplace. The difference between goods and artifacts is sometimes obvious only through context, not display.

Museums and the market

Thus, it can be demonstrated that historical fashion, though economically and aesthetically obsolete once its "season" as a desirable commodity had passed, continues to retain associations with its commercial origins. Complicity with market forces can be traced throughout the history of fashion exhibitions. Most obviously, the display furniture of the exhibition was often derived from stores, with ensuing visual similarity between the two forms of display. Moreover, exhibitions on designers and consumers celebrated the commodified life of the artifacts on show, often promoting luxury brands and lifestyles in overt or suggested ways. These exhibitions bank on consumer familiarity with brands and designers: *Great Names of Fashion* at the Fashion Museum, Bath (2015–2016), was literally a roll call of twentieth-century commercially successful fashion creators. The curators explicitly wrote,

> When making our final selection of objects for the display, we were mindful too that—generally—visitors to the Fashion Museum want to see beautiful dresses, both to marvel at their exquisite craftsmanship, but also breathtaking garments which, in a fantasy world, they themselves might like to choose to wear. (Summers and Uttley, web)

By anticipating that visitors to fashion exhibitions are, above all, fashion consumers, this exhibition benefited the museum itself, as well as the brands represented within: both loyal customers and new audiences were attracted in mutual admiration of what was on display. The partnerships and resources provided by the fashion industry to museums create reciprocal value in exhibitions, and it is logical that the fashion industry—both producers and consumers— has traditionally been seen as the primary audience and the main supporter of fashion exhibitions.

While the eighteenth- and nineteenth-century authors who described fashion museums found the notion of an exhibition devoted to such a commercial object laughable, their fears that fashion could not be sufficiently critiqued in a house of culture and art persist to this day and reflect a fundamental anxiety about the intellectual authority of a museum in a capitalist society. The case of historical fashion exhibitions highlights that simply removing a commodity from the market by putting it in a museum collection does not remove the museum itself from larger market functions. When collections were established to inspire designers, this

simultaneously placed the museum at the service of corporate brands. Equally, while exhibitions of stylish and fashionable individuals may have been intended to highlight the power of individual taste, they can be seen as simultaneously promoting aspirational consumerism. Therefore, the early fear of the influence that giddy consumers or cynical businesses might exert over the museum's mission of cataloging the products of the past in order to improve those of the future is quite a reasonable one. This is increasingly truer, as designers can make their own museums and/or exhibitions and when both venues use the same designers and properties. In these cases, the ontological difference between museal and commercial fashion is narrowed, and both display environments become so closely aligned as to be almost indistinguishable.

The evidence demonstrates that the responses to historical fashion in the museum, from unease at female consumerism to unease about brand domination, suggest an underlying fear about a loss of objectivity and a subsequent descent into irrational commodity fetishism (see Leo 2001; Socha 2003; Menkes 2007; Postrel 2007; Menkes 2011; Gamerman 2014). It is worth mentioning, however, that there may be redeeming qualities for such collaborations: one recent commentator optimistically suggested that such exhibitions might manage to "transform the department store into a space for cultural reflection, if only for those in the know. [...] the juxtaposition of the museum context and the commercial context made a holistic understanding of the complexity of these cultural objects possible" (Haller Baggesen 2014: 19). In addition, historical evidence from the development of museum exhibition design from 1900 to 1930 reveals a long tradition of museums appropriating commercial techniques—especially those geared toward focusing attention and increasing desire—for the benefit of increasing informal learning in galleries (Cain 2012: 745–746). The museum, therefore, cannot be seen as a passive agent being exploited for commercial gain; instead, commercial settings and objects can contribute important interpretive perspectives for museum audiences.

3

THE NEW OBJECTIVITY: SOCIAL SCIENCE METHODS FOR THE DISPLAY OF DRESS

One early venue for the display of dress was as part of commercial exhibitions of the industries of many countries, where an evolution of cultural production was implied through the visual ordering of the material culture of particular nations and peoples. This chapter follows the creation of similar typological and relational displays in museums of fashion. These kinds of displays, many of which were influenced by nineteenth-century ethnographic displays of European folk dress or the costumes of other countries, emphasize technological progress, delineating materials and processes as they are arranged, stage by stage, to present a picture of logical advancement. While English-speaking countries did not possess the heritage of folkwear as in other European countries, and saw even their fashionable clothing (costume) of the past as being fundamentally distinct from the clothing of the indigenous populations of colonial settlements, the precedents set by anthropological displays of textiles and regional costume lived on in the custom of creating typological and taxonomic series of mannequins illustrating the development of dress. For example, the 1946–1947 opening exhibition of the Costume Institute at the Met was comprised of period groups wearing fashions from the late eighteenth century to the end of the nineteenth century, defined by particular stylistic features peculiar to the period (Figure 3.1). This remains a popular strategy for the display of historical clothing, especially in large permanent displays, such as the V&A fashion galleries. Equally, museum exhibitions that focus on particular categories of dress—underwear, shoes, handbags, or ball gowns, for example—also classify the formal qualities of garment types, following external narratives of technological development.

Function and relation to context are used in exhibitions such as these to explain variation, and comparative displays encourage the study of fashion

Figure 3.1 Postcard, *c*. 1946, showing a tableau of about 1750–1775, part of the opening exhibition of the Costume Institute. Author's collection.

as an objective technological phenomenon in culture. Likewise, the later anthropological custom of displaying cultural artifacts in life groups to recreate a context and to imbue the items within with relational meaning also continues to be evident whenever fashion is displayed in detailed recreated settings. In this analysis, the museum is critiqued as a means by which cultural embeddedness is constituted and reproduced.

Typological taxonomies: Form and function

From the Early Modern period on, scholars of human life have struggled to explain the variation evident in apparel. French philosopher Michel de Montaigne's 1575 essay "Of the Custom of Wearing Clothes" was one of the first to seriously engage with the purpose of clothing. After comparing attitudes to clothing across history and cultures, the philosopher concluded that no particular kind of dress was natural for humans and that wearing clothing was merely a habit. Indeed, regardless of what emotional, aesthetic, or social significance dress may be said to have, the fact remains that it is a set of physical practices and that clothing is a material object. Fashion as a system reflects human mastery over materials, and many traditional histories of clothing track the adaptations of materials and techniques to preferred forms. James Laver's classic twentieth-century text on the

history of costume begins with a discussion of just such differences, assuming that their chronology can be followed and logically divided into stylistic periods by a predominance of form and material: "It is possible to contrast 'fitted' and 'draped' clothes, most modern clothes falling into the first category and Ancient Greek clothes, for example, into the other. History has shown many variations in this respect, and it is possible to find intermediate types" (1995: 7).

Given all this variation, it seemed to many early costume historians and curators that to focus on how cloth was made into clothing was the most basic logical category by which to organize a narrative about fashions in different places and epochs. Curator Alexandra Palmer took this method-based approach to her exhibition *Measure for Measure* in 1989 at the ROM, categorizing European clothing from the seventeenth to the twentieth centuries by whether they were fashioned with draping, straight cutting, tailoring, or making to shape (Figure 3.2). In this exhibition, fashion was shown to be dependent on the skilled manipulation of material. To this day, as Palmer has herself elaborated (2018), an emphasis on manufacture and construction pervades the permanent and rotating displays at the ROM. Where possible, articles of clothing are accompanied by examples of other textile arts for comparisons of surface design or weave structure and sometimes even going so far as to provide pattern diagrams in label copy to explain how a flat textile (such as a length of Egyptian gold and silver silk) can be transformed into a three-dimensional garment (an overdress made in 1801 or 1802: 2004.33.1). In a published description of this garment, which was first

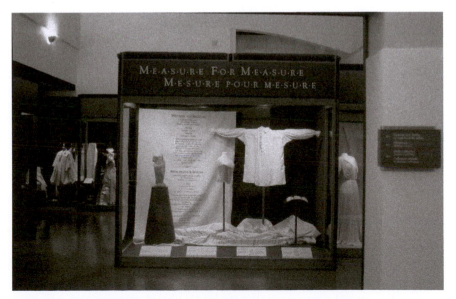

Figure 3.2 Installation view of *Measure for Measure*, opened October 12, 1989, with permission of the Royal Ontario Museum © ROM.

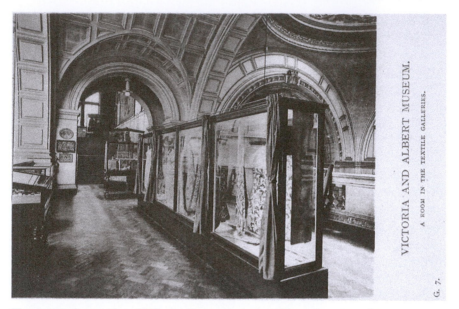

Figure 3.3 Postcard, *c.* 1910, showing cases in the V&A textile gallery. Case with costume is visible on stairs in the background. Author's collection.

highlighted in the inaugural *Jennifer Ivey Bannock in Focus Exhibit* in the ROM's Patricia Harris Gallery of Textiles and Costume in 2008, Palmer noted (2013: 282) that the gown's primary significance was its nature as a fashioned textile.

Equally, this focus on the material characterized the nomenclature and narrative scope for early galleries of costume. Forty years before opening its fashion wing, the Philadelphia Museum of Art, then known as the Pennsylvania Museum, assigned an arcade to textiles in its guidebook, although this space was actually where items of clothing that belonged to early Colonial residents of the area were displayed (Stevenson 1908). Likewise, the Boston Museum of Fine Arts focused its research on the weaving and embroidery techniques of the garments in its care, and continued to call itself a Department of Textiles, even after the 1943 donation of the Elizabeth Day McCormick collection, which was mostly comprised of historic fashionable womenswear. The V&A included "dress" in its department title only in 1978 and replaced that term with "fashion" in 2001; even in the 1980s, the Costume Court gallery was outnumbered by the department's three other galleries, housing textiles and lace (Figure 3.3). This organizational principle based on material suggests a preoccupation with technique and craft, rather than the overall aesthetic trends guiding the finished product that is made using that technique. One American journalist pointed out that the V&A's display style serves to highlight the materials on display, too:

> The Victoria and Albert is a serious design museum, hence the garments are more plentiful, the fabrics more lush, and the placards emphasise textiles and cut, not history and sociology. There are no backgrounds, no tableaux, no bright lights that might fade the fabric. (Lague Scharff 2000: TR31)

Emma Treleaven (2017) has suggested that this object-based focus is related to the discipline of ethnoarchaeology, drawing comparisons between historic methodologies and modern ones.

Following changing trends in intellectual thought, few institutions mount exhibitions of clothing-as-textile today, preferring to define these collections as fashion. Recent exceptions have been the V&A *Opus Anglicanum* (2016–2017), which was billed as a show about a particular embroidery technique for which English makers were famous in the Middle Ages but actually featured medieval religious vestments and royal ceremonial clothing; copes and chasubles were displayed flat to showcase the textile from which they were constructed, rather than wrapped around mannequins as they may have been worn. The Hermitage Museum's St. Petersburg, *Encyclopedia of Textiles* (2017) is another example of an exhibition that, while featuring tapestries, furnishing fabrics, and archaeological textiles, also features a wide variety of ecclesiastical, military, ceremonial, and fashionable clothing. In these exhibitions, the focus was on the materials and techniques that connected all these items from disparate origins. There was far less discussion of each individual garment's social, historical, or aesthetic significance—its original wearer, the context in which it was worn, its place in an evolution of style, or its overall design composition—as is typical in contemporary exhibitions on fashion.

However, this technical approach to clothing in exhibitions can also be observed in displays that focus on design and production. Beginning in the 1930s, a modernist zest for scientific principles ruled the study of the humanities, including fashion. Within this intellectual paradigm, design could be broken down to principles, patterns, and techniques, rather than being a product of ineffable inspiration. For example, the Newark Museum's 1937 display *Fashions in Fabrics* traced "the history of textile design and manufacture" through an emphasis placed on "types, colours, and designs of fabrics rather than the technique of production"; this focus on design was further layered with geographical and temporal analysis, as, for example, in a section on American fashion trends of the nineteenth century (American Home Economics Association 1937: 282). The Brooklyn Museum, it was said, "takes the same approach to fashion as an anthropologist with a training in the fine arts," with its study collection called a "Design Laboratory" and lauded as a "scientific center of study," its workrooms as futuristically modern as an "ideal study in a House of Tomorrow" ("Fashion … an Art in the Museums" 1949: 211). It was this emphasis on the rational principles of manufacturing that was highlighted when *Vogue* described the museum's acquisition of the couture wardrobe of Millicent Rogers:

One distinguished designer, Charles James, allowed Mrs Huttleston Rogers to give to the Brooklyn Museum not only the long-lived dresses he had made for her, but their actual working plans. [...] For the first time a living designer shared the fundamental principles of his craft, showed the paper patterns, the muslins, the sketches, revealing the mechanical structure behind each dress. ("Fashion... an Art in the Museums" 1949: 211)

The designer was thus revealed not as a magician or artist but as a skilled technician and craftsman. The forty-five outfits worn over ten years by Mrs. Rogers, as well as the archival material used in their creation—patterns, sketches, photographs, letters—have served as illustrations of the design process in several exhibitions held by the Brooklyn Museum (1948–1949; 1982–1983) and the Metropolitan Museum (2014) since then. Likewise, *toiles, croquis*, X-rays, and digital animations have since been used to demystify the production of fashion by designers such as Paul Poiret (Met 2007), Cristobal Balenciaga (V&A 2017–2018), and Jean Muir (National Museum of Scotland, 2009; 2016–present). These forensic techniques allow audiences unfamiliar with dressmaking and couture to closely observe the process of design.

The adaptation of dressmaking techniques for different design problems has also been a topic for fashion exhibitions. The recent exhibition *Fashion Follows Form: Designs for Sitting* (Royal Ontario Museum, 2014–2015) exhibited designs for adaptive clothing for wheelchair users by Canadian designer Izzy Camilleri. These innovative functional garments were contrasted with historical artifacts, which, while preoccupied with innovations in form, were not always sensitive to the needs of wearers. Just as Camilleri's contemporary designs translated modern trends (meant to be seen standing up) for wearers who were mainly seated, historical items such as collapsible bustles from the nineteenth century were displayed to demonstrate the technological means by which a fashionable silhouette could be maintained through changes in position. The formalist vocabulary of design, therefore, was here used to structure an exhibition narrative around the challenges of the utilitarian principles of clothing, demonstrating ideal combinations of aesthetic preference, form, and function. Fashion's whims were recast as technical challenges to be solved within particular parameters.

The uses of technology in the production of fashion are a key method by which these technical challenges can be solved, and this has also been addressed in fashion exhibitions. Most recently, the Met's *Manus X Machina* (2016) examined how handwork and machine-made techniques coexist in both high fashion and ready-to-wear. Galleries were divided into the traditional techniques used in couture: embroidery, feathers, artificial flowers, *toiles*, tailoring and dressmaking, pleating, lace, and leather. The case study of a 2014 Chanel haute couture wedding ensemble served as a centerpiece (physically sited at the center of the suite of exhibition galleries), demonstrating in one artifact the manipulation of

material between the analog and the digital, the natural and the synthetic, the handmade and the industrially produced.

The means of display chosen can also help to frame an understanding of fashion as technology. As Hjemdahl (2014) has demonstrated, the mannequins created by the Nordiska Museet in the early 1930s (Figure 3.4), and adopted throughout Scandinavia and Britain for the display of fashionable clothing (not

Figure 3.4 Undated postcard showing early nineteenth-century garments on display at the Nordiska Museet, Stockholm, Sweden. Author's collection.

folk costume), enabled the presentation of each garment or outfit as a singular object. The visual unobtrusiveness of these mannequins, which did not reach beyond the boundaries of the garment they supported and whose supports were often painted to blend in with the background, drew the viewer's attention instead to the clothing itself. Using these mechanics of display, the nature of the objects shown could be recast from relics of a bygone age or individual (see Chapters 6 and 7) to technologies that fulfill the general garment functions of protection or decoration. The design of these mannequins, as Hjemdahl argues, is a result of the functionalist, mass-produced aesthetic of the industrial age (2014: 114); the standardized mannequins are incapable of showing the specifics of the body of the original wearers and instead anonymize garments to show them as manufactured goods.

Great exhibitions and geography

Beginning in the middle of the nineteenth century, Universal Exhibitions and World's Fairs were large-scale international events designed to showcase the products of national industry; on an almost annual basis, visitors to these exhibitions across Europe and North America could see foreign and domestic novelties in manufacturing. Costumes (particularly traditional folk dress), as well as innovations in accessories and textiles, were always featured among the displays, and the publicity surrounding such events allows historians to trace how the representation of dress in these exhibitions entered public discourse around technology, consumption, and fashionability (O'Neill 2012). Whereas folk costumes demonstrated the authentic and unique traditions of culturally distinct societies, contemporary pieces highlighted their technical prestige and modernity, although both signaled pride in geo-cultural origins.

While elements of foreign costume seen in displays or on visitors were frequently integrated into fashionable dress as a result of the intercultural exchange these venues enabled (Goldthorpe 1989: 21), fashion itself became a popular exhibit category toward the end of the nineteenth century (Rose 2014: 15), as the industry gained economic significance—and some examples of these have survived in museum collections. It is well known, for example, that the V&A collection has its roots in the Great Exhibition of 1851 and still has some of the clothing and textile items from that event on permanent display (albeit in a separate section on the Great Exhibition within the British Galleries, not in the Fashion Gallery itself). Many museums followed the model of highlighting the premier pieces manufactured nationally for the organization of their collections but some also arose out of exhibitions and fairs. In America, the Philadelphia Museum of Art, for example, which had an early textile collection (encompassing clothing items), has a nucleus of items from the 1876 Philadelphia Centennial

Exhibition. Likewise, the Powerhouse Museum in Australia, which is now famous for its comprehensive costume collection, is descended from the 1879 International Exhibition held in Sydney; just like the V&A and Philadelphia, that event was musealized as the Technological, Industrial, and Sanitary Museum opened the following year (Douglas 2010: 136–137).

Apart from seeing fashion on other visitors, in manufacturing displays, and in ethnographic vignettes of folk life, visitors to some fairs and exhibitions also had the opportunity to view historical dress. As discussed in Chapters 1 and 5, there were specialized displays in 1873, 1874, and 1884, among others. Leading fashion historians such as Valerie Steele ([2012] 2016: 21) and Amy de la Haye (Clark, de la Haye, and Horsley 2014: 11) have particularly singled out the Musée Retrospectif at the 1900 Exposition Universelle in Paris as the first fashion museum. It cannot truly be classed as such, as most of what was on display was not part of a permanent public collection; however, the rich variety of artifacts on show and their arrangement (physical and intellectual) was to prove influential for future fashion museums. Alongside displays of modern Parisian fashion, especially *haute couture*, was a pavilion devoted to the past history of French clothing, demonstrating for visitors the continued global dominance of the French fashion industry. One section consisted of historical relics from French royalty, borrowed from the Musée des Arts Decoratifs; for centuries, the court was the fulcrum around which the fashionable industries operated. There was also a section of surviving fashionable dress from about 1710 to about 1870; many of the pieces on display were on loan from the painter Maurice Leloir, who also wrote the historical survey for the catalog (Cain et al. 1900) and whose collection later formed the nucleus of the City of Paris Fashion Museum at the Palais Galliera. Sections on folk costume as well as on accessories followed as historical counterparts to the international and commercial displays of the rest of the Exposition, and there was a display of fashion in illustration from paintings, books, and periodicals. While the souvenir catalog featured some photographs of live models wearing the historical garments, it seems that the majority of displays were arranged in glass vitrines. This echoed the commercial displays of fashion and accessories elsewhere in the Exposition. Where possible, items such as cravats, waistcoats, and gloves were attractively arranged flat, like merchandise. Other garments were displayed on headless tailor's dummies, sometimes with headwear floating above them.[1] This latter display style was adopted by the London Museum (now the Museum of London) for their 1914 displays of historical costumes (Figure 3.5):

> Rather a shock is given the imaginative by the large glass case of "A Georgian dinner-party" [*sic*], where the smart clothes are surmounted by huge wigs with no faces beneath them—a ghostly effect and a cruel reminder of how the most perishable works of man's hands and the most gay and frivolous of our vanities outlast our small span. (Filomena 1914: 690)

The London Museum. *Official Series No. 24.*

GEORGIAN TEA PARTY, XVIIITH CENTURY COSTUMES. J. G. JOICEY GIFT.

Figure 3.5 Postcard, *c.* 1915, showing Museum of London case of Georgian costume. Author's collection.

The Museum of London's early catalogs (1935) also featured photographs of flattened waistcoats and dummies in front of mirrors (to display the front and the back of a garment simultaneously), just as the Musée Retrospectif had done.

Many exhibitions of historical fashion continue to create narratives around geography or culture following the organizational logic of the World's Fairs. In the same ways as the waxwork displays of peasant and regional clothing, such as those premiered by the ethnographic Swedish collector Arthur Hazelius at the Paris Exhibition in 1867 (Taylor 2004: 205), a geographically specific focus promotes "authentic" traditions and customs in the face of a threatening multinational cosmopolitanism. Thus, these themes have to do with a nationalist promotion of local identity and pride, in the same way as international exhibitions were meant to showcase the preeminence of the host country. Occasionally, they coincide with political milestones, such as the *American Dress from Three Centuries* display at the Wadsworth Athenaeum in Hartford, Connecticut, which was held in 1976; in celebration of the bicentenary of the American Revolution, the history of the country was represented by thirty outfits representing the styles

worn during the three centuries of the country's existence ("Styles of Dress" 1976: 21). The exhibition design was simple, with realistic mannequins posed elegantly on open pedestals in an undecorated room. While the catalog noted that at the time of the revolution, Hartford's society was agrarian and lacked the "wealth and social sophistication that commerce brought to Boston, New York, and other east coast centers" (Callister 1976: 5), pride of place was given to garments with Hartford provenance, including the remarkable men's and women's garments associated with the family of Connecticut's early governors, Jonathan Trumbull and Jonathan Trumbull, Jr. The media coverage in the local newspaper included photographs (Hatsian 1976: 9E) of West Hartford and East Hartford locals admiring the dress of their ancestors, as though to favorably compare past and present lifestyles.

Indeed, these exhibitions function as patriotic signs of place, similar to the lucrative rebranding of cities as "fashion capitals" (see Dafydd Beard 2011). Exhibitions with location-specific titles, such as *American Fashions and Fabrics* (Met 1945), *An American Eye for Style* (Brooklyn 1986–1987), *The Elegance of France* (FIDM Museum 1996), *The London Look: Fashion from Street to Catwalk* (Museum of London 2004–2005), *Fashion Mix: French Fashion, Foreign Designers* (Galliera 2014–2015), *Paris Refashioned 1957–1968* (MFIT 2017), or *The Glamour of Italian Fashion 1946–2014* (V&A 2014 and touring worldwide), tie into the cultural prestige and economic aspirations of global capitals that seek, through a combination of marketing and media spectacles like trade fairs and "fashion weeks," to establish themselves as style destinations with unique sartorial identities. The museum institution, as Riegels Melchior (2012) points out, is thus complicit in nation-building through the promotion of this cultural heritage, attributing international success through strong local roots.

Unlike its predecessor, Diana Vreeland's *American Women of Style* (1975–1976), which coincided with the American bicentennial celebrations as a statement of patriotism, the Met's 2010 exhibition *American Woman: Fashioning a National Identity* was not linked to any political landmark moments. Instead, it celebrated archetypal social roles American women have had over the twentieth century—Heiress, Gibson Girl, Bohemian, Suffragist, Patriot, Flapper, and Screen Siren—most of which had been invented and reinforced through media representations. While some mention of specific American women who wore or designed the clothes on display was made, the exhibition was more concerned with the image of American femininity at home and abroad; the last room of the show featured a digital collage of portraits and video clips of iconic modern American women (actresses, politicians, musicians, and others) set to the soundtrack of the 1970 hit song "American Woman" by the Canadian rock group The Guess Who. It was not clear whether the curators understood the irony of using a song whose lyrics personify America as a dangerously seductive, war-mongering enchantress.

Instances such as these reveal that such nationalistic narrative orientations rely on largely arbitrary intellectual constructs (see Novak 2010: 98). Indeed, these constructs underpin most of the social sciences: political or cartographic coordinates, language, religion, or shared social rituals. Fashion exhibitions organized around places or peoples assume that the clothing on display demonstrates something specific to that place or ethnicity. Even the work of particular designers is sometimes characterized as being reflective of their place of birth (see, for example, Romano's excellent analysis of how the work of Yohji Yamamoto has been essentialized as Japanese (2011) in exhibitions).

One recent example of an exhibition that connected ethnicity, place, and fashion was *A Perfect Fit: The Garment Industry and American Jewry*, at the Yeshiva University Museum from December 4, 2005 to April 2, 2006. The curators attempted to explain why so many of the iconic creators of American clothing were Jewish. The answer to this research question is a peculiar historical coincidence: that Jewish immigrants, skilled in peddling and tailoring as a result of employment restrictions in their homelands, arrived in the United States at precisely the same moment that their skills were required in an emerging industry. There is nothing specifically Jewish about the accidental convergence of skilled labor into a growing trade and its subsequent successful growth other than the people involved—and even they might not have defined themselves as such after immigration. Other nationalities were equally active in the garment industry: Italian involvement in particular has been well documented. *A Perfect Fit* traced the production side of the ready-to-wear industry as a force for the Americanization of Jewish immigrants, so it could easily be contrasted with the *Becoming American Women* exhibition held in 1994 at the Chicago Historical Society, which focused rather on the consumption of clothing as reinforcing a new or traditional ethnic identity. The terms "American" and "Jewish" were highlighted from the very beginning in *A Perfect Fit*, and the use of these words in tandem caused a syllogistic relationship.

The three major galleries in the show traced the development of the ready-to-wear industry, and the differences between aspects of the production of menswear and womenswear, addressed Jewish immigration and employment, as well as the rise of industry infrastructure in manufacturing centers, including labor organization, and exhibited postwar developments and designers as well as the influence of Hollywood. While most documents, illustrations, and photographs were digitally scanned and printed onto the wall or the running text panel in front of the exhibits, articles of clothing and industrial artifacts like sewing machines and other tools of the trade (taken from Yeshiva University Museum collections or loaned from other sources) populated the cases and platforms.

This exhibition spoke fondly and nostalgically of the symbiotic relationship between industry and Jewish social activities in the period 1860–1960. It

encouraged social cohesion by describing a tradition of it—presenting a past where Jews worked, lived, holidayed, and worshipped together. By describing Jewish nexuses of garment industry activity, which also disseminated Jewish urban nexuses—New York, Rochester, Baltimore, Cincinnati, Chicago, Philadelphia, San Francisco, and Hollywood—*A Perfect Fit* delineated its own cultural and geographic context. Likewise, visitors to the show were aware of their own presence in one of these centers and were made to participate in this network through engaging with the exhibition. Although Jewishness was strongly emphasized in the show, it was never explicitly defined. The construct of a generic Jewishness was assumed to be universally understood and was neither questioned nor highlighted as an opportunity for possible resistance. Indeed, the visitor, probably already part of a self-selecting audience who identify with the subject matter, had to be "in the know" in order to "get" the significance of references to designer's changing their names or the name-dropping of famous and successful brands and stores. The success of Jewry in the ready-to-wear industry was justified through an appeal to supposedly inherent Jewish values (community, philanthropy, and education), taken from religious life and translated into secular ready-to-wear industrial production, theatre, and labor organization. The simplistic alliances drawn between Jewishness, Americanness, and fashion in *A Perfect Fit* highlight the difficulty of making claims about cultural identity within a museum exhibition setting.

Despite its challenges, the curatorial preoccupation with the *terroir* of fashion is particularly evident in the permanent galleries of national museums, where fashion is used as a means of illustrating the cultural capital, economic dominance, and historical development of a nation to citizens and foreign visitors alike.

The Smithsonian Institution's Hall of American Costume, opened in 1964 in what was then called the Museum of History and Technology building, was designed with modernist design principles of clean lines, uncluttered display, and good lighting: mannequins were in large glass cases or on open platforms (Figure 3.6), but the layout also mimicked the intellectual organization of the World's Fairs closely. While the older, existing display of the dresses of the First Ladies was also intended to "show the changes in American costume" (Smithsonian Institution 1964: 23) over the course of the history of the nation, it was set against architectural backdrops of period room settings and was descended from the traditions of waxwork displays of illustrious personages, such as the 1830s exhibitions of Cromwellian costume described earlier, or the well-known effigies at Madame Tussauds. The Hall of American Costume, on the other hand, took a different approach; it had four introductory text panels for each century of dress displayed and featured the clothing and accessories of men, women, and children from the seventeenth century to the 1960s (Smithsonian Institution 1963: 21) on realistic mannequins painted and styled to

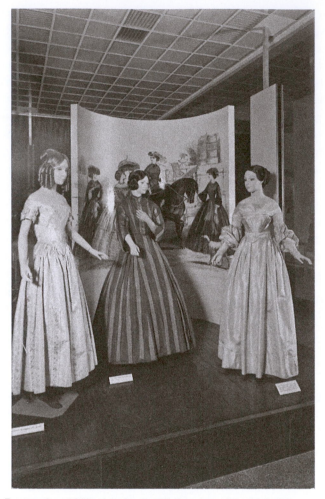

Figure 3.6 Postcard, *c.* 1965, showing installation view of the Hall of American Costume, Museum of History and Technology, Smithsonian Institution. Author's collection.

correspond to the reproductions of period illustrations, which were hung on the walls behind the figures (Smithsonian Institution 1964: 25–26). The effect was of an encyclopedia of textiles and dress, vividly illustrated with texts, images, and objects. The intellectual focus was undoubtedly on the development of manufacturing: interspersed among the historical progression were smaller exhibits meant to "provide detailed information on dress materials and the methods of fabricating garments in a number of periods" (1963: 220). These explained the ways in which garments were the end product of technological innovation and technologies in their own right.

The chronological dress display was complemented by the adjacent Textile Machinery and Fiber Hall, intended to "show the evolution of man's [sic] efforts to make materials of plant and animal fibers from prehistoric times to the present" and "demonstrate how the techniques of textile production have changed through the years" (1963: 211). The geographical specificity of American fibers was highlighted in this hall with objects like the first spinning frame built in America and "a most rare and beautiful dress made years ago entirely of silk from silkworms grown in America—the silk fibers processed in America and then hand sewn in America" (1963: 211–212). The awe and wonder of Great Exhibitions were reconstructed here through the use of demonstrations of equipment and materials: a restored Jacquard loom "in perfect working order" was described as though it was a contemporary technological marvel: "This wonderful punch-card device weaves tapestries and patterned brocades without requiring a laborious setting by human hands" (1963: 212). Visitors could also engage with the fabrics at handling stations with "many typical forms of textiles arranged so that each visitor may touch and feel them. Experts in textiles know that only by feeling fabrics can the visitor actually gain a satisfactory knowledge of different types of materials" (1963: 212). This interpretive technique continues to be relevant: it was also used in the British Galleries at the V&A starting in 2001, where a handling collection of Victorian textiles was made available (Durbin 2002: 15–16).

The feeling of civilization's progress thanks to technology, was underlined in the last of the Smithsonian's textile displays, the Hall of Textile Processing. Devices used to construct and decorate textiles used in clothing, decoration, and industrial applications were shown here. Visitors were meant to experience a sense of gratitude for the ingenuity behind the inventions on display and for their having the good fortune of belonging to their time and place: "No one who thinks of our modern world can fail to realize the role that the sewing machines of factory and home have played in the emancipation of women from monotonous toil. [...] The thoughtful visitor who studies them learns not only a mechanical but also a sociological lesson of importance" (1963: 212). This is very like the response meant to be evoked among visitors to human zoos or historical displays at World's Fairs (see Rydell 2011). When displayed in this way, the story of fashion and textiles was shown to be a story of technological progress with a moral ending, with winners demonstrating their triumph over base physiology and ignorance. This progressive view of fashion is evident in the developmental arrangement of many permanent displays of dress, which begin in earlier periods that, by contemporary standards, seem outrageous; they end with comfortably familiar examples of contemporary fashion, whose appeal to conventional taste seems to support the idea that the present is better than the past. Just as *The Spectator* wrote of the 1833 exhibition of Cromwellian costume, "It was like stepping back two centuries. The contrast was striking and redounded greatly to the credit of the modistes of the present day" ("Ancient Court Dresses" 1833:

503), so did the *Globe and Mail* of far more recent examples in 1962: "To mid-century eyes, the clothes of the Twenties look wacky but gay, those of the Thirties are dowdy, while those of the war-torn Forties can only be described as dreary" (Dickason 1962: 12). Yet most commentators understood that even the comfortable present would seem ridiculous in the future, making the knowledge of the history of fashion indispensable for those who wished to avoid the mistakes of the past.

Progress and adaptation

That understanding the past of fashion could inform the future was a belief referenced by many advocates for dress history and for museum collections and exhibitions on fashion. This was the guiding idea behind the work of the pioneering dress historian and curator C. Willett Cunnington, who advocated for a home for his collection in 1937 by wishing for "science and industry to work together for their mutual benefit" in a national center where "research may be carried on and modern fashion and fabric designing encouraged" (Representative 1937: 3). Cunnington also appropriated and appealed to the social sciences in an essay in which he laid out his methodological suggestions for the analysis of historical clothing:

> I wish to draw attention to the scientific approach to period costumes [… which] regards period costumes as fragmentary evidence of human activities in the past … things in themselves unimportant except for such deductions as can be drawn from them about the social life and mental outlook of our ancestors. (1947: 126)

If dress was one of the important markers by which human civilization could be visually plotted, change in clothing could symbolize change in culture.

Indeed, one pioneering exhibition used this assumption to critique fashion. Architect Bernard Rudofsky's 1944–1945 exhibition *Are Clothes Modern?* at the Museum of Modern Art in New York questioned the fitness of fashionable dress for modern life. Using humorously exaggerated drawings and sculptures to illustrate the ways in which historical and modern clothing (on loan from retailers, private individuals, the American Museum of Natural History, the Brooklyn Museum, the Museum of Costume Art, and the Met) distorted the body, Rudofsky made the point that in its commitment to convention and tradition, fashion had not adapted to the needs of twentieth-century wearers. Following the modernist dictum of "form follows function," fashion could only be attractive if it was practical and excessive or anachronistic decoration was ugly. The follow-up MOMA exhibition (2017–2018), *Items: Is Fashion Modern?*, took a different perspective, in that it

treated fashion change as an evolution of iconic design forms. Pieces such as blue jeans, the little black dress, or the white T-shirt are recognizable generic stereotypes despite the many specific adaptations made by designers over the twentieth and twenty-first centuries. Unlike the 1944 show, the 2017 exhibition highlighted the continued relevance of tradition, even as society changed.

This notion of progressive change through time (not merely the passage of time, which is discussed in Chapter 7) was a predominant conceptual category by which early fashion exhibitions were organized. For example, the Western Australian Museum and Art Gallery very deliberately illustrated this idea in 1934 through its inclusion of ethnographic material alongside fashionable Western dress: "The exhibits have been arranged in the showcases in such a manner that the visitor can see at a glance the development of clothing from primitive grass and fibre aprons to the elaborate ensembles of the Victorian period and to the dresses of recent years" ("Fashion Changes" 1934: 15). While most of the artifacts were probably contemporaneous, the colonialist ideology that underpinned the exhibition suggested that the clothing of the Admiralty Islands, Nubia, and New Guinea were illustrative of earlier technologies and aesthetic considerations than the 1885 dress belonging to Queen Victoria that was also included in the display. These "primitive" examples stood as evidence of what were believed to be the universal stages of the progress of human culture, with European civilization being at the pinnacle. The fact that it was a monarch's dress that was displayed in this developmental narrative was probably not accidental— the technological superiority of Europeans in the colonial period gave them the assurance of the right to political dominance as well.

Even among Western cultures, a comparative study of changes in fashion could establish prestige and dominance. For example, the 1992 McCord exhibition *Form and Fashion* (Figure 3.7) examined the museum's collections of nineteenth-century fashions worn in Montreal to argue that the city was at the forefront of leading innovations in silhouette, ahead of even New York. Surviving gowns were presented alongside fashionable portraits by the leading photographic studio, Notman, as well as European fashion plates, to show how quickly trends from Paris (the acknowledged global capital of style at the time) were disseminated in Montreal. This preeminence was important to demonstrate, as the exhibition coincided with the 350th anniversary of the founding of the city. Indeed, the display was one of a program celebrated a positive change in the museum itself: its grand reopening after a major renovation and expansion that doubled its exhibition space. For the curator, Jacqueline Beaudoin-Ross, the evolution of the contours seen in women's dress in that century were also markers of the positive social, economic, and cultural changes in Quebec society. The fact that the museum's collections largely reflected the tastes and occupations of the city's elite seemed to also underscore the social Darwinist ideology that celebrates those who have the resources with which to effect change.

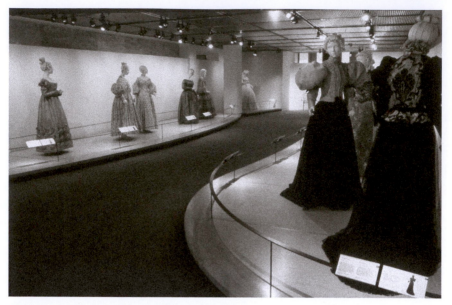

Figure 3.7 Installation view of *Form and Fashion: Nineteenth-Century Feminine Dress*, May 9, 1992–January 15, 1993 © McCord Museum.

Biology and evolution

With Darwinian and Freudian thought being firmly entrenched in cultural studies, it stands to reason that certain related assumptions would begin to be made about fashion's place as a form of human plumage. Two early theorists of dress, J. C. Flugel and James Laver, were particularly influential in characterizing fashion as a form of decoration like that of animals, playing a part in mating rituals. Their emphasis on the female as the decorative, erotic half of the human species (Flugel 1930; Laver and de la Haye 1995) continued to be referenced in fashion exhibitions long after their essentialization of sex and gender ceased to be broadly accepted in scholarly literature. Men, it was reasoned, were less flamboyant in their display and were thus less interesting visually and in analysis. This, as well as the relative paucity of surviving examples, explains why, while the history of female fashion can be presented in numerous ways, menswear, on the other hand, tends to be treated wholesale in a single exhibition. Indeed, Jeffrey Horsley has statistically demonstrated that exhibitions devoted to, or even including examples of, menswear are a small exception to the majority staged, and those displays devoted to the topic treat it as a space to discuss how the tension between conformity and extravagance in tailoring reflects masculinity (2017:15). Thus, the generic man, whose outside appearance

changes only occasionally, has appeared very infrequently in galleries. From the prosaic *Male Costume* (V&A, 1947–1948), the Biblical *Adam in the Looking Glass* (Met 1950), the exclusive *Of Men Only* (Brooklyn 1976), all the way up to the punning *Reigning Men* (LACMA 2016 and traveling), exhibits on menswear set up a binary between male and female dress. Indeed, the tensions and differences between the sexes' taste in dress were a major thematic component of *Adam in the Looking Glass*, which contained a section where female designers attempted to reform male dress (see Maglio 2017). It is likely that the class and power structures of patriarchal society make it difficult to objectively critique male fashion, as opposed to the more obviously "othered" female variety: men's dress is fashionable as an exception but is nevertheless the dominant mode from which womenswear "borrows." In exhibitions of male clothing, then, fashion is shown to be a marker of gender dimorphism; however, the entrenched social and cultural norms that led to this perceived division are rarely challenged.

In particular, the long-standing Western cultural association of women with flowers—the sexual part of the plant—is a recurring exhibition theme that positions women as closer to nature (as opposed to men and civilization) (Figure 3.8). Indeed, the 1995 Costume Institute exhibition *Bloom* featured, among its floral themes, a section on metamorphoses, a "garden of women virtually transformed into flowers … Ultimately, flower and woman seemed to be united: floral and feminine beauty reflected one another" (Martin and Koda 1995b: 4). A gallery label for a 1978 evening ensemble by Yves Saint Laurent (2006.420.50a,b) likewise drew the connection between flowers and the female: "Planting the flower at the jacket's center front, Saint Laurent makes the rose both a corsage and an emblematic transfiguration of the wearer. In the latter role, the stem with leaves as vertebra and flower as head reinforce an anthropomorphic vocabulary of flowers" (Martin and Koda 1995a: n.p.). This idea was also referenced more recently at the FIDM Museum in Los Angeles; the floral-themed selections of *Fashion Philanthropy: The Linda & Steven Plochocki Collection* (2017) were staged in a gallery bedecked with paper flowers blossoming from the walls, on mannequins adorned with floral crowns, seemingly camouflaged in their natural environment.

Martin and Koda's successor at the Costume Institute, Andrew Bolton, organized a major exhibition on a related topic: the association of female sexuality with animal characteristics. *Wild: Fashion Untamed* (2004–2005) focused on the primal associations of feathers, fur, and leather, and their use in fashion across time to construct an ideal of the sexually savage woman who threatened civilized and polite society (Bolton 2004). It is clear that cultural ideas about the monstrous-feminine (Creed 1986) are present not just in film but in fashion exhibitions also. This conflation of sex, nature, and the feminine presents biological reasons behind cultural expression, suggesting that fashion

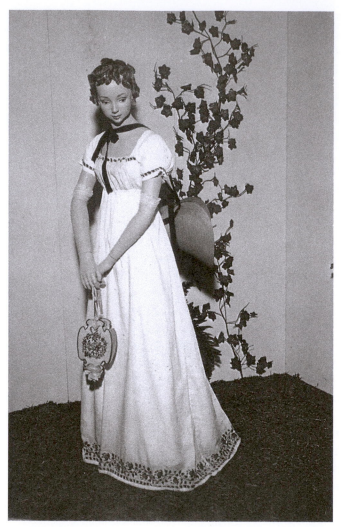

Figure 3.8 Undated postcard from the Valentine Museum, showing a mannequin in a floral gown with a floral reticule in a "garden." Author's collection.

follows some innate imperative toward biomimicry and the mating ritual. The 2017 Museum at FIT exhibition, *Force of Nature*, also addressed these ideas across ten thematic sections, demonstrating how principles from the natural sciences, especially around sexual selection, were expressed in floral and animal symbolism in fashion. The 2018 V&A exhibition *Fashioned from Nature* went even further, displaying scientific specimens and new technologies alongside fashionable dress to illustrate the deep and enduring connections between the materials of the natural world and their expression in fashion. The insatiable

consumer desire for fashion, it was argued, had devastating effects on the beauty and wonder of nature from which its inspiration and materials were drawn. The design of the show, while sparse and clinically white overall, introduced some botanical elements in acrylic panels with grasses and flowers suspended within the medium to visually divide large glass cases. These also echoed the historical garments that incorporated vegetable fibers and animal parts into their manufacture and decoration. As the underlying message of the show was to incite consumers to become more aware of the environmental impact of fashion, the artifacts on display also included ones that took inspiration from the sustainable and renewable resources of nature, such as a dress cultivated from tree roots by artist Diana Scherer.

The principles of these exhibitions are more often ideological than overtly expressed in their design. Before such themed exhibitions were the norm, museums alluded to the organic relationship of fashion to nature through the use of what may be referred to as specimen mounts. Garments and accessories pinned like entomological specimens divorce the garment from its social context. The lightly padded flattened forms used in the V&A Costume Court throughout the 1970s drew attention to the surface decoration and silhouette of the fashionable carapace (Figure 3.9). Menswear in particular, with its highly tailored linear form, lends itself well to this type of display—splayed open with the arms hanging in front, the appearance of a coat is very reminiscent of an animal skin (see Figure 2.4).

Yet the layout of some fashion exhibitions also owes much to the assumptions made about the principles behind human fashionable behavior. One exhibition that put together sociology, science, and fashion in its design is the *Pleasure Garden* gallery in the Museum of London (Figure 3.10). One of the few display areas in this social history museum to focus almost exclusively on fashion (the collections are integrated by period, rather than separated by material), the gallery emulates the popular eighteenth-century entertainment venues that brought together gardens, music, theater, and sex: Georgian visitors to pleasure gardens would promenade among the plantings after dark, listening to music, indulging in sensuous meals, and meeting for assignations with lovers or even prostitutes. Accompanied by a soundtrack of snatches of music and conversation, museum visitors walk a narrow pebbled path between an open display and a mirrored vitrine painted with tree branches and grass. Behind the glass on one side and a latticed fence with artificial trees on the other are mannequins painted charcoal (the dim lighting in the room makes them appear like shadowy silhouettes), wearing Georgian fashion and costumes from the museum collection. The female figures wear elaborate headdresses, designed by contemporary couture milliner Phillip Treacy; the hats are decorated with flowers that echo the brocaded designs on the historic costumes or the flora that is typically cultivated in England's public gardens. One figure sports large antlers

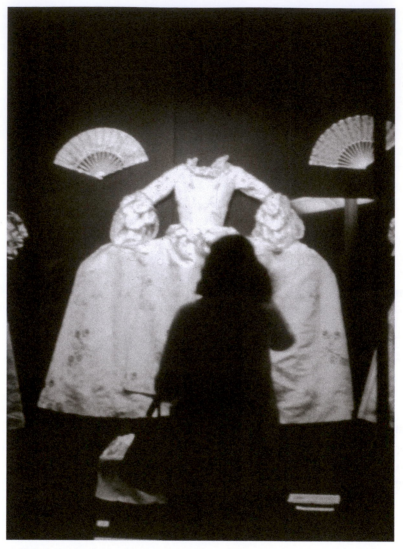

Figure 3.9 Unknown photographer, slide views of V&A Costume Court flat mounts for eighteenth-century gowns, *c.* 1980. Author's collection.

sprouting from her wig, which seem to merge with the branches of the tree under which she is posed. Like exotic animals spotted on safari, the mannequins are camouflaged in their surroundings, but also enact period mating rituals while displaying their human finery. In this way, the *Pleasure Garden* functions like a natural history diorama, with fashion as the material expression of the human drive to survive.

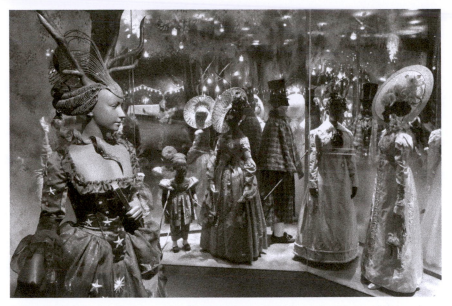

Figure 3.10 Installation view of the *Pleasure Garden* display at the Museum of London, opened in 2010. © Museum of London.

Life groups and sociology

Anthropological approaches to the display of cultural artifacts in museums can historically be divided into two schools of thought: typological classification according to form (following E. B. Tylor's ideas about cultural determinism) and the cultural relativism of anthropologist Franz Boas (Clifford 1994: 265). The typological ideology, as seen in fashion exhibitions, was described above. Yet Boas's legacy of setting artifacts within the contexts of their authentic social use has also been an important precedent for exhibiting fashion history. While dress displays in period rooms and furnished tableaux will be discussed in the following chapters as owing much to artistic and theatrical modes of presentation, they also owe a great deal to Boas's pioneering life groups at the Smithsonian Museum. These displays demonstrate the social contexts within which fashion circulates. This can be seen when dress is integrated into social history displays, like in house museums, or just galleries with figures in furnished interiors representing historic periods of settlement or development, as is typical in smaller museums featuring older display conventions. More specifically to fashion, furnished vignettes, such as those in the permanent costume galleries at the Fashion Museum in Bath, the Philadelphia Museum of Art, the Museum of the City of New York, or in temporary exhibitions such as *Vignettes of Fashion* at the Met (1964), enable an understanding of the categories of dress for specific occasions. From

1982 to 2013, National Museums Scotland even dedicated a Victorian mansion (Shambellie House) to a vignette-based museum of costume, which had rooms populated by mannequins in historic costumes from different periods; passing by rooms set in 1882, 1895, 1905, 1913, 1945, and 1952, the visitor observed the specialized spaces of the historical home, learned about the history of the family, and the fashion choices that might have been open to its former inhabitants at specific historical junctures. Once again, this is a way to focus viewer attention onto the ritual function of clothing. The setting of a Victorian parlor, for example (Figure 3.11, see also Plate 7), may be an opportunity to demonstrate at a glance the differences between servant's uniforms and middle-class domestic dress, the differences between outerwear and indoor clothing, or even the differences in adult and children's clothing.

Alternatively, exhibitions organized around clothing worn for particular social occasions, even if they are not styled to look like habitat groups, nevertheless maintain sociological assumptions. Exhibitions about ball gowns or wedding dresses, for example, assume that galas and marriages are basic human needs to which humans have adapted suitable clothing. Most museums have staged some variation of these exhibitions (Figure 3.12): the McCord's *Silhouettes* (1965) was a show of evening dresses from 1840 to 1965, and they held two wedding dress exhibitions in 1978 (*Robes de Mariées: Montreal 1830–1930* and *Robes de Mariées, 1850–1950*). The V&A held them back to back in *Ballgowns: British Glamour Since 1950*, 2012–2013, and *Wedding Dresses 1775–2014*, 2014–2015. The artifacts on display in such exhibits do not necessarily share any stylistic characteristics, such as silhouette, material, or even color. Instead, the connection between them is the social context within which the garments were worn. Any change over time demonstrated in these displays is really a reflection of broader social change that redefines what is appropriate apparel for that particular social ritual. Here, cultural behaviors are universalized and often taken as a given.

These exhibitions may be called autoethnographic, in that they have fashion as a product of Western culture at their intellectual core. The 2014–2015 exhibition at the Fashion Museum Bath demonstrated this. Entitled *Georgians: Dress for Polite Society*, the display featured garments that were, at the time, considered fashionable, tasteful, elegant, and above all, appropriate for particular social contexts. While the display itself was comprised of thirty headless torso forms crowded behind a glass vitrine, groupings (such as that of several rare and extravagant court manutas) and large wall decal illustrations (of a botanical illustration, a Chippendale-style chair, and a drawing of teapots) illuminated the events and places at which these garments were meant to be worn. Furthermore, the curator, Rosemary Harden, argued that modern standards of fashionable production and consumption—the globalized, industrial, rapidly changing garments made for display and self-expression—arose in the Georgian era.

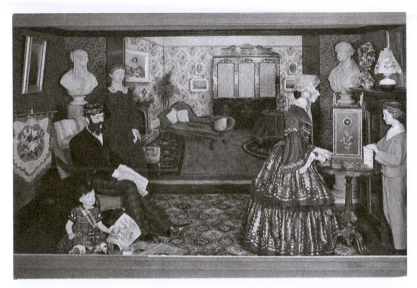

Figure 3.11 Undated postcard showing the Early Victorian parlor vignette at the Museum of Costume, Bath. Author's collection.

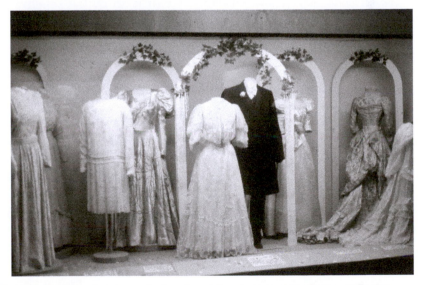

Figure 3.12 Slide showing a display of wedding dresses at the Gallery of English Costume, Platt Hall, Manchester, *c.* 1980. Courtesy Gail Niinimaa.

Relatedly, exhibitions can examine or critique wider cultural notions of what is socially appropriate, without being embedded in a particular historical era or ritual context. For example, the 2016–2017 exhibition *Tenue Correcte Exigée: Quand Le Vêtement Fait Scandale (Appropriate Dress Required:*

When Clothing Creates a Scandal) at the Musée des Arts Decoratifs in Paris examined transgressions in fashion over almost seven centuries. By displaying the items and style of dress that were seen at the time, or since, as socially inappropriate, immoral, or excessive, the exhibition documented the changing fashion dialectic of norms and taboos. This comprehensive exhibition featured gray plush mannequins in groupings of revealing, gender-bending, over-the-top, and even illegal garments, placing the focus on the clothing itself. The garments were contextualized with archival documents, paintings, tapestries, books, videos, and a scenography of graffiti phrases of sartorial disapproval, such as "mutton dressed as lamb" or "ugly as sin." As much of the clothing on display, such as bikinis, miniskirts, or women's trousers, is no longer seen as shocking, this was a deliberate attempt by the curator, Denis Bruna, to provoke the audience into questioning their own assumptions around socially appropriate dress.

Cultural configurations

The analysis undertaken in this chapter is underpinned by the structuralist belief that all forms of representation are, fundamentally arbitrary and culturally determined. Moreover, that museums are hegemonic institutions closely associated with the processes by which ideas come to be signified in objects. Exhibitions which, through the act of display, mythologize connections between objects and concepts such as progress and social norms, are the primary mechanism by which museums engage in acts of cultural representation.

As Karaminas and Gezcy have pointed out, fashion studies arose, in part, out of the disciplines of ethnography and sociology, which studied the social and cultural configurations of which dress is a marker (2012: 6). Indeed, the long and important history of exhibiting fashion at the Brooklyn Museum, for example, grew out of lectures on the subject given by its pioneering curator of ethnology Stewart Cullin, who illustrated his talks with artifacts from the collection (Appleton Read 1929: 6E). It is logical, then, that questions of technology and industry, national and social identity, sexuality and kinship, adaptation and evolution, as well as the dynamics of change within all these discourses, would also be some of the themes explored in fashion exhibitions in museums. To display fashion in this way is to understand it as an expression of society, yet this is all too frequently an unquestioning and superficial reproduction of existing social norms around dress: that it is attractive, appropriate, female-dominated, technologically advanced, and geographically specific. These exhibitions perpetuate accepted ideologies, such as capitalism and nationalism, and affirm social rituals, such as monogamy and heterosexuality, as being normative. Only recently have a few exhibitions (such as the ones cited above) used the platform granted by

the cultural hegemony of the museum institution (see Durrans 1992) to critique or negotiate the conventions and assumptions around fashion's role in society.

While the view of fashion as a document of changing social mores and lifestyles is now widely accepted, exhibitions that analyze other conventions around dress have also recently become popular. For example, even ideas of beauty are socially constructed, and therefore, displays of "masterpieces" (e.g., *Fashion Icons: Masterpieces from the Collection of the Musée Des Arts Décoratifs, Paris*, Art Gallery of South Australia, 2014–2015; *Masterworks: Unpacking Fashion*, Met, 2016–2017) or the tasteless (*The Vulgar: Fashion Redefined*, Barbican Art Gallery 2016–2017) can be seen as sociological interrogations of aesthetic ideals. Whether intentionally subversive or not, the display of dress as decoration draws not on sociological discourses but on artistic ones; these are discussed in detail in the following chapter.

4

INTERVISUALITY: DISPLAYING FASHION AS ART

Exhibitions of historical fashion have frequently drawn on the iconography of the fine arts and the socio-spatial organization of the gallery. Framing fashion as art within the museum made it subject to aesthetic priorities and allied fashion history to art historical practice. Whether presented as art or alongside art, historical fashion in the museum is, at its core, illustrative. It is collected and displayed as a result of the cumulative effect of other, previous, representations and is viewed in relation to them.

As was demonstrated earlier, fashion in a museum was often commodified as a sample to be emulated for industrial manufacture; equally, however, it is just as frequently fetishized for its beauty and perfection of craftsmanship. Whether fashion is a branch of the fine arts is still a contentious issue: for example, the Met devoted an issue of its *Bulletin* in 1967 to debating the connections between fashion, art, and beauty (Laver 1967), with art historians, designers, artists, and curators weighing in on the issue. Melissa Taylor has noted that "in the nature of a consistently renewed market, high art finds the transience of fashion in direct contrast to the longevity of art" (Taylor 2005: 449), and connections between the two are constantly reevaluated philosophically (see Bok Kim 1998; Miller 2007). Recently, fashion historian and curator Valerie Steele has contended that although fashion is more commercial and mundane, it is "in the process of being re-imagined as art" (Zarrella 2010). Designer retrospectives, from the Balenciaga and Yves Saint Laurent exhibitions curated by Diana Vreeland in 1973 and 1983 to more recent examples such as Alexander McQueen in 2011, also at the Costume Institute, have not been seen in the same light as monographic exhibitions of painters or sculptors in art museums (see Stevenson 2008). However, fashion curators, historians, and journalists do not hesitate to align the two worlds of fashion and art in titles for exhibitions, books, and articles, for

example: *The Fine Art of Costume* (Metropolitan Museum of Art 1954–1955), *The Art of Fashion in the Twentieth Century* (Royal Ontario Museum 1957), *The Art of Fashion* (Metropolitan Museum of Art 1967–1968), *An Elegant Art* (Maeder 1983), *The Art of Dress* (Ribeiro 1995; Ashelford 1996), "The Fine Art of Fashion" (Freeman 2000), "The Art of Style and the Style of Art" (Smith 2010), "Gone Global: Fashion as Art?" (Menkes 2011). Titles of exhibitions, such as "Chic Chicago: Couture Treasures from the Chicago History Museum" (2007–2008), and catalogs, such as Jan Glier Reeder's *High Style: Masterworks from the Brooklyn Museum Costume Collection at The Metropolitan Museum of Art* (2010), explicitly evoke the preciousness and aesthetic value of historic costume.

While Ribeiro writes that "clothes, however splendid the craftsmanship and luxury, are basically a commodity and cannot have the emotional impact of art or literature," she concedes, however, that "fashion acts as a link between life and art" (1995: 5). Indeed, museums have attempted to make these links explicit through references to art and artists in exhibitions about fashion: at the Met alone, these have included *Fashions and Follies: Erté and Some Contemporaries* (1968), *Cubism and Fashion* (1998–1999), and *Costume and Character in the Age of Ingres* (1999). Valerie Steele has even suggested that simply by entering a museum collection, or being exhibited in a gallery, endows fashion with "art-like qualities" (2012: 18).

Certainly, fashion and art share a history: until the entry of historical fashion into museums, the only means by which the public could learn about costumes of other countries and times was through its illustration: in books, paintings, and on the stage. As outmoded dress became a visual marker of historical difference, practitioners in the fine, decorative, applied, and performing arts lobbied for greater and more reliable information through the preservation and presentation of historical fashion: "Contemporary ideas may be stimulated by old fashion plates, prints, and paintings, and not least by the actual substance and texture, faded as it may be of the still-existing historic costume" ("History in Clothes" 1962: 9). This chapter examines the influence of artistic conventions and theories, as well as the influence of individual practitioners on the museal representation of historical fashion. It uses Nicholas Mirzoeff's notion of "intervisuality" (2002) to analyze the connections, references, and interplay between art and museum exhibitions of historical fashion. As Peter McNeil has noted, visual culture influences the interpretation of objects on display; whereas, "historical fashion has been understood and reinterpreted in large part through representation such as painting," he argues, "now we are being asked to understand fashion through contemporary photographic and styling influences" (2009: 163). The representation of historical fashion relies on its effect on visual conventions from the wider landscape of images that frames its meaning.

Visual history: Painting and antiquarianism

Rapidly improving printing technology as well as increased consumer demand from a more literate populace in the Early Modern period enabled the publication of growing numbers of antiquarian books on a variety of subjects. The quality of scholarship varied widely, and many were derivative instead of empirical, but their wide availability made them extremely influential. Books on dress and costume were particularly popular; beginning from the mid-sixteenth century, illustrated books appeared throughout continental Europe, which mapped and classified the peoples of the world across time and space using their costumes and adornment as a means of distinction (Ilg 2004). By the eighteenth century, English-language titles were also available in large numbers: these included satirical prints and periodical publications that documented the dress of contemporary people, fashionable or ordinary, to publications about the dress of other countries and the Classical World, as well as antiquarian titles examining historical dress. Dress historian Lou Taylor devoted the first chapter of her book *Establishing Dress History* (2004) to the history and influence of some of these volumes. A novelty in these publications was that an increasing number based their visual descriptions on extant material evidence as well as on written material.

For scholars who did not have physical access to extant garments, illustrations grew to be an acceptable form of material evidence. An editorial in the *Gentleman's Magazine* of 1869, arguing for a museum of costume, makes this clear when it proposes that "a museum of costume should be in epochs, illustrated by model and by picture" ("Notes and Incidents" 1869: 373). This desire was fueled by an antiquarian nostalgia for an imagined utopian past, as an 1873 article describing historical costumes at an International Exhibition demonstrates:

> The art of dress, from the earliest historic times, seems to have been considered an important study among the upper classes of society, and books of ancient costumes show combinations as tasteful, and frequently far more artistic than those of modern times. ("Antiquities" 1873: 243)

The costumes on display were intellectually assimilated in tandem with the information contained in costume books. This imaginative projection from illustrations was as vital for the purpose of inspiring artists and theater designers to produce "accurate" representations of historical characters, as it was to inspire the public to emotionally participate in the fiction thus created. The same 1869 *Gentleman's Magazine* article cited above argues that the beneficiaries of a museum of historical fashion would be stage designers and painters, as well as the audiences thereof, no longer forced to endure anachronistic representations of the past ("Notes and Incidents" 1869: 373).

Collecting with scholarly purpose was popular for painters throughout the nineteenth century. The mode of relating to the past established by the antiquarians over a century before continued to exert a considerable influence on artists well into the late Victorian period. In August 1882, *The Times* reported,

> A society has been formed to publish a quarterly work devoted to the costumes of all nations and peoples. Among the members who have already joined are Mr Alma Tadema, Mr G. Boughton, Mr R. R. Holmes, Mr Louis Fagan, Mr E. W. Godwin, Mr J. D. Linton, Baron de Cosson, and Mr Wills. The curators of the museums and libraries of St Petersburg, Florence, Paris, Vienna, Berlin, Brussels, Naples, and other cities have undertaken to help the "Costume Society" in all possible ways. Each print or chromo-lithograph will be accompanied by explanatory letter-press. ("Literary and Other Notes" 1882: 4)

This fledgling Costume Society was thus engaged in creating precisely the same kind of antiquarian-illustrated volume that its painter members would themselves have consulted in their professional work when composing a picture set in another place or time. Other members of the society included Oscar Wilde, J. M. Whistler and Frederick Leighton, and as early as 1862, Leighton had campaigned for the inclusion of costume into the galleries at South Kensington (V&A), but the venture had failed due to internal politics in the Department of Art ("Notes and Incidents" 1869: 373–374).

The sustained study of specific moments and periods in history for professional reasons likely inspired a further curiosity in the material culture of the past in some painters. As described above, this would have led them to collect artifacts with an increased personal, and not merely professional, interest; indeed at some point, the painters no longer merely took advice from other experts but strove to become experts themselves and to advocate for further development in their study among their professional peers. For example, Aileen Ribeiro points out that Joseph Strutt and Charles Alfred Stothard began as history painters (1994: 62) and went on to write influential antiquarian works on costume.

By the early twentieth century, artists felt that they could make a unique and valuable contribution to the study of history through material culture. Painters like Talbot Hughes, Edwin Austin Abbey, and Seymour Lucas (Petrov 2008) (Figure 4.1) would complete the circle of the antiquarian tradition by donating the original artifacts to museums. In his 1999 book *Vision and Accident*, author Anthony Burton provides a plausible reason for the eventual change in the V&A's collecting policy to include fashionable dress. He writes that "the main change brought by the early twentieth century was that the museum consolidated its appeal to collectors and connoisseurs, as these two overlapping constituencies grew larger and stronger" (1999: 181). Undoubtedly, the collecting of historical decorative arts like costume by fine artists would have grown into an important

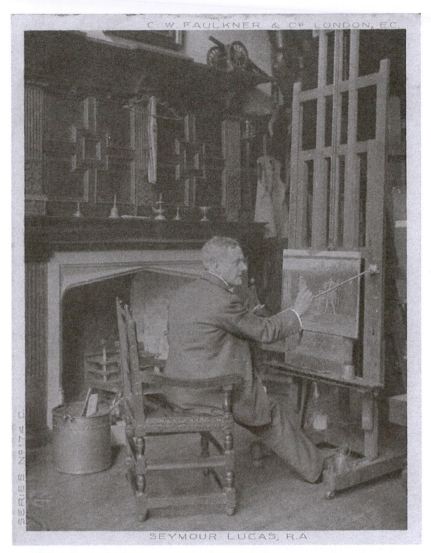

Figure 4.1 Postcard, *c*. 1900, showing painter John Seymour Lucas in his studio. Seventeenth-century buff coat in his collection is visible to the left of the mantelpiece. Author's collection.

enough trend for museums to consider, as curators would undoubtedly have been aware of their antiquarian costume collecting. The V&A is still a center of visual research for design students, and its collections play a key part in the design process (Kjølberg 2010).

Across the Atlantic, some of the earliest benefactors of the Met's fledgling costume collection were also painters: W. J. Baer and Frank D. Millet[1] (Metropolitan Museum of Art 1908: 104–105; Morris 1913: 110). The museum further justified its

first major bequest of historical fashion (the wardrobes of the Ludlow family, 1750–1860, "New Treasures" 1911: 13) in the context of design education: the museum announced its hope "that these costumes will be the nucleus of a collection for the Department of Decorative Arts, which will be valuable not only for painters and illustrators, but for the playwright and the costumer" ("Ancient Costumes" 1911: 11).

Therefore, it was thanks in large part to the advocacy of artists that fashion was included into museum collections. The eighteenth- and nineteenth-century antiquaries such as Strutt and Stothard (discussed above) had begun a tradition by taking an interest in local history and by producing texts that illustrated the evolution of costume and other related decorative arts. The practice of history painting, which arose in parallel, benefited from their efforts and many painters became antiquarians themselves, publishing books of their own findings. Taking advantage of the antiquarian role in the development of the museum, they brought the focus from textual and visual representation back to material remains. Their professional status as educated artists and experts ensured that this category of artifact was finally accepted in museums as a legitimate form of high culture, worthy of study and preservation, and party to the same processes of stylistic change (Figure 4.2). Even so, fashion was nevertheless seen as a lesser art: the Met's director Philippe de Montebello wrote as late as 1984 that costume "doesn't rank as high as porcelain—and it's certainly not as important as textiles" (quoted in

Figure 4.2 Undated postcard showing installation view from an unknown museum; a mannequin in an eighteenth-century dress has been posed alongside contemporaneous decorative arts to demonstrate stylistic continuity. Author's collection.

Palmer 1994: 93). However, artistic training continued to be important for curatorial work—at the ROM, both Dorothy Burnham and Betty (Katherine) Brett came to be curators of the costume collection after training in visual art (Palmer 2018: 43).

Fashion and art history

Although Valerie Cumming reflects the attitudes of many when she suggests that "few art historians would consider dress other than an applied or decorative art" (2004: 83), in fact, in the early part of the twentieth century, the study of costume in painting became a key aspect of art historical practice. As early as 1962, the Costume Court was praised as a source of primary material for the painting researcher:

> The aid given by the expert on fashion to the art historian is considerable. Changes of dress, however capricious in origin, become in the course of time a reliable method of dating. Fashion experts have been able to detect in old master painting anachronisms in the depiction of detail which indicated later addition, or have conclusively settled doubts as to when a picture was painted by the evidence of a mode. ("History in Clothes" 1962: 9)

Indeed, individuals now known as fashion historians were in fact art historians. According to his colleague Doris Langley Moore, James Laver became interested in fashion as a method of dating paintings for his work at the V&A's department of engraving, illustration, design and painting beginning in 1922 (Langley Moore n.d.). The first postgraduate dress history course in Britain was founded by art historian Stella Mary Newton at the Courtauld Institute in 1965 (Taylor 2002: 116); this was poetically appropriate, as the institute houses the art collection of the textile magnate Samuel Courtauld. Newton's work was carried on for many years by Aileen Ribeiro, whose research focus on the iconography of painted clothing (1995: 5) is relevant to both art and fashion historians.

In recent years, inspired perhaps by Ribeiro's work, there have been a number of exhibitions that allied fashion and painting. Exhibitions such as *Tissot and the Victorian Woman* (Art Gallery of Ontario, 2002–2003), *Whistler, Women, and Fashion* (Frick Collection, 2003), *Impressionism, Fashion, and Modernity* (Art Institute of Chicago, 2013 and traveling; Figure 4.3), *In Fine Style: The Art of Tudor and Stuart Fashion* (Queen's Gallery, Buckingham Palace and Palace of Holyroodhouse, 2013–2014), or *Degas, Impressionism, and the Paris Millinery Trade* (Fine Arts Museums of San Francisco, 2017) include fashion objects as evidence of the interest of artists in this product of modernity or their surprising fidelity to its details. Yet these items of dress and accessories are included as documentary to what is depicted in the visual sources and seek to demonstrate

Figure 4.3 A picture taken on September 24, 2012, shows a painting by Pierre-Auguste Renoir entitled *Femme à l'ombrelle (Woman with a Sunshade)* (1867) and displayed during the exhibition *Impressionism and Fashion* at the Orsay Museum in Paris. Organized by the Musée d'Orsay in Paris, the Metropolitan Museum of Art in New York, and the Art Institute of Chicago, the exhibition took place until January 20, 2013. Joel Saget/AFP/Getty Images.

the centrality of fashion as a subject within art, rather than as an art in and of itself.

In museums housing costume and textile collections, the importance of fashion eventually changed from being one of commercial inspiration to that of a celebration of aesthetic accomplishment. The Met sought to highlight this connection to the rest of its holdings in the 1954–1955 exhibition *The Fine Art of Costume*, which was described as "a choice selection of costume and accessories, chosen for their magnificent fabrics and elegance. The exhibition is arranged to provide a delightful visual experience and at the same time show how costume through form, colour, texture, and mobility reflect changing social demands" ("Fine Art of Costume" 1954). Here, the focus on spectacle and the formal qualities of fashion sought to prove that it could be visually equivalent to the fine arts: paintings were used in the exhibition both as illustrations of and comparisons to the fashions on display, as well as reminders of their aesthetic similarities as *objets d'art* produced in the same period. To exhibit dress as an art, then, is to derive meaning from and to add meaning to a historical narrative of taste. In this stylistic narrative, dress is shown to be subject to the same artistic impulses as other decorative and fine arts.

Other museums took up this attitude, albeit somewhat later: at the Museum of Fine Arts in Boston, this change occurred in 1963, with the Adolph Cavallo's exhibition *She Walks in Splendor: Great Costumes 1550–1950*; in the catalog, he wrote, "Clothes merely cover and protect the body; but when the wearer chooses or makes these clothes to express a specific idea, then the clothes become costume and the whole process, from designing to wearing, becomes art" (Cavallo 1963: 7). The idea that an aesthetic object can reflect culture is a fundamental tenet of art history, and curatorial approaches to fashion exhibitions have often appropriated the principles of art history for the construction of their narrative and argument. For example, the sections of the *Alexander McQueen: Savage Beauty* exhibition (Metropolitan Museum of Art and V&A, 2011 and 2015) classified McQueen as a Romantic artist and organized the chronology of his designs according to his thematic preoccupations, such as Romantic Gothic, Romantic Surrealism, and Romantic Naturalism. Today, many major art museums collect and/or exhibit fashion: a partial list is provided by Linda Welters (2007: 254), and an increasing number of artists are using the visual language of fashion to express ideas in their exhibits and installations.[2]

Furthermore, there is a growing trend toward exhibiting fashion objects as art history. Sometimes, as in the case of figures such as Sonia Delaunay (Tate Modern, 2015) or the designers of the Wiener Werkstatte (*Gustav Klimt: Painting, Design, and Modern Life in Vienna, 1900*; Tate Liverpool, 2008), this entails incorporating clothing made to their designs in retrospectives of their fine artworks. However, some institutions have also displayed the actual clothing of artists to demonstrate their process of artistic self-fashioning, as in exhibitions that have paired paintings and photographs with wardrobe items, from artists such as Georgia O'Keefe (*Georgia O'Keeffe: Living Modern*, Brooklyn Museum, 2017), to suggest aesthetic continuity, or in the case of the clothing and accessories belonging to Frida Kahlo (*Frida Kahlo: Making Herself Up*, V&A, 2018), making mannequins with her likeness into life-size sculptures, posing them as *tableaux vivants* of her painted self-portraits. In exhibitions like these, the garb worn by artists is shown to be an inseparable part of their artistic output: fashion history thus becomes part of the art historical canon.

Collusion/collision: Visual conventions from art

While the previous chapter highlighted the means of display inherited from fashion's commercial contexts, this was not the only source for creating the look of exhibitions of historical costume. Display forms for the costume and

textile arts were not invented but appropriated from the context of curatorial developments in art museums. The curator and art historian Norman Rosenthal wrote that "context and presentation are crucial to how we perceive a particular cultural object—be it a painting or a suit—and whether or not we call it art" (2004: 38).[3] There are some obvious examples: the placing of an artifact on a plinth or pedestal, as though it was a sculpture, and adding a label that focuses on materials and provenance are practices taken directly from the art gallery. An example of this approach was the 1963 *She Walks in Splendor* exhibition at the Museum of Fine Arts in Boston; in the catalog foreword, the museum's director noted that the exhibition was meant to emphasize the costumes' "conception and creation as works of art rather than as props in a tableau" (Townsend Rathbone 1963: 5). Some exhibitions of historical fashion took the art museum metaphor even further, literally framing mannequins on display to highlight their status as works of art produced by a design genius (*House of Worth*, Brooklyn Museum, 1962; Figure 4.4). However, changing notions in the optimal organization of gallery space were also reflected in each of the case study institutions.

The most frequently discussed phenomenon in the history of art exhibitions is the move away from decorative surroundings to the stark neutrality of the

Figure 4.4 Brooklyn Museum Archives. Records of the Department of Photography. *House of Worth*. (May 2, 1962–June 25, 1962). Installation view: entrance. Courtesy Brooklyn Museum.

so-called "white cube" (O'Doherty 1986; Greenberg, Ferguson, and Nairne 1996; Klonk 2009; Grasskamp 2011). Whereas the ornate interiors of the first art galleries in Europe and North America preserved or imitated the rich decorative schemes of the aristocratic residences of the original owners of the art on display, the twentieth century saw a gradual rethinking of this format in favor of a stripped-down aesthetic, with a linear arrangement of paintings on pale (often white) walls. Instead of focusing on the art as elements of a whole within a socioeconomic context or an artistic "school," this new approach sought to focus the viewer's attention on individual works and stylistic progression. Equally, in exhibitions of historical fashion, the *gesamtkunstwerk* focus on the artistic and socioeconomic contexts in which the clothes on display were produced and worn has been affected by the "white cube" visuality that distills the display to its barest essentials.

As was previously noted, the display of historical fashion was a relative newcomer to museums and historically coincided with the rise of modernist linearity in display; it is therefore not possible to trace the same radical changes in this type of exhibition as for the fine arts. Often, a mixture is used, as in the 1962 redesigned Costume Court at the V&A:

> The impression is sometimes given of a room in which the figures stand, but no attempt has been made to provide a complete interior setting[4] which might divert attention from the costume presented. A successful alternative has been to include some token or symbolic feature indicative of the period such as a painting, a vase, a screen, or ornamental piece of woodwork from the museum's other collections. ("Gallery of Fashion" 1962: 15)

This description demonstrates a slippage between the white cube and *gesamtkunstwerk* approaches, suggesting even a fine line between the two.[5] However, the fact that curators have periodically chosen to use the more archaic form of display over the conventional contemporary one, or vice versa, suggests that there is, indeed, a difference in the message that can be communicated by the two styles, and this will be discussed in this section.

Of the case study institutions described in this book, the Met and the Brooklyn Museum represent the two approaches. While the Met has frequently used a contextual approach to the display of historical dress, the Brooklyn Museum's exhibitions have tended to be visually sparse, focusing instead on the individual pieces as works of art. The spring 1939 exhibition of Victorian and Edwardian dresses at the Met (comprised of examples from the collections of the Met, the Museum of the City of New York, and the Brooklyn Museum) sought to visually place these costumes in their aesthetic context, albeit without evoking the period with props (Figure 4.5). The mannequins were sculpted based on physiognomies and physiques represented in portraits by Winterhalter, Carpeaux, Sargent, and

Boldini ("Victorian and Edwardian" 1939: 72), which was probably a decision inspired by the Smithsonian Institution's use of an 1864 sculpted bust by Pierce Francis Connelly as a model for the plaster of Paris figures of the First Ladies, installed in 1914[6] (dismantled by 1992). The exhibition space itself was carefully staged to highlight the costumes:

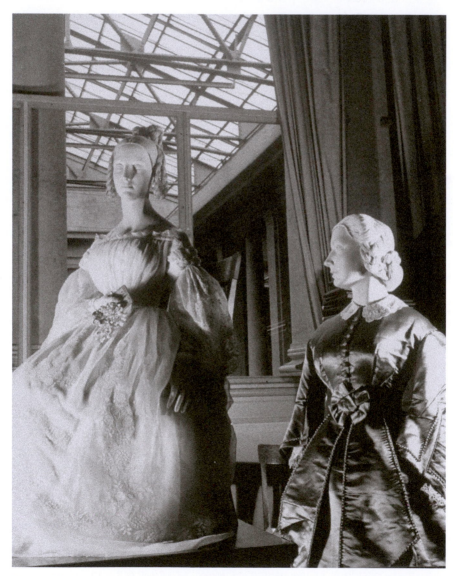

Figure 4.5 Costumes in collection of the Metropolitan Museum of Art, ready for display in *Victorian and Edwardian Dresses*, 1939. Photo by Alfred Eisenstaedt/The LIFE Picture Collection/Getty Images.

The exhibition was installed in a gallery divided into three rooms, the walls of which were decorated with mirrors and painted a soft French grey throughout. The figures were grouped on low platforms round the rooms, and no attempt was made to reproduce authentic period settings. The occasional seated figures were placed on inconspicuous stools with the idea of minimizing even the necessary furniture in order to focus complete attention on the models and dresses, and the grey of the background was chosen to bring out the charming colours of the costumes without confusion. ("Victorian and Edwardian" 1939: 73)

The historical fashions, then, were set off according to aesthetic considerations, both of their period of origin and of the period when the display was staged. Although different colors were, in different periods, seen as appropriately "neutral" for the display of art (Klonk 2009), this curatorial attempt at inconspicuousness merely draws further attention to itself as a display convention, especially when compared to the means by which fashion was normally displayed at the museum (Figure 4.6).

Another seemingly neutral but highly constructed display convention is that of the period room. Excised from its original architectural context, and reconstructed in a series of such orphaned spaces, the resulting bricolage (often furnished with an array of furniture from the period but not necessarily from the original room itself) has been seen as a tool for storytelling but of little historical value (Aynsley 2006; Harris 2007; Schwarzer 2008). However, it is a valid attempt at displaying the stylistic connections between the decorative arts, architecture, and the fine arts—an aesthetic synthesis of "prevailing artistic impulses" (Ribeiro 1995: 5) that is visually expressed, as in a *gesamtkunstwerk* approach. Recreating the "primary" context or function of an object lends it a further credibility as an authentic piece of history (Jones 2010: 184) and, for this reason, has continued to be a popular display strategy. The Met has had a long history of utilizing this conceit to display fashion: although the Ludlow costumes were not displayed alongside the other contents of the family mansion that had been acquired by the museum nor in a contemporary period room (although this was suggested by a *New York Times* journalist at the time: "Bringing the Past" 1911), in 1963–1964, the Costume Institute did populate the museum's galleries of architectural settings. *Costumes: Period Rooms Re-Occupied in Style* displayed some of the pieces of historical fashion in period rooms such as those where they might once have been worn. This approach set off both the decorative elements of the fashions and of the room settings and decorations to mutual advantage—shared formal elements in historical periods from the seventeenth to the nineteenth centuries such as scale, color, and line were more obviously apparent when highlighted by proximity.

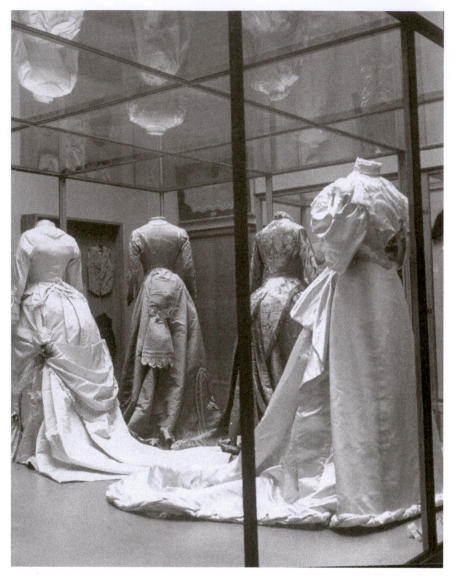

Figure 4.6 Costumes in collection of the Metropolitan Museum of Art on permanent display in 1939. Photo by Alfred Eisenstaedt/The LIFE Picture Collection/Getty Images.

Dangerous Liaisons attempted something similar in 2004, although the installation was now more obviously derived from period images and attempted to recreate a visual source rather than providing an opportunity for the audience to engage in formal analysis. The period rooms became a compositional device to frame theatrical interiors, though they shared an integrity of historical authenticity with the costumes on display within. Peter McNeil has argued that the use of the

Met's English period rooms for the aesthetic-driven, non-narrative *AngloMania* exhibit (2006) referenced the contemporary trend for irreverent collage effects in fashion styling for shop windows and magazine spreads, adding a new layer of visual sources by which to interpret the staging of fashion in an interior (2009: 164).

However, more abstract artistic renderings of interiors were also used at the Met throughout the years, as a compromise between an idealized interior setting and a historic period room. Diana Vreeland's 1982–1983 *La Belle Epoque* exhibition featured murals that evoked the locales of high-society entertainments, such as restaurants, gardens, and drawing rooms ("Costumes reflect" 1983: F2); the 2010 *American Woman* exhibition also featured similar effects—from beaches and ballrooms to the studio of Louis Comfort Tiffany (Figure 4.7). These installations left no doubt as to the socioeconomic, geographical, and historical contexts of the pieces on display; the garments fused with the backdrops to become assemblages and representations of style and period. As opposed to the period rooms, which were objects in their own right, sharing intellectual priority with the costumes, in such displays, historical objects, when used, become what Pat Kirkham describes as "functioning decorations" (1998: 177): their authenticity lends more credence to the primary subject of display, which is historical fashion.

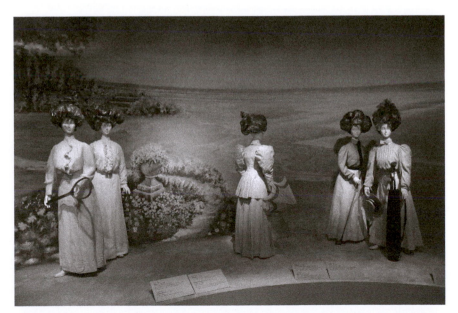

Figure 4.7 A general view of a display in the *American Woman: Fashioning a National Identity*, Costume Institute exhibition at the Metropolitan Museum of Art on May 3, 2010, in New York City. Photo by Jason Kempin/Getty Images.

It must be noted that the Brooklyn Museum, although often staging exhibitions on similar time periods and topics, has rarely, if ever, used such devices. For example, curator Elizabeth Ann Coleman's *An Opulent Era*, which ran at the museum from 1989 to 1990 and featured Belle Epoque couture fashions, did not rely on atmospheric backdrops (Figure 4.8). Blue mannequins were placed in enfilade of rooms also painted blue; the dresses were left to float in this cerulean sea, and further content was provided only by text-heavy labels on adjacent walls. It was, in fact, impossible to read the curatorial text at the same time as facing the costumes, so that their visual impact was as a series of objects unaccompanied by any other visual or textual content. Photographs and fashion plates from the period were reproduced beside label copy on the walls but not in a decorative manner; rather, they were clearly meant as encyclopedia-style illustrations and adjuncts to the text.

Likewise, the *American High Style* installation at the Brooklyn Museum (a companion to the Costume Institute's *American Woman*: the exhibition marked the transfer of Brooklyn's collection to the Met and each institution staged their own display) was a brightly lit contemporary spectacle without the theatrical

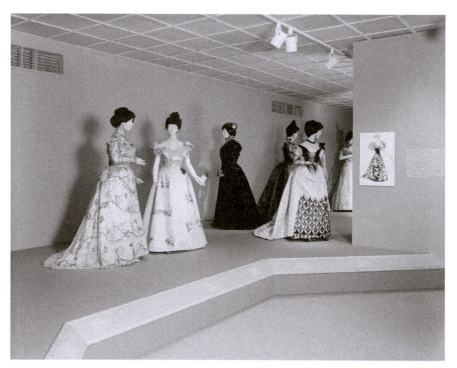

Figure 4.8 Brooklyn Museum Archives. Records of the Department of Costumes and Textiles. *Opulent Era: Fashions of Worth, Doucet and Pingat*. (December 1, 1989–February 26, 1990). Installation view: "botanical bounty." Courtesy Brooklyn Museum.

effects of the Met's corresponding exhibit (Figure 4.9). Art critic Roberta Smith wrote at the time that the Brooklyn display "offers its garments—seen against white walls—as art objects. They best assert themselves as examples of an über-art that fuses aspects of painting, sculpture, architecture, body art and theatre with exquisite craft" (Smith 2010). Indeed, the lighting, and placement of mannequins and accessories as pieces of sculpture on plinths, reinforced the impression of the exhibition as a contemporary art installation. The deliberate neutrality of the space and the individual space accorded to each item in the exhibition place Brooklyn's curators and exhibition designers in the "white cube" school of display, where the focus is on the individual object and the viewer's subjective response to it.

The different approaches of the two institutions also reflect the epistemological rationales for organizing museum material within a display. A *gesamtkunstwerk* exhibition may use vignettes to evoke a stylistic moment iconic of a period such as the Belle Epoque; a white-cube-style exhibition is often also organized chronologically but relies on the power of the individual object (isolated by the means of the display) to recall a period. Iconicity and periodicity are two of the fundamental principles that can be used to guide the look of a display, and both are derived from art history and theory. The organization of knowledge into a chronological order is fundamentally an arbitrary one and is predicated on notions

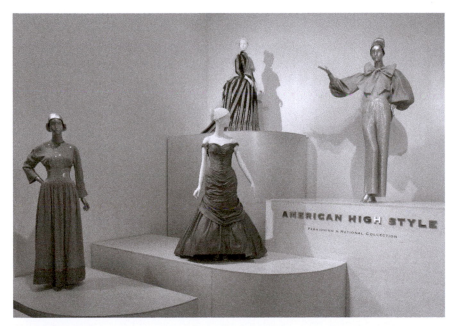

Figure 4.9 Brooklyn Museum. Digital Collections and Services. *American High Style: Fashioning a National Collection*. (May 7, 2010–August 1, 2010). Installation view. Courtesy Brooklyn Museum.

of difference and progress; the past needs to look sufficiently different from the present in order for this scheme to have effective impact. Historical fashion often needs to be set off against contemporary fashion, whether in the viewer's own mind[7] or in physical contrast to contemporary pieces also on display: for this very reason, the V&A later bemoaned the lost opportunity when the 1913 fashions displayed alongside the Hughes's collection at Harrods were not acquired by the museum at the same time as the antique examples (Mendes 1983: 78). Equally, the notion of evolution needs to be sufficiently visually recognizable, and the study of the history of artistic style and technology has developed a canonical series of key moments, which are thought to be representative of a greater whole; somewhat contradictorily, evolution needs to be punctuated with a series of disparate moments in order to highlight the process of change (see Chapter 7). These moments, when represented through images or objects, become iconic: synecdoches of a greater whole. An example of such historical fashion exhibitions is *The Age of Napoleon: Costume from Revolution to Empire* (Met, 1998–1999), which defined the stylistic developments of a historical era around a well-known figurehead.[8]

While in a *gesamtkunstwerk* installation, the assemblage is more important than the objects that make up the whole, the barer approach for a white cube exhibition by its very layout communicates and demands specialness of the pieces included within. The pieces in the *American High Style* exhibition at the Brooklyn Museum were referred to as "masterworks" (Smith 2010), and indeed, the practice of placing artifacts on plinths in spotlights where the shimmer and sheen of the luxurious materials and fine craftsmanship can be more easily seen does tend to create masterpieces through display alone. *The Golden Age of Couture*, curated by Claire Wilcox at the V&A in 2007, "was presented from a historical perspective" but "made a point of technique" (Menkes 2011), which required a heavy object focus, something that requires isolating each piece visually through a number of means, including the selection of appropriate mannequins. Alexandra Palmer writes, "Abstract faces and minimal detailing tend to represent the costume as an art object, the mannequin providing the frame" (Palmer 1988: 9) for the dress itself. This fetishistic focus on the formal qualities of a garment is even more apparent in the use of "hollow" or "invisible" mannequins, which provide the illusion that the garment is filled out by itself (for a further examination of these, see Chapter 7). If a mannequin is used, it can be rendered less obtrusive by painting it the dominant color of the dress being displayed, as in the Kyoto Costume Institute's traveling exhibition *Fashion in Colours* (Kyoto, Tokyo, and the Cooper-Hewitt, National Design Museum in New York, 2004–2005), where garments were grouped by color, and mannequins, plinths, and backdrops were also painted the same color; this had the additional effect of focusing the eye on this important compositional element.

"Good art" is considered to be comprised of formal qualities, the aesthetically pleasing nature of which is thought to transcend barriers of time and space (Staniszewski 1998: 159). Adolph Cavallo (mentioned above in connection to the Boston Museum of Fine Arts) wrote of a 1971–1972 exhibition at the Costume Institute:

Drawn entirely from the Costume Institute's own collection, the garments and accessories in *Fashion Plate* will represent a succession of fashions in clothing during the past 200 years. The clothes will be shown in conjunction with enlarged reproductions of fashion plates of their time. Both the plates and the clothes exhibit that taste for idealized line, for exaggerated form, for dramatized detail that conditions the visual language of fashion in clothing. To demonstrate fashion's consistency of action through the ages, the staff will arrange the groups of costumes and plates without regard to chronological sequence. In this way, without the distraction of tracing developments from one period to another, the visitor will be free to concentrate on the purely formal aspects of the images and to identify those elements of line, form, and colour that the designer manipulated to achieve a fashionable look, whether he was working last year or a century ago. (Cavallo 1971: 45)

In this paradigm, the masterpiece is iconic not of a period, as above, but of art itself—the touch of genius[9] that one can connect with by perceiving its physical manifestation.

Indeed, the aura of artistic genius attached to certain famous fashion designers can additionally defuse accusations of commercialism leveled at art museums that exhibit fashion.[10] N. J. Stevenson (2008) has concisely summarized the evolution and development of designer retrospective exhibitions in an attempt to rehabilitate the reputations of curators who agreed to stage such shows in the face of criticism for such exhibitions as populist exercises in brand-building. This is more true in cases where the designer or brand being celebrated is still in business, even if the exhibition focuses on the history of the house's designs. The Met's 2005 *Chanel* retrospective, sponsored by the House of Chanel and curated with heavy involvement from head designer Karl Lagerfeld, was criticized for this reason; however, an object of aesthetic awe is not necessarily always the subject of consumer desire, and these exhibitions often seek to historicize the brand and mythologize the persona of the designer as a genius. Sometimes this is overtly stated by the curator: for example, *The Genius of Charles James* at the Brooklyn Museum in 1982–1983. In the case of the couturiers Charles Frederick Worth (*House of Worth*, Brooklyn Museum, 1962) and Paul Poiret (*King of Fashion*, Metropolitan Museum of Art, 2007), the appellation of artistic genius was one they assigned to themselves in their own lifetimes and may in this way be considered historically accurate. Because the values of "good art" are held to

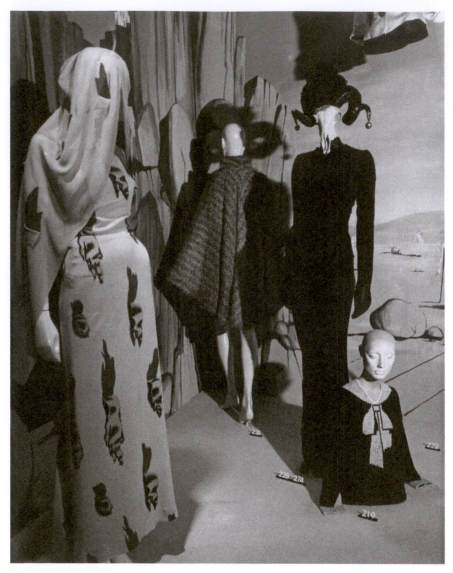

Figure 4.10 Surrealism display in *Fashion: An Anthology by Cecil Beaton*. Original caption: "A display of French fashions at the preview of an exhibition of 20th century fashion at the Victoria and Albert Museum, London, October 12, 1971. The exhibition has been designed by Michael Haynes, with exhibits selected by photographer Cecil Beaton. At far left is a 1938 pale blue evening outfit with 'tear' motifs by Schiaparelli. At centre is a 1938 gold and silver evening cape, also by Schiaparelli. At second right is a 1938 French black evening dress with black 'top' hat. At far right is a French cravat pattern jumper from around 1928." Photo by Peter King/Fox Photos/Hulton Archive/ Getty Images.

be static and unchanging, the histories of these and other couturiers could be relevant not because of the market's current tastes but because of what is said to be their timeless aesthetic appeal.

However, it cannot be said that the framing of fashion as art in a museum exhibition ever really escapes its commercial context. Often, the movements between the commercial and art worlds are very fluid, and even self-referential, as in the case of the work of the Surrealists. The painter Salvador Dali, who, like many of his fellow Surrealists, had a preoccupation with mannequins in his work, was asked by the New York department store Bonwit Teller to create window displays in March 1939 ("Dali's Display" 1939: 31). The motifs of decay and misogyny within echoed his earlier artwork displayed at the 1938 Paris Surrealist Exhibition (Kachur 2001: 57–58). In 1971, the "Schiaparelli and Surrealism" section of Cecil Beaton's *Fashion: An Anthology* exhibition at the V&A visually referenced this and other Surrealist installations in the display of Schiaparelli's couture collaborations with Dali (Figure 4.10). Any curator or museum designer who displays fashion by Elsa Schiaparelli or other Surrealist fashion designers must therefore engage in both the artistic and commercial histories of Surrealism. This was certainly the case in the exhibition *Fashion and Surrealism*, held at V&A in 1988, which was an modified version of the exhibition of the same name curated by Richard Martin and Harold Koda (both of whom later worked as curators at the Costume Institute) at the Fashion Institute of Technology in New York in 1987 (see Tregidden 1989). Making reference to such connections between art, historical fashion, and the fashion marketplace within exhibitions can be seen as an honest reflection of the commodity cycle for fashion and art.

Tasteful consumption: The uses of museum fashion in art education

Fashion history exhibitions can further subvert the commercialism of the fashion system[11] by aestheticizing dress with a rationale of promoting "good buying" by educating the consumer into a connoisseur. Thus, exhibitions of historical fashion were constructed as a means of social improvement. The fashion museum proposed by *The Spectator* in 1712, for example, was to serve as a place of consultation and advice for consumers: they could view the variety of fashions conceived over time and with the help of the curator, himself a fashion expert, discover which best suited them (219–220).

This was also the rationale for educating female consumers about fashion history in an 1873 article describing the display of antique dress in the Industrial Department of the Third Annual International Exhibition in London. The author wrote,

Ladies, however, are the acknowledged representatives of the art of the toilette. Society would be shorn of more than half its pains and pleasures, if women were to don a universal costume as uninteresting and as unbecoming as that worn by men. Hence the great advantages which a study of the principles of fine art offers to women. And if attention to dress be really one of the penalties they must pay as members of the more angelic half of creation, by all means give them the solace of sound artistic training, with definite aesthetic precepts to go upon, in carrying out the responsibilities and distinctions of their order. ("Antiquities" 1873: 220)

In a later installment of the description of these costumes (the space allotted to discussion of this aspect of the exhibition is unprecedented in nineteenth-century descriptions of historical fashion displays), the author concludes that increased exposure to "artistic and well-selected" ("Antiquities" 1873: 303) examples of timeless good taste has made a difference:

We seem gradually progressing to the adoption of a more sensible and tasteful standard than formerly, and the marked improvement in the costume of the middle and lower classes is strikingly apparent; while there is, happily, less display of violent colour and tawdry finery, there is a decided evidence of increased refinement and judgment. ("Antiquities" 1873: 51)

It is typical of the cultural commentators of the period that this piece puts the improvement in the material culture of the lower classes down to education and not to growing economic prosperity. Yet, it also brings up a means by which the exclusive material culture of the upper classes, otherwise unattainable, could be made to have desirable social and cultural value. Disciplining the largely female audience from uneducated consumers into cultured connoisseurs has been one of the social functions of art museums in modernist period (see, for example, the discussion of MOMA's *Useful Object* exhibitions in Staniszewski 1998). Navigating brand distinctions for socioeconomic status requires consumer literacy, not indiscriminate hoarding. In this way, representing historical fashion as art both evades and fuels the market forces that drive the fashion system.

Art gives the study of specimens of historical fashion an integrity and respectability not reserved for fashion in the commercial sphere. However, because of its commercial roots, it is still considered second to examples of fine art. Likewise, art is considered by many to be more fundamental in the truth of its expression of the past than surviving objects; the following chapter will consider how such illusions of authenticity have been created in exhibitions over the period under study.

Plate 1 Unknown photographer, slides showing the Metropolitan Museum of Art Costume Institute show *Vanity Fair* (1977), curated by Diana Vreeland. Author's collection.

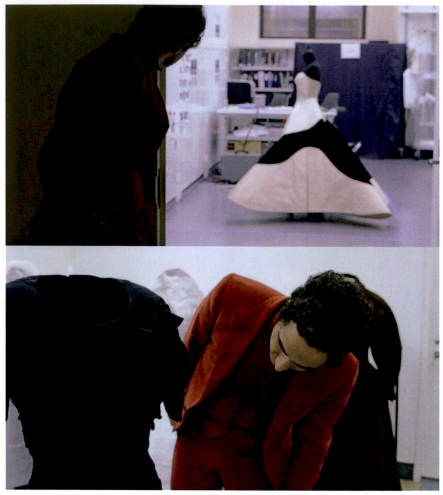

Plate 2 American designer Zac Posen is shown studying Charles James gowns in the collection of the Metropolitan Museum of Art in *House of Z* (2017). Screencaps by author.

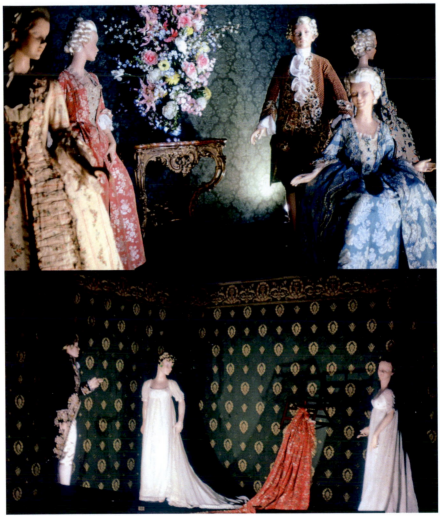

Plate 3 Slides showing Siegel mannequins in period room settings at the Costume Museum of the City of Paris, *c.* 1980. Courtesy Gail Niinimaa.

LAQUELLE ?
Robe de soirée de Paul Poiret

Plate 4 A mannequin wearing the "Sorbet" evening dress is posed like a 1913 fashion plate by Georges Lepape in the Costume Institute preview of *Poiret: King of Fashion* at the Metropolitan Museum of Art on May 7, 2007 (Photo by Peter Kramer/Getty Images). Georges Lepape, "Laquelle?," pochoir print depicting the Paul Poiret "Sorbet" evening dress in the *Gazette du Bon Ton* 11 (November 1913), Pl. V, Smithsonian Libraries.

Plate 5 Museum staff prepare garments for display in online videos from (clockwise from top left) the Los Angeles County Museum of Art (2016), Victoria and Albert Museum (2015), Museum of the City of New York (2016), and the National Gallery of Canada (2016). Screencaps by author.

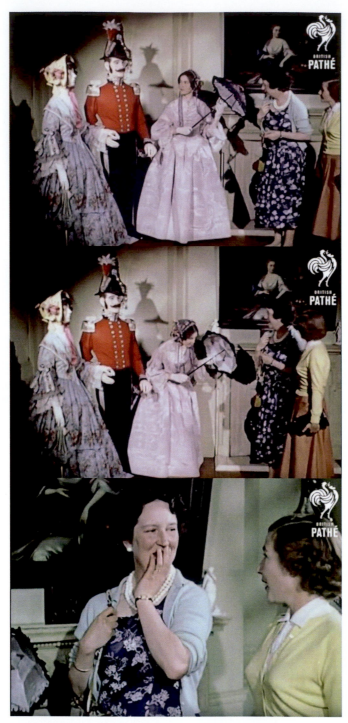

Plate 6 The reality effect of lifelike mannequins is parodied at the Museum of Costume, Bath in "Ancient Models" (1955). Screencaps by author.

Plate 7 Two undated postcards showing the same tableau in the Fashion Wing of the Philadelphia Museum of Art; mannequins have been slightly rearranged and dressed in different outfits but the vignette remains the same. Author's collection.

Plate 8 The architecture of the museum is echoed virtually in the Valentino Garavani Museum (Association Valentino Garavani Archives 2012). Screencaps by author.

5

TABLEAUX VIVANTS: THE INFLUENCE OF THEATER

A painting is primarily experienced as a two-dimensional work of art, whereas museum exhibitions operate in three dimensions, and thus, the showmanship of theater has also influenced the display of historical fashion. Early curators such as Doris Langley Moore and the team behind the Costume Institute at the Met had theater design backgrounds and infused their exhibitions with the type of spectacle with which they were professionally familiar. Even now, major museums such as the Met often draw on the expertise of theatrical lighting and set designers to stage their blockbuster shows. In this chapter, theater and performativity are used to explain how the representation of life and movement was staged in fashion exhibitions.

To a large extent, this has relied on the creation of mannequin "actors," clothing's occupants in effigy, which could be posed alongside other mannequins or objects and props, as though interacting with them. Whether by placing mannequins onto stages of period rooms or into semi-furnished vignettes, or by staging fashion shows where live models wore museum pieces, theatrical practices of choreography and spectatorship influence any display that attempts to inject a semblance of life to a mannequin pantomime. In Noordegraaf's view (2004), museums share with and draw on the visual regimes of department stores, other museums, and cinema. The interplay between the physicality of the museum, the presence and needs of visitors, and the intellectual preoccupations of the museum administration (directors, designers, and curators) is defined by Noordegraaf within a cinematic metaphor as a "script." It follows, then, that it is possible to outline the roles of the artifacts as players and museum visitors as audience.

As a form of museum interpretation, theater has had a long history. Mida (2015b) notes a dramaturgical turn in contemporary fashion exhibitions in describing the affective and spectacular qualities of displays by curators such as Andrew Bolton, Judith Clark, and Pamela Golbin. Their reliance on thematic tableaux as an aesthetic device for organizing exhibition narratives is far from new. Indeed, it is in line with some of the earliest approaches to interpreting

historical fashion, which arose out of the popular custom of masquerade in pageant- or *tableau vivant*-form. Itself a legacy of the historicism that arose in the Romantic movement of the 1830s, dressing up in historical costume (real or replica) became a fashionable pastime for the upper- and middle classes; once historical costume could no longer be animated by live models, museums would then have to rely on elaborate staging to evoke intimate moments in history.

The spectacle of authenticity

As collections and exhibitions of historical fashion have been shown to have emerged out of artistic concerns and were seen to be important for artistic development, they can be expected to demonstrate conventions characteristic of this origin. In particular, the perceived importance of an aura of "authenticity"[1] and intellectual authority to the look of a museum artifact in an exhibition was inherited from the writing and work of painters, engravers, and theater designers who studied costume in earlier periods. Anne Hollander wrote, "Any real public knowledge of authentic historical dress has been invaded and corrupted by stage conventions of such long standing that they seem to have the sanction of real history" (1993: 301–302). Hollander argued that often the perception of authenticity is triggered by a key conventional prop, such as a white wig for the eighteenth-century or a ruff for the Elizabethan period. Once the key prop is recognized, the audience slips into comfortably ignoring any possible anachronisms, certain that what they are seeing is "accurate." Indeed, a 1962 *Times* article on the rearranged Costume Court at the V&A described the usefulness of the museum for suggesting details for increased period accuracy in film and performance:

> It is not necessary for an historical play or film to be meticulously accurate in every detail of costume down to a button or bow, but some degree of accuracy has its part in recapturing the spirit of an age and here such a mine of reference as the Costume Court is rich in suggestion. ("History in Clothes" 1962: 9)

The museum's display of artifacts could define a stereotyped or conventional look for any given period.

These conventions first developed for designers out of the visual shorthands and conceptual biases in the illustrated costume history books discussed in the previous chapter. As Ulrike Ilg writes, these relied on numerous assumptions about the material world and its ability to be represented (Ilg 2004: 43). The self-positioning of the text as authoritative, as well as its vocabulary of visual symbolism—repeating poses, styles, regional costumes, and periods—

contributed to the creation of a language of costume studies, a language that evolved out of visual media and into the three-dimensional world of museums.

As images of past events rely on conventions to be understood, historian Stephen Bann uses Roland Barthes's notion of the *effet de reél*, or "reality effect," to explain the genre of the narrative historical painting, commenting that "it is precisely the authentic detail which appears almost gratuitous—which passes almost unnoticed—that will confirm and enhance the historical realism of the image" (1984: 57). Bann notes that this effect relies upon the viewer's visual literacy and familiarity with other similar works, requiring "the persistence of the effect, or at least its non-contradiction; and that implies the existence of a discourse in which such an effect can echo and reverberate" (1984: 58). He calls this the "historical series," and it is a useful concept for considering the museal portrayal of historical fashion in the period under investigation. One example can be seen in the postcards produced of the Museum of the City of New York's costume alcoves (Figure 5.1): the black-and-white image of a furnished mid-nineteenth-century period room populated by mannequins dressed in clothing of the time is cropped to imitate the photographs of the same era. The effect is

71. Drawing Room, c. 1860 Museum of the City of New York
 From 1 Pierrepont Place, Brooklyn, N. Y. 5th Ave. & 104th Street

Figure 5.1 Postcard, *c.* 1945, showing mannequins in fashions contemporary to the furnishings of a period room at the Museum of the City of New York. Author's collection.

to induce the visitor to imagine that the mannequins are the actual inhabitants of the room in 1855— the clothing, furniture, and architectural detail all of the same time as the image and not a carefully constructed illusion from 1941. This way of seeing was practiced and promoted by artists, authors, dramatists, and museums alike, creating a visual regime that disciplined the public to react positively to what they were led to believe was authentic. Indeed, the constant repetition of effect would only serve to emphasize its apparent authenticity.

The use of tableaux that recreate a two-dimensional source image is an obvious means by which to draw a visual analogy between fashion and art. If dress is "living sculpture" (Rosenthal 2004: 103), then mannequins in historical clothing can throw art into relief. Yet all too often, the result devalues both sources. While drawing on images as documents to support the authenticity of the museum presentation is normal, and laudable, the source images are rarely used alongside the reenacted tableaux, so that the general public does not necessarily recognize any added value to the exhibition. The object becomes documentary of the art as opposed to vice versa. Where the primary source material is used, the painting (or in the case of the Met's 2009 *Model as Muse* exhibition, the fashion photograph) is reduced to an illustration, while the dress artifact becomes a prop to support the reality effect of the assemblage. In addition, the audience cannot engage in the imaginative projection necessary to intellectually participate in the display's content. Rather, it is the display itself that is on display, the content and formal qualities flattened and represented as spectacle; the exhibit so conspicuously copies its source material that what is most notable is the act of representation itself. The viewing public marvels at the recreated likeness, rather than feeling transported into the past. As Handler and Gable warn, "Mimetic realism thus deadens the historical sensibility of the public. It teaches people not to question historians' stories, not to imagine other, alternative histories, but to accept an embodied tableau as the really real" (1997: 224). It is the artful assemblage, not the object, that is highlighted in this type of exhibition design.

Hyperreal effects inherited from wax museums and dioramas (see Sandberg 2003) were, in the early days of costume display, more likely to be read as authentic. For example, in France, the nucleus of the collection of the City of Paris Museum of Fashion was that collected by Maurice Leloir, an artist and member of the famous Leloir-Toudouze fashion illustrator clan. Before its current location in the Palais Galliera, the collection was displayed at the Musée Carnavalet in tableaux. An Australian newspaper reported,

> Most of the costumes were produced by the artist Leloir fifty years ago, and to this original collection later creations have been added. They are shown on beautiful wax models, each in a setting of the period. The collection is a marvel of colour, rich fabrics, and historical accuracy. Streets of old Paris,

with their low browed shops and cobble roadway, are part of the setting, and elegants of another age are seen dallying in the garden of the Palais Royal,[2] with beauties in poke bonnets and slashed gowns. (Germaine 1928: 8)

Evidently, costumes representing clothing worn in the Middle Ages and the Baroque were displayed alongside surviving artifacts; their mixed origins were camouflaged by the realistic mannequins and detailed sets. Maude Bass-Krueger (2018) has written in detail about the ideological reasons for the alterations and embellishments the historical garments underwent.

Just as in Early Modern costume books, the look of the historical fashion on display was an illusion of an objective reality, constructed through a series of stylistic decisions not always based on historical "fact." For example, the Hughes/Harrods donation of historical fashion to the V&A in 1913 was formed out of the aesthetic preferences of its painter-collector (Petrov 2008) and later presented in theatrical contexts. While initially displayed on the department store premises, the dresses were exhibited in "period surroundings" ("Collection About Which" 1913: 66). When they were moved to the V&A, the arrangement in the Central Court was carried out by Harrods's fancy-dress department, as a letter from Richard Burbidge to Sir Cecil Smith testifies: "Acting on your suggestion, I shall be pleased to place at your disposal any of the company's costume experts to render assistance and advice in setting up the exhibits" (Burbidge 1913). Commercial purveyors of theatrical and fancy-dress costumes were therefore as responsible for the final presentation of the dress collections in the museum as were the curatorial professionals responsible for its intellectual rigor.

The fact that the use of theater and fancy-dress professionals to style historical fashion exhibitions is widespread does not necessarily devalue its effectiveness: professionals in theatre and the visual arts have an intuitive sense of what "looks right,"[3] and indeed, it often does. In 1946, when the Museum of Costume Art merged with the Met to become the Costume Institute, the theatrical backgrounds of the institute's founders (Taylor 2004: 189–190) influenced the choices of display. Indeed, the very idea of a museum emerged out of theater: "In the twenties, the late Irene Lewisohn, director of the Neighbourhood Playhouse, thought that a costume museum for theatrical research might be a good thing. Her friends in the theatre agreed," wrote *Vogue* ("The Costume Institute" 1947: 242). The museum became a boon to the American fashion industry in New York City, but the founders were said to regret that their collection "has not had a parallel influence on theatrical designers" (246). The opening exhibition once the collection entered the Metropolitan Museum in 1946 was appropriately comprised of tableaux featuring fashions and accessories from the late eighteenth century to the end of the nineteenth century, arranged around the museum's collections of furniture, paintings, and silver of the period (see Figure 3.1). The period groups were defined with notes on particular stylistic features peculiar to the period: "VII:

1867–1870—Flamboyant Lines. Long, trailing skirts—bouffant overdrapes—apron effects and sashes—contrasting materials—ruchings and trimmings" ("Opening Exhibition" 1946). Indeed, the notes read like a style manual for a costume designer looking to evoke a fashion by its defining characteristics.

Nearly twenty years later, the museum was still displaying tableaux: *Vignettes of Fashion* (1964), like the opening exhibition, did not visually emulate any particular period sources but in its mix of props, lively mannequins, and outfits worn for a staged "occasion," the overall appearance was theatrical (see Figures 6.3 and 6.4). Successive generations of curators followed this established "house style," in heavily staged exhibitions with props, backdrops, and "active" mannequin groupings such as *From Queen to Empress: Victorian Dress 1837–1877* (1988–1989) and *Dangerous Liaisons* (2004; see below). In fact, many of the Costume Institute exhibitions mounted in the 2000s relied on tableaux for visual effect. The 2007 show *King of Fashion* was particularly careful to stage mannequins in interiors and poses, which echoed the illustrations of Paul Poiret's designs by such artists as Paul Iribe and Georges Lepape or photographs of models including the couturier's wife in his designs (Plate 4).

The Fashion Museum (Bath) was also originally organized as a series of historical vignettes. The realistic mannequins, posed in detailed interiors, evoked the daily lives of the original wearers of the dresses. This was intended to bring the past to life for viewers, as a journalist wrote: "It needs very little imagination to step through the pane of glass right into the world of that time" ("A Costume Dream" 1976: 12). Doris Langley Moore, the founder and stylist of the museum, was, among her other interests and activities, a costume designer for stage and screen, and her keen sense of artistic fidelity was extended to the look of her collection when it was exhibited. The first home for the collection was a house in London's West End, close to the city's theaters. When she began displaying her collections in 1955, Langley Moore and her daughter, Pandora, created a design scheme that featured painted architectural backdrops and mannequin heads whose features were cast from Roman sculptures at the British Museum (Langley Moore 1961: 280), as their features and hairstyles were similar to those that had seen fashionable revivals over the centuries (Figure 5.2). Moore's success was predicated on her having a sufficient level of historical knowledge in realizing her visual goals.

Royal Ontario Museum costume curator Alexandra Palmer writes of the importance of taste and style to the curatorial profession:

Costume and textile exhibitions have, undeniably, attracted some very original, intelligent and artistic women and men to the field who have produced dramatic results. It is indeed a skill and craft to create a dynamic-looking exhibition, particularly with old, stained, and oddly shaped historical dress. When this is well realized it can contend with the latest results in theatrical/film costume and set decoration. (Palmer 2008a: 48)

However, she also points out that combining design and scholarship is challenging even for the largest institutions, as it is difficult to attract and maintain public interest with style without compromising substance. The opposite is also true. In 1963, the *Times* praised the V&A's efforts in the new Costume Court despite their having no design staff: "[…] the impetus must come from the museum itself. It rests with its responsible officers to provide the knowledge

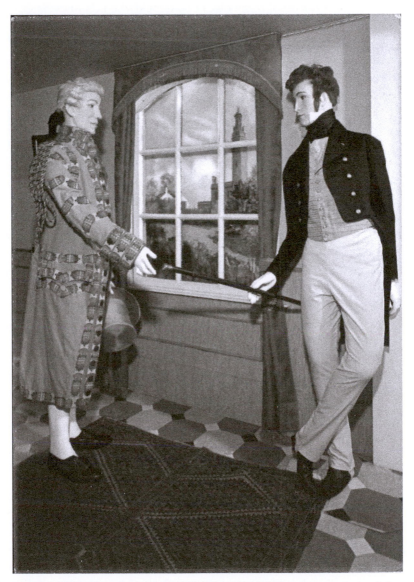

Figure 5.2 Undated postcard showing figures of a footman and Regency dandy in a vignette at the Museum of Costume, Bath. Author's collection.

and constructive thought which are essential. [...] A keeper details precise requirements as to arrangement, lighting, colour scheme and labelling which are carried into execution by the Ministry of Works" (Museums Correspondent 1963: 13). Yet this new arrangement was praised mostly for its practicality in terms of educational aims[4] and conservation standards and not for its visual effect.

In the absence of in-house design expertise, many museums use theatrical designers to effect period atmosphere. For example, the Los Angeles County Museum of Art turned to the prolific set- and costume designer Kent Elofsen to sculpt display mannequins (Maeder 1984: 47); these same figures were later loaned to the Museum of Fine Arts, Boston (MFA), where they enjoyed a second career enlivening dramatic displays with their expressive facial features (Pamela Parmal, pers. comm. March 10, 2017). The MFA had previously used the theater designers Raymond Sovey and Horace Armistead for the backdrops and lighting of their 1963 exhibition *She Walks in Splendor* (Parmal 2006: 20). Likewise, Patrick Kinmoth, an opera designer, was contracted by the Met to stage the Costume Institute exhibitions, *Dangerous Liaisons* and *AngloMania* (2004 and 2006), and went on to design Valentino retrospectives in 2010–2012 as well as the 2017 exhibition of the clothing of the Dukes of Devonshire at Chatsworth.

Some authors define museums as a type of theater: Donald Preziosi and Claire Farago, for example, argue that museums "use theatrical effects to enhance a belief in the historicity of the objects they collect," the fiction being employed to sanction one version of events over another, legitimizing "both the 'reality' of history and of a single interpretive truth" (Preziosi and Farago 2004: 13). Michelle Henning, in her discussion of a particular type of display— the diorama—suggests that this exhibitionary form's effectiveness lay in its ability to subjugate the viewer's senses and create awe. The physical space of dioramas, she argues, sought to influence visitor behavior and response, addressing "the problem of over-accumulation and the consequent distracted and drifting attention of visitors. The diorama hall, with its darkened center, illuminated scenes, and overwhelming attention to detail, closes off distractions: [... it] offers an illusion of coherence" (Henning 2006: 44). The result of this illusion, argues Henning, is not that spectators are duped into believing they are actually entering reality, but rather, they are impressed at the museum's ability to masterfully create a sense of authenticity; this is a type of appreciation akin to the awe of technical perfection visible in a film or hyperrealistic painting, for example (Henning 2006: 58–59). Equally, the lack of external or contradictory detail allows visitors to suspend their disbelief and perhaps even their critical faculties and enter fully (albeit knowingly) into the illusion. All this is possible without allowing the visitor to reassure themselves of the reality through their sense of touch.

Contemporary fashion theory devotes great attention to the phenomenon of "spectacle" (*cf.*: Evans 2003), and this concept offers an explanation for the curious collusion of fantasy and intellectual authority within the display of historical fashion. The "look" of a display affects the way in which it is looked at, positioning the viewer physically and intellectually in regard to the subject on display. An excellent example are the opposing approaches of Diana Vreeland and her successors at the Met. Vreeland's extravagant fashion history displays were said to have

> revolutionized such exhibitions for they have firmly placed costume as an art, and a rather exhilarating one, in the mind of the public. ... Mrs Vreeland's exhibitions are neither didactic nor emphatically scholarly. But her exhibition "The 18th-Century Woman" was full of musk and vivacity. ... Shine and dazzle it did, and probably pleased the more than half a million museumgoers who saw it. (Riley 1987: 84)

However, as mentioned above, some missed the educational aspect they had come to expect from museum exhibitions. A letter to the editor of the *New York Times* from a fashion history instructor at Parsons summarized the nature of the complaint:

> [...] there is almost no attempt to educate the viewer anywhere in the exhibit. The clothing is presented in no particular chronological order and is set against minimal historical background. Almost nothing is said about the fascinating and varied events that helped to shape the lives of the people who wore these clothes. Little is done to stimulate the viewer to wonder what made the 18th-century woman dress as she did. I do not understand why the Metropolitan Museum, as a great teaching institution, chose to treat clothing, which is an important human expression, in such a frivolous manner. It's enough to give fashion a bad name. (Watson 1982)

By contrast, exhibitions by those who followed Vreeland in curatorial roles at the Costume Institute were called intellectual as a marker of difference. Of the exhibition *From Queen to Empress* (Met, 1988–1989), the *New York Times* wrote, "The theatrical genius of Diana Vreeland, a consultant to the museum until last year, gave her presentations the impact of a Broadway musical. [...] This year's show, organized by Caroline Goldthorpe, a curatorial assistant at the institute, is scholarly, not flashy" (Morris 1988). Alexandra Palmer, in her review of the exhibition *Costume and History* (1992), lauded the "more rigorous interpretive approach to exhibitions" (1994: 94) necessary for the Institute to appear credible in the field of costume history study. The spectacular nature of Vreeland's shows were therefore somehow anti-intellectual, engaging the senses, whereas didactic interpretation engaged the scholarly mind.

Peeping into the past: Period rooms as *tableaux vivants*

The conventions of theater, with its "fourth wall," are an intermediate spatial orientation between the three-dimensional interactivity of objects in their original context and the flattened visual space of a represented object, whether in a two-dimensional drawing or a museum (Petrov 2011). This is an easily understood metaphor: period rooms, carefully assembled and staged as though the occupants have just left them, enable visitors to play the part of voyeurs, although they are carefully kept behind protective barriers and must view the interiors in passing. Some museums, such as the Museum of the City of New York (MCNY), populated reinstalled historic interiors from demolished mansions with mannequins dressed in period clothing, in some cases those having been worn by the room's former occupants or by their contemporaries and social equals. The MCNY "costume alcoves," which were in place from the 1930s to the 1960s, enabled voyeuristic glimpses of moments frozen in time (Figure 5.1). Similarly, the *New York Times* wrote of the 1963 exhibition that placed costumed mannequins into the Met's period rooms: "The occupants are effigies, but their costumes were once part of a living stage and as elegantly contrived as the sets they enhanced" ("Museum's Rooms" 1963: 171).

The Met repeated this conceit some forty years later, in the 2004 *Dangerous Liaisons* exhibition. Michael Katzberg (2011) has written a thorough examination of it as a staged re-production of the past with inanimate actors, highlighting the theatrical conventions utilized by the curators and designer Patrick Kinmonth. In this case, the theatrical effects were of the *tableau vivant* type, a form of theater that emulates the look of famous paintings through the frozen attitudes of participants; the use of this imitative form had special significance for the content of the exhibition, which focused on rococo visuality. My own critique of the exhibition (Petrov 2004) was that it largely ignored its responsibility to provide social context for the artifacts on display in its intense focus on slavishly (if convincingly) recreating visual tropes.

While the theme of *Dangerous Liaisons* was inspired by the Choderlos de Laclos's 1782 novel, the public was more familiar with the exhibition's theme from the 1985–1987 stage play, later adapted for film in 1988 and 1989. A review of the exhibition noted that it was these stage and screen adaptations that were more likely to have formed the reference points for visitors, who would be seduced by the proximity to the luxurious interiors into an illusion of witnessing the action at close range. The exhibition, the reviewer argued, reinforced the fantasy version of eighteenth-century life seen in the theater (Gaskell 2004: 621). Indeed, the entrance to the exhibition featured a mannequin drawing aside a curtain, inviting visitors into a private but also a staged world.

Even if they do not stage elaborate tableaux, more often than not, fashion exhibitions are enlivened by the mute pantomime of mannequins. As Sarah Schneider writes,

> Mannequin displays link the image of a body to a tacit action: a realistic mannequin, though still, often appears to be about to act or to have just acted. And both realistic and abstract mannequins simultaneously display and are displayed. Appearance is in fact a form of action. (1995: 7)

This is well illustrated by a photograph from one of the installations from the Met's 1963 *Costumes: Period Rooms Re-Occupied in Style* show, which features three mannequins in an eighteenth-century interior (Figure 5.3). Although all are wearing the historical fashions ostensibly on display, it is their poses that are most striking—it is obvious that the seated mannequin is reading a book, oblivious to the scene of silent courtship taking place behind her. While inanimate mannequins cannot, by definition, engage in either of these activities, their lifelike poses bring a sense of believable action to the installation. The grouping produces a narrative that allows a viewer to imagine beyond the frozen moment. The appeal of the mannequin-in-action is considered by Schneider to be a result of the viewer's expectation of a body in the world:

> During the 1970s consciously created "groupings" animated mannequin showrooms and windows, as mannequins were specifically designed to be sold in sets and to be staged in relation to one another. [...] In promoting their groupings, manufacturers appealed to viewers' desire for realistic representation, not just of the individual in physical movement, but of the emotional exchanges of social life as well. (1995: 98)

Indeed, a technical leaflet for history curators from that period suggested that "instead of regarding the room as a place for exhibiting artifacts, the designer might consider it a setting for meaningful activity," where the identifiable action of the figures makes clear the purpose of the artifacts on display, and the presence of the figures "introduces a dramatic element" (Halvarson 1973: 1). However, material studied in this research demonstrates that this trend was seen in museums before the 1970s; archival photographs from the Costume Institute's opening exhibitions in the 1940s show affecting scenes featuring mannequin "families." Equally, as was described above, the 1963 Costume Institute exhibition *Costumes: Period Rooms Re-Occupied in Style* saw costumed mannequins in furnished architectural settings, interacting with them and each other. The impact of these tableaux relies on the viewer relating their own social behavior with that of the mannequins via an imaginative projection (Petrov 2011) of their bodily experience onto the visual information before them. The relatable

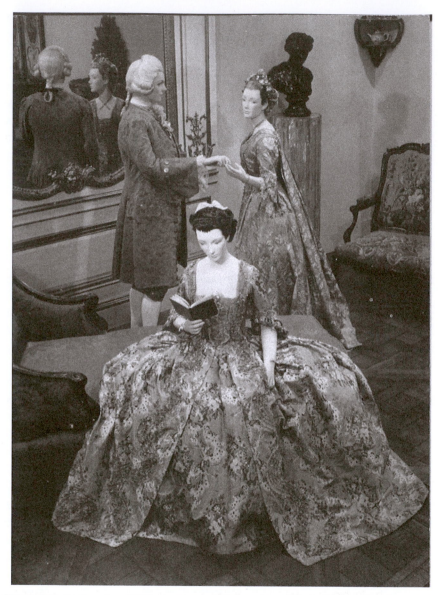

Figure 5.3 Postcard, *c.* 1965, showing installation view of *Period Rooms Re-Occupied in Style*, with a mannequin "reading" while two couples "flirt" behind. Author's collection.

body language of the mannequins humanizes the people of the past who wore the garments on display.

Action may also be implied, as in the device used by Claire Wilcox in her 2012 redisplay of the V&A permanent costume collection: an overturned shoe in the "Court and Country" section as an echo of movement among the frozen

fashions. The minimalist tableaux in glass cases, with headless mannequins and a sparse use of accessories as props, are

> disturbed by a single embodied object—a shoe on its side. This tenderly evocative indication of presence enlivens the traditional static displays of dress and museum objects. [...] this single gesture repeated in a number of cases transcends the institutional and introduces an element of the performative that is subtly handled without recourse to the full theatrical repertoire often associated with temporary fashion exhibitions. (Crawley and Barbieri 2013: 48)

The discarded shoe suggests the gestures of dressing and undressing, whether by the imagined wearer of the outfit on display or by trained hands in the exhibition mounting process, and also the impermanence of fashion itself.

Pageants: Parading the past

Alongside *tableaux vivants*, another popular form of costumed entertainment in the nineteenth and early twentieth centuries was the pageant. Often held to commemorate the anniversary of a historical event, these parades featured participants dressed in historical, reproduction, or allegorical costumes. Their purpose, according to an early twentieth-century commentator, was "as a medium for community amusement and instruction" (Wright 1919: 163), and the costumed element was integral to creating a sense of immediacy and belonging to a given historical event. Naturally, this medium also lent itself to popular history education through dress, and many museums dabbled in pageants to promote and fund-raise. For example, the Costume Museum of Canada grew out of an organization that collected antique dresses for the purposes of educational historical pageants: it was started in 1953 by Women's Institute members who held heritage fashion shows as a fund-raiser, but when a museum was built in 1983, the original clothing was kept for display purposes, and replicas were used in the fashion revues (Malaher 1989). Fascinatingly, the 30th anniversary exhibition (1983–1984) recreated the original fashion show by putting the nucleus of the collection on display, albeit on mannequins instead of living women. In New Zealand, Canterbury costume curator Rosa Reynolds, who had a background in the performing arts, began by organizing reenactments and costumed parades for centennial events (Labrum 2009: 320–323). Likewise, collectors often staged fashion shows of historical dress to garner public interest and support for the founding of permanent museums. Doris Langley Moore was famous for these: one star-studded revue in 1950, attended by

Queen Elizabeth II and her sister, Princess Margaret, featured the ballerina Alicia Markova and actress Lynn Redgrave among the models wearing gowns from Moore's collection in order to raise funds for a permanent museum ("Queen sees" 1951: 6). Currently, the Society for the Museum of Original Costume (SMOC) fund-raises for a permanent home in Vancouver with fashion shows featuring live models in antique and vintage clothing belonging to collector and curator Ivan Sayers.[5]

Even today, the term "pageant" connotes a formalized public parade. Museum galleries of fashion, therefore, also evoked these spectacles in their displays. The Philadelphia Museum of Art, for example, opened a display called "The Pageant of Fashion" in 1947, in anticipation of the building of an entire wing of the museum devoted to textiles and costume. Within, fully accessorized lifelike mannequins were placed into furnished niches, enacting the rituals of daily life of their period.

Alongside such generalized scenes of the past, specific scenes might also be reenacted. A lesser-known institution, the Valentine Museum in Richmond, Virginia, was headed by a theater professional, Leslie Cheek, Jr., in the 1950s. The museum had a very large collection of clothing and textiles but wished to enliven the usual means of display: "Feeling that the finery of another day is impersonal and even somewhat depressing when taken from a trunk and placed on a dummy, the Virginia Museum decided to design a new kind of costume exhibition and put a spark of life into it" ("Styles Reflect Changing Times" 1952: 2A). For an exhibition tracing changes in women's dress over two hundred years, titled *Habiliments for Heroines* (1952), Cheek designed a display that had mannequins as literary heroines, modeling the outfits of each era (borrowed from the collections of the Met and Brooklyn Museum). Each mannequin enacted the key scenes for her character, within a vignette filled with period props. This specificity is reminiscent of the tableaux of wax museums like Madame Tussauds, where well-known personages enacted iconic moments in their lives, while wearing period costume and surrounded by authentic props. The show was "*en effet,* a series of small stage sets" ("Muscarelle Museum" 1985: 7), and fascinatingly, a part of the show was later itself restaged, in a memorial exhibit dedicated to Cheek's life in 1985. Cheek's successor, Carl Mitchell, came from a career in the Yale School of Drama and the Virginia Museum Theater, continuing the museum's visual style of theatrical flair.

Even without named personages to provide touchstones to history, costume parades could demonstrate the many dramatic changes in clothing over time. At the Brooklyn Museum, the 1970s permanent costume gallery took the form of a theater, where a series of forty-five mannequins, primarily female, "paraded" on a conveyor belt past a background of slides and accompanied by music to provide more context (Roberts 1976: 6; Coleman

1978: 135). Visitors remained seated in the Costume Theater for this twenty-minute presentation, and although here they did not walk through history, history "walked" before them. Likewise, in the inaugural exhibition of the Paris Museum of Fashion Arts, theater and film designer Rostilav Douboujinsky animated a theater of men's fashion, with a "constantly revolving group of 10 figures that appear one at a time" (Chubb 1986: 15). Linear or circular, the fashion parade represented the passage of time before viewers in the present (see also Chapter 7).

Alternatively, as Crawley and Barbieri (2013) point out, the conventionally linear temporal and spatial frameworks of the exhibition can be restaged to disrupt straightforward chronology; they use the example of the Met's 2012 *Impossible Conversations* exhibition, which pitted Elsa Schiaparelli's couture of the 1930s and 1940s against Miuccia Prada's contemporary work—designers who were not influenced by each other's creative inheritances but nevertheless demonstrate shared interests. Such temporal flexibility, they claim, could only be made possible through a theatrical scenography (2013: 58), which included videos of the two Italian female designers (played by actresses), discussing (in paraphrased quotations) themes in their work, as displayed on mannequins posed around the screens. In this way, periods quite separate in time were made to meet in a performance.

This is also what was earlier attempted in the 1998 Costume Institute display *The Ceaseless Century*: to demonstrate the continuing references to eighteenth-century clothing in the fashions of decades since, the narrative conceit of a masked ball was used. Without looking at the labels, visitors were "cordially invited to a wondrous guessing-game of identity," where it was not clear which were authentic historical costumes and which were later pastiches. The curator noted that this was not "a clever deceit but an immeasurable and timeless joy in clothing proud of contrivance and beauty" (Martin 1998). The spectacular nature of rococo entertainments was extended to the theatrical interpretation of the costumes on display, which play-acted aspects of a distinctive past epoch.

Peter McNeil once mused, "As all costume exhibits are fabrications anyway, and clothes require animation of some type to make sense, perhaps theatricality is necessary in the museum gallery" (2009: 158). Exhibition design is therefore a form of showmanship: "a kind of theater in which the overall effect enhances one's appreciation of the individual items of clothing" (Rosenthal 2004: 38). Indeed, museums have been posited as performative sites by their very nature: "the museum serves as the stage for which the script of history is written and upon which it is performed for the viewer" (Garoian 2001: 237). The ways in which all museums construct space is choreographed in very culturally specific ways, and within the fashion exhibition, that choreography mimics that of the fashion system.

Performativity: Setting the stage

Performativity is an innate aspect of fashion practice in the every day: we literally fashion ourselves every day by choosing outfits to suit or alter our social roles, and wearing dress is in itself a form of display. Social scientists investigate "the meaning of fashion in dress in order to understand behaviour related to dressing the body" (Johnson, Torntore, and Eicher 2003a: 2). As Anne Jerslev notes, fashion can be a "medium for changing historical embodiments" (2005: 57); in museums, this is frequently reduced further into stereotyped representations of social behaviors across eras where the performativity of fashion is imitated by mannequins. Yet, as Loscialpo has argued (2016), performance is also inherent in the technology of museum display. The designed nature of the space, she argues, emphasizes its otherness from the every day, and various scenographic techniques can further highlight an object's function as an "actor," as well as to enable visitors to participate in the exhibitionary space and narrative in particular ways. In her analysis, the exhibition design itself plays not just a supporting role to an intellectual or material subject matter but instead embodies it within itself. Lou Taylor has likened these types of exhibitions to installation art (2002: 27), and indeed, this is a useful metaphor. Similarly, these exhibitions tend to be site-specific, large scale, and transform the visitor's notion of the space around them. Thus, rather than obviously relying on conventional museum viewing technologies, spaces are staged to enable very different types of encounter for visitors, ones that often transform the visitor into a part of the fashion landscape created within the galleries.

Instead of a dignified promenade past an array of logically arranged vignettes that can be passively viewed, the visitor is instead thrust into a space that has been engineered to elicit feelings of immersion. Independent curator Judith Clark excels in this type of mise-en-scéne, which plays with interior designs that embody (instead of explicitly stating in writing) the conceptual underpinnings of the exhibition; examples include moving cogwheel plinths forcing comparisons and contrasts between historical silhouettes in *Malign Muses/Spectres: When Fashion Turns Back* (MoMu/V&A 2004–2005) and the ironic use of museum labels and tags in the backroom storage treasure hunt of *The Concise Dictionary of Dress* (Blythe House 2010). The latter, which was staged in the V&A's off-site textile storage spaces, challenged visitors to draw meaning out of juxtapositions between labels defining words used when discussing fashion ("comfortable," "pretentious," "plain," etc.) and staged objects such as historical silhouettes made of Tyvek or a pornographic Pepper's Ghost projection on a formal Victorian gown in a wooden crate, all while traversing the museum backstage space. Clark forces viewers to question their expectations of a museum exhibition, upending their preconceptions of what fashion is, how they engage with a museum space, and what they take away from curatorial interpretation. Yet

it is important to note that she, as well as others who have created similar installations that perform the display's premise, are usually external actors to the museums in which the exhibitions are staged. While such extravagant staging can be incredibly insightful and can illuminate aspects of fashion history, design, production, and consumption, it is usually beyond the means of museum staff to produce themselves. Independent curators working with private collections such as Clark, freelance exhibition designers such as Patrick Kinmoth, artists who create installations on fashion themes (such as those recently highlighted by Hazel Clark and Ilari Laamanen in *Fashion after Fashion* at the Museum of Arts and Design, New York), or the displays commissioned by fashion design houses themselves are not bound by the intellectual heritage, limited resource allocation, or ethical restrictions faced by museum curators seeking to create innovation in-house. Indeed, it is unfair, as Loscialpo does, to evaluate equally the elaborately designed spectacles of these traveling exhibitions, or specially commissioned installations, to the limited interventions possible in museum costume and textile galleries.[6] Yet, as both types of exhibitions (in-house and externally curated) are viewed by similar publics without much awareness of their respective differences, within similar or related institutional spaces (museums, galleries, exhibition halls), it stands to reason that they do echo and influence each other.

Staging the museum

Perhaps as a way to distinguish themselves from other exhibitionary spaces, and as the influence of postmodernist thought has affected gallery design, museums have begun to draw attention to the conceits of the museum space itself. The Fashion Museum in Bath, for example, has a section of its galleries that reconstructs a type of visible storage (Figure 5.4). Against a backdrop of archival-quality textile storage boxes, a changing display of tailor's dummy-style Stockman mannequins dressed in clothing that still has museum labels and tags evokes the "behind-the-scenes" space for which the display is named. This case is theatrical—it merely looks like the museums' storage and study spaces, which are located elsewhere. This is a fictional space but one that underlines the constructed nature of any type of museum presentation (Wood 2016: 185–189). If it were not for this vignette, the hidden workings of the museum would stay hidden, but this staging allows a playful peek backstage. Relatedly, Marco Pecorari (2012a: 119) has described the opening exhibition at MoMu Antwerp, *Backstage: Selection I* (2002), as a staging of an archive: the garments were displayed in archival boxes, and the structure of the museum's architecture itself informed the exhibition premise, instead of an externally imposed rational narrative. This scenography highlighted the reveal of the previously unseen artifacts to public view, as though visitors had been allowed into storerooms.

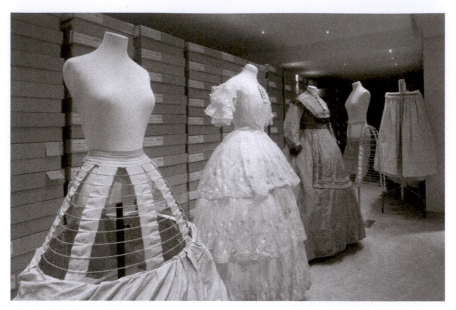

Figure 5.4 Mannequins and storage boxes on display at Fashion Museum Bath, UK. Courtesy Fashion Museum, Bath and North East Somerset Council, UK/Bridgeman Images.

American museums have evoked back-of-house operations in similar ways. For example, both the Los Angeles County Museum of Art and the Met have used backdrops resembling museum crates to dramatize the "arrival" of new collections (*Fashioning Fashion: European Dress in Detail 1700–1915*, LACMA, 2010–2011; Figure 5.5) and the excitement of new treasures emerging from their packing cases (*Masterworks: Unpacking Fashion*, Costume Institute, 2016–2017). Neither of these presentations feature actual packing materials, as they would not be archivally sound. However, the use of these materials as props stages museum labor as a performance, in ways similar to the visible conservation labs that have been installed in many museums since 1996 (Hill Stoner 2012: 751).

Even preparation for display has also become an opportunity to perform museum labor for the public—videos and time-lapse photography of installing artifacts, such as a 1780s dress (*The White Dress: Masterpiece in Focus*, National Gallery of Canada, 2016), a silk coat from 1800 (*Reigning Men: Fashion in Menswear, 1715–2015*, LACMA, 2016), or an entire exhibition (*Savage Beauty*, V&A, 2015), expand visitor understanding of the artifice of display (Plate 5). Another example is the *Dressing Room: Archiving Fashion* project staged by the Museum of the City of New York in 2016: as photography of their fashion collection took place in a temporary exhibition gallery, visitors were able to look on as mannequins were dressed and undressed. The exhibition was a performance, albeit with a practical

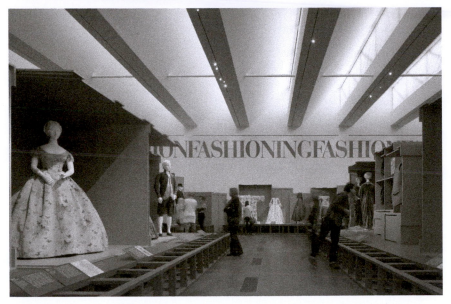

Figure 5.5 A view of *Fashioning Fashion* at the Los Angeles County Museum of Art, 2010. Photo by View Pictures/UIG via Getty Images.

purpose: a behind-the-scenes look at the work of collections management protocols on rarely displayed artifacts. While images of the complete ensembles entered the online collection database, time-lapse videos of the process were posted on the museum's social media pages, allowing even remote visitors to view them. In this instance, museum labor was the purpose of the public display, rather than a historical narrative, as is usual in galleries.

Unexpected staging can also highlight museum conventions, albeit through their disruption. The work of Claire Wilcox at the V&A is an excellent example: her innovative displays of fashion, often pushing beyond the use of the static mannequin, reflects her "commitment to re-present the performative aspects of runway fashion in novel ways, viewing the museum not only as a site of custodial responsibilities, of curation and conservation, but as a performative space, and presenting dress in a museum as spectacular, ephemeral, and experimental" (Wilcox 2016: 187). For example, the living, moving bodies of models wearing up-to-date designer clothing in the V&A's "Fashion in Motion" runway show series, created by Wilcox, draw attention to the ways in which fashion is normally presented in the same museum: the stock-still Stockman form wearing past fashions, behind glass. Elsewhere, the immersive environment of the Museum of London's "Pleasure Garden" gallery[7] (see Figure 3.10), with its mix of both moving images and still mannequins, modern and historical clothing and accessories, authentic and reproduction items, allowed visitors to experience eighteenth-

century fashionability in a very different way than traditional static displays with didactic text (see Behlen and Supianek-Chassay 2016). Transgressing the conventions of museum display in this deliberate manner brings into high relief the constructed nature of the status quo for displays of historical dress. These sporadic events and innovative environments help to define the museal status quo by their difference: unlike the runway shows or theatrical interventions, museum fashion is often old (not up-to-date designs), static (not worn by live models), and isolated from its social context (accompanied by audio and video).

Another recent example of such radical fashion museum disruption was the collaboration between the Palais Galliera City of Paris Museum of Fashion curator Olivier Saillard and the actress Tilda Swinton. As part of the 2012 Festival d'Automne at the Palais de Tokyo, *The Impossible Wardrobe* featured Swinton, dressed in a white smock and gloves, carrying out fifty-six items from the museum's collection one by one on a runway, displaying them to the audience, and posing with them in a mirror. For Saillard, this was a performative exhibition, a way to allude to the vanished bodies that once animated these garments: the ephemeral nature of the performance alluding also to the fleeting nature of fashion and the evanescence of human life itself (Saillard 2015: 6–7). The apparatus of the museum—lab coats, gloves, muslin covers and tapes, padded hangers, acid-free tissue paper, stiff support trays, even the gestures of the curator or conservator—were performed in a different context in order to call attention to their artificiality. For this is the reality for most clothing that ends up in museum storage: rather than being worn on a real body in living contexts, or even spotlit on a mannequin, most clothing is shrouded, its movement (if any) careful and guided. Swinton and Saillard performed the museum itself.

Enacting fashion in the museum

Museum spaces can also be choreographed to put visitors into the contexts of fashion—shops, studios, runways, wardrobes—where they can imaginatively enact the behaviors of couture clients, fashion journalists, or designers. One of the most notorious examples of this staging was the 2000 Armani exhibition at the Guggenheim Museum in New York. The famous Frank Lloyd Wright spiral ramp was covered with a red carpet, and guests paraded alongside mannequins wearing garments worn by the designer's celebrity clients. In this and subsequent restagings, "audience members become performers, rather than passive onlookers, allowing them to experience the performative and bodily nature of the runway" (Potvin 2012: 60). Likewise, *Valentino: Master of Couture* at Somerset House in 2012 placed visitors on a runway, surrounded by effigies of stars and socialites who regularly wear the designer's elegant pieces and attend such events as fashion weeks.

Immersion into normally restricted spaces of fashion also occurs when museum galleries are styled to recreate designer methods. The studio of legendary couturier Yves Saint Laurent was recreated at the Denver Art Museum for the retrospective *Forty Years of Fashion* in 2012 and again at the Bowes Museum for *Style Is Eternal* in 2015. Likewise, the Design Museum's *Hello, My Name Is Paul Smith* (2013) recreated the interiors of menswear designer's offices and boutiques. When the faithful recreation of a studio interior is impossible, it is often evoked with the display of a designer's working methods and materials. The National Museum of Scotland received the archive of designer Jean Muir, which enabled them to devote space to a section on her working processes, including sketches and toiles, in a 2008 special exhibition and more recently in a spotlight section of their permanent galleries (reopened 2016). Similarly, *toiles*, sketches, and pattern pieces were featured in the Met's recent Charles James retrospective (2014) and formed an important design centerpiece for the 2011 Dior exhibition at the Pushkin Museum in Moscow, sponsored by the brand itself, who were keen to highlight the workmanship behind the aesthetic impact of couture clothing. The workspaces of the craftspeople who actually construct couture have also been staged, as in the "Atelier" section furnished to evoke the *boiserie* interiors of Parisian *haute couture* houses in the ROM's *Elite Elegance* (2002) (Figure 5.6) or in the section called "Embroidery" in the V&A exhibition *The Golden Age of Couture* (2007).

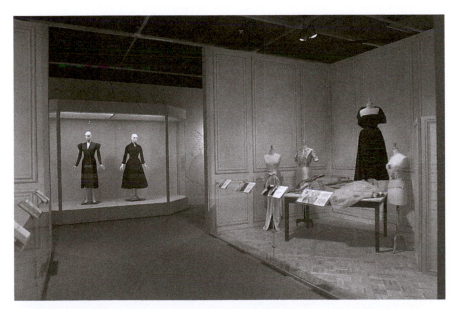

Figure 5.6 Installation view of *Elite Elegance: Couture Fashion in the 1950s*, "Atelier" section, November 23, 2002–May 4, 2003, with permission of the Royal Ontario Museum © ROM.

This behind-the-scenes access has also been constructed to represent the spaces within which fashion is consumed. The section called "Lady Alexandra: A Couture Client" in the V&A's *The Golden Age of Couture* (2007) evoked the architecture of an aristocratic dressing room. At the Met, an actual dressing room, used by the Gilded Age socialite Arabella Worsham and taken from her Manhattan townhouse in 1938, was staged in 2017 with the types of garments this elite nineteenth-century woman would have housed within (Figure 5.7). An elaborate French ball gown (which did not actually belong to Worsham herself) hung on a hook, while drawers and doors were opened to allow glimpses of undergarments and accessories. This was a historical counterpart to a display in an adjacent gallery: *Sara Berman's Closet*, a minimalist and monochromatic recreation of a walk-in wardrobe, celebrating the meticulous life of the mother and grandmother of the two artists (Maira and Alex Kalman) who reassembled it as an art installation. At the Musée des Arts Decoratifs, rolling racks with artifacts on hangers were used to evoke the wardrobes of tasteful consumers who donated them to the museum in 1999 in *Garde-robes: Intimités Devoilées* (Figure 5.8), as well as later in an exhibition curated by the couturier Christian Lacroix (*Histoires de Mode*, 2007–2008), where they represented the designer's fantasy wardrobe from which he took inspiration. Unusually, the Textilmuseet, in Borås, Sweden, has a whole wardrobe of twentieth- century pieces for visitors to try on. This handling collection of approximately 3,000 items enables visitors to touch materials that they would not otherwise be able to in a gallery, and some of the robust items of clothing and accessories are rotated as part of the "Try-On Wardrobe" activity section in the building available to all visitors. These displays are not just allusions to the production and consumption spaces of fashion (see Chapter 3) but also a way in which audiences can themselves pretend that they are performing fashion alongside or even instead of the original creators or wearers. In the most interactive of these, audiences can experience the embodied aspects of fashion within the normally hands-off museum gallery.

These stagings show the many different ways in which exhibition makers have attempted to animate fashion beyond the clothing itself. It is clear that the theatrical effects used in fashion exhibitions are most often a means by which to evoke the contexts for fashion within a gallery setting. Whether attempting to recreate a feeling of witnessing authentic historical events or merely bringing a sense of immediacy to past fashions, the influence of theater on fashion exhibitions has been evident since their earliest inception and is now even more powerful with the advent of digital technology and the increasing acceptance of temporary and experimental installations. However, despite efforts to pose fashion on animated mannequins and in elaborate settings, the primary context for clothing is the most challenging to recreate: the bodies that filled the garments in museum collections are long gone. The following chapter will therefore examine how the bodies of wearers have been imagined and made material for museum visitors to fashion exhibitions.

Figure 5.7 Installation view of the Worsham-Rockefeller dressing room at the Metropolitan Museum of Art. Photograph by Billie Grace Ward, July 10, 2017.

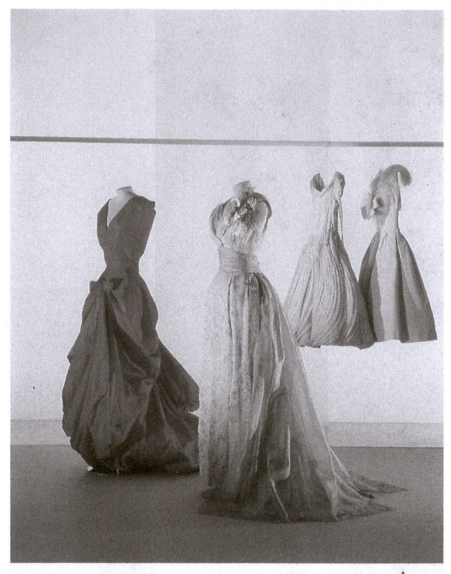

Figure 5.8 Postcard promoting the Musée de la Mode et du Textile exhibition, *Garde-Robes*, 1999–2000. Author's collection.

6

THE BODY IN THE GALLERY: REVIVIFYING HISTORICAL FASHION

The presentation of fashion in the museum differs from the ways in which it can be encountered in day-to-day life: the agency, subjectivity, and materiality of the lived body can only be represented by visual means, depriving fashion of its vitality. Museum visitors have been confronted with different conceptions of the body through exhibitions that demonstrate changing silhouettes, use ghostly mannequins, silhouettes, or hollow core supports to demonstrate how dress is a second skin, or encourage reflexive embodiment (Crossley 2006: 140) in other ways. Whether invisible, abstracted, flattened, or fully articulated and accessorized, the substitute bodies of mannequins in galleries frame the fashion on display in different ways. This chapter examines bodily boundaries and how museum exhibitions have tackled the problems of signaling absent human wearers.

The display of dress has been seen as dissatisfyingly disembodied. Fashion historian Valerie Cumming explains,

> Garments should be seen in movement on a human body, not frozen on a display figure. This is one of the many difficulties when curating collections of costume and also why some modern writers find costume collections physically and intellectually lifeless. (2004: 83)

Aileen Ribeiro also represents such a view when she writes, "It is, perhaps, a paradox that dress achieves immortality through the portrait, that the canvas gives it a vitality that cannot be achieved in the half-light of a museum existence" (Ribeiro 1995: 6). While the previous chapter demonstrated how theatrical techniques sometimes sought to bring these charismatic images to life in *tableaux vivants*, it is still challenging to communicate the experience of dress in an exhibition. Indeed, Denise Witzig has categorized fashion exhibitions as "a *tableau morte*, a tribute to human culture that is aesthetic, but without the living, breathing interpretations and insurrections of the corporeal beings the culture

represents" (2012: 91). This chapter considers how illusions of vitality have been created in exhibitions by emphasizing the embodied qualities of dress. It is different from the preceding two chapters in that it does not arise out of a vintage source explicitly linking fashion in museums to a particular theme; the study of the body is a more modern concern. However, even the earliest exhibitions of historical fashion and corresponding curatorial writing reflect an underlying preoccupation with the body, the illusion of life and consequently, evidence of the passage of time (see also Chapter 7). This chapter reviews the challenges museums have faced when representing the dressed and fashioned body, followed by a discussion of the dilemmas museums have faced in making their mannequins lifelike. However, as museum display figures are only representations of bodies once lived, the final sections also signpost the discussions of decay and obsolescence in the following chapter.

An awkward fit

In 1932, the Met faced the challenge of mounting the first display of historical fashion based on its own collections. Joseph Breck, curator of the Department of Decorative Arts, candidly described the technical preparations for this exhibition with details bordering on the grotesque:

> If the reader will recall the tiny waists and swelling bosoms of the fashionable figure in the period covered by the exhibition, it will be evident that the modern dress forms supplied by the trade are not an ideal solution of the problem. It would often be necessary to make adaptations—to carve out a waist here or build up shoulders there; and, when such modifications were not enough, to devise entirely new figures. [...] For example, this one in papier-mâché with the large shoulders had a waist inches too big for any dress in the collection. Her diaphragm had to be sawed out and a new waist created in the void. That curious bust with the sloping shoulders and the prominent bosom has been specially modelled to take the high-waisted Empire dresses; it will serve also for the tightly corseted early Victorian figures. Cast in plaster, the bust is mounted on a standard or adjustable height, with a waist segment which slides up and down according to the dictates of fashion. Attached to the waist are flexible iron bands that may be bent as desired to indicate the contours of the figure. And here are our "gentlemen." Originally, these forms were designed for the display of ladies' bathing suits; hence, provided with legs. But, unfortunately, the pose was peculiarly feminine. To give the figures a more masculine appearance one leg had to be sawed off at the hip and readjusted. This metamorphosis

accomplished, the feet were amputated, and buckled shoes, cast in plaster, substituted. (Breck 1932: 124–125)

In performing these radical changes to mannequin bodies—even performing gender reassignments for some—Breck and his team of technicians were encountering the differences between living and modeled bodies, as well as between contemporary and historical ones. The Met still operates on its mannequins in preparation for exhibiting costume (Scaturro and Fung 2016). Whereas clothing is created to fit a living, flexible body, in the museum gallery, a mannequin must be made to fit the dress; while fashion dresses the body, the museum must insert a body back into historical fashion. In mounting historical fashion, curators, conservators, technicians, and designers encounter all the varieties of fashionable silhouettes across time as well as the individual peculiarities of the bodies that originally inhabited these historic pieces.

Exhibition teams face a difficult struggle to ensure a good fit between the needs of the artifact and the display technology available to them. As fashion journalist Prudence Glynn colorfully put it,

In any *mouseion*, fashion has an obvious place. How it should be displayed is less obvious; indeed it has to my mind defeated most of those who try it. [...] In the wider context there usually seems to me to be something uneasy about a display of clothes, whether on headless stands or on whole figures petrified into attitudes of chic whoopeedoo of Adele Rootstein. How flummoxed the Martians will be when they finally exhume us from our lava of non bio-degradable plastic garbage and find a race stuffed with sawdust whose necks are finished with little wooden knobs, or a nation of six-foot acrobats without benefit of skeleton. (Glynn 1974: 6)

Additionally, museum teams, perpetually short of resources, may be forced to compromise the historical representativeness of what goes on show as a result of the display furniture available to them: Doris Langley Moore described how reusing discarded shop mannequins with modern ideal proportions compelled her museum "to show a disproportionate number of large dresses, which are naturally not the ones most often preserved," and to eschew male figures altogether (quoted in Clark, de la Haye, and Horsley 2014: 46–47). Along with proportions, ideal facial features, and even, as Caroline Evans (2013) has noted, ideal postures, have changed over centuries and decades. It is often jarring, for example, to see mannequins posed in modern stances but wearing antique clothing. Thus, the final product—the dressed mannequin in the gallery—often creates an uncomfortable cognitive dissonance arising from the contrast between the bodily norms of today and times past, as well as the viewer's experience of the lived body versus the simulacra on display.

Phenomenology and the body

The objects on display in the galleries of any museum are divorced from their original context. They are no longer in use or in situ, and indeed, their purpose and location within the museum frequently minimizes their materiality (Petrov 2011; Wehner 2011). For example, it is intuitively obvious that the ways in which people relate to clothing in the mundane circumstances of everyday life are not the ways in which they do so in museums, and this has to do with the way in which museums present objects: Amy de la Haye argues that

> to represent worn, historical clothing on a modern model is to deny the biography of the consumer who originally chose the garment, and, in the case of haute couture, who commissioned it to fit her body perfectly, and who wore it. Perhaps more than any other medium, worn clothing offers tangible evidence of lives lived, partly because its very materiality is altered by, and bears imprints of, its original owner. [...] When worn clothes enter a museum they embark on a new "life" and serve new functions. In the process, what was once intimate can become impersonal. (de la Haye 2006: 135–136)

Indeed, one common objection to the display of fashion in museums is how disembodied and lifeless it is. Although some museums, such as Bath, the Met, the ROM, and the V&A (Figure 6.1), did allow their collections to be worn by live models into the 1960s (select examples are discussed in Mida 2015a), the practice had adverse effects on the condition of the garments. While as late as 1972, some museum writers still encouraged dressing up in historical costumes to "create a social occasion which will draw attention to your society, amuse the membership, intrigue the public, and please the press" (Briggs 1972: 1), the practice increasingly came to be frowned upon, though even critics agreed that "the incompleteness of costume without the human body will probably always lead to a desire to display it on a human shaped form" (Sykas 1987: 157). The International Council of Museums published guidelines for costume collections, which explicitly forbade the wearing of historical costume for display (ICOM 1990: 127). Fashion journalist Prudence Glynn, on the other hand, represented the strong feelings of individuals who thought that the aesthetic impact of historical fashion was significantly lessened if it could not be worn by a live model:

> You understand, I deplore the death of any magnificently designed object. [...] What I hate is stuffed fashion. [...] So now, at the cost of being banned from visiting major fashion collections all over the world, I pronounce that in my view clothes in museums, with certain obvious provisions, should be

allowed to be shown on live models. [...] When you see them on the dummies, mute, pasty-faced, inviolate, you do maybe wonder at the construction, the workmanship, the beading, the social interest. When you see them live, wow! (Glynn 1980: 7)

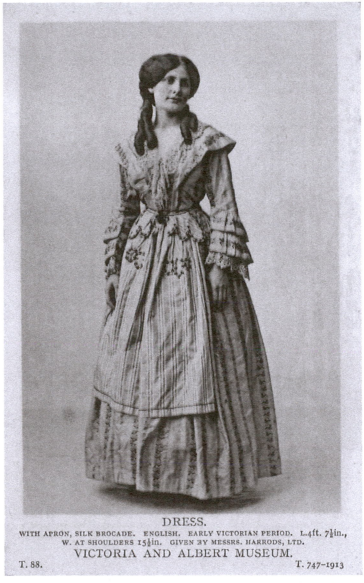

DRESS.
WITH APRON, SILK BROCADE. ENGLISH. EARLY VICTORIAN PERIOD. L.4ft. 7½in.,
W. AT SHOULDERS 15½in. GIVEN BY MESSRS. HARRODS, LTD.
VICTORIA AND ALBERT MUSEUM.
T. 88. T. 747–1913

Figure 6.1 Undated postcard showing a model wearing a dress from the Talbot Hughes collection, given to the V&A by Harrods in 1913. The text gives the gown's measurements for scale. Author's collection.

However, the risks of such practices to museum material ultimately outweighed the benefits; even Doris Langley Moore, who had allowed models to pose in her collection of clothing for film and still photographs throughout the 1950s and 1960s, had eventually come to recognize the damage this wrought on fragile fabrics (Glynn 1980: 7). Compromise was necessary: "On the lay-figure in the museum, silk, velvet, cotton, lace retain something of the potentiality of life" ("History in Clothes" 1962: 9). Some museums returned to the older wax mannequin form to imbue their displays with lifelike energy as they acted out the routines of daily life with period-appropriate bodies: "How else than by means of wooden or wax mannequins could an observer of one hundred years hence know for certain the once fashionable figure or hairdressing?," asked a New Zealand newspaper rhetorically ("A Dress Museum" 1925: 16). For the 1983 LACMA exhibition *An Elegant Art*, tableaux with custom-built realistic mannequins supported the garments on display:

> Great attention was given to the production of mannequins which were especially designed and constructed to create the appropriate eighteenth-century posture. Even the mannequins' features and expressions were designed to reveal the subtle differences in posture and posing required by the vignette locales and time periods. (Craig 1983: 98)

Although the mannequins could not move, they were frozen in attitudes that would mirror the embodied behaviors of the wearers they represented.

Where possible, mechanical means are sometimes used to animate the display of dress: the use of motorized turntables for mannequins (*Fashion: An Anthology*, V&A, 1971; *Ballgowns*, V&A, 2012), video screens or projections for mannequin "faces" (*The Fashion World of Jean Paul Gaultier*, Montreal Museum of Fine Arts, 2011), holograms (*Savage Beauty*, Metropolitan Museum of Art and V&A, 2011 and 2015), and wind machines (Figure 6.2) have all been utilized. In addition, ambient sounds and the wafting of perfume through galleries are also devices that have been used individually or in concert in exhibitions from the 1970s (particularly by Diana Vreeland at the Costume Institute) to the present day. With the advent of digital technology, photographs of period clothing on mannequins can be combined with images of models to create convincing collages, as was done by photographer Edwin Olaf for the publicity for *Catwalk: Fashion in the Rijksmuseum* exhibition in 2016 and by Virginia Dowzer and Bronwyn Kidd at the National Gallery of Victoria for the *200 Years of Australian Fashion* exhibition in 2016.[1] In the gallery, life had to be turned into merely lifelike.

The mimesis of embodiment is a key convention used in museums and, in particular, in displays of historical fashion. In 1972, an American Association for State and Local History leaflet suggested that "one can use costumed figures to tell a story […] or to enliven and humanize a historic house" (Briggs 1972: 1) and

Figure 6.2 A mannequin animated by a wind machine from the Costume Institute exhibition at the Metropolitan Museum of Art, during *Alexander McQueen: Savage Beauty* press preview, May 2, 2011, in New York (Paola Messana/AFP/Getty Images).

a year later, another leaflet stated that "even when articles of furniture and other period items are displayed in the last exceptional detail, life-size figures give realism to the room when arranged in attitudes of arrested motion" (Halvarson 1973: 1). For examples of this in practice, one can look to the installation photographs of the 1944 Brooklyn Museum *America 1744–1944* exhibition, which combined American decorative arts from across the museum's departments, or the 1963

Metropolitan Museum of Art exhibition, *Costumes: Period Rooms Re-Occupied in Style*. This is a very popular display style, frequently encountered in history museums around the world, and is also a common way of "populating" period interiors, as discussed in the previous chapter. The Regency Exhibition held at the Royal Pavilion in Brighton in 1958 used mannequins dressed in historical fashion gathered from Doris Langley Moore's collection (later part of the Fashion Museum, Bath) to showcase the newly renovated rooms of the former royal residence. Moore's conceit was revisited in 2011 for the exhibition *Dress for Excess: Fashion in Regency England* at the same venue. While it is debatable whether they truly added drama to the scene, the mannequins did give a sense of proportion to the grand interiors in which they were posed, suggesting a similar scale for the human onlookers and visitors to the exhibition.

The film studies concept of haptic visuality, or embodied spectatorship (Kuhn and Westwell 2012: 201), may explain the processes by which audiences are able to understand the sensual nature of clothing on display, even though they are using only their vision. Nevertheless, it is sometimes insufficient, and many museums of fashion have attempted to overcome this by having special stations within their galleries where visitors can try on replica garments, such as corsets or hoopskirts: the V&A installed such a section in 2001 (Durbin 2002) and was followed the next year by the ModeMuseum in Antwerp, which reproduced six items from their collection for visitors to touch and try them on (Forman 2002: T3). The Museo del Traje in Spain installed a special sensorial section in 2014, where visitors could touch replica muslin garments from a chronology of fashion (displayed on hollow-core mannequins) and compare their bodies to the row of sculpted torsos in ideally fashionable silhouettes across time.

The body: Inside and out

Waskul and Vannini, perhaps following Judith Butler's theories of performativity, suggest the existence of what they call a "dramaturgical body," which is "embedded in social practices [...] people do not merely 'have' a body—people actively do a body. The body is fashioned, crafted, negotiated, manipulated and largely in ritualized social and cultural conventions" (2006: 6). This explains the desire of social history curators to "keep foremost the need to present history to your visitors as the experience of living people" (Briggs 1972: 1). The Fashion Museum in Bath (formerly the Museum of Costume) was lauded for being able to do just this: "The clothes are mounted on naturalistic figures to give as much impression of life as possible and many are placed in period room settings or against backdrop views of Bath to give a feeling of period atmosphere" (Byrde 1985: 14). There, mannequins and backdrops were used to create an impression of the contexts within which the clothes were experienced.

For example, representations of shopping within the museum environment were influenced by the preoccupations of contemporary curators and projected onto the past but may have also influenced visitors by showing socially normative shopping behavior; the eighteenth-century female shopper in *Period Rooms Re-Occupied in Style* or the Regency hat buyers in *Vignettes of Fashion* (Figure 6.3) were at once a subject for the female viewer's gaze in 1963 and a stand-in for her, whereby the viewer knew that she was also always the viewed. Another example of reflexive embodiment on display comes from the 1964 *Vignettes of Fashion* exhibition at the Costume Institute. The exhibition sought to reconnect fashions with the social rituals for which they were originally worn: "The exhibition consists of 12 vignettes in which the mannequins are 'dressed for the occasion.' Furnishings and paintings from the museum's collections provide the clothes with authentic settings that illustrate the relationship between dress, interiors, and social manners" ("History of Styles" 1964: 30). In one vignette, "Guests for Tea" (Figure 6.4), mannequins in Edwardian tea gowns at a table set with a china tea service almost identically replicated the 1909 William MacGregor Paxton painting *Tea Leaves*, on display above them, demonstrating the performativity of social behaviors. The *New York Times* reviewer noted that "viewing the vignettes, one cannot help but compare them to contemporary developments" ("History of Styles" 1964: 30), as social norms for social occasions and the etiquette for those that remained had changed. The exhibition served as a visual reminder of this process.

Some exhibitions trace reflexive embodiment through highlighting iconic bodies. In the Costume Institute 2010 exhibition *American Woman: Fashioning a National Identity*, curators Andrew Bolton and Harold Koda focused on the changes in the "physical and fashionable appearance" of the "mass-media representations of American women from the 1890s to the 1940s," whereby the American female body became "a spirited symbol of progress, modernity, and ultimately, Americanness" (Bolton and Koda 2010: n.p.). The curators argued that the fantasy bodies created in these depictions both created and reflected the aspirational reality for historical and contemporary women; the show ended by asserting that the series of archetypal ideals featured within it were styles still embodied by the current American woman.

Even the normative boundaries of the body are essentially arbitrary and changeable. A Brooklyn Museum exhibition from 1957 to 1958, called *The Changing Silhouette of Fashion*, made this very point: in the exhibition, "ten costumes and the forms they are displayed on show the wide variety of figure mutations the American female put herself through from 1810 to 1928" ("Exhibit Depicts" 1957: 57). The article's author felt that the display demonstrated that "our women seem to have grown taller, wider and droopier since the old days" when compared with the early 1800s, when "erect posture was the mark of a lady" or the 1920s when women were "flat and rectangular as a playing card" ("Exhibit Depicts" 1957: 57). An article

Figure 6.3 Postcard, *c.* 1964, showing installation view of *Vignettes of Fashion*, "Shopping" vignette. Author's collection.

describing the acquisition of a large family collection of historical fashion by the Met in 1911 described the same expansion with some hyperbole:

> The costumes present an interesting subject for those interested in the development of the American woman. The average American girl of today could not begin to get into the gowns of the girl of the early part of the nineteenth century or into those of her mother fifty years before. The armholes of the earliest costumes would about fit the wrist of the girl of today. The

Figure 6.4 Postcard, *c.* 1964, showing installation view of *Vignettes of Fashion*, "Afternoon Tea" vignette. Author's collection.

dresses show that the women of that time were short as well as small, and the Museum authorities had infinite trouble in finding manikins [*sic*] over which the gowns could be fitted to show them properly. Figures are not made of that size now, as there are only the exceptional women so small. ("Ancient Costumes" 1911: 11)

It does not seem to have occurred to the author of the piece that the Ludlow women could themselves have been exceptional.

Whether or not bodies have fundamentally changed is a topic of some debate. In her writing on fashion, Doris Langley Moore always vehemently disputed the

popular assumption that people's physiques have radically changed over the centuries (Nunn and Langley Moore 1967: 19). Every edition of the guidebook to the Museum of Costume included statements to this effect, and in 1969, she wrote,

> To answer a question that is perpetually raised, neither the male nor the female models in the Museum are smaller on average than our visitors themselves. The height of our masculine figures is generally somewhere near 6 ft., our shortest at present on view is 5 ft. 8 in. [...] As for women, we have several dummies of 5 ft. 2 in. (a very ordinary height in the present day); but there are many of 5 ft. 8 in. to 5 ft. 10 in. and a few of 6 ft. The idea that our ancestors were undersized is based on fallacies I have tried to explain elsewhere. The diaphragm of the modern girl is certainly larger than the average in past times, doubtless indicating healthier lungs, and the waist is now free from drastic compression: but when I was a private collector I was able to find living models who could be photographed in out tightest dresses. Our visitors are so often convinced our dummies are "smaller than life" that there may be some element of optical illusion. (Langley Moore 1969: 1–2).

Royal Ontario Museum curator Alexandra Palmer, sidestepping the argument of whether the body underneath has changed, nevertheless acknowledged that the appearance of the body's proportions could be and was modified through clothing in her 1989 exhibition *Measure for Measure* (see Palmer 1990), which surveyed "mankind's imagination in creating coverings for the body over the centuries" (quoted in "New Show at ROM" 1989: 7). Thus, the measurements of the physical body are, in a manner of speaking, irrelevant: it is the ideal proportions of the body and its normative relationship with its immediate environment, including clothing, that are important. These dimensions are subject to change and social censure. Museums provide a space for encounter with these varied body norms. A recent review of the Museum at FIT exhibition *The Body: Fashion and Physique (2017–2018)* not only lauded the museum's commitment to showing the variety of silhouettes and proportions deemed fashionable over 300 years but also queried whether museums might indeed have a responsibility to document the full range of ideal and real bodies across time (Neilsen 2017: web). The vagaries of survival bias and available samples pose problems for collecting, and the article also notes the difficulties of sourcing appropriate mannequins. Yet the contrast can be valuable as a challenge to what seem like the rigid expectations of modern culture, as demonstrated by the healing journey from an eating disorder undertaken by graduate student Virginia Knight, after being confronted with the reality of her body dysmorphia while glimpsing her reflection alongside a Victorian evening dress in the 2016 Kelvingrove Museum exhibition *A Century of Style: Costume and Color, 1800–1899* (2018: web).

While the above is an extreme example, a review of the Brooklyn Museum exhibition *Of Corsets* (1980–1982) provides an example of the cognitive dissonance created by being confronted with such different conceptions of the body; *New York Times* journalist Bernadine Morris wrote,

> Tucked away in a [*sic*] obscure corner of the fourth floor of the Brooklyn Museum devoted to decorative art is a compact exhibit of antique objects displayed on wire forms suspended from the ceiling. When viewed as abstract shapes bearing some relationship to the human torso, the exhibit has a certain charm, enhanced by exquisite workmanship: rows of tiny, even stitches made by hand; rims of frothy lace; the most delicate embroideries. But when viewed in terms of use these objects were actually put to, it can be seen as a chamber of self-inflicted horrors as women tortured themselves in subjugation to the whims of fashion. For this is an exhibit of corsets, the earliest dating back to around 1780, the latest around 1950, and it is mute testimony to the distortion of the human body through the ages. (Morris 1980: C18)

Photographs of modern people looking at costumed museum mannequins[2] (even when posed) demonstrate similar ambivalence: onlookers seem fascinated, horrified, and perhaps even mildly amused at the evident difference between themselves and their predecessors (Figure 6.5). A press photo publicizing the exhibition of French costumes of the eighteenth century at the Musée Carnavalet in Paris (this collection would later be housed at the Palais Galliera) features a young girl admiring a vignette of elegantly dressed mannequins. The caption reads, "She might have worn these fancy silks and velvets if she'd been born 200 years earlier. Special mannikins were made to display the costumes because 1750 Frenchmen were considerably smaller than those of today" (Tavoularis 1954). The implication is clear: the child is confused that although the dresses on display are her size, they do not conform to her present ideals of fashionability. Viewing archival photographs such as this adds another ambivalent reaction to both the body of the mannequin on display and the pictured visitor. Vision and convention are deeply implicated in the embodied experience of self-presentation, so that Nick Crossley's assertion that "body techniques are culturally embedded and, as such, often have symbolic and normative significance" (2006: 104) deserves further analysis to unpack how specific "body techniques" gain cultural significance.

The museum can both document and create these body techniques. For example, the Costume Institute's 1988–1989 exhibition, *From Queen to Empress: Victorian Dress 1837–1877,* examined sartorial norms for the first forty years of Queen Victoria's dress. The dresses on show were accompanied by excerpts from contemporary proscriptive literature, such as magazines and etiquette books as the 1879 *Ladies Book of Etiquette.* The introductory label text

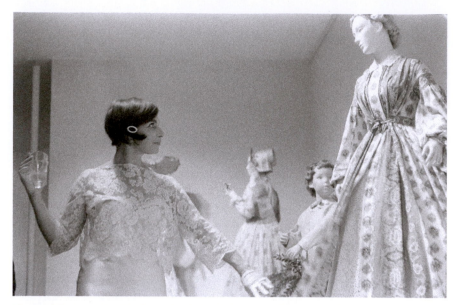

Figure 6.5 An unidentified guest holds a drink as she looks a display at the Metropolitan Museum of Art Fashion Ball, November 1960 (Photo by Walter Sanders/The LIFE Picture Collection/Getty Images).

to the exhibition noted that although the spending power of the English varied widely, fashion

> [...] had some influence on the dress of all but the very poorest. The aspiring middle classes closely copied all aspects of aristocratic behaviour. An increasing number of magazines became available, offering extensive advice on correct etiquette, including the niceties of proper dress for each and every occasion. (Goldthorpe 1988)

The curator's intellectual premise, therefore, was that the increased literacy of the nineteenth-century population in matters of social behavior and fashion affected the spread of the predominant silhouette throughout different classes. (This was also the premise of the ROM's *Corsets to Calling Cards* 1995–1997 exhibition.) The fashions highlighted in the displays, moreover, focused on the difference in body norms that had evolved over time, as the curator admitted. Speaking of the cage crinoline, she noted, "It looks like a rather monstrous contraction to us, but it was a wonderful advance for Victorian women who were freed from their bulky petticoats" (quoted in Gerston 1988). Furthermore, as a review in the *New York Times* noted, it was anticipated that the exhibition would also affect fashion: the outfits of attendees to the opening reception were enthusiastically reported

(the appearance of the innovative evening pantsuit was particularly highlighted: "In a crowd of traditionally dressed women, the most advanced looks were tailored, often with trousers, inspired by Saint Laurent's 'le smoking.'") and the inspired enthusiasm of designer Geoffrey Beene for the sundry styles of sleeves on show was the final note with which the article ended (Morris 1988). Despite the historical distance of the fashions on display, then, fashion's changeable nature lends a fluidity to body boundaries that allows them to shift in response to visual suggestion.

The dressed and undressed body

The body exists within various boundaries, both literal and metaphorical. One such boundary, which arguably affects and mediates any and all interactions with the external world, is clothing. While clothes may mimic, draw attention to, define and outline the body, allowing and enhancing its ability to participate in the world in an embodied way, they can also be seen as another aspect of the environment within which a constructed body circulates. According to Calefato, the clothed body is object and subject: "the garment as a vessel of otherness, a place where the identity of one's body is confused, an indistinct zone between covering and image" (2004: 60). While this is true of the clothed body in lived experience, within the museum, the quote takes on even more meaning. For example, the redesign of the V&A's Costume Court in 1983 was meant to be body conscious. The museum's director, Sir Roy Strong, was adamant that nothing interfered with the interplay between clothing and the body: "Dress is the sculpture of fabric on the human body. It has an aesthetic form. We are not trying to present it as part of an illustrated book or as the social history of Jane Austen's world. [...] This display is anti-camp, anti-dramatic, anti-theatre" (quoted in Menkes 1983: 8). According to the director, "the real innovation of this exhibition [was the] human element. Each of the 200 figures has been exactly proportioned to fit the garment on display, instead of pinning and folding the clothes to the dummies"; head textile conservator Sheila Landi was described "re-moulding the bosoms of a dummy with polyfilla to get the correct 1920s silhouette" (Menkes 1983: 8). In describing her preview of the new exhibition galleries, fashion journalist Suzy Menkes spoke of "the ghostly effect of no make-up and the wigs, all authentic in style but a uniform shade of pallid grey" (Figure 6.6); deathly mannequins notwithstanding, Menkes conceded that "the idea of emphasizing the natural body shapes of the wearer is illuminating when it comes to twentieth century fashion, for you can then see how great design can restructure our proportions" (Menkes 1983: 8). Erasing the facial personality of a mannequin could instead redirect focus onto the changing body norms that fashion reflects or dictates.

Figure 6.6 Undated postcard showing Derek Ryman "Alexandra" mannequin wearing an eighteenth-century dress from the V&A. Author's collection.

More radically, the once-popular practice of using silhouette heads or bodies for the display of historical fashion erases the specificity of the body inside (even its dimensionality is minimized), thus muting the importance of the body within and refocusing attention on the covering. The support for the item is not completely invisible, though, and becomes an image of a body rather than a body itself. Examples of this technique date to the 1950s and 1960s: the Costume Institute used figures with painted silhouette heads to display male dress in *Adam in the*

Looking Glass (1950). The 1962 reopening of the V&A's Costume Court saw the introduction of similar "bas-relief" figures with silhouette heads (Figure 6.7) and sometimes arms, while the costume was padded out underneath (Laver 1962); this was praised for the

> [...] tact evident in the absence of heads on the dummies which display clothes in the round, which would have introduced an element of personality of dubious value. The lack is made up for by a small silhouette on white card beneath each dummy, showing the figure complete with hairdress, headgear, hands, and feet. Life-size silhouettes give a sufficiency of animation to a number of costumes shown, so to speak, in "high relief." ("Gallery of Fashion" 1962: 15)

From 1963, Doris Langley Moore mounted clothing on enlarged photographs, fashion plates, and drawings, as well as on a mural painted by Max and Daphne Brooker (Figure 6.8) at the Costume Museum at the Assembly Rooms in Bath; she had experimented with this method as early as 1955, at the museum's previous home in Eridge Castle, Kent:

> In the long gallery a wholly original method of display is used. From 1800 to 1825 the costumes are incorporated in mural paintings; white masks in deep relief, with a lightly suggested background, are used for mounting some of the later dresses needing more volume. In the upper gallery, fashion plates and prints, enlarged to life-size and dressed in clothes of the appropriate dates, recapture enchantingly contemporary faces and attitudes. (Adburgham 1955: 3)

The ROM used a similar convention for displaying twentieth-century dresses in the 1967 *Modesty to Mod* exhibition (Figure 6.9). This display, curated by Betty (Katharine) Brett, featured very animated uninhabited clothing, articulated not according to the construction of the clothing (by following seams and fabric shapes, for example) but according to human anatomy (knees and elbows). The liveliness of these garments stapled to the walls rather than mounted on figures (Carter 1967: 13) recalls the dance of Madam Camden's haunted clothing (Figure 6.10) in the charming nineteenth-century children's story "Wardrobe Witches" (Farley 1854: 201–209). Because clothing is so critical to the experience of the body, even clothing without a body is not always lifeless.

Curators at the institutions examined in this research seem to have been very aware of the ambiguous relationship between the body and fashion, and exhibitions featuring undergarments or revealing clothing demonstrate this particularly well. The Brooklyn Museum 1980 exhibition *Of Corsets* has already been discussed above, but it was preceded in 1939 by an exhibition entitled *Style Foundations: Corsets and Fashions of Yesterday and Today*, which also

Figure 6.7 Slide showing silhouette heads used in the V&A Costume Court, c. 1980. Courtesy Gail Niinimaa.

displayed the material means by which women's bodies were changed for similar ends in different ways:

> You breathe freely in modern corsets for modern corsets are not the old fashioned torture chamber affairs that caused ladies to faint and long treatises to be written about health. The rigid, unyielding corsets of our grandmothers

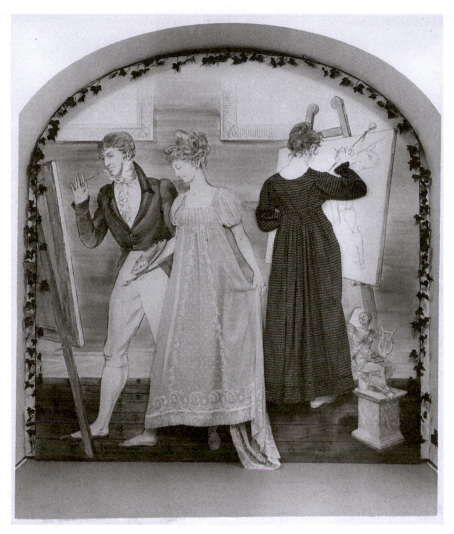

Figure 6.8 "The Painting Lesson," part of a display at the Fashion Museum Bath featuring two day dresses, early nineteenth century (cotton), English. Courtesy Fashion Museum, Bath and North East Somerset Council, UK/Bridgeman Images.

and great-grandmothers have been replaced by soft garments with skillfully placed gores of elastic that give with every breath and motion of the body. [...] The cycle of fashion is back to wasp waists, hips and high rounded bosoms; but the superb health of the modern woman will not be touched at all. Women's waists will be two inches smaller and look as if they could be spanned with two hands; but they'll breathe as freely as ever. ("Tighten Your Stays" 1939)

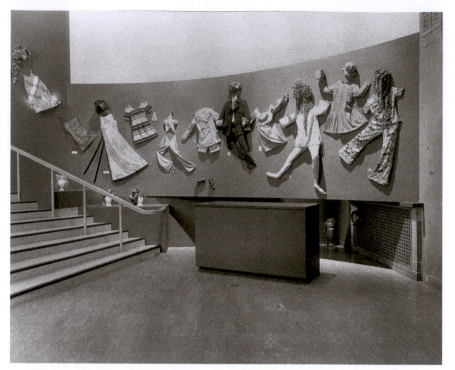

Figure 6.9 Installation view of *Modesty to Mod: Dress and Underdress in Canada, 1780–1967*, May 16, 1967–September 4, 1967, with permission of the Royal Ontario Museum © ROM.

Here, historical fashion was placed in contrast to modern technology. Although the conception of the ideal body had not changed between Victorian times and the 1930s, the text tells us, the acceptable means by which this was achieved had.

At the Costume Institute of the Met, Richard Martin and Harold Koda collaborated on two exhibitions in 1994 and 1996, both of which traced the variations in the relationship between the body and clothing over time. *Waist Not* (1994) described

> the physical and representational ideals of the human body through history. [...] But fashion's inconstant waist is not a sign for body subjugation. Rather, its changes and options suggest that fashion assumes a task of rendering more similar, at least in ideal form, the range of human bodies. (Martin and Koda 1994: n.p.)

Here, as at Brooklyn, the differences and similarities between the shaping of the body (and its ideal silhouette) were highlighted. Two years later, in the 1996

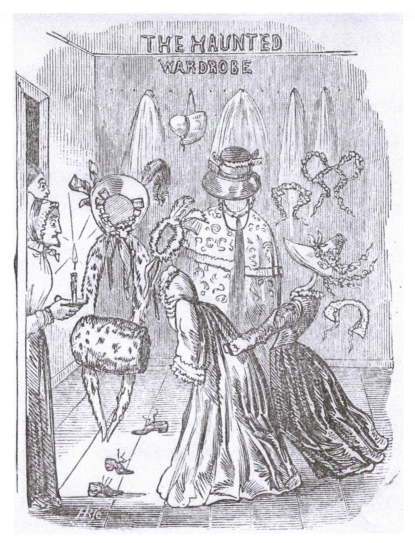

Figure 6.10 Artist unknown, "The Haunted Wardrobe," from page 199 of *Happy Hours at Hazel Nook: Or, Cottage Stories* (Farley 1854).

exhibition *Bare Witness*, Martin and Koda reiterated their position that fashion ultimately describes the body, even as it seeks to stifle it: "In fact, *Bare Witness* is not about burlesque stripping. Rather, it is about demarcating the body and making discriminating choices about the body. It is about the power of the body, concealed under the civilized apparatus of clothing, to materialize" (Martin and Koda 1996: n.p.). Their argument is actively anti-Foucauldian, asserting the subversive power of corporeality in social discourse.

Similarly, the 2008 McCord exhibition *Reveal or Conceal?/Dévoiler ou dissimuler?*, curated by Cynthia Cooper, asked its audience "to consider what this constant modification of the female body looks and feels like materially" (Matthews David 2010: 250). Unlike the Costume Institute exhibitions, however, which had a range of fully articulated or abstracted mannequins as well as dressmaker dummies and torso forms, the curator and conservators at the McCord utilized "invisible" forms to support the garments on display, taking the body out of the dresses entirely (Figure 6.11). In her review of the exhibition, Alison Matthews David was positive about the decision to custom-make mannequins that stopped the interpretation of the body at the boundaries of the garment, emphasizing their emptiness:

> The headless dummies are hollow and almost sculpted in black burlap. Their non-representational forms did not aim at any kind of false historicism. It seems appropriate for an exhibition on bodies and their social and physical malleability to craft forms individually rather than displaying the garments on "one size fits all" mannequins. The result is an elegant presentation that allows the viewer to focus his full attention on the cut, construction, colour, and fabric of the garments on display, while keeping in mind that they were worn by flesh and blood people with very different body shapes and sizes. (Matthews David 2010: 250)

However, given the exhibition's explicit focus on the body, an emphasis on the materiality of clothing was perhaps less successful than Matthews David suggests. A view of one section, "Hemline History" (a clever allusion to the description of classical fashion history in Breward 1995: 1), demonstrates this. High hemlines expose the female leg, but in an exhibition where mannequins are not possessed of limbs, all that is exposed are awkwardly empty shoes, placed under an improbable floating dress.

The body was dematerialized: neither revealed nor concealed in this representation, and this arguably led to a loss of meaning. As Doris Langley Moore had written nearly fifty years earlier,

> The relationship between a hat and a head, décolletage and a bosom, a ruffle and a wrist is so inalienable that it is a loss to be obliged to leave it to the imagination; for the fact is that it takes knowledge and training to be alert to mere suggestions. (Langley Moore 1961: 277)

This is just as true for male fashion as for female fashion; the McCord had previously featured male torsos to demonstrate the varied degrees of exposure in historical swimwear in *Clothes Make the Man/Lui: la mode au masculin* (2002–2003) (Figure 6.12), but the rest of the exhibition was criticized for

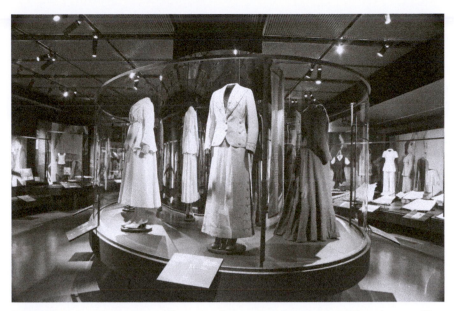

Figure 6.11 Installation view of *Reveal or Conceal?*, February 22, 2008 to January 18, 2009 © McCord Museum.

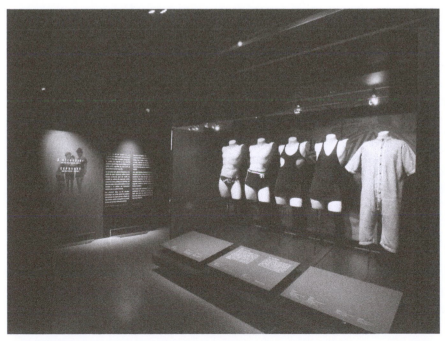

Figure 6.12 Installation view of *Clothes Make the Man*, 17 May 2002—5 January 2003 © McCord Museum.

the disembodied presentation: "The almost invisible mannequins used for display betrayed a discomfort with the idea of the 'wearer'" (Champroux 2002: 64).

Meaning in fashion is derived from the proportion for clothing to body, and this is also true in the gallery space. To once again quote Doris Langley Moore,

> After experimenting over many years with display techniques, I have found that dummies which look human, with just the degree of idealization that has always been a feature of successful fashion plates, serve our purpose much better than headless and armless or highly stylized models, and there are good reasons why they are more in favour with the public. Realism certainly ought not to be as obtrusive as in waxwork portraiture, but those to whom costume is an unfamiliar subject will find little interest in a sleeve with deep ruffles unless it is set off by an arm, or in a man's starched neckcloth and collar without the semblance of a neck. (Langley Moore 1969: 1)

The effects achieved by referencing the aesthetic body ideals (silhouettes, postures, and hairstyles) of past epochs in this abstracted manner help to evoke a period presence with a physicality that does not impose on the viewer's own, as audiences perceive these mannequins as sculptures rather than as uncanny persons.

A headless or featureless mannequin is therefore representative of a cerebral, or at least subtle, approach to fashion history, and this is probably another reason why dress has been devalued in museums—fashion's close links with the body, when displayed, evoke embodied personal memories that are nostalgic, not the rational critical distance of historical discipline (Shaw and Chase 1989). The widely varied interpretations that result from incorporated memories threaten the intellectual authority of the museum. Yet the very relatability of fashion, because of its universal presence in society, can make the work of the museum to interpret it easier.

Materializing the body

Neither naked nor dressed bodies are present in museum galleries of fashion history; instead, they are replaced with simulacra, which are a third category of body. Whether invisible, abstracted, or fully articulated and accessorized, the substituted bodies of mannequins in galleries frame the fashion on display in different ways. While it is beyond the scope of this book to discuss the conservational merits of different types of mannequin construction, the literature

of textile conservation does provide rich source material on the addition of corporeality to clothes with the use of mannequins.

By far the greatest proportion of mannequin-related literature for museums is of the how-to genre. Recognizing that most museums have very limited budgets and resources, the authors present options for mannequin construction or adaptation that maximally prevent damage to the objects on display and provide flexibility of interpretation (*cf.*: Clearwater 1980). However, even conservators admit that a purely practical approach does not necessarily result in a satisfactory display: "As we continue to examine social issues using costume collections we need to consider if we want to use mannequins not only as a form to place garments on but also a figure that supports the interpretation of the exhibition" (Kruckeberg 1990: 93). These two priorities can conflict, and Costume Institute conservator Christine Paulocik felt it necessary to highlight the importance of good communication between the staff members who represent these different interest groups: "Ideally the mounting of costume should be a collaborative effort between the curator, dresser and conservator" (Paulocik 1997: 26). Ultimately, she argued, the interpretive concerns must take priority to fulfill the educational role of the museum, and mannequins can provide context as well as support. This can be a truly daunting task, and the choices available to the curator and conservator are often unsatisfactory: "Creating an illusion of body and context is a task which may face many museum workers in the course of their professional career" (Ginsburg 1973: 50).

The following quote from a very early article on the display of clothing in museums is written in a florid style but accurately reflects the enormity of the design challenges facing museum workers:

Clothes are lovelliest when worn [...] Bereft of movement the loveliness vanishes and left is the depressing inertness of vacated clothes. To these the museum curator is heir; all his showmanship must be summoned to animate the empty costumes and enhance their embroidered beauties. Is there nothing to do but use those dreadful lay figures of wood and cloth and waxen face and arm? [...] But we who have seen them row on row in glass cases blush for shame at the showmanship that devised them. Our sensitive beings shudder at their too, too solid shape and everlasting smile. [...] There seemed to be no alternative to the hasty purchase of many lay figures, such as confound the windows of the large stores. It was appalling to think of so many disgustingly pink figures, with long-lashed eyes and coy expressions. Should they be half-busts or full figures, with heads or gruesome decapitated trunks ending in unnaturally turned wood? The lower extremities offered a nauseating choice between intricate wire cages and tri-footed wooden pedestals, too elegant in their turning and abominably comic in their splay-footed hat-stand posture. I sickened at the sight of them. (Thomas 1935: 1–3)

Examples of such mismatched "decapitated trunks" and "splay-footed hat-stands" (Figure 6.13) can be seen throughout the archival photographs of past exhibitions at the institutions under consideration here.

It was due to the dissatisfaction with such display alternatives that museum curators and conservators began to collaborate with mannequin firms to develop dummies that would better reflect museally desirable bodies. In 1980, Stella Blum, curator at the Costume Institute at the Met, provided technical assistance to Wacoal Corporation for their historical fashion mannequins, and Brooklyn Museum costume curator Elizabeth Ann Coleman worked with Goldsmiths to develop special mannequins for the 1989–1990 exhibition *Opulent Era*; both were later marketed to other museums and collections (Wacoal n.d.; Goldsmiths n.d.). Mannequins with corseted torso shapes developed by Derek Ryman for the V&A's 1983 redisplayed Costume Court (Figure 6.6) were likewise used in other museums (Goldthorpe 1985: 189). While the curatorial aim as set out in the literature was to reflect the silhouettes of the garments' original wearers, the reality shows that the resulting mannequin's body is a chimera of conservational and curatorial priorities, a hybrid of human, dress, aesthetics, and history, very distant from the disappeared human body that once inhabited the clothes on display.

This is probably why most museum exhibits tend to generalize human value through the synecdoche of culture at large—too much personal information tends to be morbid, as the value of the body remains only in what amounts to relics. Interestingly, writers on fashion history have identified this as popular with museum audiences:

> When mounting a costume display there is always the problem of making the clothes come alive in a way that is reminiscent of their wearers. Although certain types of garment are seen as decorative objects in their own right most of the clothes are viewed by the public as having been worn by their ancestors, and they like to see them shown in a way that suggests there is a body underneath rather than a headless stand. (Tarrant 1983: 107)

Some mannequins can look too human, however. The specificity of waxwork has been found by many to be disturbingly uncanny, and exhibitions have been damned for their visual similarities to wax museums. Indeed, the abstracted but recognizably human mannequins developed by the Wacoal company for period silhouettes were praised by the renowned costume historian Janet Arnold when combined with sculpted paper wigs for being able "to give an elegant line without looking like a waxwork dummy" (Arnold 1984: 378). However emotionally effective, realism in a mannequin can go too far to become prescriptive, especially if the face is recognizable. Male mannequins used for at least thirty years at the V&A (documented in photographs and on film from 1934 to 1962) were modeled on

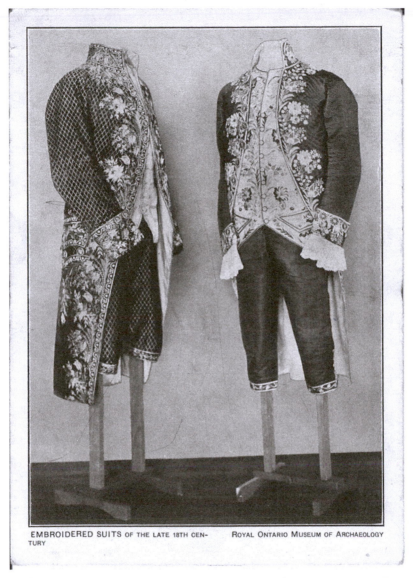

EMBROIDERED SUITS OF THE LATE 18TH CEN- ROYAL ONTARIO MUSEUM OF ARCHAEOLOGY
TURY

Figure 6.13 Undated postcard showing mannequins used for menswear at the Royal Ontario Museum. Author's collection.

historical personages such as the monarchs Charles I and George VI (see Figure 7.2); doubtless, they were meant to easily recall an era to the minds of audiences, in a period when national history was divided into reigns. However, such a display technique risks the audiences assuming that the garments worn by these lifelike dummies were also worn by their historical counterparts. When this is actually

the case, as in the Fashion Museum's *Women of Style* (2000) exhibition, where the wardrobe of Dame Margot Fonteyn was displayed on mannequins modeled after the famed ballerina, the effect is unnervingly surreal—a crowd of surrogate Margot Fonteyns represented different periods of a single woman's real life (Figure 6.14). The garments on display became relics in a very direct sense when the mannequins used seemed to be effigies. This approach is rather too obvious and might even be ineffective for evoking a sense of the original wearer. Furthermore, dummy heads run the risk of spoiling the illusion of historicity so carefully built up by display conventions of antique things in antique settings. For example, Betty (Katharine) Brett, ROM curator of textiles, explained the decision to omit mannequin heads from the design of the *Modesty to Mod* exhibition:

> The judies[3] are headless, Mrs Brett explained, because museums the world over have discovered it is impossible to design heads that don't take on a contemporary look. "Besides, we don't give the public credit for having imaginations," she added. "One young man raced in to tell me one of our judies looked just like his grandmother." (Catto 1967: W11)

Mimetic mannequins of specific historical personages, as Mary M. Brooks has discussed (2016), are particularly challenging, as their embodied reality

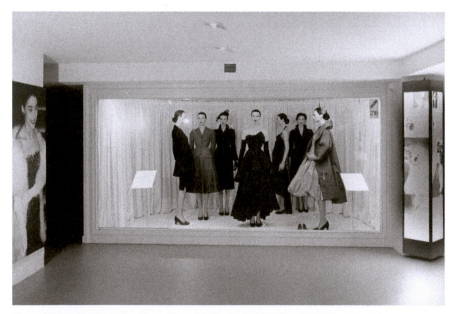

Figure 6.14 Fashions by Peter Russell, Hardy Amies, Bianca Mosca, and Christian Dior worn by Margot Fonteyn, 1940s and 1950s, shown during the 2000–2001 *Women of Style* exhibition at the Fashion Museum. Courtesy Fashion Museum, Bath and North East Somerset Council, UK/Bridgeman Images.

may differ from familiar media images. The reverse may also be true, however: abstracted mannequins with no nod to the appearance of the garment's original owner create the same uncomfortable dissonance when viewers compare the mannequin to the media image.

Artifacts and bodies deprived of their vitality can seem like soulless rationalizations. Elizabeth Wilson writes of "the uncanniness of the museum display, with clothes suspended in a kind of rigor mortis, offered a seductive example of 'hallucinatory euphoria,' a glimpse into a dystopia of depthless colours and inhuman brightness, a veritable imitation of life" (2010: 15). In the museum, cultural discourse and norms of embodiment, which would have limited power if they relied on language alone, are distilled and exuded into external, nonliving models of bodies. Eerie and distant though they may be, these plaster mannequins and painted anatomies are visual evidence for the constructed cultural expectations of fleshy life: "The life-size mannequin constitutes a composite portrait that is representative of the majority" (Parrot 1982: 53). The fact that this is only a convention is evident when one examines the issue of race in mannequins: featured or featureless, mannequins are most often painted a "neutral" white (Benjamin Moore actually has an off-white paint shade called "Mannequin Cream," 2152–60 in their range) and have Caucasian features (e.g., see Proportion London's "Fluid" mannequin, used at the V&A for their *Glamour of Italian Fashion 1945–2014, Horst: Photographer of Style*, and *Wedding Dresses 1775–2014* exhibitions, 2014–2015), thus erasing any ethnic diversity that may have been present in the individuals who originally wore the clothes. In one particularly egregious example, 1971's *Fashion: An Anthology* at the V&A painted a Rootstein mannequin sculpted to look like the black sixties supermodel Donyale Luna, white, though she was not abstracted and was given modern make-up to match with the style of the English Contemporary section of the show (Clark, de la Haye, and Horsley 2014: 119). While it can be argued that much of the fashion objects held by museums are elite examples, and historically, the elite classes of the Western world have been overwhelmingly Caucasian, to literally whitewash out the embodied markers of race in order to fit a visual priority is an example of the privileged nature of aesthetics in museum discourse.[4]

The body and time

Bodies, unless they are the surrogate metaphorical bodies or mannequins, are temporal. They age, die, and disappear and with them, so do their embodied experiences. How, then, can a museum measure, define, explain, or even approach the traces of bodies no longer present, no longer able to enact their will upon the cultural world? This chapter has presented numerous examples

of fashion history exhibitions—disembodied by conservational necessity—to elucidate the processes of the production and representation of fashioned bodies in the museum. The primary technology for the representation of the body in museums is the mannequin, which, as Alison Matthews David notes, "is a shape-shifter, who blurs the boundaries between death and life, female and male" (2018: 5), reflecting the changing cultural attitudes towards fashioned bodies. Examining the museum as a discursive institution that constructs concepts of valued bodily techniques can thus shed light not on the apparent meaning of the objects held within for their original owners but on the deeper and more fundamental attitudes toward the body held by contemporary society.

The preoccupation with creating an illusion of life in exhibitions of historical fashion, discussed throughout this chapter, suggests an accompanying anxiety about death and decay. The convention of displaying historical fashion in chronological order visually demonstrates the effects of social ideologies across time on the body underneath, for example, and as historical fashion makes the passage of time evident through its obvious obsolescence, curators have the difficult task to make it appear relevant and vital. The following chapter will discuss the historicity of historical fashion and the tensions between past and present in the curation of historical fashion.

7

THE WAY OF ALL FLESH: DISPLAYING THE HISTORICITY OF HISTORICAL FASHION

Discomfort stemming from the stillness and pastness of museums, which was so aptly identified by the Futurists in their manifesto (Marinetti [1909] 1973), is heightened by the sense of clothing as a second skin; to be surrounded, as in a fashion gallery, by stock-still bodies in lifeless clothing has the air of Gothic horror.

> What is the source of this uneasiness and ambiguity, this sense that clothes have a life of their own? Clothes without a wearer, whether on a secondhand stall, in a glass case, or merely a lover's garments strewn on the floor, can affect us unpleasantly, as if a snake had shed its skin. (Wilson 2010: 2)

Literature around fashion in museums reveals the pervasive characterization of historical fashion as "deathly" and the persistent denial of its physical decay.

Whereas the previous chapter suggested that introducing "liveliness" to gallery spaces was part of a strategy to suggest the embodied practices of wearing fashion, this chapter argues that the curatorial preoccupation with endowing a sense of life also reveals that fashion in a museum has the capacity to mark of the passage of time through its innate processes of obsolescence and decay. This also refers back to the discussion of fashionable time in museum displays in Chapter 2. As that chapter argued, fashion, when displayed in a museum, is no longer an active part of the commodity time stream. However, its presence in a museum suggests that apart from economic value, the fashion object has gathered nostalgic value: it was collected by the museum and now stands as a monument of times and people past. Its value is now rather as a witness to history and these are the terms in which it is discussed. Therefore, inspired by

the philosophical discussions about the nature of museums by French literature critic Didier Maleuvre (1999) and the pioneering work of Scandinavian media historian Mark Sandberg (2003) on the museal staging of historical subjectivity, this chapter also investigates what is historical about historical fashion and how this is materially and visually expressed in exhibitions.

This chapter does not make claims about the nature of history itself; rather, it seeks to describe how different concepts of history and the past have been articulated in museum exhibitions of historical fashion. Because historical fashion is defined oppositionally as not modern (see Introduction), it belongs to the historical tradition of dividing time into "here and now" and "then and elsewhere" (Ricouer 2004: 308); this distinction means that historical fashion's quality of being of the past is an important part of its ontology. The analysis in this chapter takes as a given the existence of historical consciousness—"a sense of belonging to a succession of past and future generations as well as to a present community and society" (Glassberg 1987: 958)—and seeks a pattern among various imaginings of the past and of history in the use of historical fashion. The museum insists on its authority to tell stories about the past because of the fact that it has historical collections: its artifacts are presented as documentary. The ways in which these objects are combined and interpreted in display, however, reflect different historical narratives and relationships between the past and the present. In this chapter, it is argued that positioning fashion as a historical object that can represent the passage of time simultaneously highlights the impermanence of the cultural processes that produced it and of the human subjects that wore it. The discomfort with decay and disrepair occasioned by viewing historical fashion is here theorized as being the result of an encounter with the "uncanny."

Deathliness and display

The previous chapter suggested that a common critique of fashion in museums is that the costumes on display are not sufficiently lively. Indeed, the feminist fashion scholar Elizabeth Wilson wrote in the first lines of her classic book *Adorned in Dreams*:

> There is something eerie about a museum of costume. A dusty silence holds still the old gowns in glass cabinets. In the aquatic half light (to preserve the fragile stuffs) the deserted gallery seems haunted. The living observer moves, with a sense of mounting panic, through a world of the dead. (Wilson 2010: 1)

In this quotation, as well as the one presented in the above section, Wilson contends that it is the deathliness suggested by unoccupied clothing that makes it uncanny; no longer true to the way in which it is corporeally experienced in

everyday life, fashion as displayed in a museum is inauthentic to its fashionable life. It is worth recalling that for most of the 2000-year history of Western fashion, clothing has been tailored to cover most of the body. When displayed, especially if laid flat (as some garments too fragile to mount on a mannequin sometimes are), the outfit can take on the appearance of a sloughed-off snakeskin. Metaphors used by other commentators on the topic of fashion museums echo the sense that fashion is meant to be part of everyday life—worn by a living body, for example—and that to display it on a mannequin in a glass case is akin to the practice of taxidermy (Glynn 1980: 7) or to confining fish to an aquarium (Museums Correspondent 1963: 13). Sometimes, the mannequins themselves, pallid and ghostly as they often are, can heighten the effect. The mannequin heads molded for the Philadelphia Museum of Art's inaugural fashion exhibition in 1947 had closed eyes (Kimball 1947); posed stiffly of furniture or against walls in niches, their cadaverous faces were reminiscent of the mummified monks in the catacombs of Palermo, their clothes taking on the appearance of shrouds.

Clothing in a wardrobe may be worn again but not once it is in a museum collection. Of the 1983 V&A Costume Court redisplay discussed in some detail in the previous chapter, Stella Mary Newton wrote,

> What used to be glaring (and injurious) daylight has been replaced by a delicate twilight, immensely more becoming to our foremothers and fathers who are now gathered in an atmosphere of pensive suspension. Waiting, one can now almost imagine, in a silent assembly, not in Dante's Purgatory but in the antechambers of some assuredly blessed abode. (Newton et al. 1984: 98)

While not dead as such, the resulting limbo state is only a shadowy reflection of the full potential of fashion outside the museum context. Alienated from its most familiar state, fashion as framed in a museum case seems uncanny.

Within a museum, the object can also be seen as memorializing life's passing. In this way, museum objects, particularly fashion, which are so intimately linked to corporeality, have the potential to make current viewers feel uncomfortable because they recognize the evidence of mortality (deathliness)—the possibility that their presence, too, will only be evident through the things they interacted with. A 1962 review of the Gallery of English Costume at Platt Hall suggests the same: "visitors drifting round the gallery will continue to catch a glimpse of themselves in the windows of the cases and gain an intimation of mortality from the thought that the suit and coat—but not the face and hands—could be on the other side of the glass 100 years from now" (Reporter 1962: 19). In such a reading, historicity and pastness (the qualities of being historical and of the past) are related to deathliness. The sudden consciousness of being in history leads to the uncanny effect of the presentiment of death (Royle 2003: 86).

Although the innovation of the fashion system depends on what Ingrid Loschek calls "creative destruction" (2009: 1), the annihilation of the old is not acceptable in a museum context. In her review of the 1962 V&A Costume Court redisplay, Alison Adburgham decried the erasure of the evocative personal histories that antique clothing carried, describing the fascination of clothes that can be seen to have been worn: "clothes which, if it were not for the astonishing skill of Messrs Achille Serre who have cleaned and restored them to their original freshness, would still carry the dust, stains, and perspiration of lives lived long before our drip-dry, deodorant days" (1962: 8). While an antique object is recognizable as such by signs of wear (Rosenstein 1987: 399), this also signifies decay, something the museum strives to impede. Sarah Scaturro has evocatively written about the interventions necessary to reverse or impede what she calls fashion's "death drive" as it passes from fashion object to museum artifact, to decayed material (2018).

There have recently been a few groundbreaking exhibitions that sought to challenge the standard museum practice of covering up the inevitable disintegration of artifacts. Curator Robyn Healy worked with the Australian National Trust to create evocative scenes of death and decay using damaged clothing from its collection in a Melbourne historic house in the *Noble Rot: An Alternative View of Fashion* exhibition in 2006. Perhaps inspired by this, *Tattered and Torn* (Empire Historic Arts, Governors Island, 2012), an installation of items deaccessioned from institutions including the Brooklyn Museum, sought to demonstrate that even damaged artifacts remain a valuable historic resource. Similarly, *Body Damage*, curated in 2013 by José Blanco F. and Raul J. Vasquez-Lopez, highlighted deterioration in accessioned and unaccessioned objects from the Historic Clothing and Textiles Collection at the Department of Textiles, Merchandising, and Interiors at the University of Georgia caused by body fluids, activities, and encounters, questioning whether the stories told by these traces and the memories they evoked might be considered beautiful and worthwhile for display.[1] Likewise, *Present Imperfect* (Amy de la Haye and Jeff Horsley, Fashion Space Gallery, 2017) investigated the aesthetics of decay and the challenges of displaying items that resist traditional methods. The same year, the Musée Galliera's curator Olivier Saillard staged an exhibition in the Costume Gallery of Florence's Palazzo Pitti called *The Ephemeral Museum of Fashion*, which took advantage of the advanced state of disrepair on some museum garments to display them for the final time in a ghostly mise-en-scéne, highlighting the transient nature of fashion itself. Many of these artifacts were draped on the backs of chairs or hung from clothes racks and coathooks (the arms intertwined in a lingering embrace); garments on mannequins with spider legs were placed amid empty frames, piled-up coat hangers and ladders, dust-covered furniture, on drop cloths, as though left behind in an abandoned mansion. The Museum at FIT exhibited *Fashion Unraveled* in 2018, demonstrating how signs of wear and

alteration help to tell object biographies and how this has inspired the intentionally deconstructed appearance of some high fashion garments, thereby challenging well-established aesthetic conventions. As is characteristic in MFIT displays, garments and textiles were shown in groupings to highlight the similarities of their construction in materials, motifs, or technique. However, these exhibitions (none of which, it must be noted, come from the institutions studied in-depth for this book) remain in the minority, and the strength of their narrative comes from its opposition to convention. As an exception, they prove the rule. It should also be noted that even the advanced deterioration and seemingly casual methods of display evident in these exhibitions were carefully controlled with conservational interventions; with the exception of *Tattered and Torn*, museum preservation methods were used even in the most dire conditions, and so the spectral effects of these clothes were illusions.

Conservation practice regularly erases or masks the signs of deterioration (Paulocik 1997), signs that outside the museum gallery might be prized as the patina of age or, in a private wardrobe, lead to the item being discarded. This is not only the case for items that will truly suffer material damage from the strain of handling, gravity, and light as a result of going on display; there are, sadly, whole classes of fashionable wear that, due to their physical composition of unstable materials, are decomposing rapidly even in storage (Palmer 2008a: 58). Rather, I contend that this is a sign of a greater discomfort with the ultimate implication of the passage of time that is evident in the clothes that so closely mirror our own bodies: death.

Such an understanding of museum objects suggests that galleries and stores of fashion in museums contain and preserve the relics of people who once lived; furthermore, the clothes themselves are reliquaries for the traces of the bodies that once inhabited them. One recent exhibition that demonstrates this particularly well was *Isabella Blow: Fashion Galore!* (Alistair O'Neill and Shonagh Marshall, Somerset House, London, 2013–2014), which was praised for leaving scuff marks, lipstick stains, and cigarette burns in situ on the deceased fashion stylist, editor, and muse's displayed designer wardrobe. As fashion scholar Felice McDowell has noted (2015: 327), these signs of wear were imbued with the memory of the events that surrounded their wearing and also a memorial to Blow herself.

That an appeal to personality is intrinsic to the study of fashion is also borne out in some of its earliest theoretical literature: in a 1947 essay, for example, noted fashion historian Dr. C. Willett Cunnington suggested that the predominant means by which fashion was studied and described were the aesthetic and the historical, "preoccupied with the exact dates of specimens and what notable people wore them" (Cunnington 1947: 125). In a 1977 article titled "Costume as History," Melinda Young Frye corroborated this view, noting that clothing "entered the collections of American museums during the last half of the 19th

[*sic*] century, when it was accepted primarily for its historical association with famous persons—its 'relic' value, as it was then termed" (1977: 38). Indeed, writing on the relevance of the study of fashion to history reveals this obsession with the aura of the person who wore the clothing originally:

> A historian who is trying to form in his mind a clear picture of people in the period he has chosen for study may usefully supplement contemporary descriptions of what men and women said and did and looked like by seeking out their painted or sculptured [*sic*] portraits. But while portraits—and even photographs too—will show how people wished to appear, only a costume collection carefully displayed can demonstrate three-dimensionally the actual appearance of historical characters. (Nevinson 1971: 38)

The author of this piece, writing for the Met, seems to believe that clothing tells a truth unmediated by forms of historical recording; that because it was worn next to the actual physical body of a long-dead historical person, it can transmit that corporeality even to the present day. This sort of fetishism is frequently seen as embarrassingly specific by scholars who, throughout the twentieth century, called for more objective contextualization for fashion. Dr. Cunnington himself spoke archly of the implications of this approach:

> It is, no doubt, of some sentimental interest to know that a particular pair of stays was once worn by Queen Anne, but unless we know that she was a typical woman of her epoch and not exceptional, her stays will tell us very little about the general run of stays and even less about the general run of women of that time. In fact, the specimen only tells us one thing, the approximate size of Queen Anne's waist, and—really—does that matter very much? Moreover there is the horrid possibility that they were not Queen Anne's stays at all. (Cunnington 1947: 125)

Even in his disapproval, however, Dr. Cunnington also acknowledged that the identity of the original wearer was critically important for the ontic authenticity of the garment under study.

The waxwork relic model that, as it has been seen, was an early means of displaying historical dress relied on the associations of the garments on show with a specific, recognizable individual. Once museums moved away from this model, individual associations became less important; working from collections that included many disparate garments from many different original wearers, museums were compelled to create whole ensembles that would necessarily represent approximations of contexts like the ones in which the clothing was originally worn. Rather than a direct 1:1 equivalence of clothing actually worn by a historical personage, as that seen in Madame Tussauds or the Westminster

Abbey funeral effigies, these mannequins were more metaphorical, imagined assemblages that stood in for an incomplete whole.

Although displays of fashion do often take the form of anonymized parades of generalized "styles," purporting to objectively illustrate cultural and social developments, often the most prized items on display are those where one can see not only the item of clothing but also other "evidence" of the individual wearing the selfsame clothing. The well-illustrated provenance of the item serves as proof of its historicity. One example of this is the V&A's *British Galleries 1500–1900* (opened in 2001) display of the embroidered seventeenth-century jacket belonging to Margaret Layton alongside a portrait of her wearing it (Figure 7.1). Unlike the displays discussed in Chapter 5, which were created to enact the accompanying visual media, the portrait of Margaret Layton is indexical of the historical truth of the jacket on display. This display demonstrates the veracity of the portrait as a historical document, which accurately captured the material reality of the jacket. Margaret Layton, who died in 1641, is not revivified in this display: rather, her jacket is shown as being

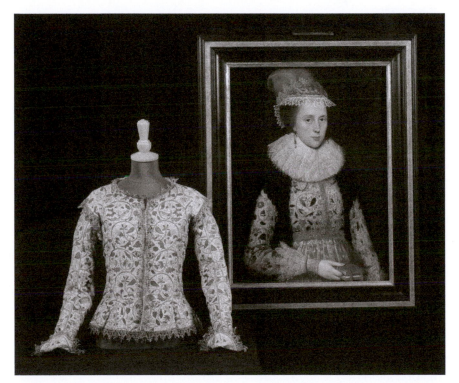

Figure 7.1 Portrait of Margaret Layton (formerly Laton) probably by Marcus Gheeraerts (the Younger), Britain, c.1620, oil on oak panel, accompanied by the Layton jacket, linen, embroidered with colored silks, silver and silver-gilt thread, made 1610–1615, altered 1620, England. © Victoria and Albert Museum, London.

convincingly and irrevocably of the past and having belonged to a specific individual who once lived.

Historical distance

Museums have developed techniques for creating relationships between themselves, their visitors, and their collections, which rely not only on hierarchies of authority but also on the intellectual and physical perception of historical distance. In the case of museums, the past is portrayed as embodied within the artifacts on display. In 1949, *Vogue* wrote, "The great museums now are casting a new eye on fashion for they know that time transforms current clothes into future valuable documents" ("Fashion An Art in Museums" 1949: 211). The fascinating paradox is that the artifacts ontologically remain of the past, though they are ontically contained in a modern setting; although encountered with present-day sensibility, the garments are nevertheless positioned as being essentially historical. A review of the V&A Costume Court from 1962 demonstrates this well:

> Clothes, most personal of all personal possessions, are evocative reminders of time past, most touching reminders; but the visitor to the Victoria and Albert Museum's new Costume Court, the ordinary man or woman who comes in from the street, must possess some sympathetic understanding, some sense of the past, to imagine the day-to-day lives of these people who now live in glass cases. (Adburgham 1962: 8)

Assuming that visitors view the displays with a certain amount of historical awareness, the challenge, then, is to develop means by which this gap in temporalities can be traversed.

An excellent example of this comes from a 1952 Pathé newsreel about an exhibition of historic menswear in the V&A. The clip opens with a pan of the façade of the building, and the narration begins:

> If you've the vision, you'll look on the Victoria and Albert Museum as something more than a treasure house of the past; certainly as more than just a doorway to outworn ideas, for it enables you to match your own streamlined century to what has gone before—to see progress against a background of romance. ("Pathé Pictorial" 1952)

The observer, it is suggested, requires a certain level of knowledge and imagination to bridge the distance between present and the past and insight to recognize the valuable information held within. The clip proceeds to show historian and curator James Laver examining a series of male mannequins that have been taken

out of their glass cases (these stand empty in the background). Like a general inspecting his troops, Laver touches and adjusts the clothing on nearly every model before walking out of the frame (Figure 7.2) as the narration highlights the difference between the time of the models on display and the current moment; Laver's behavior and the narration demonstrate a detached aesthetic expertise, coolly evaluating the relics of bygone times from a position in the present. Laver demonstrates the expert's eye, which, it is implied, the newsreel viewer can also achieve. The historical positioning of the observer in this instance, therefore, is that of distinction and difference; as Lehmann points out, to focus on the object as a garment of historical interest is to highlight its strangeness and peculiarity, to define it as "unconnected to our own experience and inaccessible to our sensibility" (1999: 300). Indeed, Mark Salber Phillips reviews the long tradition in the arts where distance has been seen as particularly critical for aesthetic experience (2003: 439). The filmed museum encounter serves to further highlight the difference between here-and-now and there-and-then. Laver's movement and the immobility of the mannequins also highlight their uncanny pastness: present to be seen, but unmovingly distant (Edwards 1999: 226). It is the lifeless motionlessness of the dressed mannequins, as contrasted with the animation of the onlooker, that endows them with their status as historical objects.

Likewise, this is also shown in another Pathé newsreel from 1955, set in the first incarnation of Doris Langley Moore's Costume Museum at Eridge Castle. Here, too, costumes on realistic mannequins were displayed in the open (not behind glass) so that the physical encounter between model and observer was unmediated. A magazine article describing the layout of the galleries from the following year suggested,

> It seems, at once, that the clock has been turned back, for this museum brings each generation to life before the eyes of its onlooker; and if the waxen figures ignore us as we pass, it is, we feel sure, only because they are engrossed in the occupations of their day. (Brentnall 1956: 36)

The clip humorously plays with this notion by setting up a scenario wherein a live model dressed in a historical costume stands still alongside the mannequins (Plate 6). When two women visitors to the museum approach her, she moves and surprises them. The humor in this scenario arises from the disruption to the distance expected of museum objects and the past they represent. The situation is comic because it is absurd: the people of the past are not available to the present, and the breaking of this convention is not only exceptional but even unbelievable. In this way, the museum becomes a place of wish-fulfillment, where the fact of absence is made present only insofar as to make it more poignant; to go any further, as in the Eridge Castle pantomime of bringing the past to life, breaks down the willing suspension of disbelief into comic absurdity.

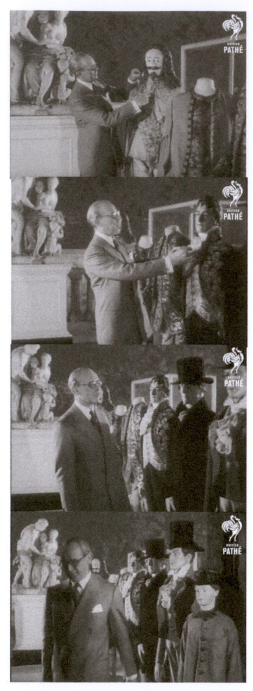

Figure 7.2 Curator and historian James Laver examines the time line of men's fashion in "Pathé Pictorial Technicolour Supplement; Men About Town" (1952); screencaps by author.

However, the desire to make the historically distant past present remains, and here, the artifact in the gallery can play an important role. For their *Europe 1600–1815* galleries, opened in 2015, the V&A placed mannequins dressed in historical fashion at floor level, in large glass cases, minimizing the distance between the visitor and the artifact. While not primarily a display about fashion, populating the spaces between decorative arts objects in this way creates an illusion of walking among history. These mannequins are oblivious to the visitor, who feels like they are themselves intruding on the time-space of historical Europeans and their material goods.

The prevalence and relative value of certain periods in fashion history over others is also noteworthy. Museum exhibitions speak to and reflect how the past is understood, rather than the past itself, representing a self-conscious temporality of the past and present. In a museum, time is unequal—some years are longer, bigger, more important, while others are forgotten altogether. A museum is an ahistorical place, too, in the sense that events can be reconfigured in all sorts of flexible ways within it. The persistent reappearance of Victoriana in fashion galleries, for example, is not only a function of the high survival rate of garments from the nineteenth century; it is also a reflection of the fact how that particular historical period is thought (by collectors and curators alike, for garments must first be preserved in order to eventually be displayed) to be particularly important. It is probable that certain historical periods evoke easier contrasts or comparisons with contemporary developments in society or aesthetics: for example, the Brooklyn Museum's 1939 corsetry exhibition was intended "to show the origins of today's wasp waists and bustles" ("Corset Show Opens" 1939: 1) by displaying underwear and outerwear of the nineteenth century alongside that season's latest styles in the same. Another example of this comes from the MFA in Boston, where conservator William Young's mannequins, used for the inaugural fashion exhibition at the MFA, had "charming whimsical faces which make them seem aware of the intrinsic value of the costumes they are wearing and of the past glories they must represent, yet without dominating them by a too-modern appearance" (Pope 1945: 37). The display dummies drew attention to the pastness of the clothing while being neither too historical nor too contemporary to frustrate the ability of visitors to relate to them.

This display strategy has a secondary effect: to increase the relatability of the distant past to viewers in the present. Neither is it necessary to overtly mirror historical objects with contemporary ones to produce recognition. In positioning mannequins to enact "universal" human experiences such as maternal affection or flirtation, for example, museum curators and designers transpose contemporary social values onto objects from a different era. The object, after all, has no innate need for any particular style of display: the choices made in exhibition result from a belief that one aesthetic will be more suitable than another for the intended narrative. The result, however historically inaccurate or implausible it may be (we

will never know if the *robe á la française* in Figure 5.3 was ever privy to furtive expressions of romance), may trigger a moment of personal empathy. This is the powerful emotional effect of the underlying desire to be reconnected with the past described by Ankersmit (2005: 9) and is difficult to resist.

Time frames and time machines

The physical arrangement of historical fashion within museum galleries suggested the possibility of time travel. The 1952 Pathé newsreel cited earlier had a narration that suggested this: "To stroll with James Laver, the author, down centuries of men's fashions, is to quicken your understanding of the past" (Pathé 1952). While Laver was able to touch the items on display, something that would certainly not have been possible for the average museum visitor, his journey through museum space and, simultaneously, chronological time was typical. This section, therefore, will discuss how the museums researched as part of this book have deployed visual conventions to position their audiences in relation to the past in this way.

While the success of individual museums at communicating this notion effectively to their audiences is debated (Penny 2002; Noordegraaf 2004), few writers on museology argue with Tony Bennett's assertion that museum space[2] was fundamentally conceived of as a means of intellectual time travel: "the museum visit thus functioned and was experienced as a form of organized walking through evolutionary time" (Bennett 1995: 186), which became a tradition shared between curators and audiences. An experienced costume curator, Naomi Tarrant believed that most audiences preferred a chronological approach, and that this type of display implicitly answered the majority of the general questions they might have about dress over time (1999: 19). Indeed, the institutions studied as part of this research each had some element of chronology in their galleries in the twentieth and into the twenty-first centuries.

The earliest displays of historical fashion at the V&A were cases arranged in a line (Figure 7.3) to represent the chronological development of dress throughout modern history. This arrangement was established in 1913 and continued relatively unchanged until the gallery was redisplayed dramatically in 1962; the new "costume court" was octagonal in shape and the physical sequence of cases could no longer be totally linear, but the display was still fundamentally evolutionary, "showing the development of fashionable dress in Europe between about 1580 and 1948" (Thornton 1962: 332). It was before this latter renovation that the Pathé News corporation filmed in the museum, when the space was arranged in a way that easily communicated the notion of the linear passage of time.

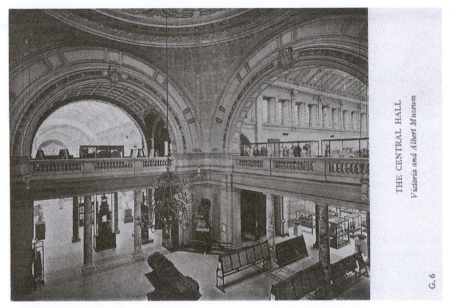

Figure 7.3 Undated postcard showing V&A Central Court; cases of costume visible in upper gallery at right. Author's collection.

This is a conceit whose tradition lives on: the majority of the galleries in the Fashion Museum (Bath) are arranged chronologically, so that visitors can metaphorically walk through time, where history is represented by historically dressed and accessorized mannequins in glass showcases on either side. It was always museum founder Doris Langley Moore's ambition that this should be so—as *Picture Post* reported in 1951 (before the collection had found a home):

> The word museum has such a musty sound. For most people it means a dead world of empty glass cases. But Mrs Langley Moore intends that London's new Museum of Costume, for which she has given her own magnificent collection, shall be refreshingly different. [...] Perhaps its greatest value will be that it will not only show dresses of long ago, but also those of the recent past, as well as contemporary clothes. (Beckett 1951: 19)

It was Moore's opinion that by bringing fashion history to the present, the past would be made more accessible and lively.

Likewise, the Costume Institute's collection was always intended to be encyclopedic, and although displays have varied in the logic of their organization, the desire to be comprehensive has always underpinned both collecting and display activities. In a 2001 exhibition, the Costume Institute documented its own history; the section for fashion (the collection also includes ethnic dress)

was titled "Costume History Timeline" and was organized chronologically. White mannequins with relatively detailed features were styled with white paper wigs (by contrast, the folk and ethnographic costumes were mounted on headless jointed tailor's dummies, thus highlighting their technical aspects rather than their being worn by human actors in social and cultural contexts) in a "continuous parade of fashion" (Koda 2001). Although the text noted the disparate collections and conflicting curatorial interests across the institute's development, the display was cohesive, reflecting what curator Harold Koda suggested was the original "simple formalist criterion" for the collection: "to clearly represent the style of their day [...] intended to form a timeline of Western fashion" (Koda 2001). Thus, in this exhibition, it was once again the continuous evolution of historical silhouettes rather than the piecemeal development of the collection that was on display.

Indeed, permanent or long-term exhibitions, even if they do not attempt to reflect all eras from which fashion survives in the museum's collection, do nevertheless tend to present an evolution of stylistic and social change. The McCord Museum's *Form and Fashion* exhibition (1992–1993), for example, documented only the fashionable clothing worn in nineteenth-century Montreal but nevertheless attempted to make larger claims about the history of fashion change more generally: "The women's attire held in the McCord Museum collection provides an apt illustration of the stylistic changes of this period through the evolving shapes of skirts, sleeves and bodices" (Beaudoin-Ross and Cooper 1992). This formalist manner of presenting historical dress seems to have been an institutional legacy: the McCord's 1965 exhibition, *Silhouettes*, was a survey arrangement of evening dresses from 1840 to 1965, demonstrating a typological evolution over time, ending in the contemporary.

Indeed, it was not just the case study institutions that featured such display techniques. The galleries of costume in Florence's Palazzo Pitti, for example, are characteristic of the typical approach to the display of dress. Opened in 1983, the displays were installed in forty-seven freestanding cases among the period setting of an enfilade of fourteen rooms in the palace. The clothing, from over 200 years of fashion, had been largely collected as textiles in a previous incarnation of the museum and was displayed on white Wacoal female mannequins (and custom matching male mannequins) styled with paper wigs drawn from corresponding visual sources. Within this survey of costume from the Baroque to the Belle Epoque were planned smaller displays themed around accessories (Arnold 1984: 378). Visitors could promenade through the series of rooms following the chronological displays, surrounded by the ghosts of Italian fashion past. More recently, LACMA's long-term fashion history exhibit was titled *A Century of Fashion, 1900–2000* (2000–2003), and featured mannequins grouped by decades: here, too, the arbitrary convention of dividing history by decades and centuries was underlined by the spatial layout of the objects on display.

Within and without history

An analysis of the text in many exhibitions also reveals a notion of history as an objective entity that stands apart from the object or indeed from fashion. The 1992 Costume Institute exhibition *Fashion and History: A Dialogue* is a particularly good example of this. The introductory text stated,

> Like other art forms, it [fashion] is both an immediate expression of contemporary culture and the genesis of a continuous history. Fashion is a dialogue between the ideas of the moment and those of the past; it is a discourse between the values and creativity of present-day society and those of history. (le Bourhis 1992)

In this formulation, history is not a narrative that arose from a series of documents, or even a social phenomenon, but instead an independent force of pastness. However, despite the curator's assertion that "the thematic organization of the diverse costumes challenges studies of clothing as simply social or historical documents" (le Bourhis 1992), the items on display were indeed documents of how ideas were (re)interpreted in different eras and places.

An illustrative approach like this runs the risk of being teleological (Hall 2000: 332). When an existing, external narrative takes precedence over the particularity of the individual object, as Mary-Ann Hansen writes, "an artifact can easily be replaced by another representing the same immaterial qualities" (Hansen 2008: 6). She elaborates, "reducing objects to representations of function or ideas leads us to a platonic relationship with matter and objects [...] objects can then be easily replaced by other objects representing the idea" (2008: 6) (Plate 7). This approach erases the differences and adaptations between objects and flattens them into a homogenous mass; it also suggests that rather than arising from a mysterious consensus reached by individuals with agency, the events of history are an inevitable fate. As opposed to presenting the historical fashions on display as contingent on ideas of taste even within a particular period, they are frozen into an illusion of stability. Admittedly, the use of umbrella terms for historical periods is difficult to avoid: objects that do come from a particular time frame must be described as such to do justice to their provenance and context. However, in exhibitions organized around "eras" or "ages," objects are transformed to props in a play or actors in a pageant, representing and recreating an external idea of a period such as "The Age of Napoleon" (Metropolitan Museum of Art 1989–1990) or "the confined world of a Victorian lady" (*Corsets to Calling Cards*, Royal Ontario Museum, 1995–1998). This type of approach demonstrates a perceived discontinuity between the past and the present.

Anne-Sofie Hjemdahl (2016) suggests that by the 1930s, museological discourses of art and design had shifted from exhibiting an organization of material typologies and highlighting particular aesthetic excellence to adding historical contextualization that emphasized periodicity. She shows how this approach enabled the construction of male curatorial authority distanced from female fashion consumption and also demonstrated modernist principles of linear progress through time. She cites the example of costume parades held by the Museum of Decorative Arts and Design in Oslo as

> playing out a kind of unified historical "dress past" against the present; "the new fashion and the new way of living." The past was presented as a time it was impossible to return to and the ancient forms, clothes and bodies were portrayed as gone, as lost and completely different from those of the contemporary fashionable woman. (2016: 109)

Equally, the parades provided a space for this encounter between past and present epochs, enabling visitors and viewers to positively judge their embodied present against the alien past.

However, this is merely one temporal lens through which to view the history of fashion. A creative example of an exhibition that dealt with the nature of history in fashion and the connections between past and present was Judith Clark's *Spectres: When Fashion Turns Back*, staged at the V&A in 2005 (originally staged as *Malign Muses* at the ModeMuseum, Antwerp, in 2004). By using highly original installation and spectatorship techniques, such as garments from different periods on mannequins mounted onto revolving cogwheels that demonstrated the self-referentiality of fashion history, Clark's exhibition manipulated space to make manifest "the illogical nature of fashion in its referencing of history, the means to distort the histories represented, and the way to experience the haunting of contemporary fashion by its past" (O'Neill 2008: 254). Furthermore, it demonstrated the duality of fashion's own cannibalistic relationship to its own obsolescence (Lehmann 1999: 301). Rather than offering up history as a commodity for the benefit of designers, however, Clark made manifest fashion's inherent historicity and opened up a critique of the museum itself. As a reviewer of the exhibition wrote, "she claims the exhibition not as an exploration of the relationship between fashion and history evidenced [*sic*] in the exhibits themselves, but as an exploration initiated by the display structures and viewing mechanisms that support and surround the exhibits" (O'Neill 2008: 258–259). The historical fashion on display in *Spectres* was documentary of an objective past but more importantly for the meaning of the exhibition as conceived by Clark also demonstrated the alterity of concepts of "now" and "then" within the museum space.

While Clark's is the best-known example of this curatorial approach, a precedent can also be found in Richard Martin's 1998 exhibition *The Ceaseless Century,* which mixed original eighteenth-century garments and accessories alongside nineteenth and twentieth-century revivals.[3] Fashions from all eras appeared side by side, "circulating and mingling with the easy elegance and conviviality of a bygone time. Costumes then and now can appear all but indistinguishable" (Martin 1998). Olivier Saillard attempted something similar in a 2011 exhibition titled *Le XVIIIe au goût du jour/A Taste of the Eighteenth Century* by staging modern and eighteenth-century pieces from the Musée Galliera side by side in the Grand Trianon at Versailles. Thanks to the interventions of Clark, Martin, and other contemporary fashion curators, historical dress can now be "perceived within temporal and spatial frameworks that are constructed, and more often than not those frameworks are theatrical. [...] Historical moments are not singular events that take place along a linear and progressive route. Time is spatial, theatrical, and scenographic" (Crawley and Barbieri 2013: 58). The display of fashion can question long-accepted conventions of historicity.

Constructing history with historical fashion

The fashion object in a gallery, therefore, is a tool with which to think historically, shrouded as it is in an aura of pastness. Indeed, a critical assessment of the impact of a given style or stylemaker is easier to undertake with a focus on past events. The past as embodied in an object, however, is not an objective reality: it is envisioned and represented according to a series of choices made by museum staff: conservators, curators, designers, and directors. If museums privileged only the authenticity of the object and its ability to communicate a stable past, representation would remain static; however, this is not the case. Objects are displayed and redisplayed, affected by "an ever-changing historical sensibility that is a product of the present, not of the past" (Handler and Gable 1997: 223). Exhibitions are created through a process of artful assemblage, creating an enhanced impression of authenticity through representations of periods out of the sparse documentation of individually surviving pieces of antique fashion. There are different approaches to doing this, as Martin and Koda noted:

> While the tradition of costume galleries in museums and historical societies had been to seek re-creation and simulation, thus providing historically correct coordination between the garment on display and its surroundings, Vreeland sought an editorial reading, accepting history as an effective force in and for contemporary life. (1993: 13)

Perhaps following the lead of Andy Warhol's displays in his *Raid the Icebox* project (RISD 1970), Vreeland subverted traditional ideas about display; the result made viewers question the historicity of museum artifacts. It is not just objects but their contexts and combinations that create implicit and explicit canons of meanings— meanings that are expressed through the spectacle of museum display. In the museums under study, exhibitions of historical fashion have attempted to recover presence by emulating "lifelike" situations and contemporary values or distancing viewers from objects for "objective" contemplation.

The museal mind-set is one of self-conscious temporality—an awareness that the present is different from the past but that the past is not unrecognizable for this distance. Equally, it is often infused with a moral purpose—to learn the lessons of the past by applying them to the present. In this way, the past is always seen through a filtered lens of today's needs (Preziosi 2007). As Susan Pearce points out, "the past is essentially unknowable, forever lost to us, and in museum displays its material traces are reconstructed into images of time past which have meaning only for the present, in which their genuinely intrinsic relationships to the past are used to authenticate a present purpose" (Pearce 1992: 209). However, for a knowing viewer, it is this referentiality that makes the history of exhibitions (the ways in which museums contextualize objects on the past– present continuum) so fascinating. The mechanisms of the museum exhibition are made visible when historical fashion is displayed as a time-dependent force. The space-time of the museum is the three-dimensional expression of the space- time of historical thought (Wallerstein 1998)—the medium is the message. The exhibitionary medium seeks to be invisible, uninvasive, immersive but smoothly conducive to shaping the viewer's understanding. The object on display anchors the relevant corresponding moment of history to the present.

However, it is important to recall that the museum is still a place of intellectual encounter and dialogue. As O'Neill writes, "the cloak of authority that pervades the lifeless quality of museum dress displays is not a neutral foil of clarity and comprehension at all; for there are many who have caught its flicker in the subdued light as a phantasmagoria thick with discontent" (2008: 259). Visitors can choose to suspend their intellectual disbelief and to interpret the dresses they see on display in the way the museum intends. Alternatively, they can respond to the dissonance and reflect on their individual experience to make meaning.

It would be incorrect to suggest that one ontological status of an object within or without a museum is more authentic than the other or that these are interchangeable—they are different but that difference is of critical importance. Historical fashion, a constructed medium to begin with, is perhaps the ideal museum object with which to explore and express the complexity of cultural meaning. In addition to its many other functions and definitions, it is a useful critique of the museum institution and the construction of history.

8

THE NEW LOOK: CONTEMPORARY TRENDS IN FASHION EXHIBITIONS

What do contemporary fashion exhibitions look like? According to Dobrila Denegri, some exhibitions are "mere displays of clothing," while others are "more complex cognitive or sensorial experiences," which address "body-related practices that can be called 'trans-fashional' and which dwell in that liminal zone between art, architecture, design, photography, film, performing arts and fashion" (2016: 299). José Teunissen suggests that such displays "use (crucial) objects, outfits, or installations as cornerstones, but the main focus is on unravelling the underlying concepts and narratives by showing the process by means of an installation, a film, or a special space, or through lighting and scenography, which give insight into the story behind the product and present underlying layers and processes" (2016: 290). Certainly, most writing on fashion curation does expand beyond the museum to include artworks dealing with clothing and the worn experience, and also designer or brand presentations for commercial gain. Yet this critical privileging of scenography as a new medium for conveying concepts suggests that the writers think that prior to their era, exhibitions of fashion were just some awkward mannequins in ill-fitting dresses haphazardly stuffed into cases. Indeed, there is a palpable narcissism of contemporaneity in the writing about fashion curation. Depending on the age of the writer, it seems impossible to them that exhibitions of fashion included any complexity or innovation before their own lifetime. This prejudice of the present, which insists that all progress has occurred only recently, leads to real mistakes in the literature. To claim, as Elizabeth Fischer does, that "clothing produced by the fashion industry has entered the museum since the late 1980s" (2016: 273) is simply incorrect. Likewise, Teunissen's claim that "since the 1970s, exhibitions and new fashion curation practices start to provide insight into the phenomenon of fashion as part of a larger narrative and a broader context" (2016: 291) devalues the important expert contributions of previous generations of fashion historians, curators, and allied museum professionals.

Indeed, as this book has shown, claims for innovation in display practices are often discovered to be unfounded when compared to archival evidence. The preceding chapters have demonstrated the surprisingly early use of many techniques, topics, and themes, which may today be thought of as modern. It seems that every generation sees itself as a new watershed: in 1973, Madeleine Ginsburg wrote that "costume and fashion are the most easily appreciated of museum objects and have never been more popular than they are today" (50), a sentiment echoed forty-four years later by journalist Natalie Atkinson: "Thanks to the proven appeal of style-related shows in recent years, general museums are now mounting crowd-pleasing fashion exhibitions as often as their specialized costume and textile counterparts do" (2017: L4). Exhibitions share themes, key objects, and layout features with international counterparts and their twentieth-century precedents. The similarities across the intellectual premise and the design expression of so many fashion history exhibitions studied in this research suggest that there is a vocabulary of shared notions of the relative importance of particular periods, themes, and aesthetics in the history of fashion across countries, decades, museum institutions, and the professionals working within them.[1] Evidence of the connections between the different contexts for fashion (in shopping, art, theater, and even the personal wardrobe) is key to the understanding of fashion in the museum context. Furthermore, fashion as presented in the museum has become a context of its own, one worthy of further investigation.

Fashion exhibitions are certainly breaking visitor records worldwide: the Met's 2015 show, *China: Through the Looking Glass,* had visitor numbers comparable to blockbuster exhibitions on Tutankhamun and the Mona Lisa; this broke the record previously held by the museum's 2011 exhibit, *Savage Beauty*, although the Alexander McQueen tribute became the V&A's most-visited exhibition ever when it was restaged there in 2015. In 2018, the Met broke records once again, when *Heavenly Bodies: Fashion and the Catholic Imagination* became the largest and most popular exhibition in the museum's history ("1,659,647 Visitors" 2018). The place of fashion exhibitions in museums can no longer be questioned when visitor queues stretch out the door; although expensive to mount, they are positive to the bottom line through their popularity and opportunities for marketing. Rikke Haller Baggesen has suggested that "the influx of exhibitions with a fashion twist, also in museums without fashion collections, is an example of how trends of interest run through the museum world, and of how following such fashions serve to promote the museum as trendy and up-to-date" (2014: 17). Fashion itself is coded as a modern phenomenon, as MOMA's 2017–2018 *Is Fashion Modern?* exhibition contended; taking its name from its 1944 predecessor, *Are Clothes Modern?*, the change in nomenclature is telling.

The last decade, in particular, has seen the growing popularity and marketability of fashion as a cultural product and a concurrent quantitative and qualitative rise

in its public visibility and academic discussion. Venues for its dissemination have mushroomed and this includes museum exhibitions. As Marco Pecorari writes, "The term 'fashion curation' is no longer linked exclusively to the museological practice but has changed its meaning, entering new fields and metaphorically performing new ways to create fashion ideas" (2012b: n.p.). Fiona Anderson (2000) traces this spread of fashion beyond museum walls and a new spirit of experimentation in its presentation to the 1990s. It seems that costume curators have answered Jennifer Harris's call to be more "eclectic and adventurous in their displays and interpretation of fashion" (1995: 79). Even exhibitions only tangentially related to fashion (at least not to fashion as a material practice) attract crowds through the use of the word: images by photographers best known for their fashion work, such as Horst P. Horst or Richard Avedon; stage costumes from performers such as Kylie Minogue, Annie Lennox, and David Bowie (all V&A); or art historical retrospectives of paintings that feature clothes (*In Fine Style; Fashion and Impressionism; Degas, Impressionism, and the Paris Millinery Trade*). Even if strictly fashion exhibitions are considered, Jeffrey Horsley has documented recent years in which as many as fifty such displays opened (Clark, de la Haye, and Horsley 2014: 170).

The exhibition without the museum

After a century of being delimited by existing museal conventions, fashion is again pushing the boundaries of display. Couture corporations celebrate and promote their heritage by displaying it in museums and traveling exhibitions or by lending archive pieces to celebrities to wear on the red carpet. Some collections are even being privately musealized as part of a corporate brand image strategy (Ferragamo, Gucci, Yves Saint Laurent, Valentino) or personal passion (Zandra Rhodes's Fashion and Textile Museum in London). Even public museums increasingly feature personalities from the fashion world to curate fashion exhibitions: Cecil Beaton and Diana Vreeland were pioneers, but more recently fashion industry stalwarts like Hamish Bowles, Christian Lacroix, and André Leon Talley have also tried their hand at curating.

Indeed, elite fashion brands like Chanel, Dior, Diane von Furstenberg, or Yves Saint Laurent can mount their own exhibitions in museums, curated by independents, and without the strict conservation restrictions, such as lighting and protective cases and barriers, required for the display of objects held in the public trust. These self-staged exhibitions are produced in order to expand the visibility of brands, as well as to provide access to the craftsmanship and tradition that otherwise only a very privileged few would have. Drawing on their extensive archives, and frequently inviting established and respected curators to provide intellectual focus, these exhibitions often travel to museum venues,

yet are less constrained by conservational concerns that these institutions may have for public collections held in trust for perpetuity. For these brands, even rare archive pieces are ultimately consumable for the purpose of continuing the design traditions into a profitable future. There is, as Mackie notes, a logic to this reuse and recycling, which is inherent to the fashion system itself: "In recalling its own past, fashion becomes its own museum of style" (1996: 337). Accordingly, the Gucci Museum, aptly located in the Palazzo della Mercanzia in Florence, was reinvented in early 2018 to be part of a multistory heritage shopping experience, including an exclusive boutique, a two-story exhibition of archive pieces curated by Maria Luisa Frisa, a gift shop and bookstore, and a restaurant.

The digital landscape also provides new means of visual access to fashion collections. *Europeana Fashion*, an online portal, argues that its centralized digital access to and in-depth information about fashion items in museums across borders create a similar experience to that of a blockbuster fashion exhibition (de Pooter, web). Likewise, Google's recent *We Wear Culture* project contains curated digital collections and virtual exhibitions that can be viewed any place, any time. Some nascent fashion museums are not even museums in the traditional sense: the New Zealand Fashion Museum, a private enterprise run as a charitable trust, has no physical location of its own but instead organizes temporary exhibitions and encourages individuals to upload images to create a local fashion archive (Foreman 2013: 12).

Increasingly, independent professional fashion curators and/or exhibition designers move between institutions to create installations that challenge the museum's traditional intellectual authority and its arbitrary arrangement of objects in space. Judith Clark is one example, and her work has been paradigm-shifting; Pantouvaki and Barbieri (2014) have suggested that she is the heir to the celebrated rule-breaking work of Diana Vreeland's tenure at the Costume Institute. Indeed, Nadia Buick has coined the term "adjunct curator" (2012) to describe individuals like Clark, who work between the private and public world of fashion display. Many of these curators share their experiences, contributing to the literature about fashion exhibitions from an extra-institutional perspective (see, for example, Frisa 2008).

Indeed, the most intellectually rigorous and thoughtful interrogations of the museum effect on fashion are owed to museum outsiders like Judith Clark. For example, her exhibition *Dictionary of Dress*, mounted at Blythe House in 2010, asked visitors to consider the many museum-specific technologies for the understanding of fashion. Labels, racks, cabinets, plinths, paper wigs, holographic projections, crates, and even Tyvek and twill tape covers were scattered across the different levels of the London museum storage facility in a game of hide and seek, asking visitors to inquire which were staged and which were unintentional. Likewise, *Vreeland After Vreeland*, the 2012 exhibition she co-curated with Maria Luisa Frisa at the Museo Fortuny in Venice, investigated,

through inventive staging of key artifacts and props, Vreeland's curatorial style at the Costume Institute. Perhaps, like the museum interventions of artist Fred Wilson, such critiques can only be possible by an outsider who can distinguish between the specificity of the collection and the generalities of museological practice.

Doing fashion history with museums

Similarly to the growing attention paid to curatorial legacies in art history and art criticism, museums have also begun to curate their own history. Svetlana Alpers argues that the ways in which a museum compels its audiences to look at objects—"the museum effect"—is a historically constructed method of endowing objects with an external set of aesthetic and cultural values (1991: 26–27), and the staging of historical galleries by some museums is designed to evoke an awareness of this effect. For example, the British Museum's Enlightenment Gallery, opened in 2003 to mark the museum's 250th anniversary, stages the early origins of the museum's collections in a way that demonstrates earlier understandings of the material world. Many galleries have recently chosen, after a period of modernist minimalism, to rehang their older paintings, particularly those of the nineteenth century in a salon-style floor-to-ceiling arrangement that better reflects the ways in which the artworks were originally meant to be seen; pioneered by British art historian and gallery director Sir Timothy Clifford, these rearrangements echo older styles of viewing art. Similarly, history museums have revived the *wunderkammer* approach and arranged exotic specimens from founding collections, or with little provenance, in cases emulating Baroque cabinets of curiosity. Even as art galleries have begun to experiment with reconstructing earlier methods of display in order to understand the power of presentation to the history of art, so have some fashion museums experimented with display to acknowledge the many ways by which fashion change can be understood to be part of the disciplinary context for dress history.

Some museums with fashion galleries intentionally acknowledge their display history as a tribute to their institutional history. The Fashion Museum in Bath, for example, still uses the Edwardian wax mannequins collected by Doris Langley Moore. At the Gallery of Costume in Manchester's Platt Hall, some of the original cases—essentially very large shadow boxes—are still in use for the historical collections, and in a separate room devoted to showing some of the nucleus of the collection, mannequins are posed in front of enlarged photographs from founder C. Willett Cunnington's publications on dress history. The V&A's redesigned Fashion Gallery contains a few nods to the museum's history throughout its permanent displays. Thoughtfully designed under the direction of Claire Wilcox, whose institutional affiliation dates back to 1979, cases contain

references to past displays. There is a riding habit from the original Harrods gift of 1913 in the "Taking the Air" section, and early twentieth–century mannequins are used to intentionally evoke earlier display styles. In the "Modern Woman" section, a 1930s Chanel pantsuit donated by Diana Vreeland for Cecil Beaton's landmark 1971 fashion exhibition is displayed by the very same Marcel Breuer chair on which a model lounged in a publicity photograph for that exhibition (Figure 8.1). The 1971 display of fashion is also referenced in the neighboring case, with a wire head hat mount that was designed for that show. Increasingly, watershed moments in a museum's history are commemorated, and sometimes even restaged, like the planned 2019 exhibition marking the fiftieth anniversary of the Museum at the Fashion Institute of Technology *Exhibitionism: 50 Years of The Museum at FIT*; there, curator Tamsen Young has proposed to selectively reconstruct past exhibitions staged at MFIT to show the evolution of the collections and curatorial ethos of the institution.

Comprehensive museum catalogs frequently feature some institutional history (Druesedow 1987; Mendes, Hart, and de la Haye, 1992; du Mortier 2016), and some even feature photographs or lists of key exhibitions. This movement toward writing institutional histories of collections through fashion exhibitions was spearheaded by Valerie Steele's landmark symposium "Museum Quality" in 2006 (later translated into a special issue of *Fashion Theory*), summarized by her brief history in *Fashion Designers A-Z* ([2012] 2016), which features photographs and summaries of major recent MFIT exhibitions. Likewise, *Fashion*

Figure 8.1 View of the Fashion Galleries, 1930s case, during the V&A exhibition *Ballgowns: British Glamour Since 1950*, May 14, 2012. © Victoria and Albert Museum, London.

Forward: Three Centuries of Fashion at the Musée des Arts Decoratifs Paris was "a celebration of the permanence of the ephemeral," as Pamela Golbin (2017: 10) wrote. Ghostly and magical, the fashions were able to transport the viewer back through history, but only if activated through mise-en-scéne: "Like Proustian madeleines that evoke past time, these treasures lay hidden away in the museum's storerooms, waiting for their prince charming to bring them back to life" (Golbin 2017: 11). The show's catalog has a thoughtful essay by Denis Bruna, which examines his institution's approaches to exhibiting textiles, historical costume, and contemporary fashion; typical in many ways, as this book has shown, the museum's holdings also followed the development from inspiring the textile and fashion industries with masterpieces of decorative arts excellence, to examining social history through clothing, to interpreting contemporary fashion to contemporary art. The catalog ends with a selective list of exhibitions of fashion and textiles held at the Musée des Arts Decoratifs since its opening in 1986; in addition to naming the curators of each, the individuals responsible for scenography and graphic design are also listed, which is a rare acknowledgment of the complex authorship of such displays in large institutions.

There is, therefore, interest among museum curators in preserving archival records of past exhibitions, both as a reflection of labor carried out and knowledge gathered. Exhibitions are ephemeral—time-bounded and often unaccompanied by published output such as a catalog—and if the research gathered is not fed back into the collection records and/or preserved for posterity, it is lost forever.[2] Projects that seek to experiment with and develop future directions for curatorial practice in the field must be informed in the practice of the past. In a world of increasing demand for academic rigor in curatorial practice, exhibitions are evaluated as scholarly output and Alexandra Palmer correctly suggests that documentation and debate around the content of fashion exhibitions will only serve to improve them in the future (2008b: 124–126). The few exhibitions made digitally available through installation photographs and curatorial insights as part of the Berg Fashion Library, for example, are made more precious as a means of studying exhibitions worldwide (museums as far apart as Santiago and London) and across time (1989–2016, at time of writing).

In addition, the preservation of exhibitionary material can dent the monolithic anonymous intellectual authority of the museum (Hooper-Greenhill 2000: 151) by attributing authorship to the curatorial and design teams responsible and thereby revealing their individual biases, strengths, and weaknesses. As few institutions maintain thorough records of past exhibitions as a matter of course (archives of the Met and the Brooklyn Museum are notable exceptions for the scope of the preserved material and its accessibility), it will take a critical mass of researchers making inquiries for this material to convince administrators of the usefulness and value of maintaining an archive of label copy, installation photographs, object lists, publicity and promotional material, catalogs and press clippings for every

exhibition. Labor-intensive and cumbersome though they may be, these records are necessary to introduce and maintain intellectual rigor into the discipline of fashion curation and to free it from accusations of frivolity.

Everything is curated

The nascent awareness of institutional legacy has coincided with a rise in the scholarly discussion of the practice of fashion curation. Table 8.1 presents a non-exhaustive list of academic conferences worldwide, which have specifically focused on the subject; there have also been special sessions at wider-ranging conferences. This demonstrates the professionalization of the discipline, as well as the increased opportunities for its discussion in a global network of professionals working in the field. Alongside the spate of recent publications and graduate programmes of study on the topic of fashion curation (such as the MA Fashion Curation at the London College of Fashion and the MA in Fashion and Textile Studies, History, Theory, and Museum Practice at the Fashion Institute of Technology), even nonspecialists can now engage in curatorial critique: in 2016, NYU's School of Professional Studies started to offer a continuing education course on "Fashion in Museums" (ARTS1-CE9193), which engaged participants in the debate of "does fashion belong in museums?" through study visits to major Manhattan museums with costume collections and displays.

To be a fashion curator is fashionable: although Valerie Steele once noted a lack of interest in fashion among her fellow fashion scholars (1991), that has recently changed: the personal style of her fellow MFIT curator Patricia Mears was profiled in a twelve-part series on the style blog *The Chic Index,* which calls itself "a curated survey of individual style" (Udé 2011). The German version of *Elle* fashion magazine featuring six fashion curators in their February 2012 issue ("Verhullungs-Kunst" 2012: 32–38) and the British magazine *Stylist* featured an interview with V&A fashion curator Sonnet Stanfill about her work as reflected through her wardrobe in 2013 ("Work Life": web). In a final, ironic twist, some museum fashion curators are musealized themselves: Diana Vreeland has been celebrated in exhibitions on her work at the Met in 1993 (*Diana Vreeland: Immoderate Style*), the Museo Fortuny in 2012 (*Diana Vreeland after Diana Vreeland*), and can be glimpsed in the V&A Fashion Gallery, where her 1930s Chanel pantsuit (collected for the museum by Cecil Beaton) was put on display in 2012 (Figure. 8.1).

This curatorial cult of personality can also be witnessed as Anna Wintour describes Andrew Bolton in *The First Monday in May,* a 2012 documentary that takes the same kind of behind-the-scenes approach to revealing the process of curating a fashion exhibition as to the creation of a couture collection: "Andrew is a real visionary," we hear her saying over a montage of scenes in the museum:

Table 8.1 *Recent academic conferences on fashion in museums*

Conference title	Location or organizing institution	Year
Museum Quality: Collecting and Exhibiting Fashion & Textiles	The Museum at FIT, New York	2006
Public Wardrobes: Rethinking Dress and Fashion in Museums	Nordiska Museet, Stockholm, Sweden	2011
The Body in the Museum: New Approaches to the Display of Dress	Museum of London	2012
The Discipline of Fashion: Between the Museum and Curating	University of Venice	2012
Fashion Curating Now	Parsons The New School for Design, New York	2013
Exhibitions and Interpretation (meeting theme of the ICOM Costume Committee)	Toronto, Canada	2015
Curation: Fashion in Context	Nordic Embassies, Berlin, Germany	2016
Fashioning Museums: A Conference Exploring the Nexus between Museums and Fashion	Australian National University, Canberra	2016
Fashion in Museums: Past, Present & Future	Rijksmuseum, Amsterdam, The Netherlands	2016
Fashion and the Museum	Het Nieuwe Instituut, Rotterdam, Netherlands	2016
From the Pleasure of Preserving to the Pleasure of Displaying: The Politics of Fashion in the Museum	Calouste Gulbenkian Foundation, Lisbon, Portugal; Universidade de Lisboa; Universidade Nova de Lisboa	2017
Front of House/Back of House: Fashion Curators and Conservators	*The Fashion Studies Journal*, New York	2017
Fashion and clothing collection, exhibition and research in small and medium-sized museums in Europe	Museum of Alsace, Haguenau-Strasbourg	2018
The Fashion of Curating Fashion	Parsons Paris	2018
La mode au musée: de la réalité à la réalité virtuelle, XIXe-XXIe siècles	Centre d'Histoire sociale/Paris I—IHTP/CNRS, Paris	2018

"Our job is help him execute his creative genius." Bolton is thus built up to be a creative force, like an artist. This kind of expressive practice that emphasizes a curator's personal vision and understanding has been identified as having its roots in the work of Diana Vreeland, and subsequent generations of fashion

curators have aspired to the level of idiosyncratic authorship in their oeuvre (Monti 2013).

While the Met may be a special case, even discussions of curatorship that emphasize its collaborative nature nevertheless privilege the role; Pantouvaki and Barbieri, for example define the role of the curator/exhibition maker as "a sentient, responsive and questioning expert of space and dress, whose insightful search for answers is guided by conversations with equally engaged collaborators" (2014: 92). Likewise, the recent edited volume by Vänskä and Clark is inspired by the art world's definition of a curator as a figurehead identified with particular display styles and critical perspectives (Clark and Vänskä 2017: 5), even as contributors within acknowledge the dialectical nature of exhibition development between curators, conservators, designers, stylists, and others. The recent issue of the journal *Fashion Projects* further contributed to the reification of the curator in its format of interviews with celebrated costume curators, even as they insisted within that "there isn't a field of fashion curation [...] the critical skills for fashion are the same critical skills for other fields" (Mida 2018: 62). In truth, the role of the fashion curator has changed over time and varies widely across different institutions, as the 2016 Scholar's Roundtable discussion at the Costume Society of America annual symposium showed (Mida 2017). All this focus on curation reduces the exhibition into an individual's expressive act, rather than an expression of a greater idea.

The fundamental questions about practice remain, however. Suzy Menkes (2011) summarized the key ones as follows: Is fashion really so exhibition worthy? Are there explicit standards by which the various shows should be judged? What is a fashion exhibition for? The answers to these questions have varied in different institutions and over time. Some fashions are not seen as exhibition-worthy but that is often a result of a mismatch between the institution's remit and the concept behind the exhibition, rather than a problem with the pieces themselves. As another insightful commentator posited, "The real question is not whether museums are too good for fashion but whether they're good enough" (Postrel 2007: 133). She refers to the visual qualities on which exhibitions rely to the exclusion of movement and touch, impossible under the circumstances. But if we concede that a museum, like any other visual medium, can never fully possess all the characteristics of what it portrays, but only translate them into different dimensions, then we understand that the question is not one of compromise but of approach. The measuring of a show's standard is more about whether the pieces and scenography carry forward the curatorial argument: by looking at the pieces on the plinths, can you see what the label text wants you to see? As ROM curator Alexandra Palmer recently commented in an interview with fellow Canadian curator Ingrid Mida, "If you go into an exhibition and you don't really understand why all those things were

together, and you haven't really got much out of it except for seeing some nice frocks, then the thesis was not clear. [...] That is not a successful exhibition" (Mida 2018: 59). The closest thing to an industry standard is the evaluation criteria for the Richard Martin Exhibition Awards from the Costume Society of America:

- excellent and innovative exhibition concept and design
- quality of research, scholarship, and interpretation presented in the exhibition
- innovative, appropriate, and engaging use of objects, media, and design elements
- adherence to good conservation standards for mounts, light levels, climate control, etc.
- overall excellence, encompassing the ability to serve as a model for other exhibitions and to evoke a transformative response from viewers

The degree to which an exhibition is excellent or innovative is, of course, relative to the other entries. It is accepted that museum visitors will spend, on average, only seconds in front of any given displayed object (Smith and Smith 2001). A small minority will linger and carefully digest the visual, written, and sensory material available to them, especially if it bears relation to something they are already familiar with; many will choose to pass by without looking at all. But that fleeting glance is often all the opportunity a curator has to make a statement. The viewer, relying on their own complex matrix of previous experiences, memories, emotions, knowledge, values, and senses (all gained through gradual acculturation and personal accumulated experience), forms their own conclusions and moves on. The power of displays might lie not in their similarity to other visualities but in the dissonance that opens a dialogue with the confused visitor, pausing to evaluate the unfamiliar (Brieber, Nadal, Leder, and Rosenberg, 2014).

Given all the various things that fashion can represent—capitalism, social conventions, art and craft, performance and identity, embodied experience, the imagined past—the curatorial concern is in adapting the presentation medium to suit the message. As Luca Marchetti (2017: web) has claimed, "The success of the more and more numerous fashion exhibitions of the last years is largely due to this enriched complexity: the museum appears now to be the ideal context in order to spectacular-ize the multilayered fashion imaginary and its cultural implications." The museum (rather than a shop vitrine, a funeral procession, a theatrical pageant, or an illustrated book) is itself more than a venue: it is a medium.

Style as substance

The focus on the devices—both literary and visual—that the museums studied have brought to bear on historical fashion of necessity highlights the constructed nature of the exhibitionary medium. In general, historical fashion in a museum can be made to fulfill a number of purposes. Historical fashion can demonstrate histories of style, document the disappeared past, communicate national histories (as in the clothing worn by famous national heroes and heroines or produced within the country), and exemplify techniques of construction and surface decoration. Moreover, as this book has shown, it can satisfy the human voyeuristic urge by its spectacular and wondrous appearance, provoke nostalgia and facilitate memory work, tell personal stories or enable their communication, and foster a sense of time-space displacement. None of these are mutually exclusive, but some are privileged over others in different display styles. Historical fashion has been used as a tool with which to imagine and represent histories and contexts.

To define the schema of a historical fashion exhibition is to recognize its many forms and its connectedness to other media. For many, museum exhibitions are one source of information about historical fashion, alongside books, films, photographs, extant objects in personal collections, etc.; the intellectual authority of the museum and the expertise of its design, conservation, and curatorial staff provide a unique synthesis of the knowledge available about the topic. Certain constant elements can be expected: there will be a historical theme (usually based on a period or aesthetic, though sometimes biographical by producer or consumer), objects, mannequins, text labels; there may be an accompanying catalog or at the very least an illustrated brochure; there will be media publicity. While one can envision a historical fashion exhibition as being staged with mannequins in a gallery setting, this would underestimate the importance of the wider context within which the exhibition is set: its boundaries are not delimited by the museum space but bleed into academic discourse, popular visual and print cultures, and the visitor's own imagination. The "museum set" (Baxandall 1991: 33) of the curator, as much as of the visitor, acts as a paratext that guides the interpretation of fashion history; because of it, objects cannot escape the context of the museum but actually gain a new meaning from that context. As the gallery architect Thierry Despont noted, "decorative art is about placing objects in environments" (Farrell 1996: 5) and indeed, any re-creation of a context, whether it is a period room or even just a mannequin with a period-appropriate figure, is also an opportunity for the willing suspension of disbelief in the sublimating artistry of the museum.

The celebration of the museum exhibition of historical fashion—whether in a store, as part of a brand retrospective, or an archival rediscovery on the part of any given museum—suggests that over the course of the twentieth century, a new visual

genre has developed. While dress on the body has a multiplicity of meanings and can tell a variety of stories (or sometimes none at all), and museum curators may strive to tell particular narratives, it is my belief that displayed dress actually subverts all those narratives by virtue of being a separate visuality altogether. An example is the Valentino Garavani Museum, in reality a virtual archive of the couturier's designs, launched in 2012 (Association Valentino Garavani Archives: web). The online animations (Plate 8) are modeled after the architecture of a museum, with Classical columns, plinths, and white mannequins. In a digital environment, there is no real need to choose this particular aesthetic: freed from the boundaries of the physical, Valentino dresses could float in an undefined space. The decision to digitally duplicate a stereotypical museum suggests that for Valentino, the medium is the message: the display style supports the brand's claims to heritage, authenticity, and value.

Thus there is a museum-ness to museum fashion, a visuality that is specific to that context. It does not merely reproduce what dress looks like in a shop, a wardrobe, a painting, on stage, in the street, or in a book but produces a specific kind of encounter. The exhibitedness of it—the fact that it's there to be looked at—differentiates it from other contexts. Crowds of mannequins—lifelike but not living—on plinths or behind glass, wearing outfits that are beyond the lived experience of most people, presented in ways that make a visual impact first (groupings with props, backgrounds, or lighting to accentuate their relationships) create spectacle. Even if only encountering a modest series of minimalist cases, visitors expect to be able to wonder at the fabrics, embellishments, waistlines, and hemlines, so different from their own.

The spectacle of fashion in the museum is a recurring trope in criticism. An Australian artist, Tony Albert, objected to the spate of fashion exhibitions in Australian museums and galleries in the strongest terms: "We've got this artificial programming now happening, and it is about the spectacle, and it is about what's fashionable, and I totally believe that is ethically wrong" (quoted in Cathcart and Taylor 2014: web). It is not only artists who have sounded caution, as Riegels Melchior has written,

> In critical terms, the celebration of fashion and the catwalk economy ... currently taking place in image building nations and museums could be described as a celebration of the surface, of values associated with the superficial, as a celebration of style and luxury. (2012: 61)

Spectacle in the context of these criticisms is tantamount to superficiality. However, this is a false equivalence. Fashion exhibitions are not a matter of style *versus* substance but simultaneously style *and* substance. Indeed, style is the substance of a fashion exhibition: organizers must utilize all the resources available to them in order to create an appropriate match between the concept and the content.

This book cannot conclude with a general statement about the optimal methods of representing historical fashion in an exhibition. Its aim is not to produce an extended exhibition review, and there is no Platonic ideal of a fashion history exhibition, so none can be proposed. Rather, through the investigation of historical methods, this book has defined the various iterations of historical fashion in a gallery setting, so that the aforementioned techniques and practices are informed ones and not chosen arbitrarily or intuitively. Some exhibitionary idioms work better than others for particular theoretical premises, and curatorial self-reflexivity about that must be encouraged. If practitioners can look back upon the choices made by their predecessors, critically evaluating the results and responding to them in their own work, they would be participating in a productive dialogue of fashion curation. After a century of practice, curatorial and design choices must now be conscious, not trial and error, and this book has gone back to the beginning, providing a meta-analysis of the possibilities and a critical discussion of the consequences thereof. Furthermore, it is a tribute to the generations of exhibition makers, some famous, others now-forgotten: their labor and expertise built the reputation of the discipline. Now is an appropriate time to contribute a more comprehensive analysis of museum practice in representing fashion history to an increasingly active professional and academic discourse.

For over one hundred years, fashion exhibitions have reminded viewers that fashion is transcendent: it is more than merely clothing, or an ugly reminder of capitalism, and more than an elite art form. Fashion lives beyond our bodies and demonstrates that time is cyclical. To claim that a fashion exhibition consists of some mannequins accompanied by explanatory labels is a little like saying that a painting is some daubs of pigment on a canvas with a title. Both claims are, strictly speaking, true but infinitely more complex in practice; this book has described some of the complexities of that practice. Many of the techniques and themes that appear modern were in fact attempted surprisingly early, as the genre of fashion exhibitions was being developed and tested. Not only do I hope that with my having defined and analyzed the schema of fashion exhibitions, curators will begin to deploy the tropes discussed in this book more consciously and effectively, but also that students of dress history will begin to see more clearly the biases and contexts of one of the major sources of information for the history of fashion. Furthermore, they can be inspired by the surprising and creative dress displays of the last century or more. The documentation of past practice in fashion exhibitions can inspire future developments.

NOTES

Introduction

1 Digital museums as well as interpretive galleries that use only images are growing exceptions.

Chapter 1

1 This is probably inspired by the contemporary practice of milliner's mannequins or "Pandora" fashion dolls, which diffused the styles of the day in miniature to elite clients (see von Boehn [1929] 1972). Museums in the twentieth century also exhibited historical fashion on dolls, for example: historical fashion dolls made by Theodora Lightfoot at the Metropolitan Museum of Art in 1915–1916 ("Love of History" 1915: 18) or the postwar Parisian couture dolls wearing historic and contemporary designs of the *Théâtre de la Mode*, which began their world tour at the Louvre Museum in 1945, passing through the Brooklyn Museum in 1949, and eventually entering the collection of the Maryhill Museum of Art in 1952 (see Charles-Roux 2002).

2 As journalist Bernard Champigneulle wrote, "It really is a strong paradox that the capital of elegance and fashion should not yet have the Dress Museum about which people have been talking for a long time" (1951: 17). The collections of the Society for Historical Costume, headed by Maurice Leloir, were donated to the City of Paris and displayed in various venues, including the Musée Carnavalet and the Palais Galliera from 1920; these were, for the most part, and until very recently, displayed on realistic mannequins in period settings. Dress historian François Boucher organized a temporary display in the Charpentier Galerie with furnished vignettes populated with dresses from the collections of the Union Française des Arts du Costume in 1951. The UFAC collections eventually entered the Museum of Fashion Arts, the costume museum of the Louvre Museum's decorative arts branch, which opened in 1986 and also featured some period settings.

3 Even as Langley Moore negotiated with the City of Bath for a permanent home for her collection, one of the city councillors was quoted as saying, "Bath does not want these discarded old clothes" (Adburgham 1963: 6).

4 The collector in question, who dreamed of creating a museum devoted to fashion like the ones she saw in England, sold her collection to the National Gallery of Victoria in 1974 (Clark 1975).

5 It is interesting to note how many early fashion and textile curators were the wives of existing male museum staff: the curator of lace at the Pennsylvania Museum in Philadelphia was the wife of SW Woodhouse Jr, the acting director (in this capacity, she provided a testimonial for laundry soap in *Good Housekeeping* magazine ("La France" 1924: 180)); Similarly, the first curator of dress and textiles at the Museum of Decorative Arts and Design in Oslo, Norway, Edle Due Kielland, was the wife of the director (Hjemdahl 2016: 112).

6 This is still the case today: interviews with leading contemporary fashion curators in volume five of the journal *Fashion Projects* (Granata 2018) reveals that only a few have had formal fashion, history, or museological training.

Chapter 2

1 While "lay figures"—mannequins used by painters for anatomical reference—had existed for centuries (Munro 2014), commercial clothing mannequins weren't necessary until the invention of mass-produced clothing in standardized sizes, a development that coincided historically with the wax museum. The store mannequin, therefore, was a literal stand-in for the future customer of the clothing on display (see: Matthews David 2018)—the opposite of the museum case, where the mannequin stands in for the past wearer.

2 It should be pointed out that this kind of misogyny persisted well into the twentieth century, with the full participation of women: a news item about the 1962 reopening of the V&A's Costume Court was categorized as "not for men" (Haddock 1962: 1287).

3 However, the British Museum's library and print rooms did contain fashion-related material that was subsequently used by individuals researching fancy dress: "The Queen's State Costume Ball is among Town Talk to come; but there is already a rush of ladies to the British Museum for model Restoration costumes" ("Personal News" 1851: 483).

4 Some designers, such as Jacques Doucet and Christobal Balenciaga, maintained their own private collections of historical dress: both of these collections are now in the custody of the Galliera.

5 Textile study rooms were established explicitly to support industry but fall outside the remit of this book. See Fee (2014) for a history of these.

6 The museum's study collection—The Edward C. Blum Design Laboratory—was moved to the Fashion Institute of Technology (FIT) to train students and designers in New York's Garment District, and loan pieces from the museum were the nucleus of what would later become the Museum at FIT (Steele [2012] 2016: 25–26).

7 Such industry connections to museums still continue. For example, in 2013, the Council of Fashion Designers of America celebrated its 50th anniversary with an exhibition, created in collaboration with the FIT; featuring work by key American designers, the exhibition traveled to Boca Raton, Florida.

8 Curator Florence Müller suggests that in France, the adoption of fashion in the Musée des Arts Decoratifs in Paris in the 1980s and subsequent exhibitions dedicated to living designers were motivated by the need to boost the commercial value of a declining Western textile industry by highlighting its traditions (2016: 254).

9 A term denoting a non-Maori New Zealander.

10 Likewise, the Philadelphia Museum of Art used wax mannequins by the celebrated maker Pierre Imans for their Quaker costumes in the 1960s (McGarvey and Carnahan 1961: 22).

11 Alongside Imans and Rootstein, Stockman and Ralph Pucci mannequins are widely used, and the Italian manufacturer Bonaveri even published a book listing a chronology of the uses of their forms in museum exhibitions (Bauzano 2012).

12 Similarly, *Fashion DNA*, the 2006 exhibition sponsored and designed by the retailer Mexx with the Rijksmuseum in Amsterdam, featured a catalog in the form of a fashion magazine, which could be purchased at newsstands across Holland; this was in keeping with the show's theme of recurring body ideals across history to the present day (du Mortier and Meijer 2016: 242–243).

13 Commercial fashion mannequins bear associations of modernity, as a review of the Costume Museum of the City of Paris demonstrates: "An effect of authenticity is achieved by placing the manikins in roomlike settings. Reproductions of period wallpaper further enhance this make-believe, but the manikins shatter it with their identical bland peachiness. They are modern and of a design suitable for department store displays, not for rare historic costumes" (Molli 1963: 13). In fact, the smiling mannequins had been specially commissioned from the firm Siegel for display ten years earlier, "all suggesting youth, without any naturalistic colouring" ("A Fascinating Evocation 1954: 1066) (Plate 3). The elision of youth and modernity is an interesting one, suggesting that the reviewer expected old costumes to be worn by mannequins of an aged appearance.

14 The mannequins have themselves been musealized, as they featured in an exhibition at New York's Museum of Art and Design, *Ralph Pucci: The Art of the Mannequin* (2015).

15 More recently, the ROM used large photographs of the Dior showroom at 30 Avenue Montaigne in Paris as backdrops for their 2017–2018 *Christian Dior* exhibition; the arched details above the mirrors of the salon were repeated as decals on the fronts of glass display cases containing mannequins.

16 Similarly, the first gallery of the *Alexander McQueen: Savage Beauty* exhibition was designed to look like the concrete of the designer's first atelier space.

17 Dior, as the company is now known, no longer have need of an institution like the Costume Institute to promote themselves: the brand was celebrated in an exhibition organized by and drawn from its own archives at the Pushkin Museum of Fine Arts in Moscow in 2011, for example (see also Menkes 2011.) However, the founder was a supporter of historical fashion in museums in his lifetime: he showed a collection of his clothing in London in support of Doris Langley Moore's projected costume museum in April 1950 ("A Costume Dream" 1976: 12).

18 This approach was also taken by the ROM for the 2017–2018 *Christian Dior* exhibition, which also used the couturier's *griffe* as a design element for the title signage and dressmaking dummies as mannequins; the interpretation featured digitized details of design and construction on tablets for garments on display.

19 For example, American *Vogue* editor-at-large André Leon Talley began his career assisting Diana Vreeland at the Costume Institute and recently curated two exhibitions on Oscar de la Renta (2015; 2017); Likewise, English *Vogue*'s editor-

at-large Hamish Bowles has lent pieces from his private collection for exhibitions at the Museum at FIT and has himself curated exhibitions, such as *House Style* at Chatsworth House (2017), as well as the fictional Met exhibition for the film *Ocean's 8* (2018).

20 It has been suggested that it is not merely donations of artifacts that drive such high-society-focused exhibitions; indeed, the straitened financial circumstances of museums require them to seek sponsorship and financial support. Journalist Alexandra Peers suggested that "the Costume Institute has been surrendered to the fashionista set for fundraising reasons; that it is the one area of the museum where it is okay to endorse corporations, so they do," and that "the Met is fighting bitterly for a handful of fortunes and that society-gown shows are an efficient way to glorify those who control those fortunes" (Peers 2014: web). This is a cynical view but one that cannot be lightly dismissed, especially given the contrast between such elitist programming and the concurrent striving of the same museums to champion their social relevance and egalitarian ambitions (see Sandell and Nightingale 2012).

21 As noted earlier, effigies are the predecessors of display dummies. In more recent times, the garb of these royal bodies has been analyzed by dress historians, because they are often the only surviving examples of costume types. Notable in this literature is Janet Arnold's work.

22 Tussauds was criticized in the nineteenth century for this; an 1846 *Punch* cartoon suggested that it may be more instructive for Tussauds to display the dress of the working classes in an alternative Chamber of Horrors, the admission money going toward improving their living conditions (Leech 1846: 210).

Chapter 3

1 Almost identical display methods are also seen in the early display rooms of the Rijksmuseum and the Stedelijk museums in Amsterdam, *c.* 1909–1919 (du Mortier 2016: 8–10). Disembodied mannequins are further discussed in Chapter 6, and the perceived ghostliness of this display style is analyzed in Chapter 7.

Chapter 4

1 It was actually Millet's widow who donated his former studio properties, but Millet himself had, prior to his tragic death in the *Titanic* disaster, served as a museum trustee.

2 For example, the Royal Academy's 2010–2011 exhibition *Aware: Art Fashion Identity* featured the work of thirty contemporary artists, including such well-known names as Marina Abramovic, Yoko Ono, Grayson Perry, Cindy Sherman, and Yinka Shonibare, who deal with themes of fashion, clothing, costume, and dress in their work. The show also included works by leading avant-garde and conceptual fashion designers such as Hussein Chalayan, Martin Margiela, and Yohji Yamamoto. Likewise, *The Art of Fashion: Installing Allusions* at the Museum Boijmans Van

Beuningen in 2009–2010 featured the ways in which contemporary fashion designers use the techniques of art and how the visuals of fashion have influenced the work of artists.

3 Rosenthal continues on to compare a dress in a museum to Marcel Duchamp's infamous urinal "fountain," found object sculpture of 1917; his point seems to be that fashion in art museums transgresses traditional disciplinary boundaries and definitions but, like modern art, is a product of modernity.

4 Quite unlike the Costume Court at the Rijksmuseum in Amsterdam opened the same year, which featured period room vignettes with lifelike mannequins commissioned from a theater designer also known for department store window displays (du Mortier and Mejer 2016: 239–240).

5 The 1983 Costume Court renovation was much more explicitly white cube in style: to prevent the visitor from being distracted from the sculptural effects of textiles, cuts, and silhouettes, the space was painted a uniform beige, and the mannequins were gray. Sir Roy Strong, the director of the museum, pointed out that this approach concentrated attention on the aesthetic form of the clothes on display: "We are not trying to present it as part of an illustrated book or as the social history of Jane Austen's world." Furthermore, Strong specifically contrasted the V&A's approach to the Met's Costume Institute, "where the clothes are in settings that strongly evoke the mood of the period in which they were designed" ("Fashion Museum Reopens" 1983: F6).

6 At the time, this fashion-centered display was the only one of its kind in the United States (Lee 1916: 238).

7 Visitors have come to expect a chronological narrative in permanent exhibitions of fashion: Claire Wilcox designed the V&A's 2012 fashion gallery redisplay with this in mind, after public consultation and feedback demonstrated demand (Schwartz 2010: 121).

8 As examples throughout this book have shown, Napoleonic relics and the Napoleonic era more generally have been popular subjects for exhibitions from the nineteenth century on.

9 I am inspired here by Wölfflin's notion of "painterliness" (*malerisch*): the notion of the mark of the artist that allows a viewer to connect with them materially (1932). The idea that a designer has a "signature style" echoes this notion. For a discussion of the painting as autograph, see Guichard 2010.

10 The way in which this aura of genius is symbiotic to the notion of the museum as a temple of the muses can be seen in popular culture; for example, episode three of *Project Runway*'s seventh season (Lifetime, 2010) had the aspiring designers visit the Met to get inspiration from iconic gowns by celebrated couturiers in the Costume Institute collection. The contestants were then given the largest budget in the show's history to create couture-like "museum-worthy" garments for the challenge. Although the discourse was nominally about artistic merit, the equivalence of high budgets and high cultural value also suggests a connection between commercial and cultural capitals.

11 More sympathetic art historians and critics, like Norman Rosenthal (2004), have pointed out that art is also a commercial industry fueled by consumerism, and that fashion and art have seen many collaborations.

Chapter 5

1 See Jones (2010) for a reevaluation of the materialist approach to authenticity in favor of a relational one.

2 It is possible that this tableau was reused from the Palais du Costume displays of 1900, organized by the couturier Felix.

3 It should be noted that this intuition is really the result of familiarity with the subject matter, built up over years of experience, rather than any lack of research rigor. The contrast being drawn is between exhibitions that demonstrate a provable reality (such as faithfully reproducing a period image) versus creating a plausible assemblage.

4 In 1925, the previous arrangement of the V&A's costumes had been criticized by dress historians Kelly and Schwabe as "shown to such disadvantage as largely to discount their educational value" (1925: xi).

5 A similar principle is behind Australia's Cavalcade of History and Fashion, a "museum without walls," which makes its collection of historical gowns accessible to the public through a mixture of parades featuring live models in period costume and presentations and exhibitions featuring gowns on mannequins.

6 See Wood (2016) for examples of good intentions stymied by a lack of resources at the Gallery of English Costume, Platt Hall, Manchester.

7 Despite holding a very significant and comprehensive collection of clothing, as of 1976, the Museum of London no longer divides its display by specialist areas, preferring instead an approach that mingles objects by period and integrated social context.

Chapter 6

1 Mida notes that the catalog for *Savage Beauty* did the opposite: images of models wearing dresses from McQueen's archive were digitally altered to look like mannequins (2015b: 48).

2 An important function of photographs showing visitors observing displays is to demonstrate the museum's physical positioning of objects in relation to viewers; most archival photographs depict displays straight-on, framed by the dimensions of the case, whereby the proportion and perspective that are so key to museum scenography are lost.

3 "Judy" is a term for a female dress form, although it is usually used for a sewing dummy and not a display mannequin. This usage seems to be peculiar to Mrs. Brett.

4 This is the case for the retail world as well (see Schneider 1997); one notable exception are the shaded mannequins used by the Museum at FIT.

Chapter 7

1 I am grateful to José Blanco F. for generously sharing his unpublished paper and presentation (2013) on this exhibition with me.

2 Museums offer a space-time hybrid, which may be divided or constructed differently depending on what concept is under discussion (see Wallerstein 1998). The Bakhtinian notion of chronotopes is also relevant here, as galleries are also "places of intersection of temporal and spatial sequences" (Folch-Serra 1990: 261). For a discussion of sequence and chronology in narrative, see Ricoeur 1980.

3 Judith Clark paid tribute to this earlier show in the "New Exhibitionism" section of her 2016–2017 exhibition, *The Vulgar: Fashion Redefined* (Barbican, London), with a homage to its staging, inviting viewers to consider how museums define taste, style, and aesthetic merit for fashion (see Fotheringham 2017).

Chapter 8

1 It is also important to consider the intellectual and institutional genealogies of practitioners, many of whom, by the end of the twentieth century, may have studied under or took over from autodidacts, thus participating in a growing tradition. See interviews in Granata 2018.

2 Madeleine Ginsburg experienced similar frustration at the indiscriminate culling of files and lost expertise when attempting to document the early history of the Costume Society (Ginsburg 2005).

REFERENCES

"1,659,647 Visitors to Costume Institute's Heavenly Bodies Show at Met Fifth Avenue and Met Cloisters Make It the Most Visited Exhibition in The Met's History" (2018), Metropolitan Museum of Art media release, 11 October, available online: https://www.metmuseum.org/press/news/2018/heavenly-bodies-most-visited-exhibition (accessed October 25, 2018).

Adburgham, A. (1955), "The Museum of Costume," *The Manchester Guardian*, 10 June: 3.

Adburgham, A. (1962), "Clothes Past," *The Guardian*, 22 June: 8.

Adburgham, A. (1963), "Museum of Costume at Bath," *The Guardian*, 13 May: 6.

Alpers, S. (1991), "The Museum as a Way of Seeing." In I. Karp and S. Lavine (eds), *Exhibiting Cultures: The Poetics and Politics of Museum Display*, 25–32, Washington: Smithsonian Institution Press.

American Home Economics Association (1932), "Historical Costume Exhibit," *Journal of Home Economics* 24 (7): 651.

American Home Economics Association (1937), "Newark," *Journal of Home Economics* 29 (4): 282.

Anaya, S. (2013), "Are Blockbuster Museum Shows Helping or Hurting Smaller Fashion Exhibitions?" *Business of Fashion*, June 12, 2013, available online: https://www.businessoffashion.com/articles/intelligence/are-blockbuster-museum-shows-helping-or-hurting-smaller-fashion-exhibitions (accessed June 13, 2013).

"Ancient Costumes in Art Museum" (1911), *New York Times*, 11 April: 13.

"Ancient Court Dresses" (1833), *The Spectator* 6 (257) (1 June): 503.

"Ancient Models" (1955), (newsreel), Pathé, 15 August.

Anderson, F. (2000), "Museums as Fashion Media." In S. Bruzzi and P. Church Gibson (eds), *Fashion Cultures: Theories, Explorations and Analysis*, 371–389, London: Routledge.

Ankersmit, F. (2005), *Sublime Historical Experience*, Stanford: Stanford University Press.

"Antiquities at the International Exhibition—Costumes" (1873), *The Antiquary*: 3–4: 219–220; 243–244; 271–272; 303; 51.

Appadurai, A. (1986), "Introduction: Commodities and the Politics of Value." In A. Appadurai (ed.), *The Social Life of Things: Commodities in Cultural Perspective*, 3–63, Cambridge: Cambridge University Press.

Appleton Read, H. (1929), "Rainbow House Talks on Art of Dress Draw Crowds to Brooklyn Museum," *Brooklyn Daily Eagle*, 24 October: 6E.

Arnold, J. (1973), *A Handbook of Costume*, New York: SG Phillips.

Arnold, J. (1984), "Costumes at Palazzo Pitti, Florence," *The Burlington Magazine* 126 (975): 371–378.

Ashelford, J. (1996), *The Art of Dress: Clothes and Society 1500–1914*, London: National Trust Enterprises.

Association Valentino Garavani Archives (2012), *Valentino Garavani Museum*, available online http://www.valentinogaravanimuseum.com/ (accessed December 4, 2017).

Atkinson, N. (2017), "The Art of the Deal," *Globe and Mail*, 8 April: L.4.

Aynsley, J. (2006), "The Modern Period Room: A Contradiction in Terms?" In T. Keeble, B. Martin, and P. Sparke (eds), *The Modern Period Room: The Construction of the Exhibited Interior 1870 to 1950*, 8–30, London: Routledge.

Baedeker, K. (1870), *The Rhine and Northern Germany*, rev. 4th edn., Koblenz: Karl Baedeker.

Bal, M. (1996), "The Discourse of the Museum." In R. Greenberg, B. W. Ferguson, and S. Nairne (eds), *Thinking about Exhibitions*, 145–158, London: Routledge.

Bal, M. (2003), "Visual Essentialism and the Object of Visual Culture," *Journal of Visual Culture* 2 (1): 5–32.

Bann, Stephen (1984), *The Clothing of Clio: A Study of the Representation of History in Nineteenth-Century Britain and France*, Cambridge: Cambridge University Press.

Bass-Krueger, M. (2018), "Fashion Collections, Collectors, and Exhibitions in France, 1874–1900: Historical Imagination, the Spectacular Past, and the Practice of Restoration," *Fashion Theory*. DOI: 10.1080/1362704X.2018.1425354, published online January 31, 2018.

Bather, F. A. (1912), "The London Museum," *Museums Journal* 11: 290–297.

Bathke, L. E., with J. Fung, G. Petersen, C. Gero, and L. Mina 2016, "Mannequins: Disassembled," *AIC News* 41 (2): 1, 3–5.

Bauzano, G. (ed.) (2012), *Mannequins Bonaveri: A History of Creativity, Fashion, and Art*, Milan: Skira.

Baxandall, M. (1991), "Exhibiting Intention: Some Preconditions of the Visual Display of Culturally Purposeful Objects." In I. Karp and S. Lavine (eds), *Exhibiting Cultures: The Poetics and Politics of Museum Display*, 33–41, Washington: Smithsonian Institution Press.

Beaudoin-Ross, J. and C. Cooper (1992), "Form and Fashion: Nineteenth Century Montreal Dress," Exhibition file, McCord Museum archives.

Beckett, M. (1951), "Out of London's Fashion Museum," *Picture Post*, 21 April: 18–19.

Behlen, B. and C. Supianek-Chassay (2016), "Peopling the Pleasure Garden: Creating an Immersive Display at the Museum of London." In M. M. Brooks and D. D. Eastop (eds), *Refashioning and Redress: Conserving and Displaying Dress*, 199–212, Los Angeles: Getty Conservation Institute.

Bell, Q. (1958), "The Greatness of a Minor Art," *The Listener*, 3 April: 586.

Bender, M. (1961), "Fashion Historian Eyes the Future for Stylists," *New York Times*, 21 November: 42.

Bennett, T. (1995), *The Birth of the Museum*, London: Routledge.

Bennett, T. (1996), "The Exhibitionary Complex." In R. Greenberg, B. W. Ferguson, and S. Nairne (eds), *Thinking about Exhibitions*, 58–80, London: Routledge.

Bennett, T. (1998), "Pedagogic Objects, Clean Eyes and Popular Instruction: On Sensory Regimes and Museum Didactics," *Configurations* 6(3): 345–371.

Bernier, O. (1981), *The Eighteenth-Century Woman*, New York: Metropolitan Museum of Art.

Blanco, J. F. and R. J. Vázquez-Lopez (2013), "Body Damage: Exploring the Beauty of Damaged Clothing," Unpublished paper delivered at *Uncommon Beauty*, Midwest Region Annual Meeting & Symposium, Chicago, Illinois, September 20–21, 2013.

Bok Kim, S. (1998), "Is Fashion Art?" *Fashion Theory* 2 (1): 51–72.

Bolton, A. (2004), *WILD: Fashion Untamed*, New York: Metropolitan Museum of Art.

Bolton, A. and H. Koda (2010), "American Woman: Fashioning a National Identity," Exhibition book, Costume Institute Archives, Metropolitan Museum of Art.

Bowles, H. (2014), *Vogue and the Metropolitan Museum of Art Costume Institute: Parties, Exhibitions, People*, New York: Abrams.

Breck, J. (1932), "A Special Exhibition of Costumes," *The Metropolitan Museum of Art Bulletin* 27 (5): 121–126.

Brentnall, M. (1956), "The Museum of Costume," *Coming Events in Britain*, July: 36–37, 50.

Breward, C. (1995), *The Culture of Fashion: A New History of Fashionable Dress*, Manchester: Manchester University Press.

Breward, C. (2003a), *Fashion*, Oxford: Oxford University Press.

Breward, C. (2003b), "Shock of the Frock," *The Guardian*, 18 October: B18.

Brieber D., M. Nadal, H. Leder, and R. Rosenberg (2014), "Art in Time and Space: Context Modulates the Relation between Art Experience and Viewing Time," *PLoS ONE* 9(6): e99019. https://doi.org/10.1371/journal.pone.0099019

"A Brief Statement Concerning the Set-up of the Museum of Costume Art" (1941), January 14, 1941, Metropolitan Museum of Art Archives Office of the Secretary Subject Files 1870–1950, C82393: "Costume Art Museum 1936–44, 1946".

Briggs, R. T. (1972), "Displaying Your Costumes: Some Effective Techniques," *American Association for State and Local History Technical Leaflet 33, rev. ed., History News* 27: 11.

"Bringing the Past to Life" (1911), *New York Times*, 13 August: 8.

Brooks, M. M. (2016), "Reflecting Presence and Absence: Displaying Dress of Known Individuals," In M. M. Brooks and D. D. Eastop (eds), *Refashioning and Redress: Conserving and Displaying Dress*, 19–32, Los Angeles: Getty Conservation Institute.

Brooks, M. M. and D. D. Eastop (eds) (2016), *Refashioning and Redress: Conserving and Displaying Dress*, Los Angeles: Getty Conservation Institute.

Brunn, M. and J. White (2002), *Museum Mannequins*, Edmonton: Alberta Regional Group of Conservators.

Brush, R. (1948), "Museums and the Textile Industry," *Museum News* 26 (12) (December 15, 1948): 7–8.

Buck, A. (1958), *Costume. Handbook for Museum Curators, Part D: Art, Section 3*, London: Museums Association.

Buckley, C. and H. Clark (2016), "In Search of the Everyday: Museums, Collections, and Representations of Fashion in London and New York," In H. Jenss (ed.), *Fashion Studies: Research Methods, Sites and Practices*, 25–41, London: Bloomsbury Publishing.

Buick, N. (2012), "Framing Fashion Curation: A Theoretical, Historical and Practical Perspective," PhD thesis, Queensland University of Technology.

Burbank, E. (1917), *Woman as Decoration*, New York: Dodd Mead and Company.

Burbidge, R. (1913), Letter to Sir Cecil Smith, August 16, 1913, Harrods donor file MA/1/H926, Victoria and Albert Museum archives.

Burton, A. (1999), *Vision and Accident: The Story of the Victoria and Albert Museum*, London: V&A Publications.

Bustle (1941), "Fashions in Clothing," *New Zealand Herald*, 11 November: 4.

Byrde, P. (1980), *Museum of Costume*, Bath: Bath City Council.

Byrde, P. (1984), "The Collections and Collecting Policies of the Major British Museums," *Textile History* 15 (2): 147–170.

Byrde, P. (1985), "The Museum of Costume and Fashion Research Centre in Bath," *The Tenth West of England Antiques Fair*, Bath.

Cain, G. et al. (1900), *Musée rétrospectif des classes 85 & 86: Le costume et ses accessoires à l'exposition universelle internationale de 1900, à Paris*, Saint-Cloud: Belin Frères.

Cain, V. (2012), "'Attraction, Attention, and Desire': Consumer Culture as Pedagogical Paradigm in Museums in the United States, 1900–1930," *Paedagogica Historica: International Journal of the History of Education* 48 (5): 745–769.

Calefato, P. (2004), *The Clothed Body*, trans. L. Adams, Berg: Oxford.

Callister, J. H. (1976), *Dress From Three Centuries*, Hartford: Wadsworth Atheneum.

Carpentier, N. (2011), "Facing the Death of the Author: Cultural Professional's Identity Work and the Fantasies of Control," *MATRIZes* 4 (2) (January–June 2011): 183–204.

Carter, J. (1967), "Princess Opens Modesty to Mod Costume Display and Has Fun Doing It," *Globe and Mail*, 17 May: 13.

Cathcart, M. and A. F. Taylor (2014), "Does Fashion Belong in Art Galleries?" *Books and Arts Daily*, 25 November, available online: http://www.abc.net.au/radionational/programs/booksandarts/does-fashion-belong-in-art-galleries/5908890 (accessed December 14, 2017).

Catto, H. (1967), "Modesty to Mod: 187 Years of Style," *The Globe and Mail*, 4 May: W11.

"Caught by the Camera No. 14" (1934), (newsreel), Pathé, 24 December.

Cavallo, A. S. (1963), "Introduction." In *She Walks in Splendor: Great Costumes, 1550–1950*, 7–9, Boston: Museum of Fine Arts, Boston.

Cavallo, A. S. (1971), "Fashion Plate: An Opening Exhibition for the New Costume Institute," *The Metropolitan Museum of Art Bulletin* 30 (1) (August—September 1971): 44–48.

"Century of Style on Display Here" (1945), *Montreal Gazette*, 2 June: 5.

Champigneulle, B. (1951), "Paris Costume Gallery Portrays Two Centuries," *The Globe and Mail*, 5 March: 17.

Champroux, N. (2002), "From Mandarin Silk Ciselé Velvet to Navy Blue Wool Gabardine: Three Centuries of Men's Fashion at the McCord Museum," *Material History Review* 56 (Fall 2002): 63–65.

Charles-Roux, E. (2002), *Théatre de la mode: fashion dolls: The survival of haute couture*, rev. 2nd ed., Portland: Palmer-Pletsch Associates.

Chrisman-Campbell, T. (2017), "Confessions of a Costume Curator," *The Atlantic*, 18 August, available online: https://www.theatlantic.com/entertainment/archive/2017/08/confessions-of-a-costume-curator/536961/ (accessed August 22, 2017).

Christy, M. (1974), "Old-Time Styles by Eleanor Brenner," *Reading Eagle*, 18 June: 11.

Chubb, A. (1986), "Stepping Down through the Ages of French Fashion," *Daily Telegraph*, 22 January: 15.

Church Osborn, W. (1944), Letter to Horace, H.F. Jayne, 20 December 1944, Metropolitan Museum of Art Archives, C82394, Office of the Secretary Subject Files 1870–1950.

Clark, H. and A. Vänskä (2017), "Introduction: Fashion Curating in the Museum and Beyond." In A. Vänskä and H. Clark (eds), *Fashion Curating: Critical Practice in the Museum and Beyond*, 1–15, London: Bloomsbury.

Clark, J. (2011), "Re-Styling History: D.V. At the Costume Institute." In L. Vreeland Immordino (ed.), *Diana Vreeland: The Eye Has to Travel*, 227–243, New York: Abrams.

Clark, J., A. De La Haye, and J. Horsley (2014), *Exhibiting Fashion: Before and after 1971*, London: Yale University Press.

Clark, R. (1975), "The Anne Schofield Costume Collection," *Art Bulletin of Victoria 16*, available online: https://www.ngv.vic.gov.au/essay/the-anne-schofield-costume-collection/ (accessed June 30, 2017).

Clearwater, W. (1980), "How to Make Mannequins," *History News* 35 (12): 36–39.

Clifford, J. (1994), "Collecting Ourselves." In S. M. Pearce (ed.), *Interpreting Objects and Collections*, 258–268, London: Routledge.

Colburn, M. (2018), "Curation and Conservation: And Interview with Sarah Scaturro," *Fashion Projects: On Fashion Curation* 5: 44–49.

Coleman, E. A. (1975), "For Men Only Exhibition," Brooklyn Museum, Records of the Department of Costumes and Textiles: Exhibitions. Of Men Only [September 18, 1975–January 18, 1976] [1] Budget.

Coleman, E. A. (1978), "Exhibits," *Proceedings of the Historical Costume and Textile Workshop*, June 21–24, 1978, East Lansing: Michigan State University.

"The Collection about Which All London Is Talking [advertisement]" (1913), *The Times*, 1 December: 66.

"Collection of Kudos for Galanos" (1954), *LIFE*, 22 November: 147–148.

Corrigan, P. (2008), *The Dressed Society: Clothing, The Body and Some Meanings of the World*, London: Sage.

"Corset Show Opening at the Brooklyn Museum" (1939), Press Release, August 31, 1939. Brooklyn Museum: Records of the Department of Costumes and Textiles: Exhibitions. *Tighten Your Stays Style Foundations: Corsets and Fashion from Yesterday and Today* [9/8/1939 – 10/1/1939].

Cosgrave, B. (2009), "The Model as Muse: Costume Institute Gala 2009," *The Telegraph*, 5 May, available online: http://fashion.telegraph.co.uk/news-features/TMG5280455/The-Model-as-Muse-Costume-Institute-Gala-2009.html (accessed June 30, 2017).

"Costume Display" (1945), *Examiner*, 6 January: 4.

"A Costume Dream Comes True" (1976), *Sydney Morning Herald*, 1 April: 12.

"Costume Institute Becomes Branch of Metropolitan" (1945), *Museum News* 22 (13) (January 1): 1.

The Costume Institute of the Metropolitan Museum of Art (1958), New York: Metropolitan Museum of Art.

"The Costume Institute of the Metropolitan Museum: In Ten Years It Has Grown from an Idea to a Generating Influence on American Fashion" (1947), *Vogue* 109 (5) (March 1, 1947): 210–211, 246, 251.

"Costume Show at Stern's" (1928), *New York Times*, 9 April: 35.

"Costumes Reflect Glamor of the Past" (1983), *The Globe and Mail*, 22 February: F2.

Costume Society of America (n.d.) "Richard Martin Exhibition Awards," available online: http://costumesocietyamerica.com/resources/grants-awards-and-honors/richard-martin-exhibition-awards/(accessed September 21, 2017).

"Court Costume in the 17th Century" (1835), *The Sydney Gazette and New South Wales Advertiser*, 3 March: 4.

Craig, B. (1983), "An Elegant Art: Fashion and Fantasy in the Eighteenth Century by Edward Maeder," *The Public Historian* 5 (4) (Autumn, 1983): 97–99.

Crawley, G. and D. Barbieri (2013), "Dress, Time, and Space: Expanding the Field through Exhibition Making." In S. Black et al. (eds), *The Handbook of Fashion Studies*, 44–60, London: Bloomsbury.

Creed, B. (1986), "Horror and the Monstrous-Feminine: An Imaginary Abjection," *Screen* 27 (1) (January 1, 1986): 44–71.

Crossley, N. (2006), *Reflexions in the Flesh*, Buckingham: Open University Press.

Cumming, V. (2004), *Understanding Fashion History*, London: BT Batsford.

Cunnington, C. W. (1947), "The Scientific Approach to Period Costumes." *Museums Journal* 47 (7) (October 1947): 125–130.

Dafydd Beard, N. (2011), "Defining the Fashion City: Fashion Capital or Style Centre?" In A. De Witt-Paul and M. Crouch (eds), *Fashion Forward*, 219–232, Oxford: Inter-disciplinary Press.

"Dali's Display" (1939), *TIME*, 27 March: 31.

De La Haye, A. (2006), "Vogue and the V&A Vitrine." *Fashion Theory* 10 (1–2): 127–152.

De La Haye, A. and E. Wilson (1999), "Introduction." In A. De La Haye and E. Wilson (eds), *Defining Dress: Dress as Object, Meaning and Identity*,1–9, Manchester: Manchester University Press.

De Pooter, G. (n.d.), "Rising Interest in Fashion Exhibition Underlines Relevance of Europeana Fashion," available online: http://www.europeana.eu/portal/en/blogs/rising_interest_in_fashion_exhibition_underlines_relevance_of_europeana_fashion (accessed November 15, 2017).

De Ruyck, T., J. Van Den Bergh, and D. Van Kemseke (2009), "Even Better than the Real Thing: Understanding Generation Y's Definition of "Authenticity" for the Levi's Brand," Proceedings of the ESOMAR qualitative conference: Marrakech (Morocco), November 16, 2009.

Denegri, D. (2016), "When Time Becomes Space." In L. Marchetti (ed.), *Fashion Curating: Understanding Fashion through the Exhibition*, 299–301, Geneva: HEAD.

Depreaux, A. (1920), "Paris Inaugurates a Hall of Fame for the Mode," *Vogue* 55 (10) (May 15, 1920): 62–63, 142, 144.

Dickason, O. (1962), "Fashion Display Spans 50 Years," *Globe and Mail*, 26 June: 12.

Douglas, C. (2010), "The Spectacle of Fashion: Museum Collection, Display and Exhibition." In B. English and L. Pomazan (eds), *Australian Fashion Unstitched: The Last 60 Years*, 127–150, Cambridge: Cambridge University Press.

"A Dress Museum" (1925), *Evening Post*, 7 November: 16.

Druesedow, J. L. (1987), *In Style: Celebrating Fifty Years of the Costume Institute*. New York: Metropolitan Museum of Art.

Du Mortier, B. M. (2016), *Costume & Fashion*, Amsterdam: Rijksmuseum.

Du Mortier, B. M. and S. Meijer (2016), "Moving Forward Together." In M. M. Brooks and D. D. Eastop (eds), *Refashioning and Redress: Conserving and Displaying Dress*, 237–250, Los Angeles: Getty Conservation Institute.

Dubé, P. (1995), "Exhibiting to See, Exhibiting to Know," *Museum International* 47 (1): 4–5.

Durbin, G. (2002), "Interactive Learning in the British Galleries, 1500–1900," available online: http://media.vam.ac.uk/media/documents/legacy_documents/file_upload/5752_file.pdf (accessed April 24, 2017)

Durrans, B. (1992), "Behind the Scenes: Museums and Selective Criticism," *Anthropology Today*, 8 (4): 11–15.

"Early Costumes" (1939), *New Zealand Herald*, 5 April: 10.

Eastlake, C. (1868*), Hints on Household Taste, in Furniture, Upholstery and Other Details*, London: Longmans Green.

Edwards, E. (1999), "Photographs as Objects of Memory." In M. Kwinth, C. Breward, and J. Aynsley (eds), *Material Memories: Design and Evocation*, 221–236, Oxford: Berg.

The Eighteenth Century Woman (1982), (Film), Dir. Suzanne Bauman and Jim Burroughs. USA: ABC Video Enterprises.

Evans, C. (2003), *Fashion at the Edge: Spectacle, Modernity and Deathliness*, London: Yale University Press.

Evans, C. (2013), *The Mechanical Smile: Modernism and the First Fashion Shows in France and America, 1900–1929*, New Haven: Yale University Press.

"Exhibit Depicts Changing Shape of Ideal Figure" (1957), *New York Times*, 7 November: 57.

"Exhibition of Costumes: Successful Opening in Madison Square Garden" (1895), *New York Times*, 10 March: 8.

Farley, H. (1854), *Happy Nights at Hazel Nook: Or, Cottage Stories*, Boston: Dayton and Wentworth.

"A Fascinating Evocation of the Elegance of the Ancien Régime: Exquisite Period Costumes of the 18th Century Now on View in the Carnavalet Museum, Paris" (1954), *Illustrated London News*, 11 December: 1066–1067.

"Fashion … an Art in the Museums" (1949), *Vogue* 113 (2) (February 1, 1949): 211, 248.

"Fashion Changes" (1934), *The West Australian*, 21 November: 15.

"Fashion Museum Reopens with a Fresh Face" (1983), *The Globe and Mail*, 12 July: F6.

Farrell, J. (1996), "Rooms with a View," *The Getty Bulletin* 10 (1) (summer 1996): 5.

Fee, S. (2014), "Before There Was Pinterest: Textile Study Rooms in North American 'Art' Museums," *Textile Society of America Symposium Proceedings*, Paper 922, available online: http://digitalcommons.unl.edu/tsaconf/922 (accessed June 30, 2016).

"Female Costume" (1833), *The Times*, 30 May: 3.

"Fifth Avenue 'Art in Fashion' Windows Display Art of Metropolitan Museum Arranged in Connection with Museum's Party of the Year for the Costume Institute" (1963), press release, November 12, 1963. Archives, Metropolitan Museum of Art, *Costume Institute Publicity 1953*.

"Fifty Years of Vogue" (1943), *Vogue* 102 (10) (November 15, 1943): 33–36, 109.

Filomena (1914), "Ladies' Page," *Illustrated London News*, 25 April: 690.

"The Fine Art of Costume" (1950), Exhibition Book, Costume Institute Archives, Metropolitan Museum of Art.

The First Monday in May (2016), (Film) Dir. Andrew Rossi, USA: Magnolia Pictures.

Fischer, E. (2016), "Three Perspectives, Three Point of View." In L. Marchetti (ed.), *Fashion Curating: Understanding Fashion through the Exhibition*, 273–275 (Geneva: HEAD).

Flecker, L. (2007), *A Practical Guide to Costume Mounting*, London: Elsevier.

Flugel, J. C. (1930), *The Psychology of Clothes*, London: The Hogarth Press Ltd.

Folch-Serra, M. (1990), "Place, Voice, Space: Mikhail Bakhtin's Dialogical Landscape," *Environment and Planning D: Society and Space* 8: 255–274.

Foreman, L. (2013), "Fashion museums are à la mode," *International Herald Tribune*, 24 September: 12.

Forman, J. (2002), "Fashion à la MoMu: Antwerp's New Museum Combines Earnest Intellectualism and Simple Whimsy," *The Globe and Mail*, 30 November: T3.

Forrest, R. (2013), "Museum Atmospherics: The Role of the Exhibition Environment in the Visitor Experience," *Visitor Studies* 16 (2): 201–216.

Fotheringham, A. (2017), "Exhibition Reviews: 'The Vulgar: Fashion Redefined,'" *Textile History* 48 (1) (May 2017): 133–144.

Freece, H. (2011), "The Gift of a Museum to a Museum: Elizabeth Day McCormick's Textile Collection at the Museum of Fine Arts," *Boston*. MA diss., University of Delaware.

Freeman, H. (2000), "The Fine Art of Fashion," *The Guardian*, 21 July: A10.

Frisa, M. L. (2008), "The Curator's Risk," *Fashion Theory* 12 (2): 171–180.

Fukai, A. (2010), "Dress and Fashion Museums." trans. Brian Moeran, In J. B. Eicher (ed.), *Berg Encyclopedia of World Dress and Fashion: Global Perspectives*, Vol. 10, 288–293, New York: Berg.

"Gallery of Fashion at V. and A.: 360 Years of Styles" (1962), *The Times*, 15 June: 15.

Gamerman, E. (2014), "Are Museums Selling Out?" *The Wall Street Journal*, 12 June, available online: http://www.wsj.com/articles/are-museums-selling-out-1402617631 (accessed August 25, 2015).

Garoian, C. R. (2001), "Performing the Museum," *Studies in Art Education* 42 (3) (Spring 2001): 234–248.

Gaskell, I. (2004), "Costume, Period Rooms, and Donors: *Dangerous Liaisons* in the Art Museum," *The Antioch Review* 62 (4) (Autumn 2004): 615–623.

Gaze, R. P. (1913), Letter to Mr Hart, October 10, 1913. MA/1/H926 NF Harrods Ltd., Victoria and Albert Museum archives.

Germaine (1928), "Museum of Fashion," *The West Australian*, 27 January: 8.

Gerston, J. (1988), "A Look at Victorian Dress," *Toledo Blade*, 25 December: G4.

Gibbs-Smith, C. (1976), "Obituary: James Laver, C.B.E.," *Costume* 10: 123–124.

Giffen J. C. (1970), "Care of Textiles and Costumes," *American Association for State and Local History Technical Leaflet 2*.

Ginsburg, M. (1973), "The Mounting and Display of Fashion and Dress," *Museums Journal* 73 (2): 50–54.

Ginsburg, M. (2005), "The Costume Society: The Early Days," *Costume* 39 (2005): 1–3.

Glassberg, D. (1987), "History and the Public: Legacies of the Progressive Era," *The Journal of American History* 73 (4) (March 1987): 957–980.

Glier Reeder, J. (2010), *High Style: Masterworks from the Brooklyn Museum Costume Collection at the Metropolitan Museum of Art*. New York: Metropolitan Museum of Art.

Glynn, P. (1971), "Beaton at His Own Game." *The Times*, 12 October: 14.

Glynn, P. (1974), "What's a Nice Dress Like You Doing in a Place Like This?" *The Times*, 3 September: 6.

Glynn, P. (1980), "Fashion," *The Times*, 25 March: 7.

Golbin, P. (2017), "The System of Fashion." In P. Berge, O. Gabet, P. Golbin, and D. Bruna, *Fashion Forward: 300 Years of Fashion*, 9–11, New York: Rizzoli.

Goldsmiths Inc. (n.d.), "Ladies for Fashions Circa 1860–1910."

Goldthorpe, C. (1985), "The Herbert Druitt Gallery of Costume," *Museums Journal* 84 (4) (March 1985): 189–190.

Goldthorpe, C. (1988), "From Queen to Empress: Victorian Dress 1837–1877." Exhibition Book, Costume Institute Archives, Metropolitan Museum of Art.

Goldthorpe, C. (1989), *From Queen to Empress: Victorian Dress 1837–1877*, New York: Metropolitan Museum of Art.

Gopnik, B. (2000), "Art or Advertising?" *The Globe and Mail*, 18 November: R7.

"Gowns That Have Cut a Pattern for History" (1916), *Vogue* 47 (11) (June 1, 1916): 59, 104.

Granata, F. (ed.) (2018), *Fashion Projects: On Fashion Curation*, 5.

Grasskamp, W. (2011), "The White Wall—On the Prehistory of the 'White Cube'," *On Curating* 9: 78–90.

"The Gratuitous Exhibitions of London, Ch VI—The Lowther Arcade. Its Economy and Manufactures" (1843), *Punch* 4: 235.

Greenberg, R., Bruce W. Ferguson, and S. Nairne (eds), (1996), *Thinking about Exhibitions*, London: Routledge.

Gresswell, C., J. Hashagen, and J. Wood (2016), "Concepts in Practice: Collaborative Approaches in Developing the Bowes Museum's Fashion and Textile Gallery." In M. M. Brooks and D. D. Eastop (eds), *Refashioning and Redress: Conserving and Displaying Dress*, 145–158, Los Angeles: Getty Conservation Institute.

Gronhammar, A. and S. Nestor (2011), *The Royal Armoury in the Cellar Vaults of the Royal Palace*, Stockholm: Livrustkammaren.

Guichard, C. (2010), "Du 'nouveau connoisseurship' à l'histoire de l'art: Original et autographie en peinture," *Annales HSS* 6 (November–December 2010): 1387–1401.

Haddock, M. (1962), "Not For Men: New Costume Court," *The Builder*, 22 June:1287.

Hall, J. R. (2000), "Cultural Meanings and Cultural Structures in Historical Explanation." *History and Theory* 39: 331–347.

Haller Baggesen, R. (2014), "Museum Metamorphosis à la Mode," *Museological Review* 18: 14–21.

Halls, Z. (1968), "Costume in the Museum," *Museums Journal* 67 (4): 297–303.

Halvarson, E. (1973), "Constructing Life-Size Figures for the Historical Museum," *American Association for State and Local History Technical Leaflet 64, History News*, 28 (6) (June 1973).

Handler, R. and E. Gable (1997), *The New History in an Old Museum: Creating the Past at Colonial Williamsburg*, Durham: Duke University Press.

Hansen, M. (2008), "Matter Matters: Materiality and Meaning," *Jacquard* 62: 4–7.

Harden, R. (1999), "Mary Carnegie," Fashion Museum (Bath), *Exhibition Files*: *Women of Style*.

Harris, J. (1995), "Costume History and Fashion Theory: Never the Twain Shall Meet?" *Bulletin of the John Rylands University Library of Manchester* 77 (1): 73–80.

Harris, J. (2007), *Moving Rooms: The Trade in Architectural Salvages*, New Haven: Yale University Press.

Harris, K. J. (1977), *Costume Display Techniques*, Nashville: American Association for State and Local History.

Hatsian, A. G. (1976), "Costumes Represent Three Centuries," *Hartford Courant*, 18 January: 9E.

"The Health Exhibition. I. The Food and Dress Sections" (1884), *Leeds Mercury*, 14 May: 3.

Healy, R. (2018), "Unfamiliar Places, Local Voices: Four Emerging Curatorial Narratives in Australia (2010–2016)." In A. Vänskä and H. Clark (eds), *Fashion Curating: Critical Practice in the Museum and Beyond*, 57–72, London: Bloomsbury.

Henning, M. (2006), *Museums, Media and Cultural Theory*, Maidenhead: Open University Press.

"The High Fashion of Bygone Days: South Kensington Exhibits" (1946), *Illustrated London News*, 2 November: 499.

Hill Stoner, J. (2012), "International Public Outreach Projects." In J. Hill Stoner and R. Rushfield (eds), *The Conservation of Easel Paintings*, 750–754, London: Routledge.

"Hints to the British Museum Committee" (1847) *Punch* 13: 59.

"History in Clothes" (1962), *The Times*, 19 June: 9.

"History of Styles Shown" (1964), *New York Times*, 22 June: 30.

Hjemdahl, A. (2014), "Exhibiting the Body, Dress and Time in Museums: A Historical Perspective." In M. R. Melchior and B. Svensson (eds), *Fashion and Museums: Theory and Practice*, 117–132, London: Bloomsbury.

Hjemdahl, A. (2016), "Fashion Time: Enacting Fashion as Cultural Heritage and as an Industry at the Museum of Decorative Arts and Design in Oslo," *Fashion Practice* 8 (1): 98–116.

Hollander, A. (1993), *Seeing through Clothes*, Berkeley: University of California Press.

Hooper, L. H. (1874), "The Exhibition of Costumes," *Appleton's Journal* 12: 623–626.

Hooper-Greenhill, E. (2000), *Museums and the Interpretation of Visual Culture*, London: Routledge.

Horsley, J. (2017), "The Absent Shadow: Reflections on the Incidence of Menswear in Recent Fashion Exhibitions," *Critical Studies in Men's Fashion* 4 (1): 11–29.

House of Z (2016) (Film), dir: Sandy Chronopoulos, USA: Condé Nast Entertainment.

ICOM (1990), "Costume Committee Guidelines for Costume Collections," *Costume* 24: 126–128.

Ilg, U. (2004), "The Cultural Significance of Costume Books in Sixteenth-Century Europe." In C. Richardson (ed.), *Clothing Culture 1350–1650*, 29–47, Aldershot: Ashgate Press.

Jerslev, A. (2005), *Performative Realism: Interdisciplinary Studies in Art and Media*, Copenhagen: Museum Tusculanum Press.

Joel, S. (1973), *Fairchild's Book of Window Display*. New York: Fairchild Publications.

Johnson, K. K. P., S. Torntore, and J. B. Eicher (2003a), "Introduction." In K. K. P. Johnson, S. Torntore, and J. B. Eicher (eds), *Fashion Foundations: Early Writings on Fashion and Dress*, 1–3, Oxford: Berg.

Johnson, K. K. P., S. Torntore, and J. B. Eicher, (2003b), "Dressing the Body." In K. K. P. Johnson, S. Torntore, and J. B. Eicher (eds), *Fashion Foundations: Early Writings on Fashion and Dress*, 7–14, Oxford: Berg.

Jones, S. (2010), "Negotiating Authentic Objects and Authentic Selves: Beyond the Deconstruction of Authenticity," *Journal of Material Culture* 15 (2): 181–203.

Kachur, L. (2001), *Displaying the Marvelous: Marcel Duchamp, Salvador Dali, and Surrealist Exhibition*, Cambridge: MIT Press.

Kaplan, F. (2002), "Exhibitions as Communicative Media." In E. Hooper-Greenhill (ed.), *Museum, Media, Message*, 37–59, London: Routledge.

Karaminas, V. and A. Geczy (2012), *Fashion and Art*, London: Berg Publishers.

Katzberg, M. (2011), "Illuminating Narratives: Period Rooms and Tableaux Vivants." In S. Dudley, A. J. Barnes, J. Binnie, J. Petrov, and J. Walklate (eds), *The Thing about Museums: Objects and Experience, Representation and Contestation* 131–142, London: Routledge.

Keck, C. K. (1974), "Care of Textiles and Costumes," *American Association for State and Local History Technical Leaflet 71*.

Kelly, F. M. and R. Schwabe (1925), *Historic Costume: A Chronicle of Fashion in Western Europe, 1490–1790*, New York: Charles Scribner's Sons.

Kimball, F. (1947), "A Fashion Wing in the Museum," *The Philadelphia Museum Bulletin* 43 (215) (November 1947): 2–15.

Kirkham, P. (1998), *Charles and Ray Eames: Designers of the Twentieth Century*, Cambridge MA: MIT Press.

Kjølberg, T. (2010), "Museums and Material Knowledge: The V&A as a Source in Fashion and Textile Design Research." In B. Cook, R. Reynolds, and C. Speight (eds), *Museums and Design Education: Looking to Learn, Learning to See*, 113–124, Aldershot: Ashgate.

Klonk, C. (2009), *Spaces of Experience: Art Gallery Interiors from 1800 to 2000*, New Haven: Yale University Press.

Knell, S. (2012), "The Intangibility of Things." In S. Dudley (ed.), *Museum Objects: Experiencing the Properties of Things, 324–335*, London: Routledge.

Knight, V. (2018), "I Was a Dress Historian Who Couldn't Get Dressed," *Racked*, 3 January, available online: https://www.racked.com/2018/1/3/16796074/body-image-textile-history-dysmorphia-recovery (accessed January 4, 2018).

Koda, H. (2001), "Dress Rehearsal: The Origins of the Costume Institute." Exhibition Book, Costume Institute Archives, Metropolitan Museum of Art.

Koda, H. and A. Bolton (2006), *Dangerous Liaisons: Fashion and Furniture in the Eighteenth Century*. New York: Metropolitan Museum of Art.

Kruckeberg, V. (1990), "Off with Their Heads! Or, Heads, Hair and Mannequins." In *Textiles and Costume on Parade: Exhibition Successes and Disasters*, 92–93, Washington: Harpers Ferry Regional Textile Group.

Kuhn, A. and G. Westwell (2012), *Dictionary of Film Studies*. Oxford: Oxford University Press.

Kusko, J. (1969), "Charm of Period Dressing," *The Australian Women's Weekly*, 16 July: 22–23.

"La France Launders Rare Heirlooms SAFELY!" (1924), *Good Housekeeping* 78 (1) (January 1924): 180.

Labrum, B. (2009), "The Female Past and Modernity: Displaying Women and Things in New Zealand Department Stores, Expositions and Museums, 1920s–1960s." In B. Fowkes Tobin and M. Goggin (eds), *Material Women 1750–1950: Consuming Desires and Collecting Practice*, 315–340, Aldershot: Ashgate.

Labrum, B. (2014), "Expanding Fashion Exhibition History and Theory: Fashion at New Zealand's National Museum since 1950," *International Journal of Fashion Studies* 1 (1): 97–117.

Lague Scharff, L. (2000), "Studying History À La Mode," *New York Times,* 30 April: TR31.

Langley Moore, D. (n.d.), "Laver, James (1899–1975)," *rev. Oxford Dictionary of National Biography*, Oxford University Press, 2004; online edition, May 2007, available online: http://www.oxforddnb.com/view/article/31337 (accessed September 10, 2011)

Langley Moore, D. (1961), "The Display of Costume," *Museums Journal* 60 (11) (February 1961): 275–281.

Langley Moore, D. (1969), *The Museum of Costume Assembly Rooms Bath: Guide to the Exhibition and a Commentary on the Trends of Fashion*, Bath: Fryson & Co.

Laver, J. (1962), "350 Years of European Costume: A New Display at the Victoria and Albert Museum," *Country Life*, 11 June: 1502–1503.

Laver, J. (1967), "Fashion, Art, and Beauty," *The Metropolitan Museum of Art Bulletin* 26 (3) (November 1967): 117–128.

Laver, J. with A. De La Haye (1995), *Costume and Fashion: A Concise History*, Revised, expanded, and updated edition, New York: Thames and Hudson.

Le Bourhis, K. (1992), "Fashion and History: A Dialogue," Exhibition book, Costume Institute Archives, Metropolitan Museum of Art.

Lee, C. (1916), "Evolutions of Fashions of Dress for Women," *Journal of Home Economics* 8 (5) (May 1916): 236–238.

Lee, C. (2018), "How *Ocean's 8* Got Anna Wintour and Kim Kardashian to Help Re-create the Met Gala," *Vulture*, 8 June, available online: http://www.vulture.com/2018/06/how-oceans-8-got-anna-wintour-to-re-create-the-met-gala.html (accessed July 3, 2018).

Leech, J. (1846), "The Great Moral Lesson at Madame Tussaud's," *Punch* 10 (January–June 1846): 210.

Lehmann, U. (1999), "Tigersprung: Fashioning History," *Fashion Theory* 3 (3): 297–322.

Leo, J. (2001), "But Where's the Art?" *U.S. News & World Report*, 14 May: 14.

Levitt, S. (1988), "'A Delicious Pageant of Wedding Fashion Down the Ages': Clothes and Museums," *Social History Curators Group Journal* 15 (1987–1988): 6–9.

'Literary and Other Notes' (1882), *The Times*, 25 August: 4.

Livingstone, D. (1989), "Costumes at an Exhibition," *The Globe and Mail*, 17 August: C1.

Los Angeles County Museum of Art (2016), *Museum Exhibition///Reigning Men: Fashion in Menswear, 1715–2015*, (online video) available online: https://www.youtube.com/watch?v=SWH9xFr2T10 (accessed December 4, 2017).

"Los Angeles Museum Has Costume Gallery" (1953), *The Museum News* 31 (12) (December 15, 1953): 2.

Loschek, I. (2009), *When Clothes Become Fashion: Design and Innovation Systems*, Oxford: Berg.

Loscialpo, F. (2016), "From the Physical to the Digital and Back: Fashion Exhibitions in the Digital Age," *International Journal of Fashion Studies* 3 (2): 222–248.

"Love of History and Art Inspiration of Costume Dolls" (1915), *Brooklyn Daily Eagle* 15 August: 18.

Mackie, E. (1996), "Fashion in the Museum: An Eighteenth-Century Project." In D. Fausch and P. Singley (eds), *Architecture: In Fashion*, 314–342, New York: Princeton Architectural Press.

Mackrell, A. (1997), *An Illustrated History of Fashion: 500 Years of Fashion Illustration*, London: B.T. Batsford Ltd.

Maeder, E. (ed) (1983), *An Elegant Art: Fashion and Fantasy in the Eighteenth Century*, New York: Harry N. Abrams Inc in association with the Los Angeles County Museum of Art.

Maeder, E. (1984), *Dressed for the Country 1860–1900*, Los Angeles: Los Angeles County Museum of Art.

Maglio, D. (2017), "A Brief Historical Overview of the First Major Menswear Exhibition in the United States—*Adam in the Looking Glass* at the Metropolitan Museum of Art, New York, 1950," *Critical Studies in Men's Fashion* 4 (1): 79–88.

Malaher, R. (1989), *Dugald Costume Museum: The Story*, Dugald: Dugald Costume Museum.

Maltz Bovy, P. (2017), "Capsule Contradictions: How Minimalist Dressing Misleads Women," *Vestoj*, February 27, 2017, available online: http://vestoj.com/capsule-contradictions/ (accessed March 3, 2017).

Maleuvre, D. (1999), *Museum Memories: History, Technology, Art*, Stanford: Stanford University Press.

Mannequins: Considerations and Construction Techniques (1988) Ottawa: Canadian Conservation Institute.

Marchetti, L. (2016), "Fashion Curating: Ideas, Issues, and Practices." In L. Marchetti (ed.), *Fashion Curating: Understanding Fashion through the Exhibition*, 207–212, Geneva: HEAD.

Marchetti, L. (2017), "Meaning through Space. A Cross-Reading of Fashion Exhibitions and Fashion Stores," Abstract for Unpublished Conference Paper Delivered at Semiofest, Toronto, July 20, 2017, available online: https://2017.semiofest.com/sessions/meaning-space-cross-reading-fashion-exhibitions-fashion-stores/ (accessed December 14, 2017).

Marinetti, F. T. ([1909] 1973), "The Founding and Manifesto of Futurism." (trans. R. W. Flint). In U. Apollonio (ed.), *The Documents of 20th Century Art: Futurist Manifestos*, 19–24, New York: Viking Press (original edition: "Manifesto del Futurismo," *Gazzetta dell'Emilia*, 5 February).

"Marketing Observer" (1975), *Business Week*, 29 September: n.p.

Maroevic, I. (1998), *Introduction to Museology: The European Approach*. Munich: Verlag Dr Christian Muller-Straten.

Martin, R. (1998), "The Ceaseless Century: 300 Years of Eighteenth Century Costume," Exhibition Binder, Costume Institute Records, Metropolitan Museum of Art.

Martin, R. and H. Koda (1993), *Diana Vreeland: Immoderate Style*, New York: Metropolitan Museum of Art.

Martin, R. and H. Koda, (1994), "Waist Not," Exhibition Book, Costume Institute Archives, Metropolitan Museum of Art.

Martin, R. and H. Koda (1995a), "Bloom," Exhibition Binder, Costume Institute Records, Metropolitan Museum of Art.

Martin, R. and H. Koda (1995b), *Bloom*, New York: Metropolitan Museum of Art.

Martin, R. and H. Koda (1996), "Bare Witness," Exhibition Book, Costume Institute Archives, Metropolitan Museum of Art.

Matthews David, A. (2010), "Exhibition Review: *Reveal or Conceal?*" *Fashion Theory* 14 (2): 245–252.

Matthews David, A. (2018), "Body Doubles: The Origins of the Fashion Mannequin," *Fashion Studies* 1 (1): 1–46, available online: http://www.fashionstudies.ca/body-doubles/ (accessed September 29, 2018).

McCracken, G. (1988), *Culture and Consumption: New Approaches to the Symbolic Character of Consumer Goods and Activities*, Bloomington: Indiana University Press.

McDowell, F. (2015), "Sketching a Silhouette: Histories of Life and Fashion in 'Isabella Blow: Fashion Galore!'," *International Journal of Fashion Studies* 2 (2): 325–330.

McGarvey, E. S. and M. Carnahan (1961), "The Fashion Wing," *Philadelphia Museum of Art Bulletin*, 57 (271) (Autumn 1961): 3–34.

McKendrick, N., J. Brewer, and J. H. Plumb (1982), *The Birth of a Consumer Society: The Commercialization of Eighteenth-Century England*, London: Europa Publications.

McNeil, P. (2009), "Libertine Acts: Fashion and Furniture." In J. Potvin (ed.), *The Places and Spaces of Fashion, 1800–2007*, 154–165, London: Routledge.

"Men in *Vogue*: Jeremy Brett, Patrick Lichfield—We'll Be Seeing You" (1971), *Vogue*, 15 April: 9.

Mendes, V. D. (1983), "Women's Dress since 1900." In N. Rothstein (ed.), *Four Hundred Years of Fashion*, 77–100, London: V&A Publications.

Mendes, V., A. Hart, and A. De La Haye (1992), "Introduction." In N. Rothstein (ed.), *Four Hundred Years of Fashion*, 1–11, London: V&A Publications.

Menkes, S. (1981), "Fresh as a Trianon Milkmaid," *The Times*, 22 December: 9.

Menkes, S. (1983), "Stripping Off for Dressing Up," *The Times*, 31 May: 8.

Menkes, S. (2007), "Museum Integrity vs. Designer Control," *International Herald Tribune*, 26 February: 9–10.

Menkes, S. (2011), "Gone Global: Fashion as Art?" *New York Times*, 4 July, available online: https://mobile.nytimes.com/2011/07/05/fashion/is-fashion-really-museum-art.html (accessed January 13, 2018).

Metropolitan Museum of Art (1907a), "Complete List of Accessions." *The Metropolitan Museum of Art Bulletin* 2 (4) (April 1907): 74–75.

Metropolitan Museum of Art (1907b), "Complete List of Accessions," *The Metropolitan Museum of Art Bulletin* 2 (8) (August 1907): 145–146.

Metropolitan Museum of Art (1908), "Complete List of Accessions," *The Metropolitan Museum of Art Bulletin* 3 (5) (May 1908): 101–105.

Mida, I. (2015a), "Animating the Body in Museum Exhibitions of Fashion and Dress," *Dress* 41 (1): 37–51.

Mida, I. (2015b), "The Enchanting Spectacle of Fashion in the Museum," *Catwalk: The Journal of Fashion, Beauty, and Style* 4 (2): 47–70.

Mida, I. (ed.) (2017), "Scholar's Roundtable Presentation: Everyone Their Own Curator: Professionalism and Authority in the Digital Age," *Dress* 43 (1): 45–61.

Mida, I. (2018), "Fashion in the Vast Museum: An Interview with Alexandra Palmer," *Fashion Projects: On Fashion Curation* 5: 56–62.

Miller, S. (2007), "Fashion as Art: Is Fashion Art?" *Fashion Theory* 11 (1): 25–40.

Mirzoeff, N. (2002), "Intervisuality." In H. Slager (ed.), *Exploding Aesthetics*, 124–133, Amsterdam: Rodopi.

Molli, J. (1963), "Paris Displays Old-Time Fashions," *The Globe and Mail*, 19 January: 13.

De Montaigne, M. ([1575] 1965), "On the Custom of Wearing Clothes," *The Complete Essays of Montaigne*, trans. Donald Frame, Stanford: Stanford University Press: 166–168.

Monti, G. (2013), "After Diana Vreeland: The Discipline of Fashion Curating as a Personal Grammar," *Catwalk: The Journal of Fashion, Beauty and Style* 2 (1): 63–90.

Montpetit, R. (1995), "Making Sense of Space," *Museum International* 47 (1): 41–45.

Moore, D. (1971), "Inspiration & Information: The Costume Institute," *The Metropolitan Museum of Art Bulletin* 30 (1) (August–September 1971): 2–10.

Morgan, F. C. (1936), "The Hereford Museum Costume Collection," *Museums Journal* 36 (9) (December 1936): 369–372.

Morris, B. (1980), "A History of Discomfort, Told by Corsets," *New York Times*, 1 October: C18.

Morris, B. (1988), "Costume Show: Victorian Elegance," *New York Times*, 6 December: B16.

Morris, F. (1913), "Lace and Textiles," *The Metropolitan Museum of Art Bulletin* 8 (5) (May 1913): 110.

Morris, F. (1929), "Exhibition of Eighteenth Century Costumes and Textiles," *The Metropolitan Museum of Art Bulletin* 24 (3) (March 1929): 78–79.

Morris, W. (1882a), *Hopes and Fears for Art*. London: Ellis & White.

Morris, W. (1882b), "The Lesser Arts of Life." In R.S. Poolecet Al (ed.), *Lectures on Art*, 174–232, London: Macmillan.

Moser, S. (2010), "The Devil Is in the Details: Museum Displays and the Creation of Knowledge," *Museum Anthropology* 33 (1): 22–32.

Müller, F. (2016), "The Fashion Exhibition: The Paradox of Proximity and the Production of Spectacle." In L. Marchetti (ed.), *Fashion Curating: Understanding Fashion through the Exhibition*, 253–257, Geneva: HEAD.

Munro, J. (2014), *Silent Partners: Artist and Mannequin From Function to Fetish*, New Haven: Yale University Press.

"Muscarelle Museum Exhibit Traces Career of Cheek" (1985), *William and Mary News* XV (15) (November 20, 1985): 7.

"The Museum as Fashion Centre: Recent Activities at the Brooklyn Museum, New York" (1941), *Museums Journal* 41 (5) (August): 109.

"Museum Exhibits Solve Fashion Enigmas" (1928), *Daily Mail*, 15 October: 10.

The Museum of Costume Picture Book (1971), Bath: Assembly Rooms and Museum of Costume.

"A Museum of Dress" (1896), *Hampshire Telegraph and Sussex Chronicle*, 11 April: 11.

Museum of the City of New York (2016), *A Mannequin Steps into Her Balenciaga* (online video), available online: https://vimeo.com/153427642 (accessed December 4, 2017).

Museums and Galleries Commision (1998), *Standards in the Museum Care of Costume and Textile Collections*, London: Museums, Libraries and Archives Council.

Museums Correspondent (1958), "Dresses from 1730 to 1900: New Costume Exhibition at the V&A," *The Times*, 8 April: 10.

Museums Correspondent (1963), "Bringing Museums to Life," *The Times*, 2 May: 13.

"Museum's Rooms Get 'Occupants': Metropolitan Making Use of Effigies in Rich Costumes" (1963), *New York Times*, 1 December: 171.

National Gallery of Canada (2016), *The White Dress: Masterpiece in Focus* (online video), available online: https://www.youtube.com/watch?v=4l3k34bDSxl (accessed December 4, 2017).

Neilsen, L. (2017), "How Museums and Cultural Institutions Have Shaped the History of Body Diversity," *Fashionista*, December 6, 2017, available online: https://fashionista.com/2017/12/mannequins-fashion-museum-fit-body-exhibit (accessed December 10, 2017).

Nevinson, J. L. (1971), "Clothes and the Historian," *The Metropolitan Museum of Art Bulletin* 30 (1) (August–September 1971): 38–43.

"New Show at ROM" (1989), *Costume Society of America News*, Fall: 7.

"New Treasures in Art Museum" (1911), *New York Times*, 12 May: 11.

"The News of the Day" (1864), *Birmingham Daily Post*, 15 August: 1.

Newton, S. M., et al. (1984), "The Dress Collection Unlock'd … : A Collective Comment," *Costume* 18: 98–101.

Noordegraaf, J. (2004), *Strategies of Display: Museum Presentation in Nineteenth- and Twentieth-Century Visual Culture*, Rotterdam: Nai Publishers.

"Notes and Incidents" (1869), *The Gentleman's Magazine* 226: 373–374.

Novak, J. D. (2010), *Learning, Creating, and Using Knowledge: Concept Maps as Facilitative Tools in Schools and Corporations*, 2nd ed., London: Routledge.

Nunn, J. and D. Langley Moore (1967), *Bath Assembly Rooms and the Museum of Costume: An Illustrated Souvenir*, Bath: Spa Committee of the Bath City Council.

Ocean's 8 (2018), (Film) Dir. Gary Ross, USA: Warner Bros. Pictures.

"Of, But Not For Men Only" (1975), *Visual Merchandising*, December: 36–38.

Old English Costumes: A Sequence of Fashions through the Eighteenth and Nineteenth Centuries (1913), London: Harrods Ltd (The St Catherine's Press).

"Old English Dress: Costume Exhibition at Harrods" (1913), *The Daily Telegraph*, 22 November, Clipping in V&A Harrods donor file MA/1/H926, Victoria and Albert Museum archives.

O'Neill, A. (2008), "Exhibition Review: *Malign Muses: When Fashion Turns Back* and *Spectres: When Fashion Turns Back*," *Fashion Theory* 12 (2): 253–260.

O'Neill, A. (2012), "A Display of 'Articles of Clothing, for Immediate, Personal, or Domestic Use': Fashion at the Great Exhibition." In A. Geczy and V. Karaminas (eds), *Fashion and Art*, 189–200, London: Berg.

"Opening Exhibition of the Costume Institute of the Metropolitan Museum of Art" (1946), Exhibition Book, Costume Institute Archives, Metropolitan Museum of Art.

"Other Times, Other Costumes" (1914), *Vogue* 43 (4) (February 15, 1914): 37, 72.

O'Doherty, B. (1986) *Inside the White Cube: The Ideology of the Gallery Space*. Santa Monica: University of California Press.

Palmer, A. (1988), "Exhibiting Costume," *Museum Quarterly* 16 (4): 9–14.

Palmer, A. (1990) "The Royal Ontario Museum Costume and Textile Gallery, 'Measure for Measure'," *Costume* 24: 113–116.

Palmer, A. (1994), "Exhibition Review: Fashion and History: A Dialogue," *Dress* 21: 93–94.

Palmer, A. (2008a), "Untouchable: Creating Desire and Knowledge in Museum Costume and Textile Exhibitions." *Fashion Theory* 12 (1): 31–64.

Palmer, A. (2008b), "Reviewing Fashion Exhibitions," *Fashion Theory* 12 (1): 121–126.

Palmer, A. (2013), "Looking at Fashion: The Material Object as Subject." In S. Black et al. (eds), *The Handbook of Fashion Studies*, 268–300, London: Bloomsbury.

Palmer, A. (2018), "Permanence and Impermanence: Curating Western Textiles and Fashion at the Royal Ontario Museum." In A. Vänskä and H. Clark (eds), *Fashion Curating: Critical Practice in the Museum and Beyond*, 39–56, London: Bloomsbury.

Pantouvaki, S. and D. Barbieri (2014), "Making Things Present: Exhibition-Maker Judith Clark and the Layered Meanings of Historical Dress in the Here and Now," *Catwalk: The Journal of Fashion, Beauty and Style* 3 (1): 77–100.

Parmal, P. A. (2006), "Textile and Fashion Arts: Their Place in History and in Museums." In P. A. Parmal et al. (eds), *MFA Highlights: Textile and Fashion Arts*, 11–21, Boston: MFA Publications.

"Party of the Year: The Museum Ball" (1960), Programme. Archives, Metropolitan Museum of Art, Costume Institute Publicity 1953.

Parrot, N. (1982), *Mannequins*, trans. Sheila De Vallée, New York: St Martin's Press.

"Pathé Pictorial Technicolour Supplement: Men about Town" (1952), (newsreel), Pathé, 07 August.

Paulocik, C. (1997), "Behind the Seams of an Exhibition." In Canadian Conservation Institute, *Fabric of an Exhibition: An Interdisciplinary Approach*, 23–30, Ottawa: Canadian Conservation Institute.

Pearce, S. M. (1992), *Museums, Objects and Collections: A Cultural Study*, London: Leicester University Press.

Pecorari, M. (2012a), "'The MoMu Effect': On the Relation between Fashion Design and Fashion Museum." In M. Ballarin and M. Dalla Mura (eds), *Museum and Design Disciplines*, 11–128, Venice: IUAV University of Venice.

Pecorari, M. (2012b), "Vreeland after Vreeland: On Fashion Curating," *Contributor Magazine*, Summer 2012: 56–57.

Peers, A. (2014), "Charles James: Beyond Fashion and the Met Costume Institute's Missed Opportunities," *Artnet News*, July 10, 2014, available online: https://news.artnet.com/exhibitions/charles-james-beyond-fashion-and-the-met-costume-institutes-missed-opportunities-2-58491 (accessed December 14, 2017).

Penny, H. G. (2002), *Objects of Culture: Ethnology and Ethnographic Museums in Imperial Germany*, Chapel Hill: University of North Carolina Press.

"Personal News and Gossip" (1851), *The Leader*, 24 May: 483.

Petrov, J. (2004), "Exhibition Review: Dangerous Liaisons: Fashion and Furniture in the 18th Century," *Dress: The Journal of the Costume Society of America* 31: 76–77.

Petrov, J. (2008), "'The Habit of Their Age': English Genre Painters, Dress Collecting, and Museums, 1910–1914," *Journal of the History of Collections* 20 (2): 237–251.

Petrov, J. (2011), "Playing Dress Up—Inhabiting Imagined Spaces through Museum Objects." In S. Dudley, A. J. Barnes, J. Binnie, J. Petrov, J. Walklate (eds), *The Thing about Museums: Objects and Experience, Representation and Contestation*, 230–241, London: Routledge.

Petrov, J. (2012), "Cross-Purposes: Museum Display and Material Culture," *CrossCurrents*, 62 (2) (June 2012): 219–223.

Petrov, J. (2014a), "'Relics of Former Splendor': Inventing the Costume Exhibition, 1833–1835," *Fashion, Style & Popular Culture* 2 (1) (October 2014): 11–28.

Petrov, J. (2014b). "Gender Considerations in Fashion History Exhibitions." In M. Riegels Melchior and B. Svensson (eds), *Fashion and Museums: Theory and Practice*, 77–90, London: Bloomsbury.

"Philadelphia Museum of Art" (1950), *Museum News* 27 (9) (April 1): 3.

Pick, F. (1938), "The Form and Purpose of a Local Museum," *Museums Journal* 38 (6): 285–306.

Planché, J. R. (1834), *History of British Costume from the Earliest Period to the Close of the 18th Century*, London: Charles Knight.

Pope, V. (1945), "Costumes on View Span 4 Centuries," *New York Times*, 1 April: 37.

Postrel, V. (2007), "Dress Sense: Why Fashion Deserves Its Place in Art Museums," *The Atlantic*, May: 133.

Potvin, J. (2009), "Introduction: Inserting Fashion into Space." In J. Potvin (ed.), *The Places and Spaces of Fashion, 1800–2007*, 1–15, London: Routledge.

Potvin, J. (2012), "Fashion and the Art Museum: When Giorgio Armani Went to the Guggenheim," *Journal of Curatorial Studies* 1 (1): 47–63.

Preziosi, D. (2007), "The Art of Art History." In S. Knell (ed.), *Museums in the Material World*, 11–117, London: Routledge.

Preziosi, D. and C. Farago (2004), "General Introduction: What Are Museums For?" In D. Preziosi and C. Farago (eds), *Grasping the World: The Idea of the Museum*, 1–10, London: Ashgate.

Purdy, D. L. (ed.) (2004), *The Rise of Fashion: A Reader*, Minneapolis: University of Minnesota Press.

"Queen Sees Unique Dress Show" (1951), *Illawarra Daily Mercury*, 23 January: 6.

Rasche, A. (1995), "Peter Jessen, der Berliner Verein Moden-Museum und der Verband der deutschen Mode-Industrie, 1916 bis 1925," *Waffen-und Kostümkunde: Zeitschrift der Gesellschaft für Historische Waffen-und Kostümkunde* 3 (37): 65–92.

Reporter, Our Own (1962), "'No Heads' A Problem for Costume Exhibition," *The Guardian*, 15 February: 19.

Representative, Our Special (1937), "Dress as a Guide to History," *The Observer*, 12 December: 3.

Ribeiro, A. (1983), "Reviews of Exhibitions," *Costume* 17: 154–157.

Ribeiro, A. (1994), "Antiquarian Attitudes—Some Early Studies in the History of Dress," *Costume* 28: 60–70.

Ribeiro, A. (1995), *The Art of Dress: Fashion in England and France, 1750–1820*, London: Yale University Press.

Ribeiro, A. (2003), *Dress and Morality*, Oxford: Berg.

Rice, A. (1955), "Easter Wears Yesteryear Elegance," *Denton Record-Chronicle*, 20 March: 43.

Ricoeur, P. (1980), "Narrative Time," *Critical Inquiry* 7 (1), "On Narrative" (Autumn 1980): 169–190.

Ricoeur, P. (2004), *Memory, History, Forgetting*, trans. Kathleen Blamey and David Pellauer, Chicago: University of Chicago Press.

Riegels Melchior, M. (2011), "Fashion Museology: Identifying and Contesting Fashion in Museums." Full Paper Draft, Presented at "Fashion: Exploring Critical Issues' Conference, Mansfield College, Oxford, September 2011.

Riegels Melchior, M. (2012), "Vanity Fair: Understanding Contemporary Links of Fashion, Museum and Nation," *Ethnologia Europaea* 42 (1): 54–61.

Riello, G. (2011), "The Object of Fashion: Methodological Approaches to the History of Fashion," *Journal of Aesthetics and Culture* 3: 1–9.

Riley, Robert (1987), "Museum a la Mode," *Dress* 13: 82–85.

Roberts, P. (1976), "Costumes Are Curator's Business," *The Milwaukee Journal*, 28 July: 6.

Robinson, J. and T. Pardoe (2000), *An Illustrated Guide to the Care of Costume and Textile Collections*, London: Museums and Galleries Commission.

Roche, D. (1994), *The Culture of Clothing: Dress and Fashion in the Ancien Régime*, trans. Jean Birrell, Cambridge: Cambridge University Press.

Romano, A. (2011), "Yohji Yamamoto and the Museum: A Contemporary Fashion Narrative." In L. Salazar (ed.), *Yohji Yamamoto*, 102–127, London: Victoria and Albert Museum.

Rose, C. (2014), *Art Nouveau Fashion 1890–1914*, London: V&A Publishing.

Rosenthal, N. (2004), "Fashion Statement: Defending Couture's Place in the Art museum," *Art + Auction* 26 (7) (January 2004): 38, 103.

Rosenstein, L. (1987), "The Aesthetic of the Antique," *Journal of Aesthetics and Art Criticism* 45 (4) (Summer 1987): 393–402.

Royle, N. (2003), *The Uncanny: An Introduction*, Manchester: Manchester University Press.

Rydell, R. (2011), "World Fairs and Museums." In S. MacDonald (ed.), *A Companion to Museum Studies*, 135–151, Hoboken, NJ: Wiley-Blackwell.

Saillard, O. (2015), "The Impossible Wardrobe." In T. Swinton and O. Saillard (eds), *The Impossible Wardrobe*, 6–7, New York: Rizzoli.

Sala, G. A. (1859), *Twice Round the Clock: Or, the Hours of the Day and Night in London*, London: Houlston and Wright.

Salber Phillips, M. (2003), "Historical Distance and the Transition from Enlightenment to Romantic Historiography," *PMLA Special Topic: Imagining History* 118 (3) (May 2003): 436–449.

Sandberg, M. B. (2003), *Living Pictures, Missing Persons: Mannequins, Museums and Modernity*, Princeton: Princeton University Press.

Sandell, R. and E. Nightingale (eds.) (2012), *Museums, Equality and Social Justice*, London: Routledge.

Scaturro, S. (2018), "Confronting Fashion's Death Drive: Conservation, Ghost Labor, and the Material Turn Within Fashion Curation." In A. Vänskä and H. Clark (eds), *Fashion Curating: Critical Practice in the Museum and Beyond*, 21–38, London: Bloomsbury.

Scaturro, S. and J. Fung (2016), "A Delicate Balance: Ethics and Aesthetics at the Costume Institute, Metropolitan Museum of Art, New York." In M. M. Brooks and D. D. Eastop (eds), *Refashioning and Redress: Conserving and Displaying Dress*, 159–172, Los Angeles: Getty Conservation Institute.

Schneider, S. K. (1995), *Vital Mummies: Performance Design for the Show-Window Mannequin*, New Haven: Yale University Press.

Schneider, S. K. (1997), "Body Design, Variable Realisms: The Case of Female Fashion Mannequins, *Design Issues* 13 (3) (Autumn 1997): 5–18.

Schwartz, J. (2010), "Curatorial Practices in Museums Housing Fashion and Dress Collections in The United States and the United Kingdom," M.Sc. diss., University of Georgia.

Schwarzer, M. (2008), "Literary Devices: Period Rooms as Fantasy and Archetype," *Curator* 51 (4): 355–360.

Shaw, C. and M. Chase (1989), *The Imagined Past: History and Nostalgia*, Manchester: Manchester University Press.

Silverman, D. (1986), *Selling Culture*, New York: Pantheon.

Silverstone, R. (1994), "The Medium Is the Museum." In R. Miles and L. Zavala (eds), *Towards the Museum of the Future: New European Perspectives*, 161–176, London: Routledge.

Sixty Years of Fashion (1960) (Film), Dir. Sam Napier-Bell, UK: Basic Films

Smith, A. (1842), "The Physiology of the London Idler. Chapter 4 of the Pantheon, Considered in Relation to the Lounger," *Punch* 3 (July–December 1842): n.p.

Smith, J. K. and L. F. Smith (2001), "Spending Time on Art," *Empirical Studies of the Arts* 19 (2): 229–236.

Smith, R. (2010), "The Art of Style and the Style of Art," *New York Times*, 6 May: C21.

Smithsonian Institution (1963), *The United States National Museum Annual Report for the Year Ended June 30, 1963*, Washington, DC: Smithsonian Institution.

Smithsonian Institution (1964), *The United States National Museum Annual Report for the Year Ended June 30, 1964*. Washington, DC: Smithsonian Institution.

Socha, M. (2003), "Museum Quality," *W*, 1 November: 106.

Staniszewski, M. A. (1998), *The Power of Display: A History of Exhibition Installations at the Museum of Modern Art*, Cambridge: MIT Press.

Steele, R. (1712), "No. 478 (Proposal for a Repository of Fashions)," *The Spectator* 3 (478), (September 8, 1712): 219–220.

Steele, V. (1991), "The F-Word," *Lingua Franca* (April 1991): 17–20.

Steele, V. (2008), "Museum Quality: The Rise of the Fashion Exhibition," *Fashion Theory* 12 (1): 7–30.

Steele, V. (2012), "Fashion." In A. Geczy and V. Karaminas (eds), *Fashion and Art*, 13–28, New York: Berg, 2009.

Steele, V. ([2012] 2016), "The Rise of the Fashion Museum." In V. Steele (ed.), *Fashion Designers A–Z: The Collection of the Museum at FIT*, 19–31, Koln: Taschen.

Stevens, J. C. (1932), "Home-Made Costume Models," *The Museums Journal* 32 (9) (September 1932): 226–227.

Stevenson, Mrs. C. (1908), "Historic Costumes," *Bulletin of the Pennsylvania Museum*, 6 (23) (July 1908): 41–44.

Stevenson, N. J. (2008), "The Fashion Retrospective," *Fashion Theory* 12 (2): 219–236.

"Styles of Dress Shown in Exhibit" (1976), *The Day*, 17 January: 21.

"Styles Reflect Changing Times" (1952), *Halifax Gazette*, 15 May: 2A.

Summerfield, P.M. (1980), "Guidelines for Curating a Costume and Textiles Collection," *Curator: The Museum Journal* 23 (4): 287–291.

Summers, E. and E. Uttley (n.d.), "Great Names of Fashion," *Berg Fashion Library*, available online: https://www-bloomsburyfashioncentral-com.login.ezproxy.library. ualberta.ca/products/berg-fashion-library/exhibition/great-names-of-fashion (accessed December 13, 2017).

Swann, P. (1968), "The Director of the Royal Ontario Museum." In University of Toronto, *President's Report, Part One, For the Year Ended June 1967*, 252–296, Toronto: University of Toronto.

Sykas, P. (1987), "Caring or wearing?" *Museums Journal* 87 (3): 155–157.

Tarrant, N. (1983), *Collecting Costume*, London: George Allen and Unwin.

Tarrant, N. (1999), "The Real Thing: The Study of Original Garments in Britain since 1947," *Costume* 33 (1): 12–22.

Tavoularis, S. (1954), "Glimpse of the Past," Unpublished Press Photograph Print with Caption, November 29, 1954, New York: United Press Association.

Taylor, L. (1998), "Doing the Laundry? A Reassessment of Object-Based Dress History," *Fashion Theory* 2 (4): 337–358.

Taylor, L. (2002), *The Study of Dress History*, Manchester: Manchester University Press.

Taylor, L. (2004), *Establishing Dress History*, Manchester: Manchester University Press.

Taylor, M. (2005), "Culture Transition: Fashion's Cultural Dialogue between Commerce and Art," *Fashion Theory* 9 (4): 445–480.

"Television" (1963), *The New York Times*, 16 December: 52.

Teunissen, J. (2016), "Fashion Curating: Broadening the Scope." In L. Marchetti (ed.), *Fashion Curating: Understanding Fashion through the Exhibition*, 289–292, Geneva: HEAD.

Thomas, T. (1935), "Costume Display," *The Museums Journal*, April 1935: 1–9.

Thornton, P. (1962), "The New Arrangement of the Costume Court in the Victoria & Albert Museum," *Museums Journal* 62 (1) (June 1962): 326–332.

"Tighten Your Stays" (1939), Brooklyn Museum: Records of the Department of Costumes and Textiles: Exhibitions. Tighten your Stays Style Foundations: Corsets and Fashion from Yesterday and Today [9/8/1939 – 10/1/1939].

Timbs, J. (1855), *Curiosities of London*, London: David Bogue.

Topalian, E. (1992), "The New Costume Institute," *New York Magazine*, 7 December: 3A–18A.

Townsend Rathbone, P. (1963), "Foreword," *She Walks in Splendor: Great* Costumes, *1550–1950*, Vol. 5, Boston: Museum of Fine Arts, Boston.

Tregidden, J. (1989), "Reviews of Exhibitions: Fashion and Surrealism," *Costume* 23: 144–146.

Treleaven, E. (2017), "Living Garments: Exploring Objects in Modern Fashion Exhibitions," *Journal of Dress History* 1 (2): 70–83.

Udé, I. (2011), "Special Guest/PATRICIA MEARS: Talks about her #1 Outfit. #1 in Twelve Acts + with Introduction," *The Chic Index*, 14 December, available online: http://thechicindex.com/special-guestpatricia-mears-talks-about-her-1-outfit-1-in-twelve-acts/(accessed April 30, 2017).

Usher, E. (1958), "Museum Specializes in Fashions," *The Windsor Daily Star*, 9 September: 25.

"Verhüllungs-Kunst" (2012), *Elle* (Germany), February: 32–38.

"The Victoria and Albert Museum" (1904), *The Times*, 1 April: 5.

Victoria and Albert Museum (2015), *Alexander McQueen: Savage Beauty—Exhibition Build*, [online video], available online: https://www.youtube.com/watch?v=rm8Tu36d-PQ (accessed December 4, 2017).

"Victorian and Edwardian Costume: Exhibition at the Metropolitan Museum of Art" (1939) *Museums Journal* 39 (2) (May): 72–73.

Von Boehm, M. (1917), "Zweihundert Jahre Kleiderkunst: Die Ausstellung Des Vereins Modemuseum In Berlin," *Dekoratlve Kunst* 20 (8) (May 1917): 257–264.

Von Boehn, M. ([1929] 1972), *Dolls*, trans. Josephine Nicoll, New York: Dover Publications.

Wacoal Corporation (n.d.), "The 19th Century Woman Mannequins."

Wallerstein, I. (1998), "The Time of Space and the Space of Time: The Future of Social Science," *Political Geography* 17 (1): 71–82.

Waskul, D. and P. Vannini (2006), "Introduction: The Body in Symbolic Interaction." In D. Waskul and P. Vannini (eds), *Body/Embodiment: Symbolic Interaction and the Sociology of the Body*, 1–18, Abingdon: Ashgate.

Watson, L. (1982), "Fashion Exhibit at the Met," *The New York Times*, 24 January: SM78.

Wehner, K. (2011), "Photography—Museum: On Posing, Imageness and the *Punctum*." In S. Dudley, A. J. Barnes, J. Binnie, J. Petrov, and J. Walklate (eds), *The Thing about Museums*, 79–94, London: Routledge.

Weissman, P. (1977), "The Costume Institute: The Early Years." In Metropolitan Museum of Art, *Vanity Fair: Treasure Trove of the Costume Institute*, n.p., New York: Metropolitan Museum of Art.

Welters, L. (2007), "Introduction: Fashion and Art." In L. Welters and A. Lillethun (eds), *The Fashion Reader*, 253–255, Oxford: Berg.

Whittlin, A. S. (1949), *The Museum: Its History and Its Tasks in Education*, London: Routledge.

Wilcox, C. (2016), "Radicalizing the Representation of Fashion: Alexander McQueen at the V&A, 1999–2015." In M. M. Brooks and D. D. Eastop (eds), *Refashioning and Redress: Conserving and Displaying Dress*, 187–198, Los Angeles: Getty Conservation Institute.

Wilson, E. (2010), *Adorned in Dreams: Fashion and Modernity*. Revised and updated ed., London: I.B. Tauris.

Wingfield, L. (1884), *Notes on Civil Costume in England From the Conquest to the Regency as Exemplified in the International Health Exhibition South Kensington*, London: William Clowes and Sons.

Witzig, D. (2012), "My Mannequin, Myself: Embodiment in Fashion's Mirror." In S. Tarrant and M. Jolles (eds), *Fashion Talks: Undressing the Power of Style*, 83–98, New York: State University of New York Press.

Wölfflin, H. (1932), *Principles of Art History, The Problem of the Development of Style in Later Art*, 7th ed., trans. M. D. Hottinger, New York: Dover Publications.

Wood, E. (2016), "Displaying Dress: New Methodologies for Historic Collections," PhD thesis, University of Manchester.

"24 Hours with Sonnet Stanfill" (2012), 16 May, available online: http://www.stylist.co.uk/stylist-network/work-life/sonnet-stanfill-curator-at-the-vanda (accessed November 16, 2016).

Wright, R. (1919), "The School of the Pageant," *Art & Life* 11 (3) (September 1919): 162–167.

Young Frye, M. (1977) "Costume as History," *Museum News* 56 (2): 37–42.

Zarrella, K. (2010), "Fashion Intelligence: An In-Depth Interview with Valerie Steele, Director and Curator-in-Chief of the Museum at the Fashion Institute of Technology," *Dossier Journal*, November, available online: https://www.dossierjournal.com/style/fashion/in-conversation-with-valerie-steele/ (accessed November 16, 2016).

INDEX